Lúcia Nagib is Professor of Film at the University of Reading. Her books include *Brazil on Screen: Cinema Novo, New Cinema, Utopia* (I.B.Tauris, 2007) and *World Cinema and the Ethics of Realism* (2011). Her books as editor include *The New Brazilian Cinema* (I.B.Tauris, 2003), *Realism and the Audiovisual Media* (with Cecília Mello, 2009) and *Theorizing World Cinema* (with Chris Perriam and Rajinder Dudrah, I.B.Tauris, 2011). She is series editor of Tauris's *World Cinema* series.

Anne Jerslev is Professor of Film and Media Studies at the University of Copenhagen. She is the author of books about David Lynch, cult films, youth and violent cinema, and media and intimacy. She is the editor of *Realism and 'Reality' in Film and Media* (2002) and, with Rune Gade, *Performative Realism* (2004).

'This well-conceived collection takes up Bazin's call for an "impure cinema". The call is defined not as a precious definition of the cinema as object, but as an iterative and sensuous search for a method of making, seeing and feeling film. Nagib and Jerslev have brought together contributors of both great experience and huge promise. This book allows us a less circumscribed and more joyous access to world cinema.'

Stephanie Hemelryk Donald
ARC Professorial Future Fellow in Comparative Film
and Cultural Studies, University of New South Wales

'Demonstrating precisely why this is the perfect moment to return to André Bazin's concept of "impure cinema", this new collection argues that connections between the intermedial and the intercultural lie at the heart of the future of film studies. Seizing the controversial implications of the concept of impurity, this book makes a major contribution to debates about how and why the cinema is always implicated in political landscapes. The two excellent opening essays by Philip Rosen and Lúcia Nagib set the theoretical agenda for this transnational collection of essays on film's dynamic life across aesthetic and geographical borders.'

Jackie Stacey
Professor of Media and Cultural Studies, University of Manchester

'*Impure Cinema* provides a much-needed discussion of the relation between cinema and the other arts.'

Torben Grodal
Professor of Film and Media Studies, University of Copenhagen

TAURIS WORLD CINEMA SERIES

Series Editor: Lúcia Nagib, Professor of Film, University of Reading
Advisory Board: Laura Mulvey (UK), Dudley Andrew (USA), Robert Stam (USA), Ismail Xavier (Brazil)

The **Tauris World Cinema Series** aims to reveal and celebrate the richness and complexity of film art across the globe, exploring a wide variety of cinemas set within their own cultures and as they interconnect in a global context.

The books in the series will represent innovative scholarship, in tune with the multicultural character of contemporary audiences. They will also draw upon an international authorship, comprising academics, film writers and journalists.

Published and forthcoming in the World Cinema series:

Brazil on Screen: Cinema Novo, New Cinema, Utopia
By Lúcia Nagib

Contemporary New Zealand Cinema
Edited by Ian Conrich and Stuart Murray

East Asian Cinemas: Exploring Transnational Connections on Film
Edited by Leon Hunt and Leung Wing-Fai

Impure Cinema: Intermedial and Intercultural Approaches to Film
Edited by Lúcia Nagib and Anne Jerslev

Lebanese Cinema: Imagining the Civil War and Beyond
By Lina Khatib

New Argentine Cinema
By Jens Andermann

New Directions in German Cinema
Edited by Paul Cooke and Chris Homewood

New Turkish Cinema: Belonging, Identity and Memory
By Asuman Suner

On Cinema
Glauber Rocha
Edited by Ismail Xavier

Performing Authorship: Self-inscription and Corporeality in the Cinema
By Cecilia Sayad

Realism of the Senses in Contemporary World Cinema: The Experience of Physical Reality
By Tiago de Luca

Theorizing World Cinema
Edited by Lúcia Nagib, Chris Perriam and Rajinder Dudrah

Viewing Film
By Donald Richie

Queries, ideas and submissions to:
Series Editor, Professor Lúcia Nagib – l.nagib@reading.ac.uk
Cinema Editor at I.B.Tauris, Anna Coatman - acoatman@ibtauris.com

Impure Cinema

INTERMEDIAL AND INTERCULTURAL APPROACHES TO FILM

Edited by Lúcia Nagib and Anne Jerslev

I.B. TAURIS

LONDON · NEW YORK

Published in 2014 by I.B.Tauris & Co Ltd
6 Salem Road, London W2 4BU
175 Fifth Avenue, New York NY 10010
www.ibtauris.com

Distributed in the United States and Canada Exclusively by Palgrave Macmillan
175 Fifth Avenue, New York NY 10010

ISBN: 978 1 78076 510 5 (HB)
 978 1 78076 511 2 (PB)

A full CIP record for this book is available from the British Library
A full CIP record is available from the Library of Congress

Library of Congress Catalog Card Number: available

Printed and bound in Great Britain by T.J. International, Padstow, Cornwall

Contents

Illustrations

Contributors

Lee Broughton is Teaching Fellow at the Centre for World Cinemas, University of Leeds. His doctoral research, titled 'Rethinking the Western genre's evolutionary model: hybridity, transculturation and national European cinemas', was funded by the Frank Parkinson Scholarship. The resultant thesis questioned Hollywood's claim to fundamental ownership of the Western genre whilst also seeking to redefine our broader understanding of Hollywood's relationship with world cinemas. His recent publications include 'Crossing borders virtual and real: an online community of Spaghetti Western fans finally meet each other face to face on the wild plains of Almeria, Spain' (*Language and Intercultural Communication*).

Paul Cooke is Centenary Professor of World Cinemas at the University of Leeds. He has published widely on contemporary German culture. He is the author of *Speaking the Taboo: A Study of the Work of Wolfgang Hilbig* (2000), *The Pocket Essential to German Expressionist Film* (2002), *Representing East Germany: From Colonization to Nostalgia* (2005) and *Contemporary German Cinema* (2012). His edited books include *World Cinema's Dialogues with Hollywood* (2007), with Stuart Taberner, *German Culture, Politics and Literature into the Twenty-First Century: Beyond Normalization* (2006), with Marc Silberman, *Screening War: Perspectives on German Suffering* (2010) and, with Chris Homewood, *New Directions in German Cinema* (2011).

Armida de la Garza is Associate Professor in the Department of Languages and Culture at Xian Jiaotong-Liverpool University, which she joined in February 2012 to set up Communication and Media Studies. She is a member of the Lingnan Centre for Film Studies Advisory Board and editor of the book series *Topics and Issues in National Cinemas* (New York/London: Continuum) as well as co-editor of the *Transnational Cinema* Journal (Bristol: Intellect). Before joining XJTLU, she was a founding member and Deputy Head of the Division of International Communication at the University of Nottingham Ningbo and, prior to that, Lecturer in the Department of Hispanic and Latin American Studies in the University of Nottingham, UK. She has published on a variety of

topics, ranging from the links between documentary and diaspora, to Realism in Latin American cinema. Her current research projects include cinema and the museum, and experiential learning.

Germán Gil-Curiel is Lecturer in the Division of International Communications, University of Nottingham in Ningbo, China. He has recently submitted his PhD thesis in French and English Literature of the Romantic Period at the University of Sheffield. He holds an MA in Comparative Literature and a BA in Modern Languages (French). Since 2005 he has been a member of the Academy for Teaching and Learning in Higher Education. His main research and teaching interests are the relationship between literature, music and film, and supernatural literature, in particular representations of death, spectres and beasts. He is also a certified literary translator and classical guitarist.

Matthew Harper received a doctorate in Italian Studies from The University of North Carolina at Chapel Hill. He came to Loyola University Maryland in 2009 as Assistant Professor of Italian. He has published articles on the cinematic works of Vittorio De Sica and Cesare Zavattini, on Zavattini's theories of cinema and on adaptation. He has presented papers on Italian episode cinema and its literary roots, gender in Giuseppe De Santis' films, twentieth-century Italian literature and theatre, and adaptations of Dante's *Divina comedia*. His research interests centre on the relationship between literature and Neorealist cinema. His book *Someone Else's Story: Adaptation and Appropriation in the Cinema of Vittorio De Sica and Cesare Zavattini* is forthcoming.

Tatiana Signorelli Heise is Lecturer in the School of Modern Languages and Cultures at the University of Glasgow. She is the author of *Remaking Brazil: Contested National Identities in Contemporary Brazilian Cinema* (University of Wales Press, 2012) and she has published articles on Brazilian audiovisual culture and documentary activism. She is currently conducting research on animal advocacy and environmental films and their broader web-based campaigns.

Brenda Hollweg is Visiting Research Fellow at the University of Leeds, School of Fine Art, History of Art and Cultural Studies. Her current research interests concern the interrelations of politics and aesthetics and the role experience and affect play in the production of knowledge. She is developing a research project on the literary and visual (personal) essay, *Essaying Europe: New Subjectivities after 1989*. In 2010, she produced a 55min video-essay, *The Road to Voting* (accessible via LUTube, University of Leeds). She is also the co-editor (with Stephen Coleman) of a forthcoming volume on the affective and aesthetic dimensions of voting. Brenda has taught at German and British universities on American literature and film, (Anglophone) cultural theory, feminist theory, the subject of collecting, exhibiting cultures and identity formation.

Anne Jerslev is Professor of Film and Media Studies at the University of Copenhagen. She is the author of books about David Lynch, Cult Films, Youth and Violent Cinema, and Media and Intimacy. Among her English language publication are (ed.) *Realism and 'Reality' in Film and Media* (Museum Tusculanum Press, 2002) and (ed. with Rune Gade) *Performative Realism* (Museum Tusculanum Press, 2004). She is currently conducting research on reality-tv and processes of celebrification across 'new' and 'old' media.

Cecília Mello is FAPESP Senior Research Fellow in the Department of History of Art, Federal University of São Paulo, Brazil. She was Postdoctoral Fellow at the Film Department, University of São Paulo (2008–2011). Her research focuses on world cinema – with an emphasis on British and Chinese cinemas – and on issues of audiovisual realism, cinema and urban spaces and intermediality. She has published several essays in Brazil and in the UK and co-edited with Lúcia Nagib *Realism and the Audiovisual Media* (Palgrave, 2009). Her PhD thesis *Everyday Voices: The Demotic Impulse in English Post-war Film and Television* (Birkbeck, 2006) focuses on issues of realism in English film and television. She is currently working on her forthcoming book *Movement and Urban Spaces in Contemporary World Cinema*.

Paulo Filipe Monteiro is Professor of drama, cinema and fiction at Universidade Nova de Lisboa. In 1999–2000 and 2006–2007 he was Dean of the Department of Communication Sciences. Since 2011 he has chaired the MA in Performing Arts and the MA in Communication. He has published numerous articles and five books, and has worked extensively as playwright, actor and director. He has written scripts for seven feature films and one television series. In 2008, he directed his fist short film. Between 2002 and 2006, he was President of the Portuguese Association of Scriptwriters and Playwrights. He was a founding member of the Federation of Scriptwriters in Europe.

Lúcia Nagib is Professor of Film at the University of Reading. Her research has focused, among other subjects, on polycentric approaches to world cinema, new waves and new cinemas, cinematic realism and intermediality. Her single-authored books include *World Cinema and the Ethics of Realism* (Continuum, 2011), *Brazil on Screen: Cinema Novo, New Cinema, Utopia* (I.B.Tauris, 2007), *The Brazilian Film Revival: Interviews with 90 Filmmakers of the 90s* (Editora 34, 2002), *Born of the Ashes: The Auteur and the Individual in Oshima's Films* (Edusp, 1995), *Around the Japanese Nouvelle Vague* (Editora da Unicamp, 1993) and *Werner Herzog: Film as Reality* (Estação Liberdade, 1991). She is the editor of *Theorizing World Cinema* (with Chris Perriam and Rajinder Dudrah, I.B.Tauris, 2011), *Realism and the Audiovisual Media* (with Cecília Mello, Palgrave, 2009), *The New Brazilian Cinema* (I.B.Tauris, 2003), *Master Mizoguchi* (Navegar, 1990) and *Ozu* (Marco Zero, 1990).

Virginia Pitts is Lecturer in Film at the University of Kent. As a scholar-practitioner, her research explores creative processes, various forms of inter-subjective relations, and the permeability of borders between mainstream and experimental or marginal cinemas. She has published in the areas of literary adaptation, political documentary, intercultural film practice and independent digital cinema. Her own practice spans drama, documentary, screen-dance and various hybrid forms for both film and television. Her films *Hassan* (1991), *Trust Me* (2000), *Fleeting Beauty* (2004) and *Beat* (2010) have screened at many of the world's top film festivals, toured art galleries and sold widely.

Griselda Pollock is Professor of Social and Critical Histories of Art and Director of the Centre for Cultural Analysis, Theory and History at the University of Leeds. Known for her major feminist interventions in cultural theory and visual analysis and work on trauma, aesthetics and psychoanalysis, she has written extensively in cultural studies and art history. Major recent publications include *Encounters in the Virtual Feminist Museum: Time, Space and the Archive* (2007), *Digital and Other Virtualities: Renegotiating the Image* (2010, edited with Anthony Bryant), *Bracha L Ettinger: Art as Compassion* (2011, edited with Catherine de Zegher) and *Concentrationary Cinema: Aesthetics as Resistance in Alain Resnais's Night and Fog* (2001, edited with Max Silverman). Forthcoming are *After-affect / After-image: Trauma and Aesthetic Transformation* (2013), *From Trauma to Cultural Memory: Representation and the Holocaust, Visual Politics and Psychoanalyses* (2013) and *Theatre of Memory: Charlotte Salomon's Orphic Journey in* Life? or Theatre? *1941–42*.

Philip Rosen is Professor of Modern Culture and Media at Brown University, where he is also Professor of American Studies and Professor of English, as well as Faculty Associate in the Watson Institute for International Studies. He is a member of the scientific board of the Permanent Seminar on Histories of Film Theories. He has published extensively on cinema, media and culture. Among his publications is *Change Mummified: Cinema, Historicity, Theory* (2001).

Julian Ross is PhD candidate and Lecturer at the Centre for World Cinemas, University of Leeds, researching Japanese independent and experimental cinema of the 1960s–70s as part of the Mixed Cinema Network. He is a commissioning editor for *Vertigo Magazine*, a library assistant at Close-Up Film Centre and a curator of film programmes based in London. His screening projects include programme coordination for 'Theatre Scorpio: Japanese Independent and Experimental Cinema of the 1960s' (July 2011) with Close-Up Film Centre, 'Shinjuku Diaries: Films from the Art Theatre Guild of Japan' (August 2011) at the BFI Southbank, 'Rituals of the Avant-Garde: Film Experiments in 1960s–70s Japan' (February 2013) at Anthology Film Archives and 'ATG and Underground Cinema' (December 2012–February 2013) at

MoMA New York. His publications include contributions to *Encyclopedia of World Cinema* (Routledge, 2013) and *Directory of World Cinema: Japan Vol. 1* (Intellect, 2010) and *Vol. 2* (Intellect, 2012).

Rob Stone is Professor of European Film at the University of Birmingham, where he directs B-Film: The Birmingham Centre for Film Studies. He is the author of *Spanish Cinema* (Longman, 2001), *Flamenco in the Works of Federico García Lorca and Carlos Saura* (Edwin Mellen, 2004), *Julio Medem* (Manchester University Press, 2007) and *Walk, Don't Run: The Cinema of Richard Linklater* (Wallflower/ Columbia University Press, 2013). He co-edited *The Unsilvered Screen: Surrealism on Film* (Wallflower, 2007), with Graeme Harper, *Screening Songs in Hispanic and Lusophone Cinema* (Manchester University Press, 2012), with Lisa Shaw, and *A Companion to Luis Buñuel* (Wiley-Blackwell 2013), with Julián Daniel Gutiérrez Albilla.

Andrew Tudor is Professor in the Department of Theatre, Film and Television at the University of York. He has published extensively in cultural studies, film studies and sociology. His books include *Theories of Film; Image and Influence: Studies in the Sociology of Film; Monsters and Mad Scientists: a Cultural History of the Horror Movie;* and *Decoding Culture: Theory and Method in Cultural Studies.* His current interests are mainly in the area of political cinema.

Haiping Yan is University Professor of Crosscultural Studies and Director of the Institute for Advanced Studies in Media and Society at Shanghai Jiaotong University. Her research interests include comparative drama, critical theory, modern Chinese literary and cultural history, and transnational and interme-dial performance studies. She served on the Executive Committee of the American Society for Theatre Research and worked as the President Elect of Women and Theatre Association. Her publications include *Chinese Women Writers and the Feminist Imagination, 1905–1948* (Routledge 2006, paperback edition 2008); *The Journey of Homecoming: A Collection of Essays on Gender, Culture, and Global Politics* (editor, All China Writers Association Press, 1996 & 1998), *Theatre and Society: An Anthology of Contemporary Chinese Drama* (editor, M.E. Sharpe Publishers, 1998 & 2000), *Other Transnationals: Asian Diaspora in Performance* (a special issue of *Modern Drama*, guest editor and contributor, Summer 2005), and *Globalization and the Development of Humanistic Studies* (co-editor, Shanghai Classics, 2006).

Acknowledgements

Most chapters in this collection originated at the conference 'Impure Cinema: Interdisciplinary and Intercultural Approaches to World Cinema', organized by the Mixed Cinema Network in Leeds, in December 2010. We would like to thank the White Rose Universities Consortium for providing the initial funding of MCN, as well as WREAC (the White Rose East Asia Centre) for their unstinting support of the network. Special thanks go to WREAC's administrator, Jennifer Rauch, who managed the 'Impure Cinema' conference with impeccable competence and dedication. We would like to express our gratitude to WUN (Worldwide Universities Network) that supported the conference with an award from its Fund for International Research Collaboration (FIRC). The participation of Anne Jerslev in this and other MCN events was possible thanks to the Leeds-Copenhagen Universities Agreement. We would like to acknowledge the support of the School of Modern Languages and Cultures and the Centre for World Cinemas, University of Leeds, whose students and staff actively contributed to the conference organization. Our thanks also go to the Leeds Art Gallery, where the conference was held, and the Henry Moore Institute, which offered complementary facilities in their building free of charge. Finally, we must express our gratitude to the Department of Media, Cognition and Communication, University of Copenhagen, for their financial support, as well as to Margarida Gil and João Pedro Monteiro Gil for kindly granting us permission to use a still of God's Comedy (A comédia de Deus, João César Monteiro, 1995) on the cover of this book.

Introduction

Lúcia Nagib and Anne Jerslev

The title of this book, *Impure Cinema: Intermedial and Intercultural Approaches to Film*, draws on André Bazin's provocative call for cinematic hybridization, in his visionary 1951 essay 'Pour un cinéma impur: défense de l'adaptation'. A response to the wave of theatrical and literary adaptations then sweeping through French cinema, as well as to the remnants of a self-defined purist avant-garde, Bazin's article is even more topical today in the face of the spiralling mixture of media that pervades our virtual space. Hugh Gray, in his pioneering rendering of Bazin's writings into English, dating back to 1967, had discreetly concealed the subversive power of such a title by translating it simply as 'In Defense of Mixed Cinema' (1967). Our book resorts to Bazin's original title precisely for its defence of impurity, applying it, on the one hand, to cinema's interbreeding with other arts and media, and on the other, to its ability to convey and promote cultural diversity.

Gray's reluctance to adopt the term 'impure' may have been due to its obvious sexual and racial reverberations, though these serve us well when it comes to reinforcing the inextricable links between the intermedial and intercultural aesthetics and contents of a film. Other aspects of the term, however, deserve further elaboration. *De rigueur*, the expression 'impure cinema' is a tautology, given cinema's very nature as a mixture of arts and media, a fact that Bazin himself was the first to recognize and meditate upon, not least in his most famous essay 'The Ontology of the Photographic Image', written in 1945 (Bazin 1967). In this foundational piece that lays out his evolutionist conception of the arts (addressed by Philip Rosen in Chapter 1 in terms of 'historicity'), Bazin defines photography as an advanced stage of the visual arts, whose mechanical objectivity had liberated painting from its 'obsession with likeness' (1967: 12). Cinema, in its turn, added the properties of time and movement to photography, thus allowing for the first time 'the image of things' to coincide with 'the image of their duration' (15). For this reason, it constituted, for Bazin, the ultimate development in a chain of mimetic arts linking together painting,

sculpture, the death mask and photography. Crucial though it was, Bazin's insight into cinema's relation with (and interdependence on) other arts was not the first of its kind. As Dudley Andrew observes, unbeknownst to Bazin, Walter Benjamin had already in the mid-1930s placed cinema as the ultimate development of the effects of photography on painting, in his no less far-sighted 'Work of Art in the Age of Mechanical Reproduction' (Andrew 2012: 123). But not even those two pre- and post-war visionaries were being entirely original, if one is to consider both the theorists and practitioners of 'pure cinema' themselves. As de la Garza argues in the opening of Chapter 4, already in 1911 'purist' Ricciotto Canudo was celebrating cinema as a 'sixth art' that promoted 'a superb conciliation of the Rhythms of Space (the Plastic Arts) and the Rhythms of Time (Music and Poetry)' (Canudo 1988: 59). Likewise, Rudolf Arnheim, a champion of pure cinema in his early writings, defended film as art only insofar as it resembled painting, music, literature and dance (1957: 8). Many vanguardists, adept in the montage that Bazin so energetically opposed, talked of and made cinema with the help of music, dance, painting, theatre and literature, examples ranging from Fernand Léger's *Ballet mécanique* (1923–4) to *The Fall of the House of Usher* (*La Chute de la maison Usher*, Jean Epstein 1928), which are explicit combinations of all these artistic media. Not to mention Bazin's favourite opponent, Sergei Eisenstein, who arrived at cinema through theatre and whose theory of vertical montage draws on the polyphonic orchestral score whose vertical structure links together, and moves forward, all horizontal staves (1969: 74).

In fact, from its early days cinema never ceased to be defined as hybrid, reasons ranging from its power to emulate pre-existing art forms to its mixed supports. In our day, Robert Stam is an example of someone who attributes cinema's intermedial nature to its technical properties as a medium, in the following terms:

> The intertextuality of cinema … is multitrack. The image track 'inherits' the history of painting and the visual arts, while the sound track 'inherits' the entire history of music, dialogue, and sound experimentation. Adaptation, in this sense, consists of amplifying the source text through these multiple intertexts. (2005: 7)

And yet Epstein, an outspoken member of the theoretical and artistic French avant-gardes, would continue to defend 'pure cinema' as late as 1946, arguing that even in the sound era cinema could be pure by devoting itself to movement and the representation of movement (1974: 412–13). Here we touch one of the cruxes of how Bazin's impure mixture would differ from that of the purists: through montage. For if movement meant cutting and piecing together fragments of reality aimed at composing a different whole on screen, Bazin would take issue with it. Indeed, 'impure' for Bazin seemed to mean in the first place

accepting reality as it offers itself to the camera with all its contingent and apparently irrelevant bits, even if this reality is nothing but a book on which a film is based. This is perhaps how one should understand his defence, in the impure cinema article, of such literal adaptations of literature as were being carried out in his day by the likes of Bresson:

> When Robert Bresson says, before making Le Journal d'un curé de campagne into a film, that he is going to follow the book page by page, even phrase by phrase, it is clearly a question of something quite different [from a Hollywood adaptation] and new values are involved. The cinéaste is no longer content, as were Corneille, La Fontaine or Molière before him, to ransack other works. His method is to bring to the screen virtually unaltered any work the excellence of which he decides on a priori. (Bazin 1967: 54)

This quote reminds us of the complexity of the Bazinian realism, which is not at all averse to artifice so long as it is aimed at warranting the prevalence of the objective over the subjective world. It also indicates that Bazin's defence of impurity is primarily political, as Nagib argues in Chapter 2, putting society and its needs ahead of the artist's creativity. Echoes of such a stance can be found in the French tradition in more recent intermedial studies, such as Jacques Aumont's L'Oeil interminable (2007), a book devoted to the relationship between cinema and painting. Here, Aumont contends that the location of intermedial dialogue in the arts, including cinema, is primarily reality itself, that is, a historical context that causes certain motifs and aesthetic features to recur across different media under varying wrappings of specificity. One interesting example he gives is the 'exceptional similarity' between the Lumière Brothers' Card Game (Partie de cartes, 1896) and Paul Cézanne's 'Les Joueurs de cartes', dating from just a few years earlier. According to Aumont, it is not even clear that the film pioneers were acquainted with the name of Cézanne, leading him to conclude:

> Lumière constitutes a true iconography of the ascending bourgeoisie in itself; hence it is not surprising that he would seem to find painters who ... were equally producing an iconography of the bourgeois in all its states. (Aumont 1989: 17)

Seductive though it is, Aumont's argument is vulnerable to discoveries derived from close analyses which offer irrefutable proof of intentional intertextuality beyond class and other social issues. Angela Dalle Vacche is someone who, in her studies of cinema and painting, takes issue with Aumont and his emphasis on the bigger picture at all costs, proposing instead to 'carve out a space of close

reading' which should at the same time be able 'to achieve broad theoretical ends' (1996: 11).

But this last argument implies a clear perspective shift, through which 'impure cinema' ceases to be an *object* to become a *method*. This is also how this book understands Bazin's provocative expression and how it intends to break away from the tautological impasse, as stated in its subtitle which announces 'intermedial and intercultural *approaches* to film'. By calling impure cinema a method, rather than an object, we are proposing not to betray or thwart Bazin's original purpose but, on the contrary, to bring to the fore his dramatic call for a new, emancipated criticism, capable of understanding cinema beyond the constraints of the medium's specificity. For it was Bazin himself who stated in another prophetic article, 'Adaptation, or the Cinema as Digest', first published in 1948, hence before his 'Impure Cinema' piece:

> the (literary?) critic of the year 2050 would find not a novel out of which a play and a film had been 'made', but rather a single work reflected through three art forms, an artistic pyramid with three sides, all equal in the eyes of the critic. (Bazin 1997: 50)

That Bazin's prediction would come to fruition much earlier than he expected only testifies to its pressing accuracy. Indeed, in recent times, intermediality has increasingly been preferred over more established approaches, such as comparative, intertextual, adaptation and genre studies, for its wider premise that keeps the (very Bazinian) interrogation, 'what is cinema?', constantly on the critic's horizon. Thus the reader of this collection can appreciate the adaptation of *Bicycle Thieves* (Harper, in Chapter 7), the comparison between two Frida Kahlo films (de la Garza, in Chapter 4), the Turkish vision of the Western genre through an Italian comic strip (Broughton, in Chapter 6) and the intertextuality between Linklater's and Weingartner's films (Cooke and Stone, in Chapter 5) in the light of the medium transformations that occur in the process.

However, in order to obtain precision of this method, it is imperative to emphasize that the impure or intermedial approach cannot rule out and indeed depends on the specifics of the medium. Stam is the first to recognize the importance of identifying 'film as film' before undertaking the analysis of 'the migratory, crossover elements shared between film and other media' (2005: 3). At the same time, there is no denying the difficulty in establishing clear borders between neighbouring arts and media, in particular those heavily reliant on ever-evolving technologies, resulting in the constructedness of any attempts to define 'film as film' (or any other arts for themselves) in the first place.

An insightful way out of this conundrum is offered by intermedial studies specialist Irina Rajewsky, who suggests that media borders come into existence most prominently when confronted with, compared against or encompassed

within other media. This she calls 'medial constraints' insofar as 'dance and theatre can never become painting, just as painting itself can never genuinely become photography' (2010: 62). She says: 'By means of intermedial strategies, the possibility *per se* of delimiting different media re-enters the picture; that is, we may conclude that the "idea" of one or another individual medium *can be*, and actually frequently *is*, called up in the recipient' (2010: 60). As an apt illustration, she offers: 'Who ... does not think of theatre when watching Lars von Trier's *Dogville?*' (61). With this she sends us back to the question of the object of study, as it is obvious that *Dogville* (2003) is not a conventional film, but one that purposely resorts to intermediality as a self-questioning device. Likewise, the method embraced in this book determines that the choices of object fall predominantly on films and other forms of audiovisuality which intentionally highlight and rely upon their mixed character in order to convey meaning. Once again, by following this path, this book sides with Bazin, who stated in his impure-cinema defence: 'If the cinema today is capable of effectively taking on the realm of the novel and the theater, it is primarily because it is sure enough of itself and master enough of its means so that it no longer need assert itself in the process' (1967: 69–70).

At the same time, privileging some works to the detriment of others on the basis of medium awareness and self-questioning reflexivity may sound equivalent to embracing Brechtian-style alienation effects, on the basis of their political credentials. Brecht's example is pertinent in this context insofar as he himself was prolific on the multifarious fronts of theatre, radio, music, opera, photography, fine arts, ballet and not least film (Silberman 2000: ix) – and it is worth mentioning that his unrelenting call for medium awareness lends one of the structuring principles to a work such as *Dogville*. Brecht's enthusiasm for mixed media was due precisely to the mutually alienating effect of their use, as he states in his defence of Piscator's recourse to film projections during the staging of his plays, because 'the on-stage actions are alienated by juxtaposition with the more general actions on the screen' (2000: 10). The fragmentation resulting from such a procedure would frontally oppose the all-encompassing impetus of the Wagnerian total artwork that triggered Adorno's famous criticism in the following terms:

> In the dubious quid pro quo of gestural, expressive and structural elements on which Wagnerian form feeds, what is supposed to emerge is something like an epic totality, a rounded and complete whole of inner and outer. Wagner's music simulates this unity of the internal and external, of subject and object, instead of giving shape to the rupture between them. In this way the process of composition becomes the agent of ideology even before the latter is imported into the music dramas via literature. (2005: 27–8)

The belief in the political correctness of medial clash and fragmentation, as opposed to the alleged totalitarianism of artistic fusion, has traditionally been equated, in the cinema, with the opposition between modern anti-illusionism and the classical narrative closure that purportedly conveys an 'impression of reality'. This has been the line of approach embraced by most post-Bazinian French criticism and the inheritors of poststructuralism who have systematically hailed intermedial relations, in particular in Godard's films, as the ultimate expression of modernity thanks to their distancing effect. Bonitzer gives evidence to this thought by discovering a Bakhtinian-sounding dialogic relation in a film such as *Passion* (Jean-Luc Godard 1982), 'as if there were a fight, a scrap in the film between cinema and painting' (1985: 30). He then goes on to define this ambiguity as 'an intrinsic duplicity of the representation, which classicism has strived to reduce and which is the symptom of modernity' (69).

Beyond the Modern Paradigm

This book, however, stops short of choosing between modern or classical styles in the cinema or even of fully acknowledging their existence, as discussed by Nagib in Chapter 2, given the imprecise and contradictory meanings modernity (and consequently classicism) has been given throughout film history. Leaving aside the fact that cinema is itself a result of industrialist modernity, the modernist avant-gardes of the 1920s, who professed pure cinema by resorting to all other arts, would be the obvious candidates for modernity. Surprisingly, however, this is not the view of Bazin and Deleuze, who preferred to date modern cinema from the end of the Second World War and Italian neorealism. Having become prevalent in film studies, this understanding continued to fructify with relation to world new waves from the 1960s and 70s as well as to more recent new cinemas, all defined as 'modern' or 'neo-modern' (Orr 2000) thanks to their recourse to Brechtian-style alienating devices, as epitomized by Godard's use of conflicting media in his films.

For its unhelpful vagueness, but most importantly for its Eurocentric resonance, modernity is not a criterion in this collection that strives to keep a distance from primacies and hierarchies in general. Far from being an exclusively European debate, the communication between different art forms dates as far back as the concept of art itself. As Nagib notes in Chapter 2, Joseph L. Anderson, for example, commenting on the 'commingling media' which participated in the genesis of Japanese cinema, went so far as recalling an old Buddhist saying, according to which 'all arts are one in essence' (1992: 262). Unsurprisingly, Japanese cinema was rarely plagued by the qualms of specificity, welcoming instead the invasion of other art forms, such as noh and other theatrical traditions, in both canonical and experimental films (see Nagib,

in Chapter 2, and Ross, in Chapter 14). Indeed, the world cinema coverage of this book allows for explorations beyond European political and historical paradigms, and this is where the intercultural approach to film avers itself as an indispensable complement to intermediality. This is because it underlines and exemplifies how culture and cultural products are always the result of struggles, negotiations and productive interactions between different systems, practices and interests. Stam rightly calls attention to the 'multicultural nature of artistic intertextuality' (2005: 3), a case in point being precisely cinema, whose industrial nature provides it with a transnational character from birth. From Lumière's travelling the globe with the *cinématographe*, the moving image as well as the moving camera have been crossing cultural boundaries in the same way that they cannibalized pre-existing arts and media. But here again object and method tend to be confused, with a political element being highlighted about recent outputs that reflect in their plot and form on the encounters and frictions of dominant and subaltern cultures. Thus, for example, for Laura Marks:

> Intercultural cinema is characterized by experimental styles that attempt to represent the experience of living between two or more cultural regimes of knowledge, or living as a minority in the still majority white, Euro-American West. (2000: 1)

Likewise, for Hamid Naficy, border-crossing films are eminently experimental:

> Since border subjectivity is cross-cultural and intercultural, border film-making tends to be accented ... Such a strategy undermines the distinction between autochthonous and alien cultures in the interest of promoting their interaction and intertextuality. As a result, the best of the border films are hybridized and experimental – characterized by multifocality, multilinguality, asynchronicity, critical distance, fragmented or multiple subjectivity, and transborder amphibolic characters – characters who might best be called 'shifters'. (2001: 32)

Again, with reference to intercultural relations, this book refrains from ascribing, in principle, a politically progressive, 'modern' and/or experimental character to films which expose in form and content their cross-border intentions. Instead such cases are scrutinized because, among other things, they push intermediality to its ultimate boundary, which is the division between art and life. It is the blurring of this separation, adding the weight of reality onto fiction, that makes a film such as *Whale Rider* (Niki Caro, 2003), explored by Pitts in Chapter 3, so fascinating, as it brings in the participation of the Māori people with their traditions and cultural baggage in the construction of a tale for global consumption. Tearing down walls between fiction and life is indeed the aim of

many intermedial and intercultural projects, starting with Brecht's metaphorical call for the breaking of the fourth wall between stage and audience in the theatre. In 1960s–70s Japan, tearing down the walls of studios and projection rooms was a constant figuration in the films of Imamura, Oshima and Matsumoto, and it is to this atmosphere of liberation fusing art and life that Ross returns in Chapter 14, focusing on the phenomenon of expanded cinema that gave literal expression to the metaphor of tearing down walls through the actual combination of film screening with on-site performance and direct intervention from artists and audiences.

Taking film to the streets was another proposal of Japanese filmmakers in the New Wave days, following an impulse that continues to thrive across the world, as demonstrated by Cooke and Stone in their study of slackers and hobos who, from Linklater's wanderings in the streets of America, migrate back into Weingartner's fiction set in Germany. Travelling as a means of cultural explorations through which film fuses with the real is the focus of many chapters in this book, examples including Varda, Elmas and High (Hollweg, in Chapter 10), Jia Zhangke and contemporary Chinese cinema (Mello, in Chapter 11 and Yan, in Chapter 12) and the cyberactivism of *The Cove* (Louie Psihoyos 2009), in which a multimedia approach to film is used as a means to trespass beyond the cultural borders between a foreign crew and Japanese traditions of slaughtering dolphins (Heise and Tudor, in Chapter 15). Film is no less political when it invades the closed space of museums and galleries to expose cultural as well as racial and gender issues, as in the case of Chantal Akerman, explored by Pollock (Chapter 13). It comes to a point where not only fictional and real walls are broken but also the constraints of medium specificity when cinema is taken over by the Internet, where David Lynch, for instance, exposes the results of a road trip across the US in more than a hundred random interviews left to the user to pick from and watch (Jerslev, in Chapter 16).

Keeping a safe distance from technological utopianisms all too keen to forecast the end of film as film through such post-medium experiments, the point of this book is to open up space to a large variety of impurities from the adaptation of supernatural horror tales (Gil, in Chapter 8) to the poetic obscenities of Portuguese multiartist João César Monteiro (Paulo Monteiro, in Chapter 9), through a lens that celebrates the mixture without spoiling the joy of the cinephile. On the other hand, one must take the concept of film in its wider sense, encompassing a whole gamut of supports which may add to but do not invalidate the findings of traditional film theory (see in this sense Elsaesser and Hagener 2010: 170ff.), including the prophetic insights from Bazin, who, it is worth remembering, always welcomed technological progress. This is precisely what intermedial and intercultural studies allow us to do.

Impure Cinema in Theory and Practice

Being the main source of inspiration for this book, André Bazin could not but inform the theoretical discussions that constitute Part I, called 'The History and Politics of Impurity'. Philip Rosen, a foremost film theorist and Bazin specialist, revisits and redresses in Chapter 1 the ways in which Bazin's ideas had been read in the 1970s as part of a classical film theory concerned with the unique specificity of cinema. If nowadays, he says, some read Bazin more generously as, among other things, a complex and perhaps prescient proponent of impurity, this is because digital media have contributed to an intense and extensive awareness of the hybridization of any single 'medium', though this awareness often threatens to limit itself to a certain technological and phenomenological immediacy. In his view, film and media theory must constantly confront the historicity of theoretical conceptualization, but the corollary should be that it must also confront the historicity of film and media. Bazin himself linked his notion of impurity with a certain historicity, though it might be debated whether his impurity extended to historical temporality itself. Beginning from such considerations, Rosen's chapter examines the impurity-historicity connection through some key encounters with impurities, mixtures and hybridities in the history of film theory.

Equally concerned with history, but emphasizing the political contours of the impure-cinema project, Lúcia Nagib, in Chapter 2, retraces Bazin's pioneering take on intermediality through an enquiry into its possible relations with his peculiar understanding of 'modern' cinema, hinging on 'realism' and 'ambiguity' as elicited by time and space uncut. Re-examining Bazin's relations with Sartre and the resonances of his ideas with Barthes' and Foucault's groundbreaking debunking of the author, she goes on to dissociate the political from the modern-classical debate, here including Bazin's populist view of cinema as mass-medium that excluded the historical avant-gardes from modernity. Nagib finally expands the concept of 'impurity' to the politics of 'dissensus', as formulated by Jacques Rancière, which she applies to the analysis of an intermedial extract of Mikio Naruse's canonical film, The Sound of the Mountain (Yama no oto, 1954).

Part II, on 'Intertextual and Intercultural Dialogues', turns the focus to border crossings within and between artworks. Virginia Pitts, in Chapter 3, addresses the debate sparked by Whale Rider (2003), adapted for screen by Niki Caro (a New Zealander of European descent) from Witi Ihimaera's novel, based on a Māori story. The chapter explores the very nature of the intercultural collaborative processes established between Caro, Ihimaera, Taumaunu (Cultural Advisor) and the elders of Whangara (home of the Whale Rider myth). While New Zealand's cinematic history proves that intercultural collaboration may replicate processes of colonial assimilation, Pitt's interviews with the two key

collaborators on *Whale Rider* reveal processes characterized by a sophisticated awareness of what distinguishes and what connects peoples from different cultures.

In Chapter 4, Armida de la Garza looks at the making and reception of the films on the life and work of Mexican painter Frida Kahlo, namely *Frida, Naturaleza Viva* (Paul Leduc 1986) and *Frida* (Julie Taymor 2002), in the light of concepts of Wagnerian total artwork, postmodern hybridization and emancipated spectatorship. As the films set Kahlo's paintings in motion in different ways, the paintings in turn become hypertext devices which provide a commentary on the difference between the two media, while the painter's iconic figure is seen to confer on filmic audiences a sense of emancipation and the possibility of transgressing boundaries through artistic creation.

Chapter 5, by Paul Cooke and Rob Stone, examines the films of Richard Linklater, recognized as one of the most 'European' of American independent filmmakers, and the appropriation of some of their features by Hans Weingartner in *The Edukators* (*Die fetten Jahren sind vorbei*, 2004). Drawing on the intellectual tradition of Debord and the work of the Situationist International, Linklater's films offer a cinematic realization of the *dérive* (drift) through characters of 'slackers' and 'hobos'. By psycho-geographical *flânerie*, the authors argue, these characters redefine and reterritorialize the spaces they traverse as arenas of imagination. In tracking these *flâneurs* on their transatlantic, transnational and transurban drifts, the discussion embraces the conjoined philosophy of slacking, the *dérive* and *flânerie*, and thereby explores the essential 'impurity' that is at the heart of European filmmaking in the age of transnational production.

Lee Broughton, in Chapter 6, moves on to comment on film adaptations of comic strips. Turkish filmmakers, he argues, were responsible for a number of similarly intertextual films that featured a variety of foreign comic strip characters. Tunç Başaran's Western feature *Captain Swing the Fearless* (*Korkusuz Kaptan Swing*, 1971), based on an Italian comic strip, details the titular hero's fight against the British redcoats in North America during the War of Independence, remaining one of Turkey's most striking and significant comic strip adaptations. The chapter discusses aspects of the intertextual and intercultural play that contributed to the production of Basaran's groundbreaking Turkish Western.

Part III, 'Literary Impurities', is devoted to two exceptional cases of adaptation that rather than 'literature into film' would be better described as 'literary films' or vice-versa. Chapter 7, by Matthew Harper, analyses Vittorio De Sica's 1949 iconic film, *Bicycle Thieves* (*Ladri di biciclette*), which is a loose adaptation of Luigi Bartolini's eponymous novel, published in 1946. Significant differences in characters, plot and endings between the film and the book have caused many critics to dismiss the role of Bartolini's novel, saying that beyond the title it has nothing in common with the film. Harper, however, focuses on the *soggetti*, or treatments, as intermediary texts which shed light on the ways that De

Sica and Zavattini actually reduced some of the themes, characters and scenes found in Bartolini's novel and transformed them into a film that revolutionized the world's view on reality and humanity's place in cinema. Chapter 8, by Germán Gil-Curiel, in turn, compares and contrasts the short story 'An Occurrence at Owl Creek Bridge' by Ambrose Bierce (1890) and two adaptations of it that were made by Robert Enrico in 1962 and by Brian James Egen and Don Maxwell in 2006. Adopting a phenomenological perspective, Gil defines the aesthetic impact and implications of experiencing the literary work through cinema.

Progressing further onto the frontiers of art and life, Part IV is devoted to 'Border-Crossing Films'. Chapter 9, by Paulo Filipe Monteiro, is devoted to João César Monteiro, a giant of Portuguese cinema whose films combine an erudite artistic palette including music, literature, painting and theatre. His hybrid cinema is, however, one in which intellectual sophistication meets the simplicity, even asceticism, of his real life as he incarnates several main roles in poor neighbourhoods and environments in Lisbon. The result, according to Paulo Monteiro, is a mixture of sordidness and epiphany that elicits the 'rude beauty' of his films. Brenda Hollweg, in Chapter 10, explores the video-essay as the border-crosser *par excellence*, as it constantly borrows from other forms, such as political manifestos, journalistic interviews, ethnographic analysis, diaries, personal letters and even computer games, thereby reflecting on its own becoming. To make her point, Hollweg draws on the work of three female filmmakers, Agnès Varda (France/Belgium), Bingöl Elmas (Turkey) and Kathy High (USA), whose video-essays attest to an overall trend in documentary work that foregrounds the self as a privileged site of knowledge.

The last two chapters in this part turn to contemporary Chinese cinema's intermedial and intercultural relations as testament to disappearing landscapes. Chapter 11, by Cecília Mello, proposes an analysis of director Jia Zhangke's *The World* (*Shi Jie*, 2004) and *Cry Me a River* (*Heshang de Aiqing*, 2008) from the point of view of their spatial practice, leading to a reflection on cinema's impurity through its affinity with architecture, and more specifically with Chinese garden design. Both films, she argues, create a series of views and a series of emotions which invite the immobile spectator to travel through space while interconnecting an external and an internal landscape. Chapter 12, by Haiping Yan, draws attention to the fact that, in the midst of China's epic economic transformation, 'home' (*jia*), a term referring to the material place and related objects used in family life and a trope evoking a 'psychic' sense of belonging, has been gaining a striking ascendancy in and across all the artistic and public media. In analysing three recent Chinese films, Yan's essay locates a distinct aesthetic arising therein and functioning as an intermedial expression of the immensely changing human geographies in the country.

Part V, 'Post-Medium Films', focuses on experiments reaching beyond the realm of the conventional film theatre. Griselda Pollock, in Chapter 13, looks at the case of Chantal Akerman, whose works are now more frequently seen in galleries and museums which, by virtue of the embrace of the lens-based and time-based art forms, are more hospitable than the conventional film theatre and provide a public for non-narrative or experimental cinema. In tracing Akerman's migration from film to installation Pollock tracks a poignant contingency occurring precisely in the relay between forms, practices and moments that allow trauma, personally and transgenerationally encrypted, to be released and transformed in the co-inhabited spaces of the aesthetic, the visual and the temporal.

In Chapter 14, Julian Ross looks at expanded cinema performances by three key Japanese avant-garde artists of the 1960–70s, namely Takahiko Iimura, Jōnouchi Motoharu and Terayama Shūji. They provide examples of intermedial practices that, on the one hand, reveal the malleability of the medial properties of cinema and performance, yet, on the other, draw our attention towards the specificity of both forms of expression. Through the analysis of these three Japanese artists' works, Ross demonstrates the necessity for and benefits of interdisciplinary approaches to boundary-defying artistic practice.

In Chapter 15, Tatiana Heise and Andrew Tudor look at *The Cove*, directed by National Geographic photographer Louie Psihoyos, which tells the story of Ric O'Barry, a former dolphin trainer who became an active campaigner against keeping dolphins in captivity. The authors explore two main issues about the film. First, the use of new media such as websites, Facebook, Twitter, text messaging and blogs to reinforce the film's impact and convert spectators into activists, and, second, the interbreeding of different film genres, given that *The Cove* is constructed like a thriller, despite being a documentary.

Providing a fitting closure to the book that at the same time interrogates the future of intermedial and intercultural artworks, Anne Jerslev, in Chapter 16, discusses David Lynch's Internet documentary work *Interview Project*, a multimodal combination of 121 short documentaries, photographs and written text. Using other Lynch cinematic outputs as terms of comparison, Jerslev argues that *Interview Project* experiments with ways of procuring a sense of the analogue indexical in a digital genre. *Interview Project* shows how texture and the (analogue) passing of time may be aesthetically produced and preserved in a digital medium. Time is inscribed in the faces of the interviewees as time passed but also as time preserved for the future on a website.

Altogether the 16 chapters offer fresh theoretical insights alongside close readings and discussions of an impressive array of audiovisual works, most of which are being looked at for the first time under such a light. If they call our attention to the different medial and cultural borders in their fabric, they also invite us to trespass these borders into new and exciting realms.

References

Adorno, Theodor W. (2005). *In Search of Wagner*, translated by Rodney Livingstone. London: Verso.

Anderson, Joseph L. (1992). 'Spoken Silents in the Japanese Cinema; or, Talking to Pictures: Essaying the *Katsuben*, Contextualizing the Texts', in Arthur Nolletti, Jr. and David Desser (eds). *Reframing Japanese Cinema.* Bloomington: Indiana University Press, pp. 259–310.

Andrew, Dudley (2012). 'Malraux, Benjamin, Bazin: A Triangle of Hope for Cinema', in Angela Dalle Vacche (ed.). *Film, Art, New Media: Museum Without Walls?* Basingstoke: Palgrave, pp. 115–40.

Arnheim, Rudolf (1957). *Film as Art*. Berkeley/Los Angeles/London: University of California Press.

Aumont, Jacques (1989). *L'Oeil interminable: cinéma et peinture*. Paris: Libraire Séguier.

Bazin, André (1967). 'In Defense of Mixed Cinema', in *What Is Cinema* vol. 1, edited and translated by Hugh Gray. Berkeley/Los Angeles/London: University of California Press, pp. 53–75.

_____ (1997). 'Adaptation, or the Cinema as Digest', in *Bazin at Work*, translated by Alain Piette and Bert Cardullo, edited by Bert Cardullo. New York/London: Routledge, pp. 41–52.

Bonitzer, Pascal (1985). *Peinture et cinéma: décadrages*. Paris: Cahiers du cinéma.

Brecht, Bertolt (2000). 'The *Verfremdungseffekt* in the Other Arts', in *Bertolt Brecht on Film and Radio*, edited and translated by Marc Silberman. London: Methuen, p. 10.

Canudo, Ricciotto (1988). 'The Birth of a Sixth Art', in Richard Abel (ed.). *French Film Theory and Criticism*, vol. 1: 1907–1939. Princeton: Princeton University Press, pp. 58–65.

Dalle Vacche, Angela (1996). *Cinema and Painting: How Art Is Used in Film.* Austin: University of Texas Press.

Eisenstein, Sergei (1969). *The Film Sense*, translated and edited by Jay Leyda. San Diego/New York/London: Harvest.

Elsaesser, Thomas and Malte Hagener (2010). *Film Theory: An Introduction through the Senses*. New York/Oxon: Routledge.

Epstein, Jean (1974). *Écrits sur le cinéma*, vol. 1. Paris: Seghers.

Marks, Laura U. (2000). *Intercultural Cinema, Embodiment, and the Senses.* Durham/London: Duke University Press.

Naficy, Hamid (2001). *An Accented Cinema: Exilic and Diasporic Filmmaking.* Princeton: Princeton University Press.

Orr, John (2000). 'Introduction', in Orr and Olga Taxidou (eds). *Post-War Cinema and Modernity: A Film Reader*. Edinburgh: Edinburgh University Press.

Rajewsky, Irina O. (2010). 'Border Talks: The Problematic Status of Media Borders in the Current Debate about Intermediality', in Lars Elleström (ed.). *Media Borders, Multimodality and Intermediality*. Basingstoke: Palgrave, pp. 51–68.

Silberman, Marc (2000). 'Introduction', in *Bertolt Brecht on Film & Radio*, edited and translated by Marc Silberman. London: Methuen, pp. ix–xv.

Stam, Robert (2005). *Literature through Film: Realism, Magic, and the Art of Adaptation*. Malden/Osford: Balckwell.

PART I

THE HISTORY
AND POLITICS
OF IMPURITY

Chapter 1

From Impurity to Historicity

Philip Rosen

Much of the history of film theory was taken up by the question of cinematic specificity. This seems to go very much against the spirit of our own times, which emphasizes technical mixtures and cultural hybridities. Here, in a book whose very title refers to André Bazin's term 'impure cinema', I want to address such concerns by thinking about Bazin in the context of so-called classical film theory. A central concern of classical film theory was to differentiate cinema from precedent forms and media. Classical film theorists treated cinema as a new medium and a relatively new art form, even though it was often acknowledged that it might draw on previous media and forms; hence the implantation of a strong tendency to define problems by notions of specificity. This line of thought could often become prescriptive, as various aesthetics based on various claims about unique formal or technical specificities of cinema coalesced with the drive for legitimation of the new global medium.

Such tendencies were associated with both aesthetically conservative and aesthetically modernist impulses. Take two prominent examples of sophisticated classical theorists who may be compared as individuals schooled in psychology as well as aesthetics. In the mid-teens, the distinguished psychologist Hugo Munsterberg argued that the then nascent techniques of mainstream film narrative mirrored mental states, and took a schematically neo-Kantian line on the aesthetics of cinema. But his aesthetic prescriptions were also implicated in a class-bound promotion of the emergent narrative norms of filmmaking for its morally virtuous potential, and he envisioned film as a means of social pedagogy. A decade and half later, Rudolf Arnheim drew not only on gestalt psychology and his knowledge of art, but also on Lessing in order to criticize dominant tendencies of mainstream cinema. His view of the relation of stylistic strategies and perception, unlike Munsterberg's account of mentality and

cinema, was friendly to formal abstractions and represented more modernist aesthetic predispositions. So the aesthetic proclivities of these two theorists look quite distinct from one another, yet both addressed the 'new medium' of cinema with reference to 'old' aesthetics.

But we can also note that they shared a certain broad modern problematic common in classical film theory, as opposed to the aesthetically modernist or anti-modernist prescriptions which distinguished them. They both sought to define what was radically new about cinema. Each made claims about the unique characteristics and potential of cinema as a technology and reasoned from those specific characteristics to aesthetic – and psychological – experiences, hence artistic possibilities that had to be associated with the medium. Furthermore, the modern and modernizing project of defining something as new and different was heightened by awareness in both theorists that cinema was disseminated as a medium of the modern masses. Each brought their considerable erudition in philosophy and current psychological theory to bear on this awareness and, to a greater or lesser degree, to counter it.[1]

Their respective arguments are of interest in themselves, of course. But they also illustrate how classical film theory was in part a lineage of discursive responses to a recurrent experience of capitalist modernity, namely the innovation, dissemination and formalization of 'new media': ever more rapidly available and cheap print newspapers, mass magazines and books; photography; phonography and radio; film; television; digital media. As each new medium appeared, each was rapidly integrated into national and international commerce and capital circulation. Each interacted with pre-existing cultural practices and also participated in emergent ones, conditioned by awareness of and/ or appeal to the modern masses. And each new medium was greeted and theorized by artists and intellectuals schooled in the previous new media – henceforth old media – and also often in what we might flippantly call 'old aesthetic theory'. So one can frame classical film theory, with its characteristic and often productive yet tendentious formulations of cinematic specificity, as partaking of such complexes of discourses of the new.[2]

Specificity and Impurity in Bazin

If the question of the cinematically specific present in so much classical film theory can be positioned within discourses of modernity and modernization, it is not surprising that contemporaneous avant-garde and radical filmmakers were likewise attracted to the notion of specificity. As is often the case in avant-gardes, they sometimes produced their own manifestos, terminologies, aesthetic slogans and theories, partly to justify and explain their work by proposing technical specificities of cinema and by making claims about the transformations of

cinematic specificities into films. Perhaps the most widely disseminated exam-
ple of such a slogan was the central aesthetic term of 1920s Soviet film, mon-
tage. As we know from French film credits, montage can simply mean film
editing, but as we also know from art history, by the 1920s it became a figure for
a number of artistic activities. Within film theory, it was promoted as a genu-
inely expansive theoretical concept, and it was Eisenstein who did so with the
greatest intellectual force. He quickly broadened the scope of the term 'mon-
tage' from its earliest meanings, and by his later theoretical writings, it came to
serve him as a trope not only for a huge number of filmic relationships, but also
for cultural practices, natural history and even human mentality itself. The
more he developed the concept of montage, the more it seemed to outrun cin-
ematic specificity.[3] But the extensive nature of his theory rarely seems to have
been comprehended by his contemporaries throughout international film cul-
ture or many of his subsequent followers. This is understandable enough, not
only because of the complexity – and sometimes the wildness – of his formula-
tions, and not only because the term montage had first appeared as an aestheti-
cally militant slogan but also because so many of his later writings were
inaccessible and left in unfinished form during his own lifetime. In the dissemi-
nation of film aesthetics centered on a slogan or even a theoretical conception
of montage, editing most often appeared as the aesthetic sine qua non of the
cinematic and cinematic art. And this most often partook of the sometimes
vague discourses of specificity, posed as the basis for understanding cinema and
making films.

Another example of a famous theoretical-polemical slogan about specificity
from the 1920s avant-garde was the quite different notion of *photogénie*, as
hyperbolized by Delluc and especially Epstein.[4] It has had a surprising and inter-
esting shelf-life, having been re-examined in the recent resurgence of interest
in cinephilia as over and against television and the digital.[5] But at the time, it
could be aligned with another term often attributed to one of the contempo-
raries of Delluc and Epstein, Henri Chomette, who made a film in 1925 called
Five Minutes of Pure Cinema (*Cinq minutes de cinéma pur*). Pure cinema became
another of those polemical slogans in some avant-garde film circles of the 1920s
and into the 1930s, in relation to a variety of filmmaking strategies and experi-
ments. It could meld not only into other notions like absolute cinema, abstract
cinema and so forth, but also bore a relation to the theoretical project to iden-
tify some postulated cinematic specificity and reason from it.

At this point, then, we have arrived at a terminology exactly opposed to the
topic of this book, 'impure cinema'. As the latter term is drawn from that tower-
ing figure in classical film theory, André Bazin, we may begin by noting its
absence from the standard translation of his works. Hugh Gray did a tremen-
dous service in the late 1960s with his ground-breaking translations of Bazin in
the two English-language volumes of *What Is Cinema?* However, some of his

translation decisions have had specific, long-lasting effects in the Anglo-American reception of Bazin. In the case of Bazin's essay 'Pour un cinéma impur: défense de l'adaptation' he rendered *cinéma impur* as 'mixed cinema' rather than 'impure cinema'. Despite any intentions Gray might have had, this aided 1970s critiques of Bazin that were soon common in the Anglophone world, by helping to obscure the possibility that there were anti-essentialist layers to Bazin's argument. Indeed, in some quarters, it may still sound strange to describe self-conscious anti-essentialist impulses in Bazin's writings.

For Gray's English-language Bazin appeared at a historical conjuncture when structuralist and poststructuralist semiotics, as well as ideological analysis of cinema, challenged not only direct appeals to the real but also realist aesthetics, no matter how sophisticated. Initiated by French theoretical polemics, the critique of Bazin as ideological idealist became almost a disciplinary tic in rapidly institutionalizing film studies.[6] It is true that the Anglo-American context was different than the French, where Bazin had served as a father figure in the great efflorescence of film culture and analysis of the 1950s and 1960s, and was therefore subject to revolt by his intellectual progeny. However, the two contexts overlapped. And a dominant tendency was to see Bazin as proposing a primordial cinematic realism, which served as the other for the new paradigm based on cinema as signifying process. With close semiotic analysis of textual systems the order of the day, Bazin's commitment to realism seemed to fatally compromise his insights into stylistic systems. With the cinematic apparatus now understood as ideological, Bazin's ontology was described as naively mistaken, and/or idealist, and/or essentialist.

Held up as prime evidence was Bazin's own deliberate and repeated opposition to one of the great theoretical slogans coming out of the 1920s avant-gardes – namely montage. Even more egregious for Bazin's reputation in the 1970s was that montage was associated with the radical political wing of classical film theory. In fact, in the 1940s, when Bazin began writing on cinema, montage aesthetics had dominated much advanced film theory for two decades, acknowledged as crucial even among those who might be identified with alternative paths, such as Balázs. A typical example is in Malraux's 1940 essay on cinema, well-known to Bazin, where Malraux remarks: 'The birth of cinema as a means of expression dates ... from the time when the cutter thought of dividing his continuity into [shots]' (Malraux 1961: 320).[7] Even though Eisenstein's later theory was formulated in the 1930s and 1940s, it was mostly unavailable to Bazin. So Bazin's critique of montage was often an attack on the idea of editing's primacy.

But montage was a primary theoretical prey for Bazin in part because he saw how the concept served as the foundation for more general attitudes towards cinema that he found limiting. Yet, within the history of film theory, one consequence of his critique of montage was the broad circulation of a persistent

idea after his death in 1959, an idea that we might call the textbook version of Bazin. This idea was that Bazin's distinctiveness as a film theorist consists in his substituting the preference for one stylistic level over another, based on an argument about what was most fundamentally specific to cinema. He was thought to have argued – in terms that may still seem familiar – not only that cinema's unique capacity lies in the technological fact that the motion picture camera registers chunks of real space and time, but furthermore that this cinematic specificity is best exploited by long takes, deep focus and camera movement, which should be privileged over editing. This is a reductive, formalistic reading of a few (admittedly major) Bazin essays, and it often seemed suitable for the pedagogy of introductory textbooks. But my point here is to note how this reading fits Bazin completely within the line of classical film theory that grounds itself in definitions of cinematic specificity.

Given both this textbook reductionism as well as the 1970s critique of Bazin as idealist and realist, even at this late date it may still be ambivalently defamiliarizing to ponder the fact that Bazin explicitly opposed one of the other great slogans of prescriptive film aesthetics from the 1920s, pure cinema. One classic source of the long take versus montage opposition is 'The Evolution of the Language of Cinema', whose earliest version was published in 1951. Yet, at almost the same time – in 1952 – he published 'Pour un cinéma impur'. There is a certain polemical wit in this title, which we can only get by rejecting Hugh Gray's translation and rendering it as the more straightforward English cognate: 'For an Impure Cinema'. The term 'impure cinema' implied a very precise target within the history of European and especially French film culture: the historical avant-garde tradition, which generated slogans like pure cinema and absolute cinema.

In retrospect, the title also implies a deeper and more radical challenge to a central line of inquiry in classical film theory as it had developed to that point. Bazin is against reasoning from a postulated technical specificity of the medium to an exclusive definition of cinematic art or even spectatorial mentality or perception as in Munsterberg and Arnheim. In fact, to make the scandalousness of this polemic clear, the essay places literary adaptation at the forefront of the contemporary development of cinema – literary adaptation, which had so long been treated as an enemy by many avant-gardist practitioners and theorists who saw film as a purely visual art. In a profound provocation, the article argues that literary adaptation constitutes the true avant-garde of post-war French filmmaking.

It is true that the essay also includes sideswipes at montage aesthetics, but the problem with them in this context is that they are aligned with pure cinema. For us in the present, this provides a different purchase on the critiques of montage aesthetics in some of Bazin's most famous writings, and it certainly obviates the old textbook Bazin. He is not just arguing against one specificity – one

which would logically entail an aesthetic privilege for editing and/or montage – in favour of a different specificity, for example, one founded in the camera rather than editing. There is bigger game here. He is arguing against grounding film and its theory in any postulate of the cinematic as an ahistorical specificity, no matter whether one associates this specificity with montage or any other allegedly fundamental property or technique, such as the registration of real objects by the camera, the long take, deep space etc. Bazin's notion of impure cinema not only opposes the historical avant-garde in cinema, but also a basic premise of much classical film theory. In so doing, it may superficially seem to go against the grain of the modern/modernist project, of defining the uniquely new in the cinematic.

Impure Cinema, Modernity and Historicity in Bazin

However, the 'Impure Cinema' essay certainly takes on board other definitive aspects of modernity, which it makes integral to cinema. For one, Bazin insists on its historicity. Over time, he indicates, there are shifting configurations and interrelations of technology on the one hand and aesthetic or formal qualities and practices on the other, making cinema always subject to change as well as stasis. This means cinema is fundamentally historical, and awareness of change and historicity is one of the defining characteristics of modernity. Also, Bazin insists that the most advanced cinema could not be separated from the public and commercial history of the medium. This leads him to points which can only supplement the scandal, for classical film aesthetics and its proponents, not just of purity, but of specificity itself. That is, not only does this essay reject the approach that derives a 'pure' film aesthetics from cinema technology, but it also insists that the need for a public must be taken into account in film theory. Now, this is a kind of awareness of the constant effects of another of the key categories of modernity, the modern masses to which technical media must appeal. But it is a very different acknowledgement of the centrality of the modern masses than we see in certain classical film theorists of specificity, who treat the masses as a potential moral danger to be managed (Munsterberg) or as a threat to realizing the benefits of cinematic specificity because of a desire for realism (Arnheim). The implication is that the impurity delineated in 'For an Impure Cinema' is partly social and sociological. Something of an anti-elitist undertone seems to supplement Bazin's digs at the historical avant-garde and pure cinema and, most consequentially, his attack on the very assumption of cinematic specificity.

But this reading does raise a problem: what then happens to Bazin's famous realism? Does it not depend on his account of specificity? To deepen our reading of his critique, I will here review points I have made elsewhere about the essay

usually understood as his foundational account of cinematic specificity and realism, 'The Ontology of the Photographic Image'.[8] It has recently come in for renewed appreciation, though perhaps leading in a different direction than it once did, as our digital era reconsiders the status of photographic and cinematic images from a different historical standpoint.

First, 'The Ontology of the Photographic Image' does not claim that a photograph or film image provides an absolutely guaranteed duplication or semblance of the real. As Bazin puts it in one sentence whose translation I have modified: 'The most exact drawing may actually tell us more about the model, but despite the promptings of our critical intelligence it will never have the irrational power of the photograph to bear away our belief.'[9] What I emphasize here is the idea that the power of the photograph depends on an irrationality.

Second, despite superficial appearances in certain much-cited passages, in 'The Ontology of the Photographic Image' the uniqueness of cinema is not reducible to a technological determination. Rather, it derives from a relation of human subjectivity towards objectivity as mediated by the technology. The name for that mediation on the side of the subject is belief, and it inserts a fundamental level of irrationality into Bazin's problematic of cinematic realism. (Gray's rendering of the French *croyance* as 'faith' rather than belief helped foster a reading of Bazin as a theorist subtly affected by religious thought.) The ambition of this belief is for an unattainable object, namely perfect duplication or even identity with the real. Indeed, Gray's translation also obscures some psychoanalytic metaphors and nuance in the essay that might have heightened awareness of Bazin's emphasis on subjectivity. These include Bazin's occasional but explicit invocation in French of concepts such as the unconscious and desire. His famous trope for the human drive to find a type of image in which belief can be invested is named in a partly playful analogy to the Oedipus complex, the 'mummy complex'. This term figures the desire to preserve objects against the ravages of time, with the aim of defending the subject against death, which time must bring. That is, the desire to preserve real objects is at bottom a desire to sustain the subject or, to shift terminological registers, maintain the ego. The 'Ontology' essay treats photography and cinema as historically privileged vehicles of this drive. But despite Bazin's often-noted word play with *objectif* (lens) and objectivity, the crucial point here is that the belief instantiated by cinematic subjectivity has irrational components by definition. After all, we cannot defeat time or death.

Third, as a matter of representation, the problem for a subject seeking ways to believe in the reality of an image is that there is a real, objective gap between film and reality. If film and reality can never completely fuse in an objective sense, then any quotient of belief in the reality of existents conveyed by the image depends on a subjective investment. This is why, as he writes elsewhere, any realism is only sustained by aesthetic decisions. Cinematic 'language' is

therefore an aesthetic configuration. It does not just flow from the technical characteristics of the medium, but is the expression of another subjectivity than that of the spectator, the attitude of the filmmaker, filmmakers, or sometimes (more collectively) culture and/or society towards reality. Bazin sketches a dialectic between two subjective activities which, in the 'Ontology' essay, are named aesthetics and psychology, but both are projections of subjects or subjectivities. It is thus a short step from the ontology to Bazin's 'myth of total cinema', which underpins his approach to cinema aesthetics as a subjective drive predating cinema, and one that can never be fulfilled.

Fourth, Bazin nevertheless argues that something about cinema makes it and its 'language' a privileged prop of this desire, this irrational will to believe. I have elsewhere argued Peter Wollen correctly fastened on a lynchpin of Bazin's conception when he invoked the semiotic concept of indexicality, derived from Peirce (Wollen 1973: 124 ff).[10] Of course Bazin did not have the term 'indexical sign' available, but Wollen was correct in seeing the concept throughout Bazin's corpus. In the 'Ontology' essay, it is explained that the presence of the represented object at the origin of the production of the image by an inhuman machine makes the image seem a trace of the actual object. This – not its appearance – gives the photograph and cinema a radically more intense appeal to the drive to believe than any previous forms of image, and cinema adds the trace of duration.[11] There is nothing irrational in recognizing that a certain technology produces an indexical representation in this sense. But for Bazin a spectator's knowledge of how a photographic or film image was produced intersects with investments of a different nature. The subjective desire of the mummy complex finds in the object-centred indexical image a privileged conduit. In photography, and even to a greater extent in cinema, it finds visual media that desire can believe in more than others.

If we treated Bazin as a typical classical film theorist, this would explain where he grounds the technical specificity of cinema: Cinema is a technology that indexically registers the actuality of objects in their spaces, but also the actuality of movement and therefore segments of actual duration as well. But if we take this line, how could such specificity be reconciled with the promotion of impurity? One solution would be a critique which finds an irresolvable antinomy, or at least an oscillation, between two different kinds of projects within Bazin's theory.

However, I would like to suggest a different approach. From the viewpoint of classical film theory's search for specificity, there is something peculiar about Bazin's conception which complicates such a critique. If we have come to something that looks like a specificity in Bazin, it is a specificity which cannot be restricted to a technical practice or a technological characteristic. In fact, to put the point strongly, even in the ontology, there can be no cinema in and for itself. Here are three reasons.

The first reason may seem the most complex. As I have already argued, Bazin's ontology depends just as much on subjective desires as on the technology that produces indexical images. I see no reason to privilege technology over subjectivity or subjectivity over technology; rather it is their relation, the dialectic between them, which constitutes cinematic 'specificity', if there is still such a thing. To put it more generally, in this account technology itself is not an independent force, determinate and determining, but the site of a relationship. Through it subjects relate to a postulated or desired reality of depicted objects. Therefore, they simultaneously relate to their own subjectivity, because they can only know and experience it through relations to intended objectivities. Furthermore, as already noted, they also relate to different subjectivities than their own.

Second, there is a kind of corollary that flows from this principle of relatedness. It is clear in a good deal of Bazin's writings that there is an awareness – perhaps most pointed in the 'Impure Cinema' essay – that cinematic technology has a history and therefore a different status at different times. This may open the way for the history of subjectivity itself, since in Bazin subjectivity in cinema is constituted in a relation that is part of this postulated but troubled specificity. However, even if this were not the case and a particular technology were unchanging, and even if subjectivity did not have a history (as I have elsewhere complained is implicit in the concept of the mummy complex (Rosen 2003)), it does not follow that their interrelationships do not change. In that case, if there is cinematic specificity in Bazin, it would exist in that shifting relationship, which means, again, that it is historical.

Third and most directly, on the side of objectivity, indexicality opens up cinema to another history: the social, cultural and perceptual history of objects. This is not to claim that Bazin is Walter Benjamin. But associating photographic and cinematic ontology with a principle of indexicality necessarily means the cinematic apparatus operates in relation to filmed objects, that is, to entities with an independent objective existence exterior to the technology (and of course also exterior to the subject). In the 'Ontology' essay, this exteriority amounts to the worldly, concrete entities registered by the camera. If cinematic technology makes indexicality a key prop for subjective desire, it means that the very nature of cinema is precisely not to be something in and for itself. It must be constituted in relation to something outside itself with a purportedly objective existence. This would mean that cinema history and even any postulate of cinematic specificity necessarily includes the non-cinematic.

To summarize these points, if we fully follow through on the implications of Bazin's ontology, both subjects and objects of cinema are necessary components of 'cinematic specificity', but they both have existences and histories exterior to cinema. And one major indication in the impure cinema essay is that these relationships which they both have to cinema in its actual existence must be

historical on a number of levels, for they include publics, economics and cultural determinants. This reinforces the point that for the ontology, cinema cannot be sufficient into itself. One might say cinema's specificity is to be not specific. Hence, it is necessarily impure.

All of this makes it look less like the 'Ontology' essay and the 'Impure Cinema' essay completely contradict one another, as antinomic projects or conceptions of cinema. But that negative point can be supplemented by some positive points to argue for compatibilities and analogies between the 'Ontology' and 'Impure Cinema' essays. I will suggest some of those compatibilities before sketching a couple of consequences for these arguments about cinema and the history of film theory.

The first point is the longest, beginning from more or less historical claims in the 'Impure Cinema' essay about the relationship of film technology and aesthetic form. Bazin there asserts that in the years leading to post-war cinema, there had occurred a stasis in technological innovation in cinema. Thus, aesthetic renovation could not occur in response to technical developments, because there were none that made a fundamental difference in the cinematic apparatus. As a result, according to Bazin, cinema's aesthetic renovations were now occurring in response to new objects of depiction. We might note in passing that the value placed on aesthetic renovation is both modern and modernist. But in a medium appealing to subjective obsessions addressed by indexicality, this modern consciousness then registers a history of depicted entities. For Bazin, in the absence of major technological change, film aesthetics (including form or style) could only refresh itself by responding to developments in the matter or content (*le fond*) of the material filmed, with all the resources cinema had already developed. This is why Dudley Andrew once suggested that 'Pour un cinéma impur' could be called 'the evolution of the content of cinema' (Andrew 1978: 177).[12]

This is what leads the 'Impure Cinema' essay to Bazin's complex theory of literary adaptation, which should be read in conjunction with other Bazin pieces of the same period, such as his magisterial article on Bresson's *Diary of a Country Priest* and his two-part article on theatre and cinema (Bazin 2004). Pushing home his argument, Bazin writes that, for a variety of reasons including both culture and commerce, in this conjuncture the literary text became one of cinema's privileged objects of depiction, provoking it to subtle aesthetic innovations. For proponents of what I have called the textbook Bazin, it has always been a peculiarity that he paid so much attention to adaptation. But in the 'Impure Cinema' essay, Bazin indicates that post-war cinema vectors cinematic respect for the pre-existent world, which is based on the appeal of indexicality to subjectivity, into a particularly intense drive to find ways to respect a pre-existent literary source. Hence, literary adaptation became a key aesthetic issue propelling the development of that cinema. As already noted, this only abets

Bazin's provocation against the purists, for he effectively locates the avant-garde of post-war French cinema in literary adaptation. But note also that in Bazin's conception, this is a transitory fact; the history of cinema will certainly be subject to future shifts and different registers of innovation. Again, it seems that ontology in the broad sense outlined above inevitably shades into historicity.[13]

Overall, then, impurity entails a conception of the inevitable historicity of cinema and its specificities, on the levels of subject, object and mediating technologies, as well as their interrelationships. Specificity is subject to change. Thus, Bazin's polemic against purist theory entails an insistence on the historicity of cinema and the historicity of its specificity.

Impurity, Historicity and Late Capitalism

Finally, and to return to our current perspectives on film theory and *its* history, another way of thinking historicity in Bazin is to return to the repeated recurrence of new media in modernity. I began by suggesting that this is an important reason specificity was implanted in classical film theory, which was instituted when cinema was still relatively new. But in our own contemporary fetishization of the newness of 'new media', we might learn something from how Bazin engaged this problematic. As we have seen, the relation of impurity and specificity in Bazin is not an opposition or antinomy, nor is it exactly an oscillation. Rather it is a constant interplay open to changes, ultimately based on a blurring of the inside and outside of the medium or media. While it is not possible to elaborate at length here, it may be worth concluding with a couple of comments about general implications for the present situation of theorizing film and media.

One implication is that it is generally inadvisable and even logically impossible to reason directly from the postulated specificity of a technology or medium to its aesthetic potential or proper methods, much less its social or cultural functions or significance. This is finally to reject the form of argument important and often productive in the history of classical film theory. But the issue is not only that a technology or a certain alignment of technologies is related to factors outside of itself. It is rather that such an 'outside' is necessarily 'inside' a media technology and its forms and usages, which is why a technological apparatus or configuration is not reducible to technological determinants.

This is a lesson of Bazinian impurity, and we may translate it into our own problematics. Take the great Bazinian theme of indexicality and subjectivity. Once the dissemination of digital media was well under way, it became commonplace to assert that indexicality, including the quotient of belief it draws,

has been historically surpassed and obviated in a 'post-photographic' age of digital imaging and computer manipulation of images. Yet we still have things like digital photography, which can have great currency and credibility, for example as journalism, as familial memory, for science and for legal institutions. From the standpoint of a strict technical specificity and its effects, the indexical should be outmoded, and yet the indexical remains massively operative, as a cultural, institutional and social function. Perhaps we should conceive the subject as society, as someone once put it (his name was Marx). Then we can say that the subjective requirements rather than the technology are actually sustaining indexicality, albeit in a new historical context and with that subjectivity itself existing in history. And by extension, then, by downgrading technological specificity without ignoring technology, we have again travelled from impurity to historicity.

Thus, we have come to some implications of this understanding of Bazin for our own period. I began by suggesting that a good deal of classical film theory can be read as a response to capitalist modernity. Part of my interest in parsing Bazin's notion of impurity has been to argue for his distinctiveness within certain major tendencies in the history of classical film theory as a way of interrogating them in the present. If we pose this history against the present, the status of impurity today would have to do with new stages of capitalist modernity, sometimes too quickly called postmodernity.

Nowadays, the term impurity may seem to hook into a more recent critical tendency. For the past 30 years or more, much advanced cultural and social theory and aesthetics has emphasized fragmentation in opposition to the supposedly reductive unifications of ontologies. In our own fields of film and media studies, this impulse has often been manifested as an appeal to hybrid formations – of cultural identities and sliding exchanges among them, as well as crossovers and hybrid formations of media forms and ontologies. (The digital, with its seeming capacity to mime, integrate and transmit any other media form, has the appearance of being the technical realization of the latter.) It seems to me important to continually frame this standpoint emphasizing hybridities against the history of capitalist modernities, which includes non-Western alternative modernities. This, of course, makes a link to the perspective just outlined about the history of film theory read as a response to capitalist modernity. Fragmentation was a conceptual nodal point in classical film theory. In this discourse, the idea of fragmentation was most explicitly invoked with respect to breaks in the perceptually or phenomenologically continuous flow of the image, with editing as the exemplary technical or aesthetic manifestation. And of course, montage was a key theoretical figure historically used to align fragmentation with claims about the cinematically specific.

It seems to me that Fredric Jameson is on to something when he considers the proliferation of the aesthetic fragment as a symptomatic characteristic of

modernity, but for both the earlier stage of industrial capitalism, and postmodernity as the current stage of capitalism. His argument is that it has different functions and consequences in each case. One essay where he elaborates this idea, 'Culture and Finance Capital' (1997), is germane in the present context, because he makes editing in cinema his central illustration. His examples are Buñuel and Brakhage on the modernist, industrial capitalism side, with the blockbuster action film and Jarman on the postmodernist, late-capitalism side. To put it very schematically, he proposes that in the modernist period, the image-fragment is neutralized, having no meaning on its own, while in the postmodernist period, the image-fragment does have meaning on its own independent of its aesthetic contextualization in relation to other image-fragments. Then, to make the typical Jamesonian argument that this is a cultural consequence of shifts within the history of capitalism, he proposes a daring analogy, which is somehow more than 'mere' analogy. He compares the aesthetics of fragmentation in the two periods to the status of money. In the modern or modernist phase, where the image-fragment has no signifying value in itself, it is connected to money in industrial capitalism:

> Modernist abstraction, I believe, is less a function of capitalist accumulation as such than of money itself in a situation of capital accumulation. Money is here both abstract (making everything equivalent) and empty and uninteresting, since its interest lies outside itself. It is thus incomplete like the modernist images I have been evoking; it directs attention elsewhere, beyond itself, towards what is supposed to complete (and also abolish) it. It knows a semiautonomy, to be sure, but not a full autonomy in which it would constitute a language or dimension in its own right. (Jameson 1997: 264–65)

At this point, it is useful to stop briefly and consider the striking analogical chains this evokes in the context of reading Bazin. For example, while Jameson's modernist film examples are Buñuel and Brakhage, his contention about the semantic neutrality of the isolated fragment in modernism is completely consonant with often-noted claims made by the textbook Bazin: that in strict montage aesthetics – or perhaps what we should call Kuleshov-effect aesthetics – a shot has no significance on its own, only in relation to other shots. More provocatively, if money is abstracted from connection like the shot in this account of modernist montage aesthetics, Bazin's critiques of montage, and of pure cinema, may be likened to critiques of the pretentions of money; that is, like money in its actuality as opposed to its appearance, the shot in Bazin is always connected to something beyond itself. Jameson's phrase, 'it [money] directs attention elsewhere, beyond itself, towards what is supposed to complete (and also abolish) it', could be compared to the subjective function of indexicality

according to Bazin. For no matter how abstracted the cinematic shot or sequence, cinema always evokes some residue of the mummy complex, and the projection of cinema beyond itself.[14]

While Jameson agrees that the postmodern, late-capitalist present engages in a proliferation of the fragment, he argues that it now functions differently. The proper analogy for the present is not between cultural/aesthetic/media fragmentation and money in a situation of capital accumulation, but rather between that fragmentation and money in a phase dominated by finance capital. As we know, contemporary finance capital is heavily entangled with 'new media' not only as a field which draws massive investment, but also because of the unprecedented speed of capital circulations, flows and manipulations enabled by digital technologies and networks. But for Jameson, in current finance capitalism, money no longer even appears to have as its end something outside itself, to be only semiautonomous. Instead, it pretends to full autonomy: that is, profit lies in relations of money to money, and hence in the sheer movement of money. Correspondingly, in the cultural sphere, the aesthetic fragment now comes to us not as something self-sufficient that must be integrated with other fragments to be meaningful, but rather as something always already meaningful and/or narrativized on its own, prior to juxtaposition with other fragments. In this, according to Jameson, it recalls connotation in Barthes' *Mythologies*; despite its seeming isolation as fragment, literal import is immediately filled with a second-level meaning from the reservoir of ideology, cliché, stereotype, prior to any textual juxtaposition. As a key illustration, Jameson invokes the series of spectacular moments in an action movie trailer. It is permissible to give away the story because the separate spectacular moments are the attraction of the film rather than the overall narrative relations; those moments come to us from a universe of images already loaded with meaning no matter what their place in the story. This suggests a hermetic system – money talks to money, images talk to images. There will be only the most minimal aspirations on the part of money or images to connect or make claims about the outside, the 'real' world. Indeed, for films, all pieces of that 'real world' are always already – and knowingly – so full of social, cultural and ideological meanings that all images may be treated with suspicion rather than belief.

We can add here that this seems to echo claims in recent film/media theory for the technologically determined end of indexicality as reality and as idea. But we can also note that this describes something different than Bazin's account of impurity as outlined above. It is no longer a matter of the interpenetration and inseparability of 'outside' and 'inside'. Rather, as Jameson would have it, there is no outside posited. The consequence is a kind of paradoxical or dialectical reversal. Superficially, if the present is constituted by a certain dominance or even universality of fragmentation, the temptation is to go with this appearance and understand impurity as dominant or even universal. But actually this

kind of fragmentation entails the opposite. Both money and mediated culture in late capitalism present themselves by predicating their own purity. They seek to make themselves operate as purely money, purely images.

Crucially, however, this reversal may well be treated as a symptom. Consider the kinds of arguments that treat digital imaging as contrary to indexicality. This is actually to reason from technology to specificity – that is, to employ, the kind of logic informing the tendencies in classical film theory Bazin opposed. Paradoxically, the claim that a technological development in our era of speed, interactivity and the consequent fragmentation effects a historical break sends us back to purity rather than historicity. This should make us suspicious.

More generally, there are other reasons to believe that any vision of a 'purified' cultural-mediatic and monetary universe that separates 'inside' and 'outside' cannot be sustained. In his own way, Jameson himself comes to the same conclusion. Writing in 1997 he cryptically and prophetically finishes his article with the warning that the system is inevitably 'steering towards a crash' (Jameson 1997: 265). Leaving aside the realization of this forecast in the devastating financial upheavals since 2007, the broader implication is that the 'outside' or reality of money cannot be suppressed or obliterated, but only covered over. By my own extension, the same can be said of images. There is preliminary support for this claim when we take full note of the proliferation of indexicalities in a media universe in which technical developments were supposed to obviate indexicality, including both its functions and the desires that it implies, but in fact have not.

More broadly, Jameson believes the intensity of fragmentation constitutes the apex of the victory of exchange value and reification. Reification fragments in order to make human and historical processes into separable things. To reify is to dehistoricize. From impurity to historicity, the moves of Bazinian logic as opposed to the logic of classical film theory may therefore remain suggestive to us today. As we consider the contemporary film/media context, we are caught in our own historical moment and the context of our own stage of capitalist modernity. Understanding real impurities, radical impurities, remains the order of the day.

Notes

1 See Munsterberg's 1916 book *Hugo Munsterberg on Film: The Photoplay: A Psychological Study and other writings* (1916); and Rudolf Arnheim's *Film as Art* (1957), a revision of his 1933 *Film als Kunst*.

2 For a parallel in our own period, one might review some of the digital utopias that became strong starting in the 1980s and still have not disappeared. See Rosen (2001), Chapter 8.

3 For the remarkable extension of the concept of montage into realms such as perception, evolution and philosophy, see Eisenstein (1987 and 1991).

4 See, for example, essays by Epstein and Delluc in Abel (1988).

5 A seminal contribution to the resuscitation of cinephilia during digitization was Willemen (1994).

6 A major exception in the 1970s was Andrew (1978).

7 This English text actually reads 'dividing his continuity into "planes"', but this is clearly a mistranslation; in a cinematic context the French word *plan*, used by Malraux, means shot.

8 The next several paragraphs draw on points made in Rosen (2011: 107–18). See also Rosen (2003) and Rosen (2001), Chapters 1 and 3.

9 The Gray translations of Bazin essays discussed in this chapter are in the 2004 edition of *What Is Cinema?*, volume 1. Gray's translation of 'The Ontology of the Photographic Image' uses the phrases 'a very faithful drawing' and 'to bear away our faith'. For comments on translations of certain key passages in Bazin and reasons to modify them, see Rosen (2011). For more recent, alternative translations see Bazin (2009).

10 For significant critiques of reading Bazin through the concept of indexicality, see Morgan (2006: 441–81) and Gunning (2007, 2008). Without pretending to an adequate response here, I do have degrees of disagreement with them. I do not think Morgan gives proper weight to 'psychology' or subjectivity in Bazin in relation to indexicality, and I am not yet convinced that Gunning's approach, which I find subtle and brilliant, constitutes that great a departure from a reading of Bazin emphasizing indexicality.

11 Of course, this insight is not exclusive to Bazin. Undoubtedly the most cited later account emphasizing the irrational appeal of the photograph as irrefutable evidence of prior existents is Roland Barthes in *Camera Lucida* (1981). Barthes is aware of Bazin, but draws different inferences about this irrational appeal.

12 Andrew (1978: 177). More generally, see Andrew's discussion of this essay and adaptation in relation to Bazin's account of the evolution of the language of cinema (177–87). In recent work, Andrew has returned to the question of adaptation in Bazin, and he also relates it to 'Ontology of the Photographic Image'. Our views were developed independently. Compare my 'Belief in Bazin' (Rosen 2011), cited above, to Dudley Andrew's Chapter 4 of *What Cinema Is! Bazin's Quest and its Charge* (2010), and also 'Bazin Phase 2: Die unreine Existenz des Kinos' (Andrew 2009).

13 For additional analogies between Bazin's theory of literary adaptation and the ontology, including rhetorical comparisons between adaptation and indexicality, see Rosen (2011) and Andrew (2009, 2010).

14 Without stopping to elaborate on the point, it is worth noting that this could also lead to reinforcing Jameson's long-held insistence that both sides of the modernism-realism debates are modern, but now within the history of film theory.

References

Abel, Richard (1988). *French Film Theory and Criticism 1907–1939: A History/ Anthology*, 2 vols. Princeton: Princeton University Press.

Andrew, Dudley (1978). *André Bazin*. Oxford: Oxford University Press.

—— (2009). 'Bazin Phase 2: Die unreine Existenz des Kinos', *Montage A/V* 18:1, pp. 33–48.

—— (2010). *What Cinema Is! Bazin's Quest and its Charge*. Malden, MA: Wiley-Blackwell.

Arnheim, Rudolf (1957). *Film as Art*. Berkeley, California: University of California Press.

Barthes, Roland (1981). *Camera Lucida. Reflections on Photography*. New York: Hill and Wang.

Bazin, André (2004). *What Is Cinema?* vol. 1, edited and translated by Hugh Gray. Berkeley: University of California Press.

—— (2009). *What Is Cinema?*, edited and translated by Timothy Barnard. Montreal: Caboose.

Eisenstein, Sergei (1987). *Nonindifferent Nature: Film and the Structure of Things*. Cambridge: Cambridge University Press.

—— (1991). *Towards a Theory of Montage*, translated by Michael Glenny and edited by Michael Glenny and Richard Taylor. London/Bloomington: BFI and Indiana University Press.

Gunning, Tom (2007). 'Moving Away from the Index', *Differences* 18:1, pp. 29–52.

—— (2008). 'What's the Point of an Index? Or Faking Photographs', in Karen Beckman and Jean Ma (eds), *Still Moving*. Durham, NC: Duke University Press, pp. 23–41.

Jameson, Fredric (1997). 'Culture and Finance Capital', *Critical Inquiry* 24:1, autumn, pp. 246–65.

Malraux, André (1961). 'Sketch for a Psychology of the Motion Picture', in Suzanne Langer (ed.), *Reflections on Art: A Source Book of Writings by Artists, Critics and Philosophers*. New York: Oxford University Press, pp. 317–28.

Morgan, Daniel (2006). 'Rethinking Bazin: Ontology and Realist Aesthetics', *Critical Inquiry* 32, pp. 443–81.

Munsterberg, Hugo (2001). *Hugo Munsterberg on Film: The Photoplay: A Psychological Study and other writings*, edited by Alan Langdale. New York: Routledge.

Rosen, Philip (2001). *Change Mummified: Cinema, Historicity, Theory*. Minnesota: University of Minnesota Press.

—— (2003). 'History of Image, Image of History: Subject and Ontology in Bazin', in Ivone Margulies (ed.), *Rites of Realism: Essays on Corporeal Cinema*. Chapel Hill: Duke University Press, pp. 42–79.

———— (2011). 'Belief in Bazin', in Dudley Andrew and Hervé Joubert-Laurencin (eds), *Opening Bazin: Postwar Film Theory and its Afterlife*. New York: Oxford University Press, pp. 107–18.

Willemen, Paul (1994). 'Through the Glass Darkly: Cinéphilia Reconsidered', in *Looks and Frictions: Essays in Cultural Studies and Film Theory*. London: BFI.

Wollen, Peter (1973). *Signs and Meanings in the Cinema*, revised edition. Bloomington: Indiana University Press.

Chapter 2

The Politics of Impurity

Lúcia Nagib

In our day, it has become redundant to champion the breaking of boundaries of territory, race, genre, gender and the like in the arts and media. This is a *fait accompli* widely acknowledged and even celebrated by concepts such as 'transnationalism', 'multiculturalism' and 'hybridization'. Cinema, whose nature as a meeting point of all other arts is universally recognized, is particularly prone to the celebration of hybridity, something that in my view presents two kinds of risks. On the one hand, formalist intermedial analyses of cinema tend to disregard context to the point of becoming purely narcissistic exercises, undertaken by well-informed critics who rejoice in simply decoding more or less hidden or more or less sophisticated intertextual references in a film's narrative mesh. On the other hand, the obstinate champions of hybridization, in particular those coming from cultural studies, must confront the fact that this has already been achieved by an overwhelming and irresistible globalization, which has moreover entailed the disappearance, in the uniformly hybrid masses, of the figure of the Other, that is to say, of the oppressed minorities which are the very *raison d'être* of cultural studies. It thus becomes imperative for those critics to reinstate difference, albeit at the price of an essentialization that was the primary object of their attack.

My aim in this chapter is to investigate the politics of hybridization by positing the intermedial phenomenon not as an accomplished project or an end in itself, but as a problem, that is to say, the site of a crisis, or default of means, that requires other, metaphorical procedures in order to fill in a gap which is at the very core of artistic creation. I will start by retracing the history of Bazin's pioneering take on intermediality, which he famously defined as 'impure cinema'. This will include an enquiry into its possible relations with his peculiar understanding of 'modern' cinema, hinging on 'realism' and 'ambiguity' as elicited by time and space uncut. I will proceed by dissociating the political from the modern–classical debate, so as to expand the concept of 'impurity' to the

politics of 'dissensus', as formulated by Jacques Rancière, which, by way of con-
clusion, I will apply to the analysis of an intermedial film extract, drawn from
the Japanese canon.

Let us first consider Bazin's provocative use of the expression 'impure cinema'
to signify a medium contaminated by other art forms, notably literature and
theatre. It is not by chance that Bazin's American translator Hugh Gray chose
to render the title of his famous article 'Pour un cinéma impur: Défense de
l'adaptation', first published in 1950, simply as 'In Defense of Mixed Cinema'
(Bazin 1967a). In so doing, Gray probably intended to avoid any uncomfortable
sexual or racial connotations inherent in the word 'impure'. Even if questions
of gender and race are entirely absent from Bazin's text, the article's tone of
'defence', as stated in its very title, hints at a politics in favour of certain films
and against others, and in favour of a certain criticism and against others. What
was that politics?

As is common knowledge, Bazin always kept his distance from direct politi-
cal engagement, despite the solid social grounding of his realist project. As
Andrew points out in his Bazin biography (1990: 133ff), he never hesitated to
embrace heresy against his own Catholic and socialist beliefs when it came to
preserving his independence and freedom of thought – as well as those of his
film-loving readers. If this attitude was entirely in tune with the liberating spirit
of the immediate post-war period, it caused him incessant trouble thereafter,
with the rise of Stalinist communism within the French press. Andrew (1990:
138ff) recounts in detail how Bazin's article 'The Myth of Stalin in the Soviet
Cinema', a virulent attack on the Soviet socialist realist cinema, first published
in 1950, put an end to his collaboration with the left-wing review *Travail et
Culture*. It moreover attracted the ire of the likes of Georges Sadoul, then the
Communist Party's spokesperson for cinema, who accused him of obstructing
the only viable alternative to Hollywood bourgeois production. His sin was
simply to stand by his belief that any social realism had to be first and foremost
aesthetic:

> All the great Soviet films used to be filled with an exemplary realistic
> humanism that was diametrically opposed to the starry-eyed mystifica-
> tions of Western cinema. Recent Soviet cinema claims to be more real-
> istic than ever, but this realism serves as an excuse for the introduction
> of a personal mythology foreign to all the great pre-war films, a mythol-
> ogy whose presence necessarily disrupts the aesthetic economy of these
> recent works. (Bazin 1997: 30)

Bazin remained unshaken in this conviction until his death, as testified by one
of his last articles, 'Cinéma et Engagement' (1957), a paean to a humanist aes-
thetics that overrides all political impositions. All realisms, he stated in this

article, are only valid insofar as they are 'aesthetic catalysts in a synthesis lying more deeply than the social plane'. And he concluded: 'Whether it is a film or a totally different form of expression, the artist must teach us something about himself that is worthwhile. But this discovery does not necessarily pass through social actuality or history' (Bazin 1957: 684).[1]

This is not to say that the Bazinian thought was in any way apolitical, and indeed, as Jean Ungaro reminds us, he was profoundly interested in the political thinkers of his time, such as Malraux and Sartre (Ungaro 2000: 59). Published at the apex of the existentialist debate, the article 'Pour un cinéma impur' had been influenced by and was even the result of this debate. Evidence of this is the assertion that 'we must say of the cinema that its existence precedes its essence' (1967a: 71), a phrase all the more astonishing, coming from a Catholic critic, when we know that it stemmed directly from Sartre's atheistic existentialism as expressed in this passage:

> Atheistic existentialism, which I represent ... states that, if God does not exist, there is at least one being in whom existence precedes essence, a being who exists before he can be defined by any concept, and that this being is man or, as Heidegger puts it, human reality. (Sartre 2000: 15)

Carefully circumventing all the religious implications of such a position, Bazin's adherence to Sartre, here as elsewhere in his writings, had the aim of indicating his disagreement with essentialist ideas of film as a self-sufficient medium, as formulated by theorists such as Arnheim, Balázs and Epstein, and cherished by the modernist avant-gardes of the 1920s. Bazin's very use of the term 'cinéma impur' was a direct response to the 'cinéma pur' project, first launched by Henri Chomette and very much in vogue during the 1920s and 30s among avant-garde and Dada artists and filmmakers, such as René Clair, Man Ray and Fernand Léger. Under the influence of experimentalists Walter Ruttman, Hans Richter and Viking Eggeling, the adepts of 'cinéma pur' proposed to draw exclusively on the techniques inherent in the film medium, such as movement, lighting, contrast, rhythm and – most in conflict with Bazinian thought – montage. Such a fascination with cinema's technological artifice, tending towards complete abstraction from figurative mimesis and narrative representation (Chomette in Abel 1993: 372), could not be further removed from Bazin's idea of cinema as a 'window on the world', a realist vocation to which he subordinated all technological progress.

'Pure cinema' was moreover, in an era still unacquainted with synchronized sound, understood as composed of 'purely visual means', as stated in René Clair's article 'Pure Cinema and Commercial Cinema' (in Abel 1993: 370). If Bazin's rejection of such an idea is only understated in the 'Impure Cinema' article, it is the object of a direct invective in the opening lines of one of his most influential

pieces, 'The Evolution of the Language of Cinema', in which he accuses an artistic 'elite' of being 'perfectly accommodated to the "exquisite embarrassment" of silence', for fearing that 'the realism that the sound would bring could only mean a surrender to chaos' (Bazin 1967b: 23). As a result, and given that it could be claimed that the talkies effectively dealt a *coup de grâce* to Eisensteinian-style montage (see in this respect Williams 1992: 133ff), Bazin was at ease in proclaiming the victory of 'those directors who put their faith in reality' over those who 'put their faith in the image' (1967b: 24). 'The talkie', he said, 'sounded the knell of a certain aesthetic of the language of film, but only wherever it had turned its back on its vocation in the service of realism' (1967b: 38).

As far as politics is concerned, Bazin's view of 'pure cinema' as 'elitist' gives the cue to the political aim of his impure thesis, drawing on cinema's popular and mass-medium character. Indeed, the 'Impure Cinema' article is based on the quasi-utopian hope that screen adaptations of theatre and literature would recover a dimension 'that the arts had gradually lost from the time of the Renaissance onwards: namely the public' (1967a: 75).[2] However, Bazin's populist commitment was marred by contradictions, for he never hesitated to blame this same public when some of his favourite films, such as *The Rules of the Game* (*La Règle du jeu*, Jean Renoir 1939), *The Magnificent Ambersons* (Orson Welles 1942) or *Les Dames du Bois de Boulogne* (Robert Bresson 1945), resulted in commercial flops. For him, 'if the public is cinema's supreme judge to whose verdict we must surrender, it can also be entirely mistaken in the immediate present, just like an experienced critic' (Bazin 1983: 226). This he writes in an article ironically named 'Découverte du cinéma: défense de l'avant-garde', a manifesto celebrating the launch of the Biarritz Film Festival in which he takes the opportunity, not to defend, but to lash out at the formalist avant-gardes for their 'intellectualist and idealist conception of art' (1983: 226). Here, Bazin's anti-avant-garde convictions take him to the extreme of making blatant errors of judgment, such as stating that '*The Andalousian Dog* [*Un chien andalou*, Luis Buñuel and Salvador Dalí, 1929], despite involving multiple artists of incontestable talent, has aged much more than Griffith's *Broken Blossoms* [1919]' (1983: 225). He did, however, in later writings, find a way to rehabilitate former 'cinéma pur' modernists, such as René Clair, whose mature production he conveniently changed into impure, hailing it as 'théâtre cinématographique' made by a director who belongs to the 'history of the French dramatic art before cinema' (Bazin 1983: 91).

The Impure Auteur

The same political drive in support of a popular and impure cinema led Bazin to reject, at least partially, the *politique des auteurs* as formulated in the mid-1950s

by the young critics of the *Cahiers du Cinéma*, under the leadership of his own adopted son, François Truffaut. For him, it was as mistaken to believe in the specificity of the film medium as it was to defend the existence of a single man (women were never in question in those days) behind a film. In his famous article 'On the *politique des auteurs*' (Bazin 1985), he insists that 'the work transcends the director' and reminds us that 'the anonymous works that have come down to us' were 'the products not of an artist, but of an art, not of a man, but of society' (249–50). The possible dissonance this would present with his humanist stance, that placed 'man' above 'actuality and history', as pointed out above, was one that Bazin himself seemed aware of, as he goes on to explain that 'the individual transcends society, but society is also and above all within him' (251).

There is no need to rehearse here the suspicions aroused by Bazin's ideas in the politicized 1960s–70s, which entailed his eclipse from film studies for nearly three decades. Old *Cahiers du Cinéma* and *Screen* writers are themselves currently busy publishing their retractions, as illustrated by Colin MacCabe, who attributes his misunderstanding of Bazin in the 1970s to what he calls 'the nets of Parisian theory':

> When I first wrote about Bazin in *Screen* in the summer of 1974, I treated him as a theoretically naïve empiricist, a kind of idiot of the family. In fact, what was idiotic was to construct an Althusserian straw man out of Bazin's commitment to the real. Bazin's elegant writing interrelated the variables of filmmaking – industry, art, technology – with a depth and sophistication that *Screen*'s analyses desperately needed. (MacCabe 2011: 66)

This kind of re-evaluation carries within it a tacit political acquittal, as, in retrospect, it is impossible to overlook the fact that Bazin's ideas not only did not clash against, but directly informed the politics of the 'nets of Parisian theory', including the likes of Barthes and Foucault. Suffice it to recall that Barthes' groundbreaking 1968 article, 'The Death of the Author', retraces the genealogy of the figure of the artistic author since the Renaissance in the very same way that Bazin had done in 'On the *politique des auteurs*', in order to conclude that the modern emphasis on the individual author is 'the epitome and culmination of capitalist ideology'. In its place, Barthes proposed the 'scriptor', who bears 'no passions, humours or feelings of their own', but only 'the immense dictionary of life' that 'can know no halt' (Barthes 1977: 143ff).

In the same vein, Foucault, a year later, in 'Qu'est-ce qu'un auteur?', reinforced the notion of a disembodied author, devoid of an essence, who is nothing but the filter of society, that is to say, a mere function. 'The author function', says Foucault, 'is thus typical of the mode of existence, circulation and operation

of certain discourses within society' (Foucault 1994: 798). Germane as it is to Bazin's anti-auteurism, the 'author function' is also akin to his impure project. The proof is that the *politique des auteurs* was first formulated by Truffaut, in 1954, in terms of medium specificity and a direct attack on theatrical and literary adaptations to the screen as observed in French cinema's 'Tradition of Quality' (Truffaut in Grant 2008: 9ff). The logic here is obvious, for the more a film is contaminated by other media the weaker becomes the trace of individual creation. As a consequence, if the demise of the author, along with the medium's specificity, is political, the *politique des auteurs* is not.

Barthes and Foucault were certainly not alone in dismissing authorship, and indeed, as Robert Stam notes, this was widely subscribed to by structuralists and poststructuralists, who replaced ideas of purity, essence and origin with those of intertextuality and dialogism, as represented respectively by Kristeva and Bakhtin, the latter a defender, as much as Foucault, of the author as 'orchestrator of pre-existing discourses' (Stam 2005: 4). Stam suggests, furthermore, that intertextual and intermedial studies are necessarily intercultural insofar as they contribute to 'de-segregate' and 'transnationalize' criticism itself, as well as to abolish unavowed hierarchies between different artistic forms (2005: 17). Given that Barthes, Foucault and poststructuralist thought in general provided the main theoretical underpinnings to Cultural Studies, we can now summarize the parameters governing the politics of the aesthetics of cinema, from Bazin to our day, as a) the dissolution of the work in a mixture of media, and b) the dissolution of the individual author – both seen as democratizing, popular procedures, hence endowed with progressive potential.

With regard to cinema and audiovisual media in general, however, these processes, posited as political objectives, sound modest, if not irrelevant. Modes of spectatorship have significantly shifted in our day from the public film theatre to the individual browsing the Web, where mixed media and collective authorship are the rule. Web environments, such as blogs and social networks, are entirely based on cross-media communication, where everybody is at once an artist and a critic. In fact, our Internet age has reached a point where Bazin's utopian idea of a total media fusion, formulated in 'Adaptation, or the Cinema as Digest', seems to have come true several decades in advance of the hundred years he had predicted in these wonderful lines:

> [T]he (literary?) critic of the year 2050 would find not a novel out of which a play and a film had been 'made', but rather a single work reflected through three art forms, an artistic pyramid with three sides, all equal in the eyes of the critic. (Bazin 1997: 50)

As for the intercultural aspect of hybridization, this also seems to have been achieved by present-day amateur artists-cum-critics, permanently in touch,

through the Web, with their multi-ethnic peers –not to mention current world cinema's modes of co-production that merge national and regional traits into a single global trend. Indeed, as Mette Hjort recently warned us, transnational processes end up 'playing a strangely homogenizing role that brings to mind Hegel's sarcastic reference to the "night in which all cows are black," as a response to thinking in which conceptual distinctions are effaced rather than properly developed' (Hjort 2010: 13). For the well-intentioned critic, especially from Cultural Studies, it then becomes imperative to retrieve the lost essence in the praise of difference, the Other purified of all promiscuity with the oppressor, as seen in the defence of the diasporic, the peripheral, the accented vernacular as opposed to the neutral, official and equally pure language. This tendency has reached its peak with the recent ethical turn in Cultural Studies, drawing on Derrida and above all Lévinas and his defence of the 'infinite alterity of the other'. I have elsewhere expanded on this turn (Nagib 2011), which I deem essentializing to the point of frontally contradicting the politics of hybridization which is paradoxically sustained by the same current with equal vigour. My intention here is to suggest an alternative route which posits intermediality, not as a political objective projected into the future, but as an ever-present dialectical crisis, the site of a profound dilemma between the depurative drive inherent in all artistic forms and the awareness of its insufficiency. This dilemma, I suggest, is by its own nature political.

The Political Object

As we have seen, while intermedial approaches often derive from a political stance, impurity alone is insufficient to establish a film's political agenda, starting with the fact that all films are multimedial by definition, let alone the ever-growing mixture of media currently taking place in the virtual space. Suffice it to remember that the modernist 'pure cinema' filmmakers themselves – including the above-mentioned Epstein, Man Ray, Fernand Léger and René Clair – stemmed from, and worked on, a cross-media platform which included music, painting, theatre, opera and dance. Additional elements are thus required to characterize the political in cinema's impurity. These Bazin defined as 'realism' and 'modernity', on the basis of which he formed his pantheon, topped by Renoir and followed by Welles, Rossellini, Stroheim, Ophüls, Bresson and a few others. What these filmmakers had in common, and what Bazin defined as simultaneously realist and modern about them, was their ability to render space and time uncut, primarily through the use of depth of field. Whether their films were 'impure' – or at least *more* impure than, say, the 'classical' Hollywood films placed in opposition to them – is a question which requires further elaboration.

As is well known, the sin of Hollywood as well as Soviet cinema, in the eyes of Bazin, was montage, which 'rules out ambiguity of expression' proper to depth of field and the sequence-shot (Bazin 1967b: 36). It is also known that this ambiguity is part and parcel of Bazin's realist conception, customarily understood as the contingent, unpredictable real as captured by the likes of Rossellini, De Sica and Visconti in their neorealist phase, through the use of location shooting and non-professional acting. Again depth of field is essential to allow this spontaneous authenticity to emerge. However, the complexity of depth-of-field realism accrues when applied to an utterly constructed film such as *Citizen Kane* (Orson Welles 1941) in which, according to Bazin, ambiguity results from the 'temporal realism' (1967b: 36–7) of the recurrent deep-focus shots interspersed amidst heavily edited stock.

The unravelling of what Bazin actually understood by 'temporal realism' within the depth of field has recently been the object of an illuminating essay by Diane Arnaud (2011). Retranslating a passage of Bazin's article 'Théâtre et cinéma' on Cocteau's *The Storm Within* (*Les Parents terribles*, 1948), Arnaud, via Deleuze, restores the Bazinian idea of an 'excess of theatricality' allowed to intrude into the cinematic space of depth of field which establishes a direct link between realism and impure cinema (2011: 85). This she gleans from Bazin's analysis of a passage of Cocteau's film in which the camera position is identified with an exterior point of view replicating that of the theatre spectator. As a result of the fact that the shooting style here is a tracking shot in depth of field, that never overlaps with the subjective point of view of the film's character, Cocteau's film viewer, in Arnaud's exegesis, is given 'a free choice among several possible *découpages*, with the feeling – in the background, so to speak – of being totally present at the event' (88). Realism is thus translated, in this case, as a surplus of space and time which enables the development of spectatorial agency. Interestingly, such an effect derives, not from the prevalence of phenomenological reality, but from a fidelity to the theatrical origin of the film, which, in turn, testifies to the reflexive awareness of the possibilities of the film medium – or 'cinematographic intelligence', in Bazin's words (1967c: 69) – on the part of the filmmaker, triggering that of the viewer.

Once again reminiscent of Sartre and his thesis on existential freedom of choice, 'excess of theatricality' chimes even more with notions of 'cinematic excess', as would be developed decades later by Stephen Heath and Kristin Thompson on the basis of the Barthesian concept of 'third meaning'. At stake here is an excessive materiality of the image whose significance reaches beyond its narrative function (Thompson 1986: 130ff). But still, this tells us little about politics, unless we stretch Bazin's deep-focus theory beyond its intermedial potential to encompass a self-reflexive reality of the film medium intended to arouse Brechtian-style critical spectatorship. Bazin's writings give us scant elements to back such a hypothesis, despite their multiple references to medium

realism, a typical case being the documentary reality of the actors that overflows their characters, such as Stroheim in *Grand Illusion* (*La Grande illusion*, Jean Renoir 1937), Michel Simon in *Boudu Saved from Drowning* (*Boudu sauvé des eaux*, Jean Renoir 1932) and Falconetti in *The Passion of Joan of Arc* (*La Passion de Jeanne d'Arc*, Carl Theodor Dreyer 1928). But this is also where the combination of deep-focus realism and mixed media translates into a will to abolish the schism between art and life which has been at the core of the politics of intermedial proposals of all times. Shröter (2010: 116) goes back to Wagner and his conception of a total artwork to demonstrate how the idea of breaking boundaries between different media is tantamount to the fusion of art and life, as reflected in Wagner's emulation of the Greek amphitheatre which enabled the integration of artists and recipients. More significantly, Schröter likens this fusion to the Marxist idea which saw the division of labour as an 'alienation' to be abolished (115). An obvious example of this latter sense is the removal of the theatre's fourth wall as proposed by Brecht, an intermedial artist *par excellence* who was also acutely aware of border-crossing between media and genres, as well as art and life, as a powerful metaphor for a classless society.

This glimpse of politics behind the deep-focus device would however be insufficient to justify Bazin's anti-modernist defence of what he described as 'modern' cinema produced after the Second World War, an awkward equation that obscures his otherwise crystalline and uncompromising aesthetic politics. Such an anachronistic view of the modern, that excludes modernism itself, continues nevertheless to be widely adopted in Bazinian as well as anti-Bazinian scholarship, granting political sanction to his pantheon and perpetuating a confusing notion of the 'modern' (and its 'classical' counterpart) in the cinema. Fortunately, since Miriam Hansen's groundbreaking article, 'The mass production of the senses: classical cinema as vernacular modernism' (2000), more complex organizations of film history have started to emerge. Among other compelling arguments, Hansen highlights the self-reflexive potential of old Hollywood classics – for example, the excessive physicality of the slapstick comedy (2000: 342–3) – to explain how such films could have sparked vernacular modernisms elsewhere in the world, a point that interestingly chimes with the Bazinian 'theatrical excess' that fuses art and real life within the depth of field. More recently, Laura Mulvey formulated a similar argument, drawing on the self-reflexive potential of the rear-projection device, which 'smuggles something of modernism' into the 'classical' narrative (2011: 208). These examples demonstrate how unproductive it has become to stick to a rigid classical-modern divide, hence to search for progressive politics exclusively within the Bazinian modern pantheon and its heirs. Nonetheless, 'impurity' viewed as a metaphorical surplus to fill in the gap of a medium insufficiency remains, in my view, a useful tool, one which allows us to identify political materials capable of advancing film theory in new and exciting directions.

Intermediality as Dissensus

In order to test intermediality as the location of the political in filmmaking I will now experiment with Jacques Rancière's philosophy of art and cinema as a possible alternative to the modern-classical debate. Rancière has repeatedly questioned the political efficacy of reflexive art that proposes to fuse with life by removing the separation between subject and object, stage and audience, in the following terms:

> We do not have to transform spectators into actors, and ignoramuses into scholars. We have to recognize the knowledge at work in the igno-ramus and the activity peculiar to the spectator. Every spectator is already an actor in her story; every actor, every man of action, is the spectator of the same story. (Rancière 2009: 17)

For him, the intention 'to produce an effect of strangeness in order to engender an awareness of the underlying reasons of that strangeness ... is tantamount to suppressing it' (2010: 143). Rancière is certainly not the first to challenge Brechtian-style anti-illusionistic reflexivity for its authoritarian pedagogy, even if democratic in origin, but he is no less scathing of representational art of political intention, which resorts to the mimetic device in order to reveal, in his words, 'the power of the commodity, the reign of the spectacle or the pornogra-phy of power'. He says: ' ... since it is very difficult to find anybody who is actu-ally ignorant of such things, the mechanism ends up spinning around itself', that is, reproducing consensus (144). Such a statement encapsulates not only a criticism of didactic representational art, but also a tongue-in-cheek reference to Cultural Studies' customary method of decoding, for an audience of peers, ideological structures buried within art pieces which elicit misrepresentations of minorities of race, gender and sexuality. Instead of this innocuous exercise, Rancière proposes the investigation of dissensus, which he explains as follows:

> If there exists a connection between art and politics, it should be cast in terms of dissensus, the very kernel of the aesthetic regime: artworks can produce effects of dissensus precisely because they neither give lessons nor have any destination. (Rancière 2010: 140)

Dissensus is moreover, for Rancière, the element that separates the aesthetic from the representative regimes in art, a division which he seems to understand as an advantageous substitute to Bazin's diachronic classical-modern model, though he does so via Deleuze's revision of Bazin, that is, the opposition between move-ment-image and time-image. These he also contests by arguing, among other things, that 'cinema is the art that realizes the original identity of thought and non-thought', a dialectic that jeopardizes 'any attempt to distinguish two images

by means of specific traits, and so to fix a border separating a classical from a modern cinema' (Rancière 2006: 122). This is how he defines his own model:

> The representative regime understands artistic activity on the model of active form that imposes itself upon inert matter and subjects it to its representational ends. The aesthetic regime of art rejects the idea of form willfully imposing itself on matter and instead identifies the power of the work with the identity of contraries: the identity of active and passive, of thought and non-thought, of intentional and unintentional. (Rancière 2006: 117)

In the aesthetic regime, according to Rancière, the function of fiction is not to oppose the imagined to the real, but to re-frame the real, that is, to frame a dissensus. Fiction, in this regime, 'is a way of changing existing modes of sensory presentations and forms of enunciation; of varying frames, scales and rhythms; and of building new relationships between reality and appearance, the individual and the collective' (Rancière 2010: 141). In the consensual representative mode, sensory reality is given as univocal, whereas 'political and artistic fictions introduce dissensus by hollowing out that "real" and multiplying it in a polemical way' (149).

The advantages of Rancière's regimes, in my view, are that, by avoiding a diachronic division of history, they allow, in tune with Hansen and Mulvey, to locate a combination of both classical and modern in a single film, sometimes even in a single scene, as in the extract I will be analysing in a moment. Moreover, it presents the irresistible attraction, at least as far as intermediality is concerned, of redefining political art as that which refuses to anticipate its effects, questioning, instead, its own limits and powers. That is to say, an art which accepts its own insufficiency and, even when it infiltrates the world of market and social relations, 'remains content to be mere images', in Rancière's words (149).

Rancière does not refer to intermediality or intertextuality in his description of dissensus as the location of the political in art. Nevertheless, I will take the liberty of looking at intermedial cinema as a fertile ground for the investigation of the political according to Rancière's model, in particular if placed in an historical perspective going back to Bazin's pioneering idea of impure cinema, running through poststructuralism's defence of hybridization, and arriving in our day with cultural studies' defence of othered, oppressed minorities. This is because, in the first place, the recourse to different media within a film immediately suspends the pedagogical character of representational narratives by introducing a dilemma, or 'dissensus', in Rancière's terms, which, rather than giving univocal lessons, multiplies the meanings of the referent. Secondly, the content of a film becomes impure insofar as its form incorporates other forms, thus diluting frontiers and genres, including those of sex and gender that lie at the core of cultural studies, as my filmic example will hopefully demonstrate.

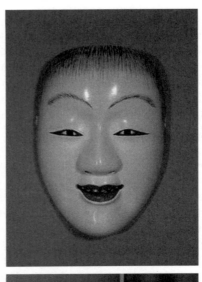

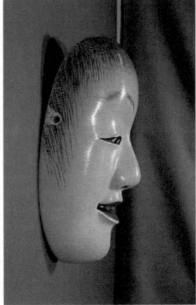

Figures 1 and 2: The Doji mask represents the face of a boy whose features are not yet defined into those of a male adult.

My choice of a Japanese canonical film for the application of the dissensual method is not fortuitous. Japanese cinema has never made any secret of its impurity since its birth in the kabuki houses, from which it has borrowed a number of hybrid devices, such as the *onnagata* (the male impersonator of female roles) and the live film commentator called *benshi*. Its evolution is marked by the interface with bunraku, noh and kabuki theatres, e-makimono painting, ukiyo-e engravings, dance and music. Commenting on the 'commingling media' which participated in the genesis of Japanese cinema, Joseph L. Anderson reminds us of an old Buddhist saying, according to which 'all arts are one in essence' (1992: 262). It is probably thanks to this tradition that Japanese cinema was quick to overcome the dilemma of specificity, remaining entirely at ease with its own insufficiency that entails constant recourse to intermediality. My chosen excerpt to illustrate this is drawn from *The Sound of the Mountain* (*Yama no oto*), directed by Mikio Naruse in 1954, a film that could be easily qualified as 'classic' in the Bazinian sense, due to its full reliance on montage, but whose qualities derive from a combination of representative and aesthetic regimes.

The Sound of the Mountain is an intermedial dialogue from its origin, for it is an adaptation of Yasunari Kawabata's famous novel that gained him the Nobel prize in literature. The novel is narrated in the first person by the protagonist, the sexagenarian Shingo, who is enthralled by the physical and spiritual purity he seems to recognize in his daughter-in-law Kikuko, endowed with immaculate beauty and impeccable demeanour. However, his mind is haunted by real and imaginary enigmas around him, starting with the 'sound of the mountain', which only he can hear and which seems to presage his own death. Shingo is also worried by the inexplicable behaviour of his son, Shuichi, who has kept a mistress since the beginning of his marriage, despite having, in the eyes of his father, a perfect wife. The screen adaptation, masterfully carried out by Naruse and his favourite screenwriter Yoko Mizuki, stands out for the way cinema's prerogatives, that is, the combination of image, sound and movement, are explored in order to convey situations which exceed literary expression. They started by ridding the story of its countless metaphors of nature, which are used in the novel to illustrate the patriarch's spiritual states, including the sound of the mountain that only survived in the film's title. A first-class cast includes, in the role of the irreproachable Kikuko, Setsuko Hara, the most famous actress at the time in her country who was moreover conveniently known as 'the eternal virgin of Japan', the symbol of purity *par excellence*.

The specific scene I will focus on concerns a noh mask. As is well known, noh theatre has been an elite art from its origin in the fourteenth century. Sponsored by the shogunate, it remained an exclusive property of the aristocracy and forbidden to the rest of the population until the end of the Edo period, in 1868. Noh thus became the site *par excellence* for the exercise of gesture depuration and an obstinate quest for perfection in the manner of other Buddhist

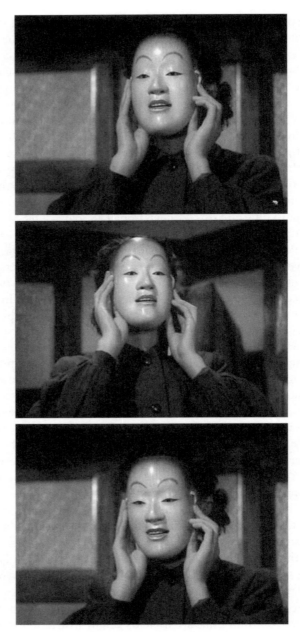

Figures 3, 4, 5 and 6: The secretary slightly raises and lowers her face, giving the impression that the mask is effectively changing its expression (The Sound of the Mountain).

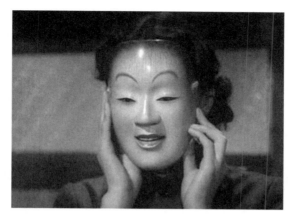

Figures 3, 4, 5 and 6: (Continued)

arts, such as the tea ceremony. Interestingly, however, noh's highest aspiration is not any clear message, but mystery and ambiguity. In the words of a noh actor, himself a mask maker, noh's main aesthetic principle is the pursuit of beauty as encapsulated by the concept of *yugen*, which 'refers … to a sort of mysterious, unfathomable aesthetic quality … a complex sensation, impossible to describe exactly' (Udaka 2010: 7). In tune with *yugen*'s ineffable meaning, all noh masks are ambiguous by definition, representing characters at once dead and alive, cheerful and sombre, malicious and childish, mean and innocent, feminine and masculine, according to the actor's head and body movements, as well as the incidental lighting. In the novel, but even more so in the film, the noh mask was utilized to give expression to the way in which Shingo's pursuit of purity, similar in all respects to the quest for the elusive *yugen*, is frustrated by the revelation of his own impure feelings. It is also the moment in which the representative regime, in Rancière's terms, or classical in Bazin's, dissolves into an 'impure' aesthetics, in which noh's expressive symbolism is used to fill in a gap in cinema's narrative properties.

Here is the scene. An old school acquaintance of Shingo's has just died and a mutual friend comes to pay him a visit in his office. The friend presents him with a noh mask that the deceased's widow had asked him to sell. He tells Shingo that their old colleague had died while in the company of a young girl at a spa, thus providing a suggestive sexual backdrop to the appreciation of the mask. This is then unveiled and placed on the face of Shingo's secretary. As the friend explains, the mask represents the face of a boy, a typical Doji mask, whose features are not yet entirely defined and fixed into those of an adult; the plump freshness of its cheeks and the loose locks around it give it an androgynous appearance (Figures 1 and 2). Shingo's friend asks the secretary to slightly raise and lower her face, which gives the impression that the mask is effectively

changing its expression, as if parting and closing its lips and eyelids (Figures 3–6). The shot-reverse-shot montage shows us Shingo's shock at the sight of this, as his feelings seem suddenly revealed by the ambiguous mask. All of a sudden, he discovers, by looking at it, that he feels himself sexually attracted to his daughter-in-law, whose suffering, disguised under her face frozen into a living mask, is then offered to us by an inset of Setsuko Hara, in the role of Kikuko, displaying the same enigmatic half-smile of the noh mask (Figures 7 and 8). In this brief moment, Kikuko reveals her flesh-and-bone 'impure' being behind her virginal mask, as it becomes clear in retrospect that she reciprocates her father-in-law's attraction to her.

Shingo's feelings are all the more troubling as they carry a mixture of adultery (betrayal of his wife), homosexuality (attraction to a male mask), incest (attraction to a member of kin) and paedophilia (attraction to the mask of a boy)

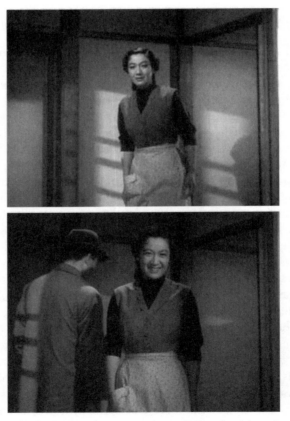

Figures 7 and 8: Kikuko displays the same enigmatic half-smile of the noh mask (The Sound of the Mountain).

which are unconfessed, unconfessable and above all, unknown to the character himself until that moment. The conversation with the secretary that follows – and which sends the spectator back to the representative regime – reinforces this discomfort, for she confirms to Shingo that his son, Shuichi, resents Kikuko's childishness and would have preferred her to behave like a prostitute in bed, that is, like the mature mistress he has kept since he got married. Dissolution of frontiers thus takes place here at all levels: between different art media, modern and classical genres, and between genders and sexualities, all of which remain as elusive and non-pedagogical as *yugen*.

One could conclude, following Bazin's reasoning, that this extract of *The Sound of the Mountain* fulfils cinema's political function of bringing to the masses a slice of this elite, coded and difficult theatre which is noh, albeit in a diluted and simplified fashion. One could also understand that the film addresses, in a courageous manner, despite its rather conservative narrative structure, some key political questions at the core of Cultural Studies, such as the oppression of women and sexual minorities. But it is on the level of representation that these approaches search for the political, a realm in which the film has very little to offer. What seems to me truly political here is the recourse to intermediality that ushers in the aesthetic regime, evidencing a moment of crisis of the medium which requires another for its completion. This is where questions of gender and female oppression become entirely explicit and all the more political as their signification in the film form, rather than the content, refuses, in Rancière's expression, to anticipate its effects or to give any lessons. The way in which the noh mask is utilized thus introduces dissensus, which establishes new relations between reality and appearance, the individual and the collective, multiplying the possibilities of the film medium in a polemical way, while challenging its own limits and the power of representation.

Notes

1 Translations by the author, unless otherwise stated.
2 I have slightly changed the translation of this quote for the sake of clarity.

References

Abel, Richard (ed.) (1993). *French Film Theory and Criticism 1907–1939*. Princeton, New Jersey: Princeton University Press.
Anderson, Joseph L. (1992). 'Spoken Silents in the Japanese Cinema; or, Talking to Pictures: Essaying the *Katsuben*, Contexturalizing the Texts', in Arthur Nolletti, Jr. and David Desser (eds). *Reframing Japanese*

Cinema: Authorship, Genre, History. Bloomington/Indianapolis: Indiana University Press, pp. 259–310.

Andrew, Dudley (1990). *André Bazin*. New York: Columbia University Press.

Arnaud, Diane (2011). 'From Bazin to Deleuze: A Matter of Depth', in Dudley Andrew and Hervé Joubert-Laurencin (eds), *Opening Bazin*. Oxford/New York: Oxford University Press, pp. 85–94.

Barthes, Roland (1977). 'The Death of the Author', in *Image, Music, Text*, essays selected and translated by Stephen Heath. London: Fontana, pp. 142–54.

Bazin, André (1957). 'Cinéma et engagement', *Esprit*, April, pp. 681–4.

—— (1967a). 'In Defense of Mixed Cinema', in *What Is Cinema?* vol. 1, edited and translated by Hugh Gray. Berkeley/Los Angeles/London: University of California Press, pp. 53–75.

—— (1967b). 'The Evolution of the Language of Cinema', in *What Is Cinema?* vol. 1, edited and translated by Hugh Gray. Berkeley/Los Angeles/London: University of California Press, pp. 23–40.

—— (1967c). 'Theater and Cinema', in *What Is Cinema?* vol. 1, edited and translated by Hugh Gray. Berkeley/Los Angeles/London: University of California Press, pp. 76–94.

—— (1983). 'Découverte du cinéma: Défense de l'avant-garde', in *André Bazin. Le Cinéma français de la Libération à la Nouvelle Vague (1945–1958)*, edited by Jean Narboni. Paris: Cahiers du Cinéma, pp. 225–7.

—— (1985). 'On the *politique des auteurs*', in Jim Hillier (ed.) *Cahiers du Cinéma: The 1950s – Neo-Realism, Hollywood, New Wave*. Cambridge, Massachusetts: Harvard University Press, pp. 248–59.

—— (1997). 'The Myth of Stalin in the Soviet Cinema', in *Bazin at Work: Major Essays & Reviews from the Forties & Fifties*, translated by Alain Piette and Bert Cardullo, edited by Bert Cardullo. New York/London: Routledge, pp. 23–40.

—— (1997). 'Adaptation, or the Cinema as Digest', in *Bazin at Work: Major Essays & Reviews from the Forties & Fifties*, translated by Alain Piette and Bert Cardullo, edited by Bert Cardullo. New York/London: Routledge, pp. 41–52.

Foucault, Michel (1994). 'Qu'est-ce qu'un auteur?', in *Dits et écrits 1954–1988*, edited by Daniel Defert and François Ewald. Paris: Gallimard, pp. 789–821.

Hansen, Miriam (2000). 'The mass production of the senses: classical cinema as vernacular modernism', in Christine Gledhill and Linda Williams (eds), *Reinventing Film Studies*. London: Arnold, pp. 332–51.

Hjort, Mette (2010). 'On the plurality of cinematic transnationalism', in Natasa Durovicova and Kathleen Newman (eds), *World Cinemas, Transnational Perspectives*. New York/Abingdon: Routledge, pp. 12–33.

Le Fanu, Mark (2005). *Mizoguchi and Japan*. London: BFI.

MacCabe, Colin (2011). 'Bazin as Modernist', in Dudley Andrew and Hervé Joubert-Laurencin (eds), Opening Bazin. Oxford/New York: Oxford University Press, pp. 66–76.

Mulvey, Laura (2011). 'Rear-Projection and the Paradoxes of Hollywood Realism', in Lúcia Nagib, Chris Perriam and Rajinder Dudrah (eds), Theorizing World Cinema. London/New York: I.B.Tauris, pp. 207–20.

Nagib, Lúcia (2011). World Cinema and the Ethics of Realism. New York/London: Continuum.

Rancière, Jacques (2006). Film Fables, translated by Emiliano Battista. Oxford: Berg.

———— (2009). The Emancipated Spectator, translated by Gregory Elliott. London: Verso.

———— (2010). Dissensus: On Politics and Aesthetics, edited and translated by Steven Corcoran. New York/London: Continuum.

Sartre, Jean-Paul (2000). Existentialism and Human Emotions, translated by Bernard Frechtman. New York: Citadel.

Schröter, Jens (2010). 'The Politics of Intermediality', Film and Media Studies, 2, pp. 107–24.

Thompson, Kristin (1986). 'The Concept of Cinematic Excess', in Philip Rosen (ed.), Narrative, Apparatus, Ideology: A Film Reader. New York: Columbia University Press, pp. 130–42.

Truffaut, François (2008). 'A Certain Tendency of the French Cinema', in Barry Keith Grant (ed.), Auteurs and Authorship: a film reader. Malden/Oxford/ Victoria: Blackwell, pp. 9–18.

Stam, Robert (2005). Literature through Film: Realism, Magic, and the Art of Adaptation. Malden/Oxford/Victoria: Blackwell.

Udaka, Michishige (2010). The Secrets of Noh Masks. Tokyo/New York/London: Kodansha.

Ungaro, Jean (2000). André Bazin: généalogies d'une théorie. Paris: L'Harmattan.

Williams, Alan (1992). 'Historical and Theoretical Issues in the Coming of Recorded Sound to the Cinema', in Rick Altman (ed.), Sound Theory, Sound Practice. New York/London: Routledge, pp. 126–38.

PART II

INTERTEXTUAL AND INTERCULTURAL DIALOGUES

Contestations of Intercultural Collaboration: The Case of *Whale Rider*

Virginia Pitts

In traditional Māori culture, stories belonged collectively to the *whānau* (extended families), *hapū* (sub-tribes) or *iwi* (tribes) and, in any telling of the story, questions arising about authenticity and accountability were moderated by elders (Lee 2005: 10). Using *Whale Rider* (Niki Caro 2003) as a case study, this chapter explores how such issues of accountability and authenticity may be managed through the integration of Indigenous[1] tradition and modernity in the production process and the aesthetic construction of a film destined for global consumption. In response to the difficulty many critics exhibit both in acknowledging Māori participation in the making of *Whale Rider* and in formulating a reading position that functions beyond a Western positivist orientation, primary research has been undertaken that reveals a mode of intercultural creative collaboration in which dialogic negotiation by (and with) Indigenous people provides an alternative to processes of either cultural domination or utopian synthesis.

Myth, Novel, Film

Adapted from a novel by celebrated Māori author, Witi Ihimaera, Niki Caro's film tells the story of a young Māori girl's struggle to overturn patriarchal resistance towards her future role as a leader. Both novel and film draw from the ancient genealogical *pūrākau* (myth) associated with Ngati Konohi, a sub-tribe of Ngati Porou based in Whangara on the east coast of New Zealand's North Island. According to this *pūrākau*, the tribe's founding father, Kahutia Te Rangi,

foiled his brother's plan to kill him by sinking their *waka* (large, intricately carved canoe). Left adrift in the ocean near Hawaiki (the Māori ancient homeland), Kahutia Te Rangi was saved by a *paikea* (humpback whale), who transported him to Whangara in Aotearoa (New Zealand). Once there, he was renamed Paikea in honour of the creature that delivered him. The traditional function of *pūrākau*[2] in Māori culture is to convey a 'moral lesson or esoteric truth' (Roberts 2008). According to Ihimaera, although people already occupied Aotearoa, they lacked the *mauri* (life principle) needed to live in close communion with the world. For him, then, the value of the Paikea *pūrākau* to the people of Aotearoa was to generate a 'oneness' between humans and sea creatures (Ihimaera 1987: 27).

Ihimaera was motivated to adapt this *pūrākau* in the mid-1980s by two incidents that occurred in close succession: his daughters' complaints about action movies being dominated by male heroes who save helpless females and the unusual sight of a whale swimming up the Hudson River in New York, where he was working at the time. The Paikea myth immediately sprang to mind for Ihimaera, who is related to Ngati Konohi through his mother, and he set about writing a feminist revision of the myth that replaces the male hero with a female heroine. Says Ihimaera, 'Having a girl ride the whale, which is also a symbol of patriarchy, was my sneaky literary way of socking it to the guy thing' (*Making the Film* (nd)). His dual intention to honour the original *pūrākau* and adapt its message for a contemporary era is achieved by creating three intersecting storylines, two set in mythic time and one in a contemporary naturalistic setting. All three storylines are positioned within a broader structural framework (Spring, Summer, Autumn and Winter) linking them to the cycles of nature. The book first introduces the two mythic plotlines: one follows Kahutia Te Rangi's journey to Aotearoa according to the original myth, while the other, more substantial plotline takes place in the depths of the ocean and in a deeper mythic time stretching back and forth into infinity. This storyline follows the journey of a herd of whales headed by the Ancient One and suggests broader themes about our species' relationship to the planet, such as in its moving depiction of the herd being forced to flee south into walls of crashing ice due to the poisoning of its habitat by nuclear bomb testing off the island of Moruroa.[3] Expressing Ihimaera's belief in the symbiosis between humans and sea creatures, the besieged herd reflects the foundering human community above sea level and, in line with his feminist agenda, both leaders – Koro above sea level and the Ancient One below – require educating by their female partners in order to be released from patriarchal assumptions about gender and leadership.

In the novel, the mythic strands weave in and out of a contemporary naturalistic plotline narrated by a young man, Rawiri, who recounts the fortunes of his niece (Kahu). She is the granddaughter of Koro Apirana, who longs for a

grandson to lead his people. After a difficult birth, baby Kahu's mother (Rehua) insists Kahu's umbilical cord be buried on the *marae* (courtyard in front of the meeting house) of her father's people rather than Koro's.[4] This is concealed from Koro, who is already horrified by Rehua's decision to name the baby girl after his family's godly *male* ancestor, and angry at his wife (Nanny Flowers) for giving permission for this behind his back. Three months after giving birth, Rehua dies and Kahu is taken away to be brought up by her mother's family. Each summer, however, Kahu returns to Whangara, where her love for Koro blossoms despite his constant rejection of her for being a girl. He does not recognize her early and intense interest in *Māoritanga* (Māori culture, practices and beliefs) as anything but a nuisance, and constantly shoos her away from the *wānanga* (place of learning) he runs to teach the skills of ancient Māori tradition to the local boys – the only legitimate recipients of such knowledge in his view. As Kahu grows from toddler to pre-schooler, it becomes clear to all but Koro that she has inherited the ancient gift of communication with sea creatures, and this is confirmed when, assisted by dolphins, she retrieves from the ocean floor a carved stone Koro had thrown in the (unfulfilled) expectation of identifying the next leader among the boys he is preparing for the role.

Māori philosophy perceives the past as embedded in the present, giving rise to a spirituality in which ancestors lead the way into the future. In Ihimaera's novel, this is expressed structurally when the mythic storyline surfaces in the naturalistic (present) storyline as 200 whales become stranded following their doomed attempt to escape the effects of nuclear test explosions. A massive rescue effort involving both Māori and Pākehā (New Zealanders of European descent), old and young, the navy, wildlife groups and the media, fails spectacularly and all 200 whales die. The following day, the Ancient One strands himself at Whangara and lashes out at the locals' attempts to save him. Koro understands and proclaims that if the whale is saved, so is their future, but if the whale dies so do they. Demonstrating her courage, young Kahu is prepared to sacrifice her life to safeguard the future of her people and it is only when *she* communicates with the Ancient One that his death-wish subsides (Figure 1). With her astride him, the whale returns to the ocean before delivering the girl back to land to lead her *iwi*.

While the events of this denouement also occur in the climax of Caro's filmic adaptation, she makes a number of changes to the plot and structure in order to tell the story in 100 minutes and connect with a modern cinema audience. Rather than an episodic narrative that depicts Kahu's childhood during annual summer holidays, Caro chose to plot the entire screen story in her eleventh year. Sacrificed for the screen adaptation are Ihimaera's substantial mythic plotlines and thus also some of the broader themes and political commentary they carry in the novel. However, Caro's underwater sequences with whales do suggest the mythic time and space more manifestly rendered by Ihimaera,

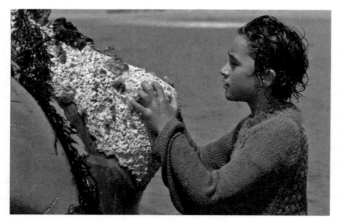

Figure 1: Pai (Keisha Castle-Hughes) joins with mythical ancient whale to save the herd and her community (Whale Rider).

and this is crystallized in the film when the young protagonist rides the stranded whale back into the ocean. Caro cleverly scripts Koro's *wānanga* scenes to edu-cate the audience about Māori cultural traditions and introduces a new element to the story in the form of Porourangi's emblematically unfinished *waka* (canoe), which languishes on its building frame in the dunes. This addition provides an arresting image in the final scene when tradition and modernity symbolically meet as the completed *waka* is 'flown' through the air by crane and into the sea.

Although the feminist interpretation of the Paikea *pūrākau* was first rendered by Ihimaera, Caro further centralizes a female perspective by shifting the narra-tor role from Rawiri to Kahu, who is renamed Pai (short for Paikea) in the film. Hence, the relationship between ten-year-old Pai and her stubborn grandfather is foregrounded in a story more focused on the unconditional love she gives Koro in her quest to gain his recognition. The catalyst for Koro's rejection of Pai is given more impact by opening the naturalistic plotline *in medias res* via a dramatic scene in which Pai's mother and a twin brother (not present in the novel) both die during childbirth. Updating the contemporary plotline of Ihimaera's novel, a more pressing need for local leadership is constructed by Caro in her depiction of a small community fraying at the edges: some of the local boys have fathers who have either dropped out or are in prison, and Rawiri remains good-natured but is transformed from the industrious manual worker who travels abroad in Ihimaera's novel to an overweight stay-at-home stoner lacking in direction. Another character shift occurs with Nanny Flowers, who remains strong-willed in Caro's film, but is not as stroppy as the character painted by Ihimaera. In Caro's adaptation, Pai's father, Porourangi (Koro's first-born), is transformed into an artist whose work Koro rejects. He also becomes

the character who lives overseas and is more keenly subjected to Koro's ever-deepening disappointment in him for not fulfilling a leadership role in the community. Koro's quest for a leader is thus sharpened in Caro's adaptation because, in the novel, Porourangi is actually accepted as the leader from his generation, and it is only from the *next* generation that Koro seeks someone worthy of assuming the chiefly mantle.

Although neither book nor film question the legitimacy of hereditary leadership claims in traditional Māori culture, Caro looked beyond this model for a style of leadership worth celebrating in the character of Pai:

> It sounds sort of kooky, but for Pai I was looking to somebody like the Dalai Lama for that leadership style, which I believe is the very best kind. A really effective leader is not the guy at the front shouting and being the boss, it's the person who leads by compassion and empowers, inspires everybody else to be the best that they can be. (Shepheard 2003: 86)

Unusually for a feature film, there are no subplots in Caro's script, and this places further emphasis on the emotional centre of the story – the relationship between Pai and Koro.

Cultural Politics: Exclusions and Difference

Despite concerted efforts to secure financing from the New Zealand Film Commission (NZFC), Māori filmmakers have, per capita, directed far fewer fiction feature films than Pākehā. By the time *Whale Rider* was released in 2003, only four of the 92 dramatic feature films financed by the NZFC were directed by Māori.[5] This constitutes 4.3 per cent of the NZFC's dramatic feature film output at a time when, according to the 2001 census, Māori constituted 14.28 per cent of the population. Furthermore, a persistent obsession with Māori by Pākehā and foreign filmmakers has resulted in some culturally unacceptable production experiences[6] and a cluster of films characterized by either negative othering or naïve romanticization of Māori.[7] Consequently, the fact that a Pākehā was commissioned to adapt Ihimaera's novel and direct the film sparked fears that the authorial exclusions and presumptuous cultural projections of the past would be perpetuated.

Heated debate on the topic via a series of open letters in New Zealand's screen industry trade magazine, *Onfilm*, exemplifies how these skewed bicultural power relations inflect the politics of New Zealand filmmaking. The debate was triggered by an interview with John Barnett, the producer of *Whale Rider*, who accuses Pākehā academics of proscribing the telling of stories outside of one's own culture. He argues instead that cultural forms 'evolved by one group of people'

are 'built on by others' and that 'at each iteration the definitive form is a reflection of things that have gone before'. Furthermore, Barnett asserts that to deny this is tantamount to an 'apartheid' view of culture (Barnett 2002: 2). While his appreciation of how hybrid cultural forms evolve is valid, Barnett's view does not acknowledge the profound effect unequal power relations can have on the gate-keeping and evolution of this work in an industrial context. A more extreme disavowal of the unequal postcolonial playing field is evident in letters by writer/producer Alan Brash. He refuses any distinction between a Pākehā directing a Māori story (*Whale Rider*) and a Māori directing a James Bond film (*Die Another Day*, Lee Tamahori 2002) or the making of *The Māori Merchant of Venice* (*Te Tangata Whai Rawa O Weneti*, Don Selwyn 2002) by a Māori director (Brash 2003: 11). Brash states that Māori ought to be '"grateful" for being allowed to "borrow" the technology of film-making' and opines that non-Māori taxpayers helped fund several Māori-themed feature films. However, he fails to note the corresponding fact that Māori and other non-Pākehā taxpayers helped fund the 88 NZFC-funded dramatic features directed by Pākehā prior to 2003.

Māori filmmakers Barry Barclay and Carey Carter contest Barnett and Brash's views in their responses, also published as open letters in *Onfilm*. Barclay first objects to Barnett's reversal of the term apartheid to describe 'Indigenous attempts to protect their cultures from appropriation and financial exploitation by Western producers' (Barclay 2003: 11). He also critiques Barnett's emphasis on the 'universal' nature of a story to 'the detriment of genuine Indigenous efforts' (14), while questioning the applicability of European concepts of intellectual property rights to the acquisition of Indigenous stories.[8] Carey Carter adds to the debate by critiquing Brash's ignorance of the struggles Māori filmmakers have faced in seeking the same access to finance as Pākehā for the telling of their stories on film (Carter 2003a: 11). Acknowledging Barclay's lifelong efforts to achieve that same access, Carter argues that ' ... before we debate who should and who shouldn't have the right to tell a Māori story, let's get the playing field on equal terms' by giving 'Māori a shot at telling their own stories' (Carter 2003b: 9).[9] Evident here is the apparent threat intercultural cinema poses to Indigenous filmmaking in New Zealand, particularly when the intercultural creative team is comprised of Māori and Pākehā. Due to the lodging of a Treaty of Waitangi Claim against the NZFC in 1998,[10] Barclay has argued that any film with Māori content is seen by the NZFC as counting towards an 'unspoken quota' (Pitts 2001).[11] While distinctions between Indigenous and intercultural filmmaking are often muddied due to these cultural politics, and Carter expresses his concern at the historical tendency of non-Māori to overlook or misunderstand the crucial 'spiritual essence' of Māori stories, he also sees a place for intercultural cinema, with the proviso that cultural guidelines are issued and met by filmmakers as a criteria for funding (Carter 2003b: 9).

The binary conception of cultural difference inflecting much of the *Onfilm* debate about *Whale Rider* also appears in academic and critical commentary.

For example, it has been argued that Māori culture is 'largely incomprehensible to the western viewer' (Hokowhitu 2007: 23), and that Pākehā appreciation of *Whale Rider* is based on 'familiar western narrative and filmic tropes' that make the film no different from *The Lion King, Billy Elliot, Harry Potter* or *Bend it Like Beckham* (Murdoch 2003: 100). Another commentator argues, therefore, that the film 'is no longer a Māori story' despite 'masquerading as such' (Bennett 2006: 21). The Māori mythic framework of the story has thus been treated with scepticism and conflated with a western 'mode of magic realism that ... has become stock standard and quirklessy formulaic' (Murdoch 2003: 104). Despite Ihimaera's previous iteration of the myth, some critics have accused Caro of orchestrating a feminist appropriation of an Indigenous *pūrākau* (Hokowhitu 2007; *Metro Magazine* 2004: 173) and thus of reproducing her own culture only to 'portray it as another's' (Hokowhitu 2007: 29).The filmmakers have also been accused of taking 'what they consider to be basic elements of Māori culture' and piecing 'them together to create a representation of Māori as an outside majority audience might want to see it' (Bennett 2006: 21).

Public airing of the spiritual/philosophical orientation shared by the filmmakers and their Māori collaborators has also been dismissed as a cynical public-relations exercise designed to vindicate and authenticate the cross-cultural re-imagining of an Indigenous *pūrākau*. Claire Murdoch, for example, is suspicious of such discourse for turning the making of the *Whale Rider* into 'an echo-chamber in which events of significance in the film find authenticating spiritual reverberations in the events of its production' (2003: 100). Accordingly, because 'one culture's spiritual link to the natural world is another's New Age mysticism' (Morris 2003: 18–19), non-Māori should be 'constructively cynical' about the film's 'indigenous-yet-accessible' quality and their own 'readiness/neediness to embrace it ...' (Murdoch 2003: 105).[12]

Such responses to the film and its production context contain little reference to the actual processes of intercultural collaboration involved in its making. Even where mention *is* made (for example by Murdoch 2003), the degree to which Indigenous collaborators actually influenced decisions about the production process and shaped the representation of Māori culture in the film is not discernible. The research on which this article is based was thus designed to investigate these areas. To this end, separate interviews took place with the two key collaborators – the film's writer-director, Niki Caro, and the Māori cultural advisor, Hone Taumaunu, who is also the senior elder of Ngati Konohi in Whangara. These interviews were followed up by email exchanges, including communication with Witi Ihimaera. A methodology was thus adopted that results in an interpretive process identified by Paisley Livingston as involving a reciprocal relationship between 'internal and external evidence, whereby "internal" refers to the meaningful features of the audio-visual display, and "external" refers to evidence pertaining to the context in which the film was made ...' (Livingston 2009: 108). In this case, the external evidence is focused

on the collaborative processes involved in the development of the script and
the production of the film.

Creative Collaboration: Development, Pre-Production, Production

Apart from Caro and Taumaunu, other members of the intercultural collabora-
tive team included Witi Ihimaera's sister, Carol Haapu, who worked on specific
tasks such as teaching the actors how to perform the *karakia* (incantations or
ritual chants)[13] and Ihimaera himself, who was the film's Associate Producer.
He describes this role as one through which he could ensure that the guiding
philosophy and production processes of the film would 'continue to come from
a Māori direction and a Māori perspective' (Matthews 2003: 23). By collaborat-
ing with a team so closely attached to the Whale Rider *pūrākau* and so dedi-
cated to protecting its cinematic iteration, Caro felt released into the work at
hand because, as she explains, 'I knew that if I put a foot wrong, or if it looked
like I was off course, they would bring me back' (Pitts 2006a). Nevertheless, she
went to great lengths to arrive at this confidence and to pave the way for a suc-
cessful collaboration. Apart from researching relevant Māori history and cus-
toms, Caro's biggest preparatory undertaking was to learn the Māori language.
She considered this an absolute prerequisite for a respectful entrance into
Whangara and, according to Taumaunu, Caro's efforts to educate herself in this
way were crucial to the success of the collaboration. He also highly valued
Caro's decision to shoot the film in Whangara. He explains: 'The cast and crew
knew that they had come to the real place, and Niki was very aware that it was
our history she was making, and that it was taking something out of our gut'
(Pitts 2006b).

In accordance with the tradition of telling *pūrākau*, the screenplay develop-
ment process for *Whale Rider* involved extensive consultation. Ihimaera was
sent every draft of the script, and the last two drafts were also sent to the elders
of Whangara for approval. The few comments or queries made by Ihimaera
tended to focus on issues of cultural appropriateness. For example, during a
scene in which Pai enters her home and smells cigarette smoke in the house,
she tells the older ladies 'Māori women have got to stop smoking, we've got to
protect our child-bearing properties', to which the ladies joke (after Pai has left
the room), 'You'd have to be smoking in a pretty funny place to wreck your
child-bearing properties'. According to Caro, Ihimaera was concerned about
the joke linking 'a smoking or death image with a vaginal or life image' (Pitts
2006a). The way he dealt with this was to allow Caro to shoot the scene as she
had scripted it on the understanding that she seek his approval to include the
scene in the film before locking off the edit. This was done and both he and

Taumaumu subsequently granted their approval. Ihimaera was also briefly con-
cerned about the final sequence in which the *waka* is seen to soar through the
air, as it was an entirely new and powerful image that removes the *waka* from its
traditional function at a crucial moment in the story (Figure 2). Following a
discussion with Caro, he was satisfied with her explanation that it expresses 'the
way the community are changing, the way they are opening up and revealing
the beauty that had always been inherent' (in Pitts 2006a).

On another occasion Taumaunu received a call from Ihimaera about the
scene in which a boy blows raspberries while crossing the stage with a cut-out
of the *hapū*'s emblematic whale. Ihimaera was concerned that the action might
be seen to denigrate the whale rider *pūrākau* in the sacred meeting house, but
Taumaunu considered it an instance of perfectly harmless humour and Ihimaera
accepted that. However, Taumaunu was not so soft on expletives. Having dis-
tributed copies of the penultimate draft among Whangara's elders and canvassed
their views, he presented Caro with their unanimous request to remove the
'four-letter words starting with "f"' that were in the script, insisting that, even if
Whangara's young people swear elsewhere, they do not in and around the
village' (Pitts 2006b). As requested, Caro removed the expletives.

Following this consultative work during script development, the pre-
production stage also witnessed the integration of filmmaking processes with
traditional Māori ritual. For example, Taumaunu decided that no filming would
take place in Whangara until it had gone through a ceremonial blessing involv-
ing cast and crew. He considered this necessary because the arrival of the film
crew and the making of the film had the potential to 'de-stabilize the spirituality
that is upon Whangara and our history and our traditions' (in Pitts 2006b). The
blessing took form in a number of ways. Prior to the land above Whangara

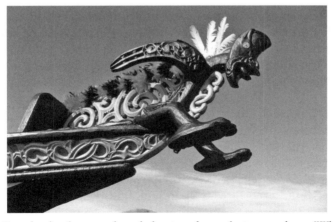

Figure 2: Completed waka *soars through the air to the sea for inaugural row* (Whale Rider).

being reshaped for the East Coast Highway, the hills and rocks making up the sweep of the bay resembled a whale with its tail submerged. Taumaunu devised a ceremony 'to lock in and link' the cast and crew to the land between the head and the tail of the formerly whale-shaped coastline. From a sacred fresh-water spring on the headland that represents the whale's tail, Taumaunu collected pebbles, which he later made into pendants. Back in Whangara, he conducted an intercultural ceremony that included a *karakia* to thank the Māori gods and a Christian prayer to acknowledge the presence of the Anglican Church in the village. During this ceremony, everybody was asked to join hands to 'unify the environment' and, after blessing every cast and crew member individually, Taumaunu gave each of them one of the pendants he had made, which they wore for the duration of the production (Pitts 2006b).[14] There was also a ceremony to launch the film's *waka*, accompanied by *karakia* and a ceremonial row around the bay before the official welcome on the *marae*, which included temporarily lifting the *tapu* (sacredness) of the *marae* for the visitors.[15]

As cultural advisor during the production process, Taumaunu's primary concern was that his people were neither 'trivialized' nor his heritage 'denigrated for the benefit of a spectacle' (Pitts 2006b). Under this broad guiding principle, his advice was multifaceted. As well as the script comments discussed above, he wrote *karakia* for the Māori rituals in the film, for example to farewell the spirit of the mother who died in the opening and those *karakia* associated with the *waka* and the whale. Taumaunu contributed to the characterization of Koro and the creation of a key emotional turning-point in the film through discussions with Caro about how his decline into a depressed state might materialize. His suggestion that Koro keen at the base of a carving of his ancestors is, he says, a typically 'Māori way of breaking down' (Pitts 2006b), the effect of which is accessible to non-Māori through the emotional resonance of Rawiri Paratene's performance. Taumaunu also worked with the actors to ensure the east-coast dialect was authentic in the Māori dialogue and to 'convince the audience that the Māori characters were fluent speakers', a job he describes as a challenge given that 'half the Māori actors couldn't actually speak Māori' (Pitts 2006b). His input here also ensured that the actors' involvement in the project had a cultural value beyond the development or consolidation of acting careers.

Crucially, Taumaunu was given his own video monitor during the production process in order to comment on anything that arose and, effectively, approve every shot in the film. Examples of his input include direction to the art department regarding the setting of props; vetoing the cutting of *karakia* partway through when Caro felt a scene was too long; ensuring the use of the *marae* was appropriate in terms of who sits where, how people are called on to the *marae*, where the chief is positioned and so forth. Consequently, some of his input involved the staging of shots. Another example of this occurred during

the filming of the final scene in which Pai is formally acknowledged as the new chief: Caro had positioned Pai and Koro at the back of the *waka* to be emblematically framed by the sky, but this had to be changed and the original shot plans discarded when Taumaunu informed her it was the wrong place for a chief to sit (Pitts 2006a).[16] This scene also required flexibility from the filmmakers in response to the unplanned, namely that the 60 members of the outrigger group contracted to row the *waka* included female rowers, which is not traditional. Though concerned about this initially, following discussions with Taumaunu, Caro considered the presence of the women to be fortuitous in the context of 'a people moving forward' (Pitts 2006a). For Taumaunu, the only 'slightly odd note' in the film occurs during this scene, as he believes contemporary daywear would have been more appropriate for the ceremony than traditional Māori costume (Pitts 2006b). However, he knew that Carol Haapu and the local community wanted the scene to be conveyed in the form of a traditional ritual, which they believed would present Ngati Konohi to the world in a good light. Both Taumaunu and Caro agreed that the wishes of the community participants were of paramount importance in this instance.

The intimate knowledge of the script gained by Taumaunu in the development stage of the project assisted him in reconciling issues that arose during production and enabled him to very quickly judge the degree to which protocols were negotiable. For example, the use of the *marae* is not always strictly traditional, such as when Koro uses it to teach Māori culture to the local boys. Because Koro was training rather than giving a formal speech, Taumaunu felt that behaviours did not need to adhere so rigidly to traditional form. Hence, Pai enters the *marae* and sneaks around the sacred house to spy on the training, which would not be appropriate in other settings, and Koro shouts 'get out now!' which, Taumaunu explains, 'he would never have done on a *marae* if he was giving a speech rather than conducting a training session' (Pitts 2006b). Taumaunu insists he was never pressured to compromise the non-negotiable protocols that were inconvenient to either the crafting of the film or the production process, and summarizes the process as follows: 'Everything was done according to my wishes' (Pitts 2006b).

Production Culture

One of the distinctive aspects of this filmmaking experience was the evolution of a production culture that was far more intimate and flexible than that of the industry standard. For example, throughout the filming period, an expanding group of *kuia* (female elders) was present. Supplied with chairs, blankets and cups of tea, the *kuia* positioned themselves near the monitors in order to watch what was being filmed and became something of a test audience for Caro,

especially when she had written something she hoped was funny. When shooting those scenes she would check to see if the *kuia* were laughing and, if they were, she felt confident the scene was working. In addition to the *kuia*, more and more people from the region turned up to the shoot each day. Says Caro, 'People's mates and dogs and kids and everybody came, and most of them ended up in the film' (Pitts 2006a) (Figure 3). Such blurring of the subject-object relation was embraced by Caro, who notes, 'We were making the film, but they were watching us make the film, as well as contributing to its production both behind and in front of the camera' (Pitts 2006a). Although the film was post-produced in Germany, a preview screening for Ngati Konohi acted as a more formal invitation to return (and comment on) the filmmakers' gaze. In Taumaunu's view, the fact that there were no requests for changes at this stage is a reflection of how the filming period was a time in which everybody 'established a tremendous empathy and rapport and became one' (Pitts 2006b). He elaborates:

> It was a very intimate family. We really got to understand and to love people. On the final morning ... we had a big breakfast together before everyone returned to Auckland, and I've never seen so many Pākehā having a real *tangi* (cry), a real weepy session before they got in their cars. It was quite an emotional experience – a Māori experience. (Pitts 2006b)

Both Caro and Taumaunu are convinced that the success of the production as a process and a creative product was based on the genuinely collaborative nature

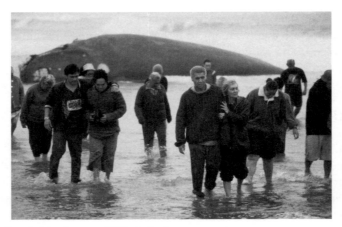

Figure 3: *Locals join the cast of* Whale Rider *as extras.*

of the experience. Distinct from collective decision-making, Caro describes 'collaboration' in this context as meaning that everything about her vision for *Whale Rider* was in accord with what her collaborators told her (Pitts 2006a). The production company, South Pacific Pictures, was party to this process in the first instance by agreeing to shoot the film in Whangara when it would have been much cheaper to make the film in Auckland, where most of the cast and crew lived.[17] Caro was also gratified to learn that the production of the film in Whangara had helped to heal some historical wounds in the region, had encouraged members of Ngati Konohi to return to Whangara after long absences, and that many of the *kuia* who turned up on set each day had not, in fact, been out of their houses for years and that the making of the film had triggered their coming together (Pitts 2006a). Taumaunu argues that there is no coincidence in the fact that the 'love and friendship' evident in the production culture was utterly in sync with the message in the story about the need to 'develop good relationships' (Pitts 2006b). Caro agrees, asserting that 'what lands on the screen is absolutely informed by the culture you create in the filmmaking process – it's very symbiotic' (Pitts 2006a). For Caro, the production culture and processes involved in the making of *Whale Rider* set a new benchmark, and showed her a 'practical way of working' which she took to northern Minnesota for the making of her first Hollywood film, *North Country* (2005) (Pitts 2006a).[18]

Contestations: Spirituality and Representation

The filmmakers' embrace of Māori customs and spirituality did not stop at a consideration of production protocols. Also evident is respect for the Māori belief that the land and the environment are interlinked with 'the deceased, the living and the unborn', and that all these elements form part of a whole containing their own *mauri* (Roberts 2008).[19] Hence, good omens are understood by Māori to manifest in non-human phenomena, often involving other beings and the forces of nature. For example, very early on in the process, when Caro was reticent about tackling a Māori story, a whale was beached close to where she lived at Karekare – an extremely rare event on that particular coastline. Anxious at first about it being a bad sign, Caro was assured by Māori *moko* (tattoo) artist, Tim Worrall, that it was in fact a very good omen because, historically, if a whale died on the beach it was fortuitous for the local community as it ensured a supply of oil and meat as well as bone and teeth for weapons (Pitts 2006a). Indeed, for Ihimaera the *mauri* of the Whale Rider *pūrākau* was delivered to him the day a whale swam up the Hudson River. He explains that the *pūrākau* 'lodged itself' in his 'heart and brain' as a child when he would cycle the long distance from Gisborne to Whangara to gaze at the carving of

Paikeha on the meeting house, but that 'the *mauri* of the *pūrākau* had been waiting for me to grow up' (Ihimaera 2010). He then wrote *The Whale Rider* in six weeks and, on the night it was launched in Whangara, the people there 'saw for the first time in ages a whale spouting on the horizon' (Ihimaera 2010).

Taumaunu also believes 'absolutely that there are signs that ensure success' and 'signs that say pack up and get out'. He recalls, for example, that the production almost always got precisely what it needed from the weather, be that a 'dull grey day', a 'boisterous and wild' sea, 'a calm day with a gentler breeze ruffling the hair' or a 'strong light' (Pitts 2006b), which is most unusual in filmmaking. Even on the penultimate day of the shoot, when it seemed that the production's good fortune had run out due to torrential rain halting the proceedings, the storm suddenly evaporated and a rainbow appeared perfectly arched over the *waka*. Caro recalls that 'the next morning we had ideal conditions – way off the met service radar – and that was our very last opportunity to shoot the final scene in the film' (Pitts 2006a). Neither Caro nor Taumaunu view this consistent good fortune as merely a series of coincidences. Taumaunu interpreted the appearance of the rainbow over the *waka* as an omen indicating that 'there would be a journey and the film would be richly received' (Pitts 2006b). He also believes that the good fortune the production experienced was made possible by the blessing he performed prior to production, which allowed the spirit of the Paikea legend to 'be let loose to travel the world' (Pitts 2006b).[20]

That the synchronicities Ihimaera, Taumaunu and Caro draw meaning from have been branded by some commentators as little more than questionable new age mysticism or 'media-tasty instances of coincidence, mysticism and … poetic rightness' (Murdoch 2003: 100) demonstrates a naturalized positivist perspective. An unfortunate correlation of this perspective is the (likely unwitting) dismissal of a Māori worldview or, at best, a racializing operation whereby a spiritual belief held by an Indigenous person can be regarded as authentic, yet that very same belief held by a non-Indigenous collaborator is dismissed as phoney.[21]

Claims that 'the specific cultural edge of the particular *iwi* has been taken away' (Bennett 2006: 21) are also contestable. The *iwi* referred to, Ngati Porou, is a very large tribal confederation, yet the presentation of Māori in *Whale Rider* operates at a *hapū* level, thereby favouring highly specific community representation over broader generalization. Regarding the *marae* setting, for example, which has been the object of criticism for not being conveyed in purely traditional form, Taumaunu says it is depicted to reflect how the *marae* is very much part of the community's daily reality in Whangara (Pitts 2006b). In light of the research presented here, arguments that the filmmakers created an outsider's view of Māori are revealed to be erroneous. While the close

intercultural collaboration and attendant approval processes involved in the making of *Whale Rider* cannot forestall criticism or claim to represent the views of *all* Māori, the scope of Māori influence on the development and production of the film, as well as on the production culture that set the context for creative activity, functions beyond the surface-level minutiae of cultural 'accuracy' to an extent that can be described as a higher degree of dispersed authorship than is the norm in mainstream cinema. That the Māori influence on the construction of the film remains unacknowledged in most commentary points to a need for the kind of contextual research undertaken here and a structural imbalance present in much criticism founded in representational theories. As Lúcia Nagib explains, some of this criticism has led to

> the establishment of a hierarchy that ascribes a superior position to those who purportedly hold the knowledge of the real (the critic) as opposed to those who re-present it in an artwork ... [By these means the critic is led] to become judgmental rather than appreciative, normative rather than inquisitive, a moralizing preacher rather than a passionate learner, thus reenacting the very power relations Cultural Studies aspires to debunk. (Nagib 2011: 3)

Conceptions of Cultural Difference: Binary and Relational

The notion that *Whale Rider* masquerades as a Māori story due to the ethnicity of its director and producer is contested by the Māori participants in the project. Faced with these criticisms, Taumaunu argues that they overlook 'the collaborative interaction that generated the spirituality of the work' and insists that Caro's approach to developing the script and making the film 'was all so sound that it was unimaginable to cut her off in mid sentence and dismiss her as "Pākehā"' (Pitts 2006b). He also considers the universal aspects of the story to be as valuable as the cultural specificity his role was designed to protect (Taumaunu 2007). For Ihimaera, *Whale Rider* remains unequivocally a Māori story precisely because 'it comes from a specific, regional myth', it 'deals with a specific people who are in a specific location, in such a way that it can only be a Whangara film' and, just because 'the director happens to be blue-eyed', this affects nothing because 'so are a lot of Māori' (Matthews 2003: 23).

Proceeding inductively, it can be argued that, while the critics of *Whale Rider* discussed here tend to exhibit binary conceptions of cultural difference, key members of the film's intercultural collaborative team demonstrate a relational approach that engages a democratic process described by Jacques Rancière as 'the action of subjects who, by working the interval between identities, reconfigure the distributions of ... the universal and the particular' (Rancière

2006: 61–2). The intercultural processes involved in the making of *Whale Rider* may thus be understood as rooted in a rejection of dialectical reasoning in the sphere of cultural difference in favour of the idea of a 'third space' distinguished by cultural multiplicity and exchange. Rather than a 'synthesis' in the Hegelian sense, this 'third space' is occupied by the juxtaposition and intersection of different cultures, as well as the cultural products that arise from that relation. Homi Bhabha describes this space as one in which 'the negotiation of incommensurable differences creates a tension peculiar to borderline existences' (Bhabha 1994: 218). The potential for such 'tension' to be productive and address certain inadequacies of dialectical reasoning can be found in the processes and conceptual orientation of 'dialogism'.

Initially elaborated by Bakhtin as a metalinguistic term to challenge the ahistorical nature of structural linguistics, 'dialogism' can be described as the characteristic epistemological mode in a world in which 'there is a constant interaction between meanings, all of which have the potential of conditioning others' (Holquist 1981: 426). Central to the concept of dialogism and how it might be applied to conceptions of cultural difference is Bakhtin's recognition that 'opposition pure and simple necessarily leads to chaos and cannot serve as the basis of a system' and that 'true differentiation presupposes a simultaneous resemblance and difference ...' (Holquist 2002: 26). The argument that Māori culture is necessarily incomprehensible to non-Māori is thus contestable. As Hermans and Dimaggio state in their study of how the processes of globalization and localization demand a dialogical conceptualization of self and identity, never before have there been so many people from different cultural backgrounds 'so interconnected with each other as in the present era' (2007: 31). Different cultures can therefore be seen to come together 'within the self of one and the same individual', and this has resulted in the development of hybrid identities (35). Paul Willemen's description of intercultural comprehension achieved in a dialogic mode accurately describes the process between the key collaborators in the making of *Whale Rider*, that is by asking questions and receiving responses without relinquishing either culture's 'unity and open totality' (Willemen 1994: 214).[22] Caro's description of working with Ngati Konohi as an experience that was so 'rich' it was 'just like waking up' (Pitts 2006a) suggests how this process can be mutually enriching and relativizing.

From Creative Process to Creative Outcome

That the very vision for the film was shaped by a dialogic mode of intercultural collaboration is also evident in its aesthetic construction, which interweaves the respective naturalistic and symbolic registers of New Zealand mainstream cinema and Māori storytelling paradigms. Where caution has been advised about the

accessible indigeneity of the film, and claims made about the impossibility of Māori *pūrākau* being received appropriately by non-Māori, I assert the productive potential of artists and audiences being inspired by Indigenous mythology and, as a result, developing better intercultural working processes and expanded viewing practices. While it has been suggested that *Whale Rider* asks a lot of audiences 'for whom talk of destiny, tragedy, and legend is usually restricted to fantasy' genres 'set in other times, worlds, or galaxies' (Morris 2003: 19), the popularity of the film around the world suggests that audiences have not been flummoxed by this. Furthermore, such a position at once denies Māori familiarity with Western storytelling and any capacity for Westerners to comprehend non-Western storytelling paradigms. Granted, the changes made to Ihimaera's novel in the process of screen adaptation involve the simplification of novelistic narrative complexities in order to compress the action to feature-film length, and the centralization of the protagonist-antagonist relationship can be seen to reflect mainstream screen storytelling conventions. However, the Indigenous symbolic register framing the naturalistic hero-journey points to a style of hybrid storytelling that utilizes the power of Indigenous mythology to provide analogies for contemporary fears, conflicts and ideals. Such mixing of narrative modalities is not antithetical to the function of *pūrākau*. As Jenny Lee explains, 'the telling of *pūrākau* includes storytelling in contemporary contexts' (Lee 2005: 2). In fact the word *pūrākau* is made up of the Māori words for base (*pū*) and tree (*rākau*), thus demonstrating 'a Māori understanding of stories' in which there is an original source, yet 'there may be many branches, versions or interpretations' (Lee 2005: 8).

While New Zealand's cinematic history proves that intercultural collaboration may replicate processes of colonial assimilation, research presented here reveals that the key collaborators in the making of *Whale Rider* exhibit a sophisticated awareness of how peoples from different cultures are at once distinguishable and connected. This materializes in the democratization of traditional screen production culture in accordance with Māori spirituality and protocols, which, in turn, triggers a higher degree of dispersed authorship than is the norm in mainstream cinema production. That the ascription of agency to both human and non-human entities appears not only in the original *Whale Rider pūrākau*, but also in the novel, the film and the Indigenous philosophy guiding the film's production, provides further evidence that the subordination of one cultural perspective to a monolithic and positivist Western other has not in fact occurred. Both the film and the process of its making may, therefore, be understood as expressing something at the heart of what Sean Cubitt terms a 'posthuman politics' in which 'the value of public good is no longer de facto concerned with humans alone' (Cubitt 2009: 15).[23] Despite the conquest of animism by monotheism in Western thought during the enlightenment, the fact that 'indigenous peoples have maintained and developed animism' is for Cubitt, 'a lesson for us' (18).

Consequently, in a genuinely dialogic intercultural encounter, the 'ethics' of drawing from an Indigenous symbolic register in a film destined for global consumption need not necessarily be cast in terms of the exploitative appropriation of an oppressed culture by the powerful. Rather, in the case of *Whale Rider*, it may be understood as an operation that challenges the scientific positivism built into strictly conventional realist narratives by bringing into the public eye the value of metaphorical storytelling modes formulated by Indigenous cultures to cement a relationship between humans and the other beings and forces with which we share a planet. This is not to deny the legitimacy of Indigenous Cinemas, support for which is essential to redress historical exclusions and maintain cultural self-expression in contemporary form. Rather, it is to argue for the validity of intercultural filmmaking wrought by non-exploitative dialogic exchange as an additional cultural space and posit the intercultural creative processes involved in the making of *Whale Rider* as an exemplar for such activity.

Glossary of Māori Terms

Aotearoa	New Zealand
atua	an ancestor with continuing influence, or a god, demon or supernatural being
hapū	sub-tribe(s), section of a large kinship group
iwi	tribe(s), extended kinship group
karakia	incantation(s), ritual chant(s), prayer(s), blessing(s)
kuia	female elder(s)
kumara	sweet potato
Māori	indigenous New Zealander, indigenous person of Aotearoa/New Zealand
Māoritanga	Māori culture, practices and beliefs
marae	courtyard in front of meeting house, often also used to include the complex of buildings around the *marae*
mauri	life principle, material symbol of a life principle or its special nature, source of emotions
moko	1. lizard, skink and gecko; 2. Māori tattooing designs on the face or body
noa	ordinary, free from restrictions
paikea	humpback whale(s)
Pākehā	New Zealander(s) of European descent
pūrākau	ancient legend(s), myth(s), story/stories
taonga	prized possessions, treasure
tapu	sacred, prohibited, restricted, set apart, forbidden, under the protection of an ancestor with continuing influence

waka	large intricately carved canoe(s)
wānanga	place of learning; tribal knowledge, lore, learning; instructor, wise person, sage, authority, expert, guru, philosopher, savant
whakanoa	to remove *tapu* – to free things that have the extensions of *tapu* without affecting the intrinsic *tapu whānau* extended family/ families

Notes

1 Following Barclay, I use the capital 'I' for Indigenous to distinguish the politicized position of First Nations peoples (and First Nations Cinemas) from a more generalized use of the term differentiating the national from the global.

2 In the Māori language, the plural is indicated by context rather than a change in the word.

3 Moruroa was the site of nuclear testing by France for 30 years from 1966. In 1974, the testing was moved from the atmosphere to the ocean floor.

4 Following the birth of a child, it is Māori custom to bury the placenta and umbilical cord in a culturally significant piece of land.

5 Prior to the making of *Whale Rider*, the four feature-length fiction films directed by Māori were *Ngati* (Barry Barclay, 1987), *Mauri* (Merata Mita, 1988), *Te Rua* (Barry Barclay, 1991) and *Once Were Warriors* (Lee Tamahori, 1994).

6 The exploitation of Māori by non-Māori filmmakers began as early as 1928 when Hollywood director, Alexander Markey, was commissioned by Universal Studios to make a romantic drama about Māori, *Under the Southern Cross* (1929). Among other insults, Markey stole the *taonga* (prized possessions, treasure) that Māori had loaned to the production as props.

7 For commentary on such processes and representations, see Barclay 1990, 1996; Blythe 1994; Mita 1996; Pihama 1996; Pitts 2008.

8 Barclay went on to explore the complex relationship between Māori *taonga* and the commercial world of Western intellectual property rights in his book *Mana Tuturu* (2005).

9 At the Hawaii International Film Festival in 2001, Barry Barclay was presented with the inaugural Legacy Appreciation Award for 'his ground-breaking work as a filmmaker and writer, and his tireless advocacy of the rights of Indigenous people, in particular the rights of Māori' (*Onfilm* 2001: 20). During his keynote address at this festival, Barclay introduced the term 'Fourth Cinema' to describe cinema created by Indigenous Peoples and to separate these films from the categories of First, Second and Third Cinema.

10 This Treaty of Waitangi claim against the New Zealand Film Commission was lodged by a group of Māori filmmakers including Barry Barclay. Their claim argues that the NZFC and its Act of Parliament are inconsistent with the principles of the Treaty of Waitangi (New Zealand's founding document, signed between Māori chiefs and the Crown in 1840) in that they have failed to actively promote and protect Māori culture and language. Because cinema is a

'paramount' contemporary mode of expression for Māori language and culture, the claimants assert the 'fundamental right' of Māori to access Film Commission resources 'to tell their own stories in ways which Māori deem consistent with their own culture' (clause 15). At the time *Whale Rider* received NZFC financing, the claim was languishing at the Waitangi Tribunal.

11 By 'unspoken quota', Barclay means a tacit agreement between the NZFC and Māori that the number of Māori films produced should roughly reflect the percentage of the nation's Māori population.

12 It should be noted that Paula Morris is, in fact, largely positive about the film and does discuss the apparent integrity of the cross-cultural collaborative process.

13 In traditional Māori culture there were *karakia* for all aspects of life, the purpose of which was to enable people to carry out their daily activities in union with ancestors and spiritual powers. See http://www.maoridictionary.co.nz/index.cfm? dictionaryKeywords=karakia&search.x=0&search.y=0&search=search&n=1&i diom=&phrase=&proverb=&loan=, last accessed 25 August 2012.

14 Obviously, cast members removed the pendants when necessary for filming.

15 All formal greetings and discussion take place on the *marae*, and the *tapu* is always lifted for visitors, be they from another tribe or another culture altogether. When *tapu* is removed, things become *noa* (ordinary, free from restrictions), the process being called *whakanoa*. See http://www.maoridictionary.co.nz/index.cfm?diction aryKeywords=tapu&search.x=0&search.y=0&search=search&n=1&idiom=&p hrase=&proverb=&loan=, last accessed 25 August 2012.

16 The only people who sit in the front or the back of the *waka* are the experts monitoring the wind and direction of the *waka* – training that a chief and his granddaughter would not have. Taumaunu advised Caro to position Koro and Pai in the middle of the *waka*, which is where such people are placed so that, in the event of it overturning, the rowers can make a raft of themselves for them (Pitts 2006a).

17 By filming in such a remote location, the expense of housing and feeding the cast and crew and paying them per diem was a considerable addition to the normal fees payable.

18 Prior to their acceptance of an alternative production culture, Caro recounts the initial surprise of cast and crew on that 'enormous Hollywood film' in response to her employment of what she calls the '*Whale Rider* model' of filmmaking (Pitts 2006a).

19 On a Māori 'world view', see also Awatere 1984; Walker 1985; Durie 2005.

20 In light of the key collaborators' belief that the universe provides guiding signs, it is interesting to compare the good fortune attached to *Whale Rider* with the extraordinary run of ill fortune experienced during the production of *River Queen* (Vincent Ward 2005), which followed a more traditional Western production model. An intercultural love story set during the Māori land wars of the 1860s, Ward's film was beset with problems from the start, including atrociously bad weather, widespread respiratory infections among the crew, the departure of five production office staff in the first few weeks of production, the (temporary) resignation of the cinematographer due to an injury, the postponement of the entire production half way through the shoot due to the hospitalization of the lead

actress (Samantha Morton) following severe influenza and secondary bacterial infection, deteriorating relations between Morton and Ward when shooting resumed, another on-set injury due to an accident with a horse, a serious driving accident for principal cast member, Cliff Curtis, and finally, the firing of Ward several weeks after shooting resumed (*Onfilm* 2004b: 3). Ward is candid about the minimal consultation with Māori during the early stages of his project and states that 'in the end you just want to tell your story' (Ward 2005: 17).

21 I describe these dismissals as unwitting because the academic commentary on *Whale Rider* discussed here appears rooted in solidarity with the project of Indigenous filmmaking.

22 It should be noted that Willemen applied the term to describe a mode of cross-cultural *interpretation* of films, not a mode of collaboration in the field of intercultural film*making*.

23 Cubitt elaborates, saying the polis 'is not exclusively made of its population. It is rocks and earth, water and air, plants and animals, buildings, services, communications' (Cubitt 2009: 15).

References

Awatere, Donna (1984). *Māori Sovereignty*. Auckland: Broadsheet.

Barclay, Barry (1990). *Our Own Image*. Auckland: Longman Paul.

——— (1996). 'Amongst Landscapes', in Jonathan Dennis and Jan Bieringa (eds), *Film in Aotearoa New Zealand* (2nd edition). Wellington: Victoria University Press, pp. 116–29.

——— (2003). 'An open letter to John Barnett', *Onfilm*, February, pp. 11 and 14.

——— (2005). *Mana Tuturu*. Auckland: Auckland University Press.

——— et al. (claimants) (1998). *Statement of Claim* (to Waitangi Tribunal), 19 August.

Barnett, John (2002). 'Right royal Barney', *Onfilm*, December, pp. 2–3.

Bennett, Kirsty (2006). 'Fourth cinema and the politics of staring', *Illusions*, 38, pp. 19–23.

Bhabha, Homi K. (1994). *The Location of Culture*. London/New York: Routledge.

Blythe, Martin J. (1994). *Naming the Other: Images of the Māori in New Zealand Film and Television*. Metuchen, NJ: Scarecrow Press.

Brash, Alan (2003). 'A Brash response to Barry Barclay'. *Onfilm*, March, p. 11.

Carter, Carey (2003a). 'A response to "Brash stupidity"'. Letter to the editor, *Onfilm*, April, pp. 11 and 16.

——— (2003b). 'Carter's final word to Brash'. Letter to the editor, *Onfilm*, June, pp. 9 and 19.

Cubitt, Sean (2009). 'After Tolerence', paper presented at *The Internet as Labor and playground: A Conference on Digital Labor*, Eugene Lange College, The

New School, New York, 12–14 November, http://www.slideshare.net/sean-cubitt/after-tolerance, last accessed 25 August 2012.

Dennis, Jonathan and Jan Bieringa (eds) (1996). *Film in Aotearoa New Zealand* (2nd edition). Wellington: Victoria University Press.

Durie, Mason (2005). *Ngā Tai Matatū. Tides of Māori Endurance*. Victoria: Oxford University Press.

Hermans, Hubert J.M. and Giancarlo Dimaggio (2007). 'Self, identity, and globalisation in times of uncertainty: a dialogical analysis', *Review of General Psychology*, 11: 1, pp. 31–61, http://www.socsci.ru.nl/~hermans/100.pdf, last accessed 25 August 2012.

Hokowhitu, Brendan (2007). 'Understanding Whangara: *Whale Rider* as simulacrum'. *New Zealand Journal of Media Studies*, 10:2, pp. 22–30.

Holquist, Michael (1981). 'Introduction', in Michael Holquist (ed.), *The Dialogic Imagination. Four Essays by M.M. Bakhtin*, translated by Caryl Emerson and Michael Holquist. Austin/ London: University of Texas Press, pp. xv–xxxiii.

——— (2002) *Dialogism* (2nd edition). Oxford/New York: Routledge.

Ihimaera, Witi (1987). *The Whale Rider*. Auckland: Reed.

——— (2010). Personal email sent to the author on 21 November.

Lee, Jenny (Ngāti Māhuta) (2005). 'Māori cultural regeneration: *pūrākau* as pedagogy', paper presented as part of the symposium *Indigenous (Māori) pedagogies: Towards community and cultural regeneration*, with Te Kawehau Hoskins and Wiremu Doherty. Centre for Research in Lifelong Learning International Conference, Stirling, Scotland, 24 June.

Livingston, Paisley (2009). *Cinema, Philosophy, Bergman*. Oxford: Oxford University Press.

Making the Film (nd). Available at http://www.piccom.org/home/whalerider/thefilm3.html, last accessed 21 January 2007.

Matthews, Philip (2003). 'Myth making', in *Listener*, 1 February, pp. 19–24.

Metro Magazine (2004). November, 143, pp. 173–174.

Mita, Merata (1996). 'The Soul and the Image', in Jonathan Dennis and Jan Bieringa (eds), *Film in Aotearoa New Zealand* (2nd edition). Wellington: Victoria University Press, pp. 36–54.

Morris, Meaghan E (1994). 'Brasschaat-Bombay: A Way of Inhabiting a Culture', Introduction to Paul Willemen, *Looks and frictions: essays in cultural studies and film theory*. London/Bloomington: BFI and Indiana University Press, pp. 1–23.

Morris, Paula (2003). '*Whale Rider* review', *Cineaste*, Winter, pp. 18–19.

Murdoch, Claire (2003).'Holy sea-cow', *Landfall*, 206, pp. 97–105.

Nagib, Lúcia (2011). *World Cinema and Ethics of Realism*. New York/London: Continuum.

Onfilm (2001). November, p. 20.

——— (2004b). May, p. 3.

Pihama, Leonie (1996). 'Repositioning Māori Representation: contextualizing *Once Were Warriors*', in Jonathan Dennis and Jan Bieringa (eds), *Film in Aotearoa New Zealand* (2nd edition). Wellington: Victoria University Press, pp. 191–2.

Pitts, Virginia (2001). Interview with Barry Barclay on Māori filmmaking and Indigenous film policy. January, Auckland, 4 hours, unpublished.

——— (2006a). Interview with Niki Caro on cross-cultural collaboration in the making of *Whale Rider*. 15 September, Auckland, 1.5 hours, unpublished.

——— (2006b). Interview with Hone Taumaunu on cross-cultural collaboration in the making of *Whale Rider*. 11 November, Whangara, 3 hours, unpublished.

——— (2008). 'Cross-Cultural Filmmaking in New Zealand National Cinema'. PhD thesis, University of Auckland.

Rancière, Jacques (2006). *Hatred of Democracy*, trans. Steve Corcoran. London: Verso.

Roberts, Jude (2008). *Mauri Ora–Mauri Global*, at http://mauriglobal.blogspot. com/, last accessed 25 August 2012.

Shepheard, Nicola (2003). 'Niki Caro. Riding the Whale', *North and South*, February, pp. 81–7.

Taumaunu, Hone (2007). Personal email to the author on 14 June.

Walker, Ranganui (1985). 'Being Māori ', in *Ngā Pepa A Ranginui. The Walker Papers 1996*. Auckland: Penguin, pp.13–30.

Ward, Vincent (2005). 'Reflections on film', Interviewed by Lynette Read. *Take*, Summer, pp. 16–19.

Willemen, Paul (1994). 'The National', in *Looks and Frictions: Essays in Cultural Studies and Film Theory*. London/Bloomington: BFI and Indiana University Press, pp. 206–19.

Chapter 4

Adapting Frida Kahlo: The Film-Paintings[1]

Armida de la Garza

The ubiquity of digital technology and the trend towards convergence of the media may have brought the radical hybridity of cinema to the forefront again, but the concern with the specificity of the medium, and ascribing either positive or negative values to this hybridity, is far from new. From Ricciotto Canudo's argument in 1911, that cinema ought to be regarded as a synthesis of all arts, echoing Nietzsche's – and then Wagner's – idea of the *Gesamtkunstwerk* or total artwork, in which art would ultimately become life, the preoccupation with cinema's ambiguous existence across borders has been ongoing, perhaps heightening during times of what we might call centrifugal social relations, when new modes of organization are being forged. Indeed, it is no coincidence that at present we should be considering the implications of cinema's hybridity again, when a number of social processes have been 'short-circuited' (Baudrillard 1994: 17), fast change is pervasive and the philosophical perspective that seems best suited to cope with reality is one that focuses on process and becoming (Deleuze 2004), on networks and relations rather than on fixed states. Film itself might be the epitome of the Zeitgeist: as Gerald Mast observed, film 'is not a passive container; it is an active index. As the views within the frame are constantly changing ... the way the image is framed is perpetually in the process of making new meanings' (Mast 1984: 85).

The main difference, however, is the historical context: whereas reflections on the impurity of cinema took place, upon its invention, during an optimistic period of faith, of belief in social progress and even, at least in Latin America, on the belief that cinema's very vocation was to play a role in this transformation (Mulvey 2003: 263), the present context is one of radical disbelief, or as Michel de Certeau puts it, of belief having become 'polluted like the air and the water ... There are now too many things to believe and not enough credibility to go around' (de Certeau 1988: 178–9).

The question now is thus not only whether cinema's capacity for, as it were, interbreeding with other arts makes it particularly able to convey and promote cultural diversity; nor how its multiple media share strategic narrative and aesthetic devices; but also what the role of cinema can be, with all its wealth of realized potential from the other arts – pathos, for Eisenstein (1987) – in the present postmodern context of disenchantment, when even the value of cultural diversity is sometimes questioned, as when it is understood to lead to a less cohesive, too heterogeneous a community to be deserving of that name. Here I take Jacques Rancière's proposition that under the present 'aesthetic regime' of art it is the capacity of a given practice to elicit a 'redistribution of the sensible' (Rancière 2004: 22) that makes it an artistic one. This is particularly helpful to understand the role cinema can play, for its potential to broaden what is visible and audible to audiences in their given circumstances – what Rancière understands as emancipation – is precisely what is being highlighted.

Films on the lives and work of painters are bound to participate in 'the parcelling out of the visible' (Rancière 2004: 19), both in that they mix high and popular culture, and in that they offer cinematic ways to engage with their paintings. Here I shall discuss two feature films on the life and work of Mexican painter Frida Kahlo, and their audience reception. Both films throw into relief, and in some ways also problematize, the common ground shared by film and painting and how the appropriation of artistic work in a community of reception holds the potential for emancipation as in Rancière's understanding of it. I begin with a brief introduction of what this overlapping terrain between film and painting is, then use this as a framework for the case studies and finally attempt conclusions.

Film/Painting

In some accounts, narrative film is a direct descendent of the nineteenth-century novel. The argument is that in its bourgeois subjectivity and focus on the individual and on private life, the nineteenth-century novel 'not only influenced' narrative film, but 'in some sense *became* film, while the modern novel evolved in a different direction' (Elliott 2003: 3). In other accounts, however, narrative film is a direct descendent of perspectival painting. Not only because they share essential tools like frame, light and colour, but because film continues the efforts to represent a three-dimensional space on a bi-dimensional surface from the point of view of the individual subject of the Renaissance, and it is thus highly ideological: it seeks to make of human vision the rule of representation (Aumont et al. 1992). This way of viewing, which Aloïs Riegl called optical view, 'is so much in control of the perceived object that it can fully display the power of the perceiving subject' (Dalle Vacche 2003: 6). This Riegl contrasted with what he called haptical view, typical of non-Western cultures which 'prefer to process

representations as if they were independent objects that exist out there, all by themselves, regardless of any producing or receiving agency', a fact he attributed 'to a feeling of awe toward the world's matter' (Dalle Vacche 2003: 5). Thus both the literary and the visual account of cinema's lineage firmly place narrative film within a Western tradition of representation that is often interpreted as imperialistic in nature, in that it seeks mastery over the depicted world.

This is further compounded when the two most common metaphors deployed to understand film are brought into the equation, namely film as a window onto a world that seems to flow realistically, but is in fact charged with ideology, and film as a mirror, where a society can, after Lacan, (mis)recognize itself, temporarily inhabiting perspectives other than those to which it is bound by its very subjectivity (Lacan 2006 [1977]). The latter metaphor, the mirror, is associated with Hollywood and a highly passive spectator, who is nonetheless fully enthralled by the narrative; the former with art cinema and, more obliquely, with the avant-garde. The feature films I am discussing today closely match both these descriptions. But before we go into detailed analysis of them, a brief introduction to their subject, Frida Kahlo.

Frida Kahlo

There is a vast literature on Frida Kahlo's life, which Serge Daney, recalling existentialist conceptions of one's own life as a constructed work of art, called 'her involuntary work' (Daney 2010). Indeed, there have been calls to sideline her star status, to be able to engage with her work, so thoroughly commodified have her story, her paintings and other related merchandise become (Brugger 2010: 12). She had a short, intense, painful and extraordinary life, which became not only the source of her painting, but also of her iconic, even mythical status as a signifier of Mexican identity, of feminism and of the value of the marginal. An art critic who attempted to summarize her life in six phrases chose 'road accident, miscarriage, a marital fiasco, jealousy, alcohol problems and life in a wheelchair' (Rebel 2008: 70). A better formulation might be that she was all about transgressing borders, about impurity, mixture, intertextuality: in sum, all the main concerns of cinema, painting and the topics to which this volume is devoted. She was the daughter of a European father, Guillermo Kahlo, and a Mexican mother of indigenous descent, Matilde Calderón, thus the *mestiza par excellence*, authentically embodying the myth of 'original' Mexican identity, in which hybridity is paradoxically taken as essence. Also famous for cross-dressing, and for her active sexual life with both men and women, she continuously transgressed gender boundaries. There are some who understand her body as an early instance of the cyborg, in that the various prostheses she wore to walk mixed technology and biology.

Her work comprises 139 paintings, mostly on small to medium-sized canvasses, and various drawings. It is also hybrid, drawing from European genres of painting such as the self-portrait (46 of these) and the still life, but also from pre-Hispanic painting from the Mayas and the Aztecs, and from Latin American genres such as the *retablo* (devotional painting based on the Catholic iconography), frequently including words and legends. This would have readily placed her work under Rancière's aesthetic rather than poetic artistic regime. Though most of the paintings are on topics that concerned her private world (even if, of course, the private is also public) some address public issues more openly, such as what she regarded as the transformative power of socialism. European criticism has interpreted her work using frameworks such as *naïf* surrealism of a kind that would draw from the likes of René Magritte and Henri Rousseau. However, alternative criticism and Frida herself often questioned this classification, speaking of her paintings in ways that recall the haptic qualities of non-Western cultures instead: painting reality in a non-mimetic way, following conventions that often came from pre-Columbian and folk painting and, as she famously contended, certainly not painting dreams.

Although her fame and popularity were born outside the realm of cinema, a play of meanings nonetheless accrued from her self-portraits, various photographs and home movies, and the identity she performed in her private life, that is, a star persona, especially as the indigenous clothes or masculine attire she used to wear recalled costume and performance (Dyer 2004). There are several documentaries on her life, also touching upon her work, but only two feature films have been made to date, and both have taken diametrically different approaches to the representation of her biography and her painting on film.

Frida, Naturaleza Viva

The first film, *Frida, Naturaleza Viva* (Paul Leduc, 1986), was part of a wider reappraisal of Frida Kahlo that took place from the early 1980s, as a signifier of Mexican identity, as an icon for the feminist movement and as a case in point on the creative value of the marginal. The film was conceived in a way that would match form and content. The title itself alludes to the name of the genre 'Still Life' – *naturaleza muerta* in Spanish – but calling it 'Living Nature' (*naturaleza viva*) instead. Credits are introduced to look as if written in brushstrokes. It features only minimal dialogue, as if the aim were to let the viewer engage with texture, colour and light of the successive images first. It begins by telling the viewer that she is about to see 'the thoughts and memories of Frida Kahlo that come to her mind while she is lying in her deathbed', and the film does end with Frida's death.[2] However, Leduc for the most part eschewed chronological narrative and presented instead a collection of scenes from different points in her life,

in a random order, as if seeking to halt the narrative sequence of cinema by presenting a collage instead of a story. The film aimed to be the equivalent of the simultaneous presentation of non-synchronic scenes typical of narrative painting until before impressionism, a technique that Kahlo herself employed in *The Suicide of Dorothy Hale* (1938). Many of Kahlo's paintings are shown at various points in the film, mainly in scenes that take place at a carpentry where frames for them are being made, and scenes from an exhibition in which the camera follows visitors around. Nearly all scenes are introduced with the camera moving slowly from left to right and then focusing on a painting, briefly showing it complete and then closing up onto details, thus guiding the eye and timing attention. The film was almost unanimously received as a film-painting and acclaimed in the following terms (all cited in Leduc 2012): 'The most convincing filmed portrait of an artist ever made' (Ruby Rich); 'As in Bosch's *Garden of Earthly Delights*, as in Picasso's *Guernica*, as in Mexican muralism itself, the work as a whole is more than the sum of its symbolic, tragic and hallucinating parts, and juxtaposition is the way this is achieved ... no words are needed' (Homero Alsina); 'This is a film made by means of successive scenes, similar to strokes' (Louis Marcorelles).

It has been argued that prior to the nineteenth century, narrative painting tended to focus on 'the essential moment', that is, the moment of change, depicting, for instance, Moses at the very moment of receiving the Ten Commandments. But later in that century painting conquered the mobile gaze, that is, the capacity to grasp the fleeting moment and therefore to conceptualize it both as fugitive and as equivalent to any other moment, something that in the twentieth century became the very stuff of cinema (Aumont et al. 1992). Indeed, in Leduc's *Frida*, it is this kind of instants which come across, snapshots of any moment whatsoever in what might have been Kahlo's life as opposed to any essential moments of transformation. Although some crucial events are hinted at, such as Diego Rivera's betrayal with her sister Cristina and her only solo exhibition in Mexico, most of the film shows Kahlo going about her (anything but) ordinary life – including going to the cinema and in marionette performances – with its intense pain and pleasure, and sometimes in the process of painting. In this sense, the film might be understood as impressionistic along the lines of Jacques Aumont's description of the Lumières' vistas. On the whole, Leduc's *Frida* is very much in the tradition of modernist art cinema. Following her role as Frida, actor Ofelia Medina started a career as a political activist in defence of indigenous causes, a role she maintains today.

Frida

At the other extreme there is *Frida* (Julie Taymor, 2002), for the most part a highly conventional biopic, made under the full sway of neoliberal policies, just

as Kahlo's family were taking steps towards registering her name as a trade brand, protected by copyright, which they finally achieved in 2004 (Castellanos 2007).

As Dennis Bingham puts it, as a genre, the biopic's charge is 'to enter the biographical subject into the pantheon of cultural mythology' (Bingham 2010: 10), in this case beyond the borders of Mexico.[3]

> [It] narrates, exhibits, and celebrates the life of a subject in order to dem-onstrate, investigate or question his or her importance in the world ... and for both artist and spectator to discover what it would be like to be that person, or ... that person's audience. (Bingham 2010: 10)

If this is the case the biopic might perhaps be thought of as eliciting engagement with the sensible from perspectives not normally held by viewers more openly than other fiction films, staking as it does a claim to historicity. Bingham further claims that due to Western culture's difficulty with the issue of women in the public sphere, 'biopics of women are structured so differently from male biopics as to constitute their own genre ... trapping [women] for decades in a cycle of fail-ure, victimization and the downward trajectory' (Bingham 2010: 23–24). This has been especially the case with films about artists, which tend to 'drown in angst, grotesque behaviour, and impossible suppositions on how and why the artist creates' (Blumental et al. 2007: 244). Julie Taymor claimed that her aim was instead to render a portrayal in which Kahlo would come across as a subject with agency and as a creator: 'Frida created herself' (Blumental et al. 2007: 244).

The film closely follows the biography by Hayden Herrera (1983), using 'essential moments' to construct a narrative driven by cause and effect. Kahlo's early involvement in student socialist circles, the accident, her turbulent mar-riage to Diego Rivera, their life in the United States, Trotsky's arrival at their house in Coyoacán and the various health problems that besieged her until her death structure the narrative. The film is also conventional in that it worked mostly as a vehicle for its star Salma Hayek, by then Hollywood's best known Latina. And, spoken in English, and with what the press called 'a committed Mexican beauty in a relationship ... with a committed Anglo film star' this film depicted, as John King reminds us, 'a myth of ethnic fusion and harmony, at a time when the US Bureau Census was predicting that by 2050, the Latino pop-ulation would be half that of the "white" inhabitants' (King 2003: 142). Thus the icon of Mexicanity that Frida Kahlo has become was in this case, through Hayek's stardom, re-signified in line with the cultural production that befitted the North American Free Trade Agreement (NAFTA) at the time. Moreover, at no point does *Frida* challenge the biopic's foundational conventions: it does not question the relation between individual agency and history, nor the ten-sion between private imagination and public discourse.

Nevertheless, the film is reflexive, or at least experimental, as regards its use of digital animation, including the presentation of five *tableaux vivants* (*Frida and Diego Rivera*, 1931; *Self Portrait with Cropped Hair*, 1940; *The Two Fridas*, 1939; *The Broken Column*, 1944; and *The Dream/The Bed*, 1940) and a scroll, evoking Russian constructivist poster art emblematic of the period – and a collage technique used by Frida in *My Dress Hangs There* – which interrupt the narrative and call attention to the film's status as representation. Music is sometimes deployed to the same effect. The narrative also employed the film-within-the-film device as we see Kahlo attending a screening of *King Kong* in New York, which Taymor uses to allegorize Diego Rivera's ascent, and subsequent fall, in the city.

The colour scheme, digitally enhanced, closely follows that of her paintings from the period being staged. This 'chromatic paradigm', one of the ways in which film and painting intersect, 'is worth mentioning because films which explore colour inevitably raise questions about the relation of film, painting, creativity and femininity' (Dalle Vacche 2008: 183). As Paul Coates contends, 'only objects placed out of focus register first and foremost as colours ... Since industry practice habitually applies soft focus to women the identification of colour and femininity is reinforced' (Coates 2010: 25). Further, the dichotomy between colour and black and white is one of the binary oppositions on which Orientalist discourse has traditionally rested. In Western art criticism,

> the purging of colour is usually accomplished in one of two ways. In the first, colour is made out to be the property of some foreign body – usually the feminine, the oriental, the primitive, the infantile ... in the second, colour is relegated to the realm of the superficial. (Batchelor 2006: 64)

Gilles Deleuze too had pointed to the ways in which colour, on account of the highly affective response it is able to arouse, has the power to destabilize a visual narrative, unbinding time from our linear and post-Industrial Revolution way of experiencing it, allowing for a more subjective perception of it, and in a sense, an emancipatory perception (Deleuze 2009). Likewise, André Bazin argued that when colour film literally copied from paintings the result was 'little more than a decorative and dramatic rehash of the paintings which provided its source' (Bazin 1974: 130), apparently thinking that proceeding inversely was more appropriate to the aims of cinema, namely releasing the dimension of time inherent in painting. He thus expressed admiration for Jean Renoir's *French Cancan* (1954) as follows:

> Rivette pointed out to me that, unlike those who think that to be inspired by painting means to compose a shot imitating a painting and then bringing it to life, Renoir starts from a non-pictorial arrangement

and cuts when the framing of a scene has evoked a painting. (Bazin 1974: 135)

This is the case in some scenes of *Frida*. And although Taymor never gives colour total 'freedom', in the Deleuzian sense, she does give it a prominent role. While this gesture can be interpreted as a process of self-exoticizing, and understood as part of its tourism promotion efforts, the film nonetheless succeeds in linking colour, femininity and the marginal to creation. As Leo Braudy would have put it, Taymor's *Frida* is a 'closed film' in that the universe it depicts closes upon itself, is inwardly oriented and centripetal, like a painting. It does not call attention to what lies beyond the frame (Braudy 1976: 44–51).

In sum, despite the constraints imposed by their different times, places and modes of production both Leduc's 'modernist mirror' and Taymor's 'Hollywood window' succeed, in different ways, in putting across their own versions of what we may call a film-portrait. Leduc's evokes Walter Benjamin's contention that the practice of writing history should not be sequential, but based on the establishing of constellations, like a collage process in which past moments and historical material operate as a denaturalizing shock to the present (Benjamin 1973: 254). In this way he also seems to have been able to break away from the ideological implications embedded in narrative cinema.

Taymor followed a different path. In his 'Cinema as a Total Art Form' (2000), Peter Greenaway argued for a filmmaking that relied less on the psychological, character-driven novel and sought to explore the cinematic image in the light of its relation with other arts, such as theatre and painting. Despite its Hollywood origins and its character-driven narrative, Taymor's *Frida* is nonetheless organized around chiaroscuros, colour, textures and framing. Its highly stylized mise-en-scène and animation recalls Kahlo's paintings and the whole process of pictorial representation more directly. Further, inasmuch as digital technologies provide a wider range of controls to filmmakers comparable to the control of painters, new media are transforming traditional aesthetic conventions: 'the assumed trajectory of digital technology ... has always been the perfecting of photographic realism. Yet the debate about the aesthetic capacity of, and use of, DI underscores its alternative aspect: its expressive dimension' (Choi 2011: 138).

Moreover, Angela Dalle Vacche has added to the mirror metaphor for cinema the argument that, in its humble, technological origins, destined to capture the ordinary experience of everyday reality, film can be not only a mirror but actually a mobile mirror whose position can be shifted to explore what lies beyond the centre: 'marginality, randomness and the ephemeral' (Dalle Vacche 2008: 194). Both these films remind us of the great importance that mirrors played in Kahlo's painting as she was often bed-ridden, and how her rendition of the margins, sharply in contrast with Rivera's murals of historical and political developments at the time, have proven more enduring and significant (Figure 1).

Figure 1: Cinema as (Kahlo's) 'mobile mirror' in Leduc's Frida, Naturaleza Viva.

Audience Reception

So, returning to the question at the beginning of this chapter, how are we to make out the meaning of these two film-paintings and the work and the painter they intertextually engage with when it comes to their communities of reception? Are they to be understood as having made an intervention in the public sphere, as regards gender or ethnic roles in Mexican society of the 1980s and the early twenty-first century? Or were they simply consumed as part of a marketing strategy to raise the value of Kahlo's works and boost sales of all related merchandise, as her name is turned into a cash-generating industry? Can either of them in any sense be said to recover the emancipatory potential that was once ascribed to art?

Rancière has attempted two answers to the question of what can possibly be the role of art in these postmodern times of, as I mentioned above, 'polluted faith'. The first one is that sharing an aesthetic experience has the potential to foster community, creating new forms of social bonds (Rancière 2009: 78), an act that, in relation to cinema, the Frankfurt School would have conceptualized more in terms of partaking in a common popular culture. One instance of such a sharing of artistic experience that actively shaped community is the short video *What Do I Need Feet For?* (¿*Pies, para qué los Quiero?*), a three-minute cut-out animation made by children between the ages of seven and 12 at Comunicación Comunitaria, a media school founded and run by Irma Avila Pietrasanta in Mexico City. The piece can be viewed as a response to these and other films and cultural products on Kahlo circulating in the public sphere.

Built around a drawing by Kahlo entitled *What do I need feet for, if I have wings to fly?* (1953), which she painted shortly after the amputation of her right leg, the video depicts Kahlo in bed, painting a picture of a foot, when it

suddenly becomes animated, leaps out of the canvass and leaves the room flying through the window (Figure 2). A voice wondering where it might be going is heard, and then the bed itself becomes animated and Frida follows her foot through the window, trying to get it back. Her bed goes through the exhibition of her paintings at the gallery – the children were impressed when they learned she had been taken to the inaugural ceremony on her bed – and then goes into a black 'universe' where there are 'worlds' – circles – of some of the most iconic images in her paintings, such as the world of eyebrows, and the world of monkeys. Throughout her search, whispers can be heard saying 'you are free, we are free'. Then she finds her foot, floating about, and when she gets hold of it to bring it back to the painting, wings grow out of her back and she is herself able to fly, at which point the voice of an adult woman can be heard that says 'what do I need feet for, if I have wings to fly' (Figure 3). The allegory of Kahlo painting her way out of pain and all sorts of constraints – including an unfixed identity, permanently under construction – into emancipation is further achieved as the foot, when becoming animated, takes the shape of a 'miracle', that is, a small metallic devotional object in the shape of a foot, that the grateful faithful in Mexico place near statues or paintings of saints they believe have granted them a miracle (Figure 4). The video thus achieves an extremely original film/portrait of Kahlo, one in which the emancipatory potential of art is highlighted, both for the artist and for the audience, here also constituted as a community of reception, for the children's video is an artistic intervention in its own right.

Rancière's second answer to the meaning of a work of art is to call for recognition that the act of viewing, far from a mere passive exercise in deception,

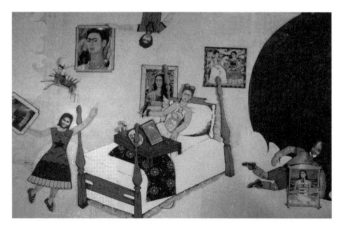

Figure 2: Kahlo's 'animated bed' flying over the exhibition, where some of the filmmakers have included themselves.

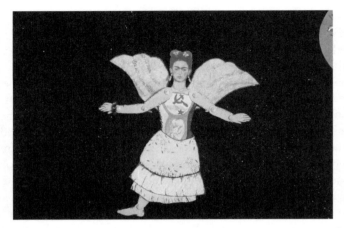

Figure 3: *'What do I need feet for, if I have wings to fly', after Frida Kahlo, by children learning animation at Comunicación Comunitaria A.C.*

is in fact a highly active process, indeed offering the possibility to resist and transform the status quo by provoking, as Rancière puts it, 'a dissociation between the work of the arms and the activity of the gaze ... [a disruption of] the way in which bodies fit their functions and destinations' (Rancière 2009: 70–72). In other words, disrupting the fit whereby each one of us is 'plugged' into the system by means of culture. For Louis Althusser (2005), this would have been equivalent to enabling the means to refuse being 'hailed' by the dominant ideology. Neighbourhood cinemas, Rancière says, 'have been replaced by multiplexes that supply each sociologically determinate audience a type of art designed and formatted to suit it' (2009: 81).

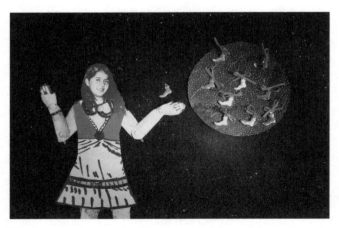

Figure 4: *'World of miracles' showing Kahlo's foot flying toward one of the filmmakers.*

From the point of view of venue, neither Leduc's nor Taymor's *Frida* were able to mount this challenge. Despite winning all the Arieles – the prizes granted by the Mexican Academy of Cinematographic Arts – that year, the audience for Leduc's film mainly comprised highly-educated, middle-class viewers or students attending the National Film Theatre in Mexico City or cinemas in the festival circuit in Mexico or abroad. 16 years later, Taymor's film was shown in the multiplex network available in shopping districts of the main cities in the country. Both films have largely continued to match their 'sociologically pre-determined' audience, even if now they are available on DVD, can be downloaded from the Internet and have also been shown on television.

However, there is evidence that audiences did not necessarily engage with *Frida* as an instance of 'global Hollywood', that is, a transnational film product for a global market seeking to either recuperate difference or recreate it as a kind of neutered, colourful, commodified exoticism. Indeed respondents to a series of interviews and focus groups that were held in the city of Monterrey, Mexico, in 2010 for this research showed they had engaged with the film mainly for its representations of national and gender identity as negotiated in the star-like persona of Kahlo, but also that the historical context of its reception played an important role.

Some of the respondents said they had liked *Frida* because 'it is not a Hollywood film where there is a super-hero that saves the world. Instead, it is a Mexican woman who is also a painter, and one among the best' (S, female, age 22). Rather than the myth of ethnic fusion and harmony for a purported American audience King alluded to above, the audience in Monterrey understood *Frida* as an affirmation of Mexican identity vis-à-vis the United States. As put by another respondent:

> We all know that they do not like Mexicans in the US, not only now with the Arizona law,[4] but always. So the fact that she went there, and became well known and highly valued, was a great triumph. (M, female, age 28)

Most striking, however, was the way that nearly all participants brought the present context of drug-trafficking related violence to bear upon their reception of the film. 'To me', said one,

> the key message of the film is how something extremely good came out of something really awful, because Frida suffered the accident, but thanks to that, she became a great painter and we can enjoy her work today. I hope the same will happen to Mexico, that the violence and insecurity we are living at present will be like the accident, that something good will come out of all this pain and that if the country has to break into

pieces, it will break like Frida's broken column, in order to be rebuilt afterwards. (A, male, age 22)

By the same token, another one put it as follows:

Because of her situation, Frida told herself: 'I don't know how many days I have left, I am in great pain, I will live life to the fullest'. Having had the accident helped her to live intensely. And the same is happening to us now, because of the way we live. I think for this reason she really stands for Mexico at present, she is now our best national icon. (R, female, age 20)

Further, another one put her thoughts in language from painting:

We are in the wrong track, that is all we hear, no one wants to be in a country where the future looks horrible [*pinta horrible*, in Spanish], but it is also a colourful country, like her paintings, and there are truly remarkable things here, watching Frida's paintings in films like this can return our self esteem. We have little faith in ourselves. (Y, female, age 21)

In the end, everyone agreed the film had provided a reasonably good representation of Kahlo because, a bit like Dorian Grey, 'she is simply un-representable. Salma or whoever you see, you will be disappointed' (R, male, age 19). All in all, both cinema and painting express a community's anxieties, fears and hopes. But it seems that at the end of the day, that ultimate kernel of meaning, like Lacan's 'the real', does remain stubbornly unrepresentable.

Conclusion

The debate on the artistic status of cinema and on the nature and purpose of the arts is of course historically bound. For most of the twentieth century the former was argued on the specificity – purity? – of the medium, and the latter as enabling emancipation, understood as a project of social justice. In the twenty-first century, however, with an epistemology increasingly based on interdisciplinarity, boundaries between subjects and academic fields coming down and grand narratives forgotten, film is again reconceptualized as inherently mixed, and the kind of emancipation that art – in singular – can perhaps deliver is more to do with a temporary and precarious reallocation of the field of perception.

Films on the lives and work of painters are particularly well suited to ponder upon these issues, not only because of their inherent hybridity, but also because, being on the life of an artist, they are bound to foreground the social role of art as a creative process that can be appropriated by a community of reception.

Here I have discussed how this is done by two very different films on Frida Kahlo and some of their audiences. While the university students in Nuevo León brought their personal circumstances to bear upon their understanding of the film and saw Kahlo as a metaphor for the nation, one that allowed them to partake in a community through the sharing of aesthetic experience, the children in Mexico City understood Kahlo's quest as one of emancipation through artistic creation, just what they attempted themselves through their video. Indeed, when they whispered 'you are free' while Frida was looking for her foot in the gallery exhibition, they added 'we are free', vividly dramatizing just the extent to which impure cinema can give one wings.

Notes

1 I am grateful to Lucila Hinojosa Córdova from the Universidad Autónoma de Nuevo León for her assistance with the interviews and focus groups for this research, and to Irma Avila Pietrasanta for sharing with me *¿Pies, para qué los quiero?* and other videos made by children at Comunicación Comunitaria. *¿Pies, para qué los quiero?* can be found at http://www.comunicacioncomunitaria.org/index.php?option=com_content&view=article&id=111

2 '*Desde su lecho de moribunda, Frida Kahlo (1907–1954), la gran pintora, reconstruye acorde a las auténticas palpitaciones de la memoria, es decir, de una manera inconexa y fragmentada, únicamente a través de las imágenes, su vida y su obra, que fue medular en la época del muralismo mexicano*' (Leduc 1986, opening scene), although Kahlo did not paint murals. ('From her deathbed, Frida Kahlo, the great painter, remembers her life and work, which was central during the times of Mexican muralism, in a fragmentary and episodic fashion, only through images and the palpitations of memory', my translation).

3 According to *Box Office Mojo*, the film was shown, predictably, in Argentina, Chile, Mexico, Spain and the US, but also in Australia, Austria, Bulgaria, the Czech Republic, Finland, Germany – where it grossed $6,008,488, nearly twice the figure for Mexico, the second largest – Greece, Hungary, Italy, the Netherlands, New Zealand, Norway, Poland, Taiwan and Turkey. www.boxofficemojo.com/movies/?page=intl&id=frida.htm, last accessed 17 August 2012.

4 Passed in April 2010, the 'Arizona Law' made of the failure to carry immigration documents a crime and gave the police broad power to detain anyone on the basis of their physical appearance.

References

Althusser, Louis (2005). *For Marx*. London: Verso.
Aumont, Jacques, Alain Bergala and Michel Marie (1992). *Aesthetics of Film*, translated by Richard Neupert. Austin: University of Texas Press.

Batchelor, David (2006). 'Chromophobia', in Angela Dalle Vacche and Brian Price (eds), *Colour: The Film Reader*. London: Routledge, pp. 63–75.

Baudrillard, Jean (1994). *Simulacra and Simulation*. Ann Arbor: The University of Michigan Press.

Bazin, André (1974). *Jean Renoir*, translated by W. W. Halsey II and William H. Simon. New York: Delta.

Benjamin, Walter (1973). *Thesis on The Philosophy of History*, edited by Hannah Arendt. London: Fontana.

Bingham, Dennis (2010). *Whose Lives Are They Anyway? The Biopic as Contemporary Film Genre*. Chapel Hill: Rutgers University Press.

Blumental, Eileen, Julie Taymor and Antonio Monda (2007). *Julie Taymor, Playing with Fire: Theatre, Opera, Film*. New York: Abrams.

Braudy, Leo (1976). *The World in a Frame: What We See in Films*. New York: Anchor Press.

Brugger, Ingried (2010). 'A Small World That's Become So Big ...', in Martin Gropius Bau (ed.), *Frida Kahlo: A Retrospective*. Munich: Prestel, pp. 12–17.

Castellanos, Laura (2007). 'Frida Kahlo: Marca Registrada', *El Universal*, 27 May, at http://www.eluniversal.com.mx/nacion/151291.html, last accessed 17 August 2012.

Certeau, Michel de (1988). *The Practice of Everyday Life*. Berkeley: University of California Press.

Choi, Jinhee (2011). 'Perfecting the Complete Cinema: Rudolf Arnheim and the Digital Intermediate', in Scott Higgins (ed.), *Arnheim for Film and Media Studies*. London: Routledge, pp. 127–40.

Coates, Paul (2010). *Cinema and Colour: The Saturated Image*. London: British Film Institute.

Dalle Vacche, Angela (2008). 'Cinema and Art History: Film Has Two Eyes', in James Donald and Michael Renov (eds), *The Sage Book of Film Studies*. London: Sage, pp. 180–97.

——— (2003). *The Visual Turn: Classical Film Theory and Art History*. New Brunswick: Rutgers.

Daney, Serge (2010). *Paul Leduc*. Retrieved from 'Filmografía Parcial': http://paulleduc.net, last accessed 17 August 2012.

Deleuze, Gilles (2004). *Difference and Repetition*. London: Continuum.

——— (2009). *Cinema 2*, translated by Hugh Tomlinson and Robert Galeta. London: Continuum.

Dyer, Richard (2004). *Heavenly Bodies*. New York: Routledge.

Eisenstein, Sergei (1987). *Non-indifferent Nature: Film and the Structure of Things*, translated by Herbert Marshall. New York: Cambridge University Press.

Elliott, Kamilla (2003). *Rethinking the Novel/Film Debate*. Cambridge: Cambridge University Press.

Greenaway, Peter (2000). *Interviews*, edited by Vernon Gras and Marguerite Gras. Mississippi: University of Mississippi Press.

Herrera, Hayden (1983). *Frida: A Biography*. London: Harper & Row.

King, John (2003). 'Stars: Mapping the Firmament', in Stephen Hart and Richard Young (eds), *Contemporary Latin American Cultural Studies*. London: Hodder Arnold, pp. 140–50.

Lacan, Jacques (2006 [1977]). *Ecrits: The First Complete Edition in English*, translated by Bruce Fink. New York: W.W. Norton.

Leduc, Paul (n.d.). *Paul Leduc*. Retrieved from http://paulleduc.net, last accessed 17 August 2012.

Mast, Gerald (1984). *Film Theory and Criticism: Introductory Readings*, edited by Gerald Mast, Marshall Cohen and Leo Braudy. London: Routledge.

Mulvey, Laura (2003). 'Then and Now, Cinema as History', in Lúcia Nagib (ed.), *The New Brazilian Cinema*. London: I.B.Tauris, pp. 261–69.

Rancière, Jacques (2004). *The Politics of Aesthetics*, translated by Gabriel Rockhill. London: Continuum.

——— (2009). *The Emancipated Spectator*, translated by Gregory Elliott. London: Verso.

Rebel, Ernst. (2008). *Self-portraits*. Cologne: Taschen.

Chapter 5

Transatlantic Drift: Hobos, Slackers, *Flâneurs*, Idiots and Edukators

Paul Cooke and Rob Stone

As a drifter moves from place to place without job or home, so an idea does not belong to any individual or movement but moves amongst them all, picking up influences and impurities as it goes. For example, the very notion of drift is one that appears in the legends of the hobo in American literature, folk songs and film and reappears in the intellectual tradition of the *dérive* as theorized and performed by Guy Debord and The Situationist International. It then re-emerges in the communities of the largely independent American cinema of Richard Linklater and persists in the influence of his films, such as *Slacker* (1991) and *Before Sunrise* (1995), on the so-called Mumblecore generation and on many European filmmakers indebted to Debord and Linklater. As shall be examined, subscription to the *dérive* inspires films about those who transcend the potential banality of their relatively bourgeois existence through the elec-tive affinities they find in the ephemeral associations that populate numerous such films. It is the interwoven enactment and philosophy of the *dérive* or drift that enables resistance to all kinds of social, political, generic and narrative imperatives. In addition, we contend that reflections upon the true value and meaning of this 'transatlantic' drift inform the social and political ambitions of several films whose self-conscious exploration of the productive tension between their form (primarily long takes and their 'becoming' time-images, shallow depth of field and hand-held camera) and content (youthful protest, unfocused idealism and nonconformism) is in the service of a specifically anti-capitalist ideology. Drawing on the theories of Debord and Gilles Deleuze, we will analyse the figure of the hobo and the importance of drift in films directed by Linklater,

as well as its influence on contemporary European cinema. We will then move to an analysis of *The Edukators* (*Die fetten Jahre sind vorbei*, 2003) directed by Hans Weingartner, a filmmaker who readily acknowledges his debt to Linklater and provides a particularly good example of intertextual relations with his cinema.

Following the Hobo

The hobo emerged as a figure ripe for legend and literature in North America in the nineteenth century and became an archetypical protagonist of the Great Depression. He or she was a migratory labourer in a world without work and thus a homeless, penniless wanderer, defined by a life on the road or railways, whose label may have derived from an abbreviation of the ironic reply of 'Ho-meward bo-und' to the eternal question of where they were headed. Writers John Steinbeck and Charles Bukowski and folk singer Woody Guthrie were sometime hobos, as were Jack Kerouac, author of *On The Road* (1957), and the actor Robert Mitchum. Notable films depicting hobos of the Great Depression include William Wellman's *Wild Boys of the Road* (1933) and Preston Sturges' *Sullivan's Travels* (1941), while the figure made a comeback in period films of the 1970s, such as Robert Aldrich's *Emperor of the North* (1973), Robert Altman's *Thieves Like Us* (1974), Walter Hill's *Hard Times* (1975) and Hal Ashby's biopic of Guthrie, *Bound for Glory* (1976). These later films all found new relevance in the figure of the hobo for young audiences suffering the economic and moral fallout of the war in Vietnam and of Watergate, and the rise of a close alliance between the banking sector and national government. When this came crashing down in the mid-2000s, the hobo duly reappeared in Sean Penn's *Into the Wild* (2007) and Kelly Reichardt's *Wendy and Lucy* (2008) as a figure of exclusion and somewhat self-destructive defiance. In European cinema, meanwhile, the arch-satirist Luis Buñuel deliberately mistook pilgrims for hobos in *The Milky Way* (*La Voie lactée*, 1969). Wim Wenders adopted the hobo as an anti-authoritarian figure that resembled a newer version of Robert Musil's *Mann ohne Eigenschaften*, a 'man without qualities', whose moral ambivalence, seeming indifference and passive analysis rejects what Wenders sees as the unreconstructed values of the post-war West German state in *Alice in the Cities* (*Alice in den Städten*, 1974), *The Wrong Move* (*Falsche Bewegung*, 1975) and *Kings of the Road* (*Im Lauf der Zeit*, 1976), before tracking the hobo back to its American roots in *Paris, Texas* (1984).

In his wanderings between European and American cinema, the hobo is thus an archetype of impure cinema, because his/her drift effects an accumulation of experiences and influences that results in an indistinct outcast figure, one whose very impurity defines and maintains a lack of clear origins and explicit

direction. The hobo's appearances in urban centres are indeed disruptive because his or her very rootlessness and rejection of settlement often renders the figure as threatening Other. As the character played by Charles Gunning called Hitchhiker (a modern-day hobo) exclaims in *Slacker*: 'I may live badly, but at least I don't have to work to do it' – a line that Linklater actually appropriated from Buñuel's *Tristana* (1970), in which Don Lope (Fernando Rey) exclaims:

> I say to hell with the work you have to do to earn a living! That kind of work does us no honour; all it does is fill up the bellies of the pigs who exploit us. But the work you do because you like to do it, because you've heard the call, you've got a vocation – that's ennobling! We should all be able to work like that. Look at me, Saturno – I don't work. And I don't care if they hang me, I won't work! Yet I'm alive! I may live badly, but at least I don't have to work to do it!

Slacker is a kind of Buñuelian pilgrimage of drifters to the ethics of anti-work that celebrates Robert Louis Stevenson's observation that 'idleness so called, which does not consist in doing nothing, but in doing a great deal not recognized in the dogmatic formularies of the ruling class, has as good a right to state its position as industry itself' (Stevenson 2009: 1). The association of urban drift with revolutionary idleness in *Slacker* and other films directed by Linklater clearly derives from Guy Debord, who appears as Mr. Debord (Hymie Samuelson) in *Waking Life* (2001), Linklater's rotoscoped palimpsest of *Slacker*, to declare: 'Free the passions. Never work. Live without dead time.' Debord promoted drifting as a member of The Situationist International, which was formed in 1957 and dissolved in 1972 following its failure to capitalize on the achievements of the 1968 riots in Paris. The Situationist International proposed an instinctive attitude to experience and the *dérive* was emblematic in this regard, because it promoted the transformation of an urban environment by means of its intuitive exploration. The result was psychogeography, which, as Lesley Speed perceives, indicates that 'the relationship between Linklater's films and The Situationist International is an instance of postmodern revivalism' (2007: 103).

The revival of the *dérive* would become a structural and dialogic strategy in the films of Linklater. In his prototypical *It's Impossible to Learn to Plow by Reading Books* (1988) it is enacted by Linklater himself as drifter, aimlessly travelling America and recording his encounters with fellow wanderers at the no-money level that is evident in the rudimentary filmmaking. The subsequent paradigm is *Slacker*, which moves from person to person in the director's hometown of Austin, reterritorialized by this urban *dérive* that Linklater defined as 'a nomad education of movement that features a changing curriculum of [one's] own making, based on the passion and pursuit of the moment' (Linklater 2004). In effect, *Slacker* is a guerrilla film with great political resonance, for its creative

characters are all daydreaming in a kind of hibernation throughout three suc-
cessive Republican presidencies. This sense of lucid dreaming, which will
become explicit in *Waking Life*, is most often conveyed in long takes that, we
contend, may correspond to Gilles Deleuze's concept of time-images, whose
form, content, subversive meaning and political resonance was a determining
factor in the cinema he associated with particular European filmmakers follow-
ing the Second World War (Deleuze 2005a; 2005b). The direct time-image is
understood to be a comparatively long and ostensibly aimless take that ignores
the coercion of narrative, thereby disengaging the protagonist, whose temporal
dislocation is also perceived by the audience. Commonly associated with alien-
ation and existential angst, the direct time-image also expresses a longing for
metaphysical transcendence from the prison of the image, whose meaning is
heightened by, and inseparable from, its prolongation. A direct time-image may
make time visible, even tangible, because of the way that the film's protagonists
and its audience are subject to the duration of the shot. Following Henri
Bergson, it also embodies time as something indefinable, thereby compounding
limitations of language and making verbal description impossible. Instead, it
forces the audience to scrabble for meaning by thinking in terms of the image:
why is it so prolonged and what can be found within it to justify, explain or
resolve such uncomfortable duration?

This questioning is essential to the meaning of *Slacker*, in which Linklater
relocates the sense of alienation and existential posture that Deleuze found evi-
dent in certain films of Alain Resnais, Jean-Luc Godard and Michelangelo
Antonioni to Austin in the early 1990s and uses it to express the mindset of an
isolated, regional community-of-the-streets whose liberal philosophy and idly
creative lifestyle is at odds with the majority of the American electorate. Thus,
the long takes of a multitude of hobo-like characters walking and talking evoke
diffidence towards narrative that is rendered by the snub of going with the flow
and just drifting with the movement and dialogue of the actors, whose tempo-
ralized existence is expressed in the guise of the time-image. 'Yeah, I just love
it!' says Linklater:

> You know, to me that's the purest cinema, the André Bazin idea of pure
> cinema. There's no cutting, there's nothing else. It forces you into the real-
> ity of the moment. You could if you wanted to cut away, but I like this way
> of making film. You see it in Preston Sturges too. Go back and watch
> *Sullivan's Travels* and you'll realise, 'Holy crap, the whole scene is like one
> take!' You wouldn't know it because the camera's moving around and within
> the frame it's got so much energy. It's like a musical. (Stone 2013a: 121)

As *Slacker*'s cinematic game of tag develops, it becomes apparent that the film is a
kind of passed-along song of the common people, whose polyphony celebrates

Figure 1: Modern-day hobos in Slacker *(courtesy of Richard Linklater).*

what Georg Sorensen has defined as 'a community of sentiment' (2003: 83–102) (Figure 1). *Slacker* thus resembles that which Mikhail Bakhtin (1984) described as a carnival of street-level interaction, in which all the characters are incomplete and truth is somewhere in their hubbub of carrying voices. For Bakhtin, 'the carnival spirit offers the chance to have a new outlook on the world, to realize the relative nature of all that exists, and to enter a completely new order of things' (1984: 34). Those who drift through *Slacker* mostly effect 'a posture of feigned ambivalence to the tail end of the recession of the late 1980s so that privately nurtured romantic ideas of the self might be protected instead of surrendering them to social and political expectations' (Stone 2013a: 9). Just as the collectivization of voices and gestures in *Slacker* expresses a socialist alternative to what Linklater (2004) sees as the 'democratic ineptitude' of their nation, so their freedom to do nothing is asserted in the going-nowhere time-images that make up this carnival of their everyday drift. Debord defined the *dérive* as 'a mode of experimental behaviour linked to the conditions of urban society: a technique of rapid passage through varied ambiances' (1958). Linklater offers variations on this theme in successive films that feature psychogeographical *flânerie* in the urban wanderings and loiterings of *Dazed and Confused* (1993), *SubUrbia* (1996), *Waking Life* (2001), *Before Sunrise* (1995), *Live from Shiva's Dance Floor* (2003) and *Before Sunset* (2004), each of which transforms functional, demarcated, urban terrain into places of imaginative, romantic, reflective and subversive endeavour (Stone 2013a).

Following Linklater, Debord and Deleuze

There is a similar reengagement with the ethos and practice of The Situationist International in many examples of recent European cinema. Drift redefines

communities of conversation as empty phatic noise effecting bourgeois malaise in Angela Schanelec's *Passing Summer* (*Mein langsames Leben*, 2001) (Cooke 2012) and it sustains the time-wary construction, deconstruction and reconstruction of an anonymous European city in José Luis Guerín's *In the City of Sylvia* (*En la ciudad de Sylvia*, 2007) (Stone 2013b). The long takes that make up the urban drift both herald and desecrate the reality of city life in Michael Haneke's *Code Unknown* (*Code inconnu: Récit incomplet de divers voyages*, 2000) and they provide a platform for the simple comic stasis of its bemused inhabitants in Jesús Ponce's *Déjate caer* (2007). Together, the drift and its time-images evince the vicarious, imaginative carnival of Cédric Klapisch's *Paris* (2008) and the troubled reconfiguration of the Situationist 'spectacle' in Hans Weingartner's *The Edukators*. The transatlantic drift that allows for the conjoined philosophical enquiry and practice of the hobo, the *flâneur*, slacking, the *dérive*, carnival and the time-image thus constitutes an example of the impurity that is a significant trend of European filmmaking in this age of transnational production and digital distribution. Furthermore, the collusion of these elements entails a theoretical response to the cinematic reterritorialization of urban spaces because the visual, auditory, sensual, romantic, spiritual, philosophical and political encounters that occur in them suggest and are suggested by the fluid nature of the films themselves.

As slacker characters reflect upon their time in these spaces and set about the reflective or philosophical monologues and dialogues that signify more meaningful endeavours than wage-slavery or consumerist self-aggrandizement, so the long takes they inhabit resemble time-images that accommodate and 'think through' their non-conformism in a synchronous manner that also expresses the time it takes an audience to experience the chronotope that becomes cinematic. The potential for narrative momentum is therefore deliberately frustrated by the simmering open-endedness of these long takes, for their recognition as time-images only becomes apparent in the gradual postponement of any contrasting movement-image with its duty-bound servitude to narrative resolution. Instead, by not cutting into the lengthening take, the drifting monologues, loose dialogues and aimless reflections upon creative and revolutionary intent tend to merge into one another, thereby facilitating the passed-along protest song that is typified by *Slacker*. In sum, slacking and the film that propounds it do not explore laziness but imagination, reflection and collaboration as a rebuttal to convention, conformity, consumerism and competition. Stasis as a healthy period of inactivity in the cause of equilibrium is certainly courted, while every stuttering search for words or any stoppage of narrative flow resembles a moment of meditation in which reality, drifting characters and exploratory dialogues converge on a new way of expressing and defining what it means to be a citizen. That is, not a person owing loyalty to a state or nation, nor a voting resident of a city or town or even a civilian defined by living in a

particular place. Instead, it is a person who is independent, who chooses not to vote, a militant who is defined by drifting.

Moreover, this impure union of documentary-like film form and romantic content is so resolutely 'in the moment' that it reprises Debord's notion of the *dérive* as a model for narrative form and Deleuze's theory of the time-image as one that expresses the eruption of real time onscreen as both process and purveyor of meaning. Bergson describes time in terms of its duration or *durée*: 'Its essence being to flow, not one of its parts is still there when another part comes along' (1992: 12). Or as 'Pinball-Playing Man' (Richard Linklater) puts it in *Waking Life*: 'There's only one instant and it's right now and it's eternity.' Bergson celebrates this instant for its 'uninterrupted upsurge of novelty' (1992: 18) and he presents the flow of life as something that is always unique and possessed of an infinite capacity for change. Consequently, once free from consumerist, conformist, conventional, man-made measurements and uses of time, the liberated human consciousness may discover that its own perception of the infinite moment is the only structure it needs. Revolutionary intent is therefore allied with perception of the time-image and the simultaneous representation of drift in films that promote a radical subjectivity about their time. In so doing, such films as *Slacker* and *Waking Life* reference and resemble the fact that the *dérive* was originally a kind of art project with a political objective that The Situationist International performed in order to express their scorn for materialism, authority and constraints on the imagination that promulgated the commodification of the individual within what Debord defined as the 'Society of the Spectacle'. As with the *flâneur*, whose urban wanderings as described by Charles Baudelaire (1964) reimagined, remodelled and redeployed evolving metropolises, The Situationist International, just like slackers in the films of Linklater, rejected functionally geometrical town-planning and its quantitative divisions of utilitarian space and sought instead to investigate fresh designs and purposes for the monotonous arrangement and consumerist paraphernalia of modern-day living. Their movements and actions in cities and suburbs were intended to challenge old values with the invention of new truths. In *Slacker*, for example, doing this in Austin transforms the capital of Texas, home of the Bush dynasty, into an oasis of dissent against corporate America.

Thereafter, in making *Before Sunrise* in Vienna and *Before Sunset* in Paris, Linklater explicitly mixed the hobo and his/her slacker descendants into an already impure collage of European traditions that included the aforementioned *flâneur*, the *dérive*, the time-image and understandings of the flow of life in relation to an intuitive sense of time. Indeed, because this collage is like a rolling snowball in the way that it accumulates impurities, it was fitting that the collage-word 'slacktivism' was coined as an apparently oxymoronic but truthfully nuanced description of a type of revolutionary intent. This manifests itself through the kind of inaction and disengagement that a character in *Slacker*

describes as 'withdrawing in disgust [which] is not the same as apathy'. Thus, although the term slacktivist has come to be used pejoratively, as a slight on those whose support of causes barely extends to a bumper sticker or clicking 'like' on charity appeals on Facebook (also termed clicktivism), true slacker activism entails a retreat from consumerism that leaves no carbon footprint or receipts from the purchase of branded goods. Instead, action by inaction seeks reflection upon the temporal consequences of idleness and finds it refreshing, peaceful, non-competitive and non-contaminating. The temporalized move-ment of slackers seeks communication with the like-minded and finds it by effortless chance rather than by strenuous organization. These encounters, such as those conjured in *Slacker* and in the *flâneur*-like encounters of the American Jesse (Ethan Hawke) and the French Céline (Julie Delpy) with people, places and things on their drifts around the streets of Vienna and Paris in *Before Sunrise* and *Before Sunset* respectively, constitute an ongoing intercultural exchange expressed in films that resemble temporal collages (Figure 2). It is, as Siegfried Kracauer asserts in his essay on the redemption of physical reality, as if 'the street in the extended sense of the word is not only the arena of fleeting impres-sions and chance encounters but a place where the flow of life is bound to assert itself – life eternally dissolving the patterns which it is about to form' (1960: 72). Moreover, because the meandering movement of these characters is most often elaborated in the kind of long takes that Deleuze theorized as direct time-images, in which the 'sensory-motor schema is loosened and a little time in the pure state rises up to the surface of the screen' (2005b: xii), so it is our conten-tion that the time-image presents itself as the ideal expression of the *dérive*, its *durée*, and the *flânerie* and slacking of those who meet within it.

The political resonance of the direct time-image emerges from its refusal to serve narrative and generic conventions, which, in turn, destabilizes traditional or hegemonically imposed definitions and understandings of representation and entails a paradigmatic shift in film studies by treating what happens onscreen

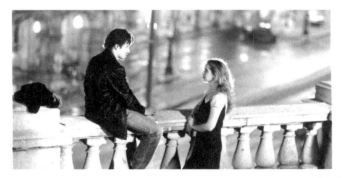

Figure 2: The urban drift reaches Vienna in Before Sunrise *(courtesy of Richard Linklater).*

'as event rather than representation' (Stam 2000: 258). After Deleuze had expounded upon the temporal nature of creation and its fusion with thought on film, this clumping together of the shot and the thought in an indivisible and impure bundle made mere representation impossible. This is because the essential fluidity and temporality of the shot/thought guided our intuition to the provocative experience of 'thinking through' direct time-images from several films that, taken together, resemble a collage of dissent against those in power during the eras in which these films are made. The mash-up of the time-image, drift and slacking rejects classical form and content and any narrative subjugation of time in favour of an intuitive understanding that is shared between characters in films from a range of countries that nonetheless are united in opposition to corporate principles, conventions and mandates. Indeed, this is an entirely deliberate strategy by filmmakers such as Linklater, who claims 'the ultimate rejection of Hollywood structure is to see time passing' (Linklater 2004). It is also crucial to many filmmakers associated with the grungy, defiantly impure wave of alternative, regional and independent films in America which often illustrated the antithesis of Republicanism. The slacker ethos permeates Víctor Nuñez's *Ruby in Paradise* (1993), Rose Troche's *Go Fish* (1994) and Kevin Smith's *Clerks* (1994), for example, as well as the more recent Mumblecore movement with its characteristic ultra-low budget production values evident in the likes of Aaron Katz's *Quiet City* (2007), which opposed the second tenure of President George Bush Jr. and the second Gulf War by means of tentative gestures towards a new surge of Renaissance humanism for the early twenty-first century.

Renaissance humanism sought to define citizenry in terms of the eloquent expression of communities' togetherness and slacking clearly adopts this ambition, which has been rediscovered and explored in a variety of films from all areas of world cinema. For example, Denmark's *The Idiots* (*Idioterne*, Lars von Trier, 1998) which emerged from the Dogme 95 movement (Kelly 2001), punctuates the transatlantic drift of influences that links Linklater and Weingartner and reveals another vital stage in the boiling-down of the political imperative from community (*Slacker*) to commune (*The Idiots*) to cell (*The Edukators*). In *Slacker* the activism is accidental. The philosophical and creative pursuits of individuals in Austin's west campus area congeal into a coincidental community with its wholly impure posture of laid-back resistance. However, the commune of *The Idiots* is composed of pseudo drop-outs who take to 'spassing' (pretending to be mentally and/or physically disabled) in order to point up the intolerance and latent fascism of the Danish middle classes, in confrontations that range from the amusing and scatological to the hysterical and violent. The protest here is angrier than in *Slacker*, more confused than in *The Edukators*, where creativity, anger and activism cohere into a revolutionary cell with the

explicit cause of shaming the wealthy. The flailing activism of *The Idiots* represents von Trier's take on his own generation:

> Once you've rebelled back and forth more than a couple of times, then you're no longer very sure where you are. Right? Left? Then it's also difficult to figure out in which direction you should rebel next time. Confusing ... (Kelly 2001: 143)

Other recent films from around the world that share the confusion and the ambition include Sweden's *Together* (*Tillsammans*, Lukas Moodysson, 2000), New Zealand's *Hopeless* (Stephen Hickey, 2000), Japan's *No One's Ark* (*Baka no hakobune*, Yamashita Nobuhiro, 2003), South Korea's *3-Iron* (*Bin-jip*, Ki-duk Kim, 2004), Spain's *Dark Blue Almost Black* (*Azuloscurocasinegro*, Daniel Sánchez Arévalo, 2006), Ireland's *Once* (John Carney, 2006) and Iran's *Slackistan* (Hammad Khan, 2009). However, it is in Germany's *The Edukators* that the ethos of *Slacker* impacts most decisively upon aesthetic form, content and filmmaking practice, as we shall see.

Following the Years of Plenty

The Austrian-born Weingartner has declared himself a huge fan of *Slacker*, having written to Linklater to tell him how much he loved the film, which led to him securing the position of production assistant on *Before Sunrise* when Linklater came to shoot it in Vienna. Weingartner also appears in *Before Sunrise* as an extra in the café scene, where he can be spotted in a blue shirt, bearded, deep in discussion with female patrons (Figure 3). Weingartner also insists that *The Edukators* 'is full of references to [*Slacker*]' (Guerrilla Warrior 2010), although these are mostly at the level of kindred ideology and its expression in a loose, hand-held aesthetic incorporating long, circling takes of the protagonists that make it clear that the camera shares their radical subjectivity. However, the film also highlights a few important differences in the socio-political context of the two filmmakers. While characters in the cinema of Linklater express resistance to corporate America through their occupation of the direct time-image's eternal present, in that of Weingartner the time-image becomes at times a node in the film's dialectical engagement with the legacies of Europe's troubled past.

The film centres upon two young men living in Berlin who adopt a bizarre form of passive-aggressive activism in order to challenge the values of contemporary society. Jan (Daniel Brühl) is a masked participant in street demonstrations who also stands up for a belittled tramp on a streetcar, perhaps

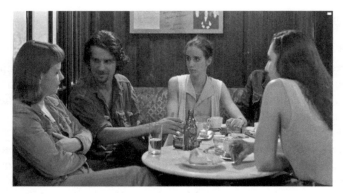

Figure 3: Hans Weingartner (second left) in the café scene in Before Sunrise.

because this itinerant wretch is all that remains of the hobo and his box car in
the corporate world of global capitalism; Peter (Stipe Erceg) is his more
restrained and opportunistic accomplice. Together they scout the terrain of the
city, re-imagining it as an arena of revolutionary thought and action, and con-
clude their nocturnal *dérives* by breaking into the homes of the wealthy and
rearranging the furniture into quasi pop-art installations – stereo in the fridge,
porcelain figurines in the toilet. This unnerves their bourgeois inhabitants,
undermining their sense of security in their own home and, by extension, the
concomitant sanctity of private property upon which this society is built. 'The
years of plenty are gone', proclaims one of the notes the self-styled Edukators
(sic) leave behind to explain the purpose of their visit, thereby providing the
film with its German-language title. Events spin out of control, however, when
Jan brings Peter's girlfriend Jule (Julia Jentsch) on a reconnaissance mission and
she persuades him to enter the luxury home of a businessman to whom she owes
€100,000 after crashing into his sedan without insurance. The fine line between
rearranging the contents of the house and trashing the place is erased, however,
and the misadventure concludes with the pair having to kidnap the owner
when he returns home unexpectedly. They call on Peter to help them figure out
what to do next and, for want of a resolution or the resolve to kill their hostage,
escape to a cabin in the Tyrolean mountains.

Weingartner's frame, like that of Linklater, is similarly fluid in motion, while
his use of a lightweight digital camera with a short-focus lens creating a shallow
depth of field allows the audience to engage directly with the revolution-minded
characters and even gives the film an occasional air of cinéma-vérité documen-
tary that recalls the aesthetics of Dogme 95. 'We live in a Capitalist dictatorship.
You stole everything you possess', spits Jan at their businessman hostage. Yet he
and Peter are not above being thrilled at a brief mention of their activities in a
newspaper, their engagement in Debord's 'Society of the Spectacle', however

tiny, indicating perhaps that their youthful zeal may be struggling to fill a hollow pose. Unlike Linklater's slackers, who just want 'to be left alone with other like-minded loners' (Stone 2013a: 68), and von Trier's idiots, who pretend to be superior to society and ultimately implode when their bluff of rebellion is blown, Weingartner's revolutionaries express an emotional response to the nostalgic mythopeia of previous generations of activists that means they see themselves as providing a new spin on a tradition of youthful revolution. Consequently, they must struggle to disregard what sell-outs their political ancestors have become when their hostage reveals himself as a former revolutionary, for this may also indicate their own future. Denying their own destiny to be, as their hostage Hardenberg (Burghart Klaußner) describes, forty-somethings who 'wake up one morning and vote conservative', the Edukators cling to a threadbare mission. *Slacker*, *The Idiots* and *The Edukators* suggest in their darkest moments that the flow of life is also an inexorable drift towards conformity, to be resisted at the risk of exclusion, insanity, incarceration or death; yet it is also in their lighter passages, when the hand-held camera floats amongst the slackers, idiots and Edukators, that the drift towards radical engagement is made possible by friendship. Perhaps, as Hardenberg suggests in his recollection of the sexual entanglements that made his previous attempt at 'revolution' fun, the community of Austin, the commune of idiots and the cell of Jan, Jule and Peter are at heart merely attempts at forming meaningful relationships in this world and, in so doing, making these bonds significant.

The approach to filming these drifting patterns of friendship by Linklater, von Trier and Weingartner partly results from the basing of their actual productions upon an organic response to the evolution of content through rehearsal, improvisation and constant rewriting. Indeed, in this respect, the example to them all was John Cassavetes, whose work had a decisive influence on independent American cinema and Linklater, on von Trier and his fellow creators of Dogme 95 for whom Cassavetes' *The Killing of a Chinese Bookie* (1976) was vital, and on Weingartner. As Weingartner claimed:

> My main inspiration is John Cassavetes, who had a style that was very near to reality in the '60s and '70s. At that time, cameras were bigger and not as light sensitive, and there was only 11 minutes of film in them. Then you had to change the film, which took a bit of effort. Everything is much easier today with digital technology. You can get closer still to reality. If Cassavetes were still alive, he would film with DV. (Weingartner 2011)

The guerrilla-style of shooting adopted by all these filmmakers certainly suits the revolutionary intent and activities of the protagonists of *The Edukators*. As the making-of feature on the DVD makes clear, Weingartner avoided a fixed schedule when filming, rethinking and refilming scenes as the narrative

developed and as the actors grew into their roles. This filmmaking process is thus influenced by and reflective of the *dérive*-inspired principle of responding to the constantly evolving creative context. Within the diegesis, moreover, as Rachel Palfreyman notes, the type of direct action that the Edukators take constitutes a Situationist response to late capitalism and a challenge to Debord's 'society of the spectacle', in which members of that society are forced into passive acceptance of an all-encompassing process of commodification (Palfreyman 2011: 173). The extent of this commodification is self-consciously 'performed' in the film when an angry Jan attempts to calm himself by breathing from an oxygen tank, suggesting that even air can be sold as a life-style product in this late-capitalist environment. Indeed, it is because commodification is now so complete, as Jule and Jan lament, that the revolutionary zeal of the 1960s, which is often symbolized in the figure of Ché Guevara, can be appropriated by the mores of the same capitalist consumer culture that it once attempted to undermine. As in *Slacker*, it is fitting that the film's protagonists ponder the potential and discourse of resistance in a reformulation of the *dérive* that peters out in direct time-images; but whereas *Slacker* is content to elide all explicit mention of Reaganomics, *The Edukators* self-consciously revisits the politics of the 1960s, when German groups such as Kommune 1 adopted Situationist tactics in their protests against the West German state (Homewood 2010: 333). Precisely because slackers cannot afford to be idle, their deliberate performance of idleness resembles a political stance; but unlike those of Linklater, who repossessed public spaces in *Slacker*, the process of reterritorialization undertaken by Weingartner's slacker characters focuses on the measured appropriation of the private sphere as Jan and Peter drift through the streets of Berlin's most exclusive neighbourhoods to select their targets for re-education. The randomness of their selection is, however, limited. They only enter houses that have a security system put in by the firm Peter used to work for and only after they have carried out extensive surveillance. Also, as Palfreyman suggests, at least before Jule gets involved, there is a decidedly non-Situationist precision to their activity inside each villa and their careful re-placing of the house contents into well-ordered sculptures, their interventions challenging the 'society of the spectacle' with a spectacle of their own (Palfreyman 2011: 178).

Most revealingly, therefore, when Jule joins the activities the approach of the group changes; specifically it is 'slackened' because her motivations are, initially at least, somewhat vaguer than those of Peter and particularly those of Jan, who is clearly driven by a moral conviction that leads him to give regular sermons to his friend on the broader ramifications of the slightest action that might undermine the political purpose of their activity as he understands it. Jule, however, once enthused, talks Jan into foregoing the planning stage and spontaneously breaking into the house of the banker who has made her life a misery by forcing her to pay compensation for the car crash. Jule's is not a random, intuitive,

chance-filled protest after all; it is revenge. Yet despite this more focused and even conventional objective, it is Jule who most thoroughly embraces the potential for instinctive enjoyment when inside the house, drinking champagne, throwing furniture into the indoor swimming pool and instigating a brief moment of intimacy with her boyfriend's fellow Edukator. In the process, she takes their performance-protest to a new level, allowing them to move beyond the group's individual acts of reterritorialization and gain a broader perspective. This is symbolized in the moment when she and Jan stand on top of Jan's building drinking, taking in the whole of the city set out beneath them and wondering aloud, 'how many people down there are thinking of a revolution?' Here is their city, its potential for transformation proven in their performative revolution. Its owners, once imprisoned by the paraphernalia of consumerism, are now liberated by the Edukators' use of all this bought-in stuff against them. This is urban planning in disarray, its fearful inhabitants subject to the vague but real threat of their Edukators' revolutionary disrespect. Unbeknown to the timorous populace, however, the group is forced to leave their urban playground because of Jule's heated blunder, which results in them kidnapping the banker and extending their *dérive* and the film beyond Berlin, first to the mountains and then, ultimately, to a remote island where they will attack Europe's main satellite television hub in order to plunge television screens across the continent into darkness, in a final declaration of war on the society of the spectacle on a scale they could never have imagined at the beginning of their revolution.

Although both *Slacker* and *The Edukators* deterritorialize notions of their respective nationhoods in order to reterritorialize the transnational spaces of America and Europe as their shared sphere of engagement, the active resolution of Weingartner's film seems to fulfill the potential that is only pondered in the open-ended *Slacker*. *The Edukators*, as Roger Cook suggests, has a far stronger sense of narrative than a film like *Slacker* and, as a consequence, it follows many of the conventions of mainstream Hollywood genre cinema (Cook 2010: 324). Weingartner even points the spectator towards the importance of Hollywood models in a number of interviews he gave on the occasion of the film's international release, particularly suggesting links to the ethos of *The Matrix* (Larry and Andy Wachowski, 1999) that are echoed in the film's dialogue (Stolz and Völker 2004). Within the context of German cinema, this can, however, itself be seen as a form of slacking, because Weingartner's appropriation of the traits of genre cinema is so far removed from the often more austere, self-consciously cerebral aesthetics of the New German Cinema and the work of those filmmakers who rode the wave of student protest in the 1960s that it may constitute a determinedly idle form of protest. And yet, even here one senses a further dimension of the *dérive*, broadly defined, within Weingartner's mode of working, for the film seems to drift across genres,

accumulating impurities that make it at the same time 'a Heimat film, a heist film, a family melodrama, a mountain film, [and] an anti-capitalist fable' (Palfreyman 2011: 169).That said, however unstable its generic affiliations might be and however impure is the final mix, within the Deleuzian economy described above in connection with Linklater's work, the plot, like those classical Hollywood genre films Deleuze discusses in *Cinema 1*, is largely driven by the movement-image in which time is subordinated to the needs of narrative development. Nonetheless, such movement-images are themselves at times disrupted and, in the process, deconstructed.

Somewhat counterintuitively, in the early scenes of the film this is not achieved by slowing things down, but by accelerating them. Weingartner's use of speeded-up film and jump cuts deliberately telescopes the emotional responses of the characters, seeming to fast-forward the narrative, albeit in a deliberately jerky and consequently jarring fashion. At the same time, and working against the deconstruction of the movement-image through ellipsis and speed, the film also evokes the time-image in its later scenes in order to further slacken the politics in the same way that this oppositional tactic, as identified by Robert Stam, appears in the American cinema typified by *Slacker* in which 'we find a slackening of narrative time' (Stam 2000: 318). This is most overt in the part of the film that plays in the Tirolean Mountains. It is at this point that the film evokes that most German of genres, the mountain film, a favoured form under the Nazis made famous in the 1930s by the likes of Leni Riefenstahl and Arnold Fanck, when the nation's spectacular countryside provided a dramatic backdrop to their melodramatic stories of rural folk negotiating a new sense of belonging in the face of modernity (Rentschler 1996: 32–8). The mountain locale in Weingartner's film provides a space for the Edukators to learn about the ghosts of Germany's activist past, and in so doing points to the problem of history that the slacker in Germany must face in a very different way to the inhabitants of Linklater's Austin or von Trier's Copenhagen; for Hardenberg claims to have been a student activist during the 1960s, a leader of the so-called 68er generation who has now become part of the establishment.

Whether Hardenberg's account of his past is accurate or a sly tactic to win over his guards, the conversation between these four temporary occupants of a mountain refuge offers a moment of reflection on the trajectory of West German political activism since the 1960s, the zeal of the younger generation, the so-called 89ers who have come of age since unification, being countered by the tired pragmatism of this 68er. Moreover, the location of this discussion in a mountain locale that recalls the films of Riefenstahl and National Socialism also gestures to earlier generational conflicts and the anger the 68ers felt towards their parents for failing to accept their culpability for the crimes of the Third Reich. Over a period of days the group seems to grow together, at times

nostalgically celebrating a past time when 'authentic' political action was possible, in the process challenging some of the apparently bourgeois values of the Edukators themselves. Tensions grow as Peter learns of the feelings that Jule and Jan have for each other, unable to imagine at this point the type of *ménage à trois* that Hardenberg insists was all part of the authentic revolutionary lifestyle back in his day. Conversely, at times the historical legacy of 1968 is challenged. It is the younger generation of so-called Edukators that must learn from the mistakes of the past, refusing to go down the path to violence that might inevitably follow from their decision to kidnap Hardenberg. Tellingly, they refuse to present him as a political prisoner to the media, as the German Red Army Faction did with the likes of Hanns-Martin Schleyer in the 1970s, with all its violent and tragic consequences. Even more revealingly, their deliberations are not resolved in any decisive manner but simply fudged in a sleepy, sun-addled and silent return to Berlin on the Autobahn, passing citizens of the city on their way to the bourgeois pleasures of similar sojourns in the mountains.

Yet, as the argument in the mountains goes back and forth across the generations, the movement-image is juxtaposed with longer takes that are potentially time-images of the verdant countryside that surrounds them, images that allow for the 'thinking-through' of their dilemma. The hand-held camera weaves amongst them in long, drifting takes, twisting to see who is speaking and framing their discussion against a timeless landscape that points to the eternal nature of their debate and the involvement of the audience as an engaged listener and learner in the presence of these Edukators. As is their wont, these prolonged takes that evoke a sense of hollow, hanging time and may thus be perceived in accordance with Deleuze's theorizing of the time-image, interrupt the incessant onward flow of the narrative, creating space for reflection. On the one hand they offer a very different concept of 'spectacle' that can exist beyond the confines of commodification within spectacular society. On the other they present a point of juxtaposition to the historical debate playing out inside and around the mountain refuge. For all the potential problems of invoking the mountain film, the timeless permanence of the mountainscapes caught in these time-images challenges the very trajectory of modernity in all the forms it presents itself within the protagonists' arguments, be it the Marxist materialism of Jan, Peter and Jule, reconfigured for the age of globalization, or the conservatism of Hardenberg and his belief in the essential selfishness of human nature and the inevitability that these youngsters too will grow out of their idealism (Figure 4). Once more, the time-image allows for the expression of the slacking and re-education of those who inhabit it, with the duration of the mountain scene seeming both to escape but also spur on the creative potential of the political project even as its legitimacy drifts away.

Figure 4: Hardenberg (Burghart Klaußner) contemplates the timeless permanence of the mountainscape in The Edukators.

Conclusion

In conclusion, we might consider the external debate about the ending of the film. As already mentioned, filming *The Edukators* was an unpredictable process, which explains why Weingartner did not manage to present a final cut of his film for its premiere at Cannes; instead he provided a makeshift ending that foreclosed on the planned final sequence which was subsequently excluded by issues of foreign rights from being included in the international release. In the cut produced for its Cannes screening, the film ends with a close-up of a note on the wall of Jan and Peter's now-abandoned flat which reads 'some people never change'. This, the audience assumes, is a reference to Hardenberg who is revealed in an insert shot to be waiting in a car outside the flat as a SWAT team storm in aiming to arrest the group. The one-time revolutionary and recent hostage, it would appear, remains a loyal member of the conservative establishment, for all his apparent mountain-top return to former political radicalism. The final image is of Jule rousing herself from sleeping between Jan and Peter and answering the door to a Spanish maid who has come to clean the room, the ensuing credits scrolling over a faint outline of a huge satellite dish. In the longer version that was released domestically, however, this sequence of the SWAT attack is followed by a shot of the Edukators examining a map of the Mediterranean island that Jan has referred to previously in the film. Subsequently, the group boards and sails off in a boat that appears to belong to Hardenberg towards the island where we can assume they intend to carry out their plan to sabotage Europe's television transmitters. The two endings generated a great deal of discussion in the blogosphere, particularly regarding their implications for Hardenberg's ultimate political position in the film (*Die fetten Jahre sind vorbei – das Ende* [Spoiler] 2006). If in the shorter version Hardenberg must be read as having betrayed the Edukators, in the longer version it is at least

ambiguous; for it appears that he is in cahoots with them, lending them his boat, and that the note in the flat stating 'some people never change' may consequently be read as a declaration of Hardenberg's continuing loyalty to the politics of his youth.Thus, despite the awkward and illogical, perhaps ironic sense of cohesion provided by Weingartner's overlay of Jeff Buckley's version of 'Hallelujah' on the penultimate scenes of the Edukators arguing and their ideology collapsing in disarray, by releasing these two versions of the film with their conflicting conclusions Weingartner delivers a deliberately loose and ambiguous open-ending that debunks the neat, narrative climax implied in the Hollywood-esque SWAT attack. Nevertheless, both versions ultimately validate the political potential of the Edukators' form of direct action and, in true slacker style, the different endings merely open up different ways of getting to this point because, like the time-image itself, they indicate alternative versions of the world on screen: one in which Hardenberg is a conformist, one in which he might not be. Nonetheless, it is always a world in which resistance is to be praised. That is to say, whether Hardenberg has changed or stayed the same makes no difference to the Edukators, who are either resolved to proceed with their campaign by the strengthening of the opposition or are justified in its righteousness by the support of this benevolent hero.

Any number of films could have drifted into this chapter. There are, for example, other antecedents of cinematic slacking such as Jean-Luc Godard's *Masculine Feminine* (*Masculin Féminin*, 1965) in which the children of Marx and Coca-Cola are all theory and no action, as well as further descendants, such as Laurent Cantet's *Time Out* (*L'Emploi du temps*, 2001) in which the redundant businessman clinging to routine is all action and no theory. Such characters are the flotsam and jetsam of an idiosyncratic cinematic history of revolutionary activism. It is one that bobs along in the drift of ideology and concomitant aesthetics that represent and express anti-capitalist thought and endeavour in films that tend to avoid narrative resolution. Instead, they subvert the hierarchy of the movement-image over the direct time-image, which expresses better than any rhetoric the weaponry of reflection, imagination and creativity in the face of conformity, consumerism and the credit-crunch. In reading *Slacker* and *The Edukators* alongside each other we see impurity expressed as the accumulation of influences in a transnational and transatlantic drift that posits a radical, alternative subjectivity to that which is propounded by bank-wary governments and propagated in corporate media, which includes the majority of mainstream cinema. As a result, new understandings of a fresh global citizenry emerge and illustrate a profoundly universal intercultural awareness based on exclusion from the fast-track capitalism that otherwise dominates and is dedicated to stifling the revolution that the hobos, slackers, *flâneurs*, idiots and Edukators of the world may yet incite. As Jan states: 'For all revolutions, one thing is clear. Even if some didn't work, the most important thing is that the best ideas survived'.

References

Bakhtin, Mikhail, M. (1984). *Rabelais and His World*, translated by Hélène Iswolsky. Bloomington: Indiana University Press.

Baudelaire, Charles (1964). *The Painter of Modern Life*. New York: Da Capo Press.

Bergson, Henri (1992). *The Creative Mind: An Introduction to Metaphysics*. Secaucus: Citadel Press.

Cook, Roger F. (2010). '*Die fetten Jahre sind vorbei*: Edukating the Post-Left Generation', in Jaimey Fisher and Brad Prager (eds), *The Collapse of the Conventional: German Film and its Politics at the Turn of the Twenty-first Century*. Detroit: Wayne State Press, pp. 309–32.

Cooke, Paul (2012). *Contemporary German Cinema*. Manchester: Manchester University Press, pp. 44–76.

Debord, Guy (1958). *Definitions. Internationale Situationniste* Nr. 1 (June 1958). Available at http://www.cddc.vt.edu/sionline/si/definitions.html (last accessed on 25 August 2012).

Deleuze, Gilles (2005a). *Cinema 1*. London/New York: Continuum Impacts.

—— (2005b). *Cinema 2*. London/New York: Continuum Impacts.

Die fetten Jahre sind vorbei – das Ende (Spoiler) (2006). Available at http://www.wer-weiss-was.de/theme95/article2645049.html (last accessed on 25 August 2012).

Guerrilla Warrior (2010). Interview with Daniel Brühl. Available at http://www.danielbruhl.com/modules.php?name=Forums&file=viewtopic&p=981 (last accessed on 25 August 2012).

Homewood, Chris (2010). 'Have the Best Ideas Stood the Test of Time? Negotiating the Legacy of 1968 in *The Edukators*', in Ingo Cornils and Sarah Waters (eds), *Memories of 1968. International Perspectives, Cultural History and Literary Imagination*, Vol. 16. Bern: Peter Lang, pp. 321–42.

Kelly, Richard (2001). *The Name of This Book Is Dogme 95*. England: Faber and Faber.

Kracauer, Siegfried (1960). *Theory of Film: The Redemption of Physical Reality*. New York: Oxford University Press.

Linklater, Richard (2004). Commentary on region 1 DVD of *It's Impossible to Learn to Plow by Reading Books*. Criterion Collection.

Palfreyman, Rachel (2011). 'Play for Today: Situationist Protests and Uncanny Encounters in Hans Weingartner's *The Edukators* (2004)', in Paul Cooke and Chris Homewood (eds), *New Directions in German Cinema*. London/New York: I.B.Tauris.

Rentschler, Eric (1996). *The Ministry of Illusion*. Cambridge: University of Harvard Press, pp. 32–8.

Sorensen, Georg (2003). *The Transformation of the State: Beyond the Myth of Retreat*. Basingstoke: Palgrave Macmillan.

Speed, Lesley (2007). 'The Possibilities of Roads Not Taken: Intellect and Utopia in the Films of Richard Linklater', *Journal of Popular Film & Television*, 35:3, pp. 98–106.

Stam, Robert (2000). *Film Theory: An Introduction*. Oxford: Blackwell Publishing.

Stevenson, Robert Louis (2009). *An Apology for Idlers*. London: Penguin. [First printed 1877, 'An Apology for Idlers' in *Cornhill Magazine*, July 1877, Vol. XXXVI, 80–6].

Stolz, Matthias and Isabel Völker (2004), 'Sind Sie in Cannes auf dem Teppich geblieben?', *Die Zeit*, 30 December.

Stone, Rob (2013a). *Walk, Don't Run: The Cinema of Richard Linklater*. London and New York: Wallflower & Columbia University Press.

——— (2013b). 'En la ciudad de Sylvia and the *durée* of a *dérive*', in María Delgado and Robin Fiddian (eds), *Spanish Cinema 1973–2010: Auteurism, Politics, Landscape and Memory*. Manchester: Manchester University Press, pp. 249–71.

Weingartner, Hans (2011). 'Interview mit Hans Weingartner: Das weisse Rauschen', digital VD. Available at http://www.digitalvd.de/interviews/Hans-Weingartner-Das-weisse-Rauschen.html (last accessed on 25 August 2012). Author's translation.

Chapter 6

Captain Swing the Fearless: A Turkish Film Adaptation of an Italian Western Comic Strip

Lee Broughton

In the classic essay 'In Defense of Mixed Cinema', André Bazin observes that when the arts are mixed they sometimes give rise to 'fruitful cross-breedings which add to the qualities derived from the parents' (2005 [1967]: 61). However, Bazin also acknowledges that the innovations brought forth by these successful cross-breedings run the risk of being completely ignored or flatly rejected by staid critics and arbiters of taste who are governed by prejudicial value judgments (2005 [1967]: 71). Dimitris Eleftheriotis suggests that some American film critics and canon creators employ similarly prejudicial value judgments when the boundaries of established Hollywood genres like the Western are blurred or manipulated by foreign filmmakers (2001: 92). Eleftheriotis asserts that, when American critics used the term Spaghetti Western to describe Westerns produced by Italian filmmakers during the 1960s, they set in place a cultural distinction centred around negative notions of 'hybridity' and 'foreignness': Italian Westerns were thus dismissed as 'impure' and 'inferior' filmic products that threatened to contaminate a pure and culturally specific Hollywood genre (2001: 92). Indeed, Christopher Frayling indicates that many contemporaneous American film critics automatically questioned the cinematic worth of Italian Westerns simply because the films and their producers had 'no "cultural roots" in American history or folklore' (1981: 121).

This line of thinking ultimately insists that only American or Hollywood-based filmmakers possess the cultural roots needed to successfully produce films

set in America's historical past and it has effectively allowed Hollywood to claim fundamental ownership of the Western genre. As a consequence, film critics have often sought to set up distinctions between Hollywood Westerns and European Westerns. As with the Italian Westerns, German, Spanish and Turkish Westerns have been routinely saddled with derogative monikers – Sauerkraut Western, Paella Western and Kebab Western respectively – that are intended to signal the films' impure nature in a wholly negative way. This 'othering' of non-American and non-Hollywood Westerns has effectively been used to justify the exclusion of European Westerns from many standard histories of the Western genre.

In keeping with Bazin's (2005 [1967]) original thoughts concerning the defence of mixed cinema, this chapter seeks to positively evaluate the intertextual and intercultural play found in Tunç Başaran's Turkish Western *Captain Swing the Fearless* (*Korkusuz Kaptan Swing*, 1971). A film adaptation of an Italian Western comic strip, *Captain Swing the Fearless* represents an engagement with the Western genre that is culturally once removed from Hollywood. As such Başaran's film might be the hybrid text *par excellence*, bringing as it does both difference and innovation to well-established genre conventions.

Bazin expressed the hope that film adaptations of classic novels would remain true to their literary sources 'because the film-maker has everything to gain from fidelity' (2005 [1967]: 65). Since the documentary *Turkish Fantastic Cinema Part 2* (Mesut Kara, 2008) indicates that *Captain Swing the Fearless'* content 'is identical to the source material', an unusually high degree of fidelity would appear to be apparent in Başaran's adaptation of the original *Captain Swing* comic strip. While some may balk at the suggestion that a comic strip like *Captain Swing* might be likened to the classic literature that Bazin cites (2005 [1967]: 64), it seems clear that Başaran's exercise in faithful adaptation resulted in one of Turkish cinema's most striking and best-loved popular films. Indeed, the actor Salih Güney reports that to this day members of the Turkish public still call him 'Kaptan Swing' (Kara 2008). But more crucially, Başaran's faithful adaptation of the original Italian comic strip results in a film that is groundbreaking in the way that it depicts American patriots as insurgent agitators and the British redcoats as cruel dominators.

Yeşilçam, Adaptation and Appropriation

Popular films produced in Turkey during the 1950s, 1960s and 1970s were referred to locally as Yeşilçam films. Ahmet Gürata reports that during the 1960s, the Turkish popular film industry was one of the largest in the world, typically producing an average of 200 films a year (2006: 242). However, relatively few of these films featured entirely original characters or subject matter.

Citing the work of Giovanni Scognamillo, Gürata observes that, of the 301 films that Turkey produced in 1972, a good 90 per cent of them were either 'remakes, adaptations or spin-offs' of some description (2006: 242). Iain Robert Smith notes that many Turkish films from this period 'self-consciously appropriated elements from US popular culture, often taking characters, plots, and music and recontextualizing them within films produced in the local industry' (2008: 3). Indeed, subtitled DVD releases have enabled English-speaking fans of cult movies and esoteric world cinema films to familiarize themselves with the unauthorized Turkish re-workings of popular American features like William Friedkin's *The Exorcist* (1973), Michael Winner's *Death Wish* (1974) and Richard Donner's *Superman* (1978) – see *Satan* (*Şeytan*, Metin Erksan, 1974), *The Executioner* (*Cellat*, Memduh Ün, 1975) and *Superman Returns* (*Süpermen dönüyor*, Kunt Tulgar, 1979) – respectively. Eleftheriotis laments that very 'little critical/theoretical work in English' has been devoted to Turkish national cinema per se (2006: 225) while observing that the scant body of academic work that has focused on Turkish popular cinema has ultimately examined what he terms to be 'profoundly impure films, genres and narrative strands' (2006: 224). 'Profoundly impure' would serve as an apt description of *Captain Swing the Fearless*' content.

Smith acknowledges that in addition to American media productions, Turkey's popular filmmakers also looked towards the Indian and Egyptian film industries for inspiration (2008: 12). Nevertheless, there is much evidence to suggest that the Turkish film industry also kept a keen eye on Italian media productions. Italian comic strips and photo novels and distinctly Italian film genres like the *giallo* thrillers all clearly asserted an influence on Turkey's popular filmmakers. The costumed super-villain adventure *Kilink in Istanbul* (*Kilink Istanbul'da*, Yilmaz Atadeniz, 1967) and the disturbing thriller *Woman Despiser* (*Kadin Düsmani*, Ilhan Engin, 1967) are good examples of Turkish films that display an Italian influence. But the influence of Italian media productions can perhaps be felt most strongly in the Western genre features that Turkish filmmakers started producing during the 1960s after Italy's homegrown Westerns proved to be extremely popular.

Vassilis Barounis has catalogued over 70 Turkish Westerns that were produced between 1964 and 1979 (2008: 25–30) and *Captain Swing the Fearless* belongs to this corpus of films. However, Başaran's film is quite distinct for a number of reasons. While most Turkish Westerns seemingly betray the obvious influence of the cinematic Italian Western, foregrounding violent anti-heroes and revenge narratives, and sometimes even featuring Italian Western characters like Django, Sartana and Ringo (Barounis 2008: 25–30), *Captain Swing the Fearless* is actually based on an Italian Western comic strip entitled *Il Comandante Mark*. Film adaptations of comic strips tend to be produced by the national

cinemas of the countries that the strips originated in – see *Batman* (Leslie Martinson, USA, 1966), *Modesty Blaise* (Joseph Losey, UK, 1966) and *Danger: Diabolik* (*Diabolik*, Mario Bava, Italy, 1968) – but Turkish popular cinema has traditionally employed a more transnational and inclusive approach. For example, T. Fikret Uçak's *The Three Mighty Men* (*3 Dev Adam*, 1973) transports the USA's Captain America and Mexico's El Santo to Istanbul in order to pit them against a villainous variant of Spiderman. Gürata indicates that 'the notion of plagiarism in Turkey was not identical with that prevalent in the West' (2006: 242) and this would seemingly account for Turkish popular cinema's repeated but unauthorized use of a number of internationally popular comic strip characters. As such, Başaran's appropriation and adaptation of an Italian comic strip like *Captain Swing* would have been accepted as standard business practice within the Turkish film industry.

'Easterns' and the American War of Independence Films

Captain Swing the Fearless is also distinguished by the fact that it is actually an 'Eastern', set in and around the state of New York sometime between 1775 and 1783, the years of the American War of Independence. Brian Garfield notes that Easterns are classed as Westerns 'despite their Eastern settings because their themes mark their genre' (1982: ix). Action narratives involving gunplay, horse riding, conflict on a wild American frontier and contact with Native Americans are some of the themes that allow Easterns to be comfortably classed as Westerns. Because of their historical timeframe and setting, these Westerns sometimes feature scenarios that relate to the American War of Independence. Westerns that loosely drew their inspiration from the literary works of James Fenimore Cooper were particularly popular during the early days of silent cinema when the nascent American film industry was actually based on the East Coast of the USA. Scott Simmon suggests that the pastoral landscapes found in these films might have had an influence on their narratives, opening up a cinematic space where Euro-American protagonists could enjoy harmonious relations with Native Americans (2003: 21–3). A similar argument can be made with regard to the German Westerns that were filmed in particularly scenic Yugoslavian locations during the 1960s. The general *mise-en-scène* that makes up *Captain Swing the Fearless*' external scenes – which feature an abundance of green woodlands and meadows and tranquil rivers – seemingly functions in a similar way since one of Captain Swing's (Salih Güney) closest friends is the Native American, Sad Owl (Süleyman Turan) (Figure 1).

However, any similarities that might be found between *Captain Swing the Fearless*' content and that of early American Westerns and Hollywood's War of

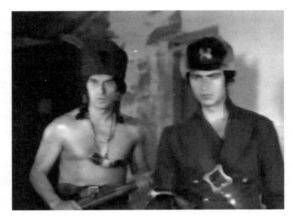

Figure 1: Sad Owl and Captain Swing (Captain Swing the Fearless).

Independence films really ends there. Kim Newman asserts that the War of Independence 'remains an oddly uncomfortable subject for American cinema' before adding that 'all the major [Hollywood] films about the period ... concentrate on fighting the Indians to the exclusion of throwing out the Brits' (1990: 4). Indeed, John Tuska notes that 'as early as D.W. Griffith's *America* (United Artists 1924), viewers learned that the British were not the real enemies during the Revolutionary war, but rather Lionel Barrymore and his band of Indian renegades' (1985: 251). John Ford's *Drums Along the Mohawk* (1939) promotes precisely the same ideology. In Ford's film two newlyweds, Gilbert and Lana Martin (Henry Fonda and Claudette Colbert) settle in the Mohawk Valley region of the state of New York and become popular members of the local farming community. When the Revolutionary War breaks out an American Tory named Caldwell (John Carradine) seeks to assist the British cause by cajoling a band of Native Americans into attacking the peaceful farmers. With no regular troops available to assist them, the patriot farmers are forced to band together and retaliate against Caldwell and his Indian charges. M. Paul Holsinger observes that *Drums Along the Mohawk* endures as 'one of America's most popular films', having enjoyed two highly successful cinema runs (in 1939 and 1947) before becoming 'a regular staple of many late-night and Sunday afternoon television broadcasts throughout the country' (1999: 26), and it remained Hollywood's quintessential American Revolution film until the appearance of Roland Emmerich's German-American co-production, *The Patriot* (2000). By comparing *Drums Along the Mohawk* and *Captain Swing the Fearless'* depictions of the Revolutionary War, it becomes clear that Başaran's Turkish film is groundbreaking in the way that it represents insurgent American patriots coming into conflict with cruel and villainous British redcoats.

Drums Along the Mohawk's Content in Context

William K. Everson suggests that John Ford possessed 'the professional Irishman's dislike of the British', which he expressed by including 'many barbed and over-drawn British stereotypes' in his films (1969: 47). If Everson's assessment of Ford is taken to be correct, the director would surely have viewed *Drums Along the Mohawk* as the perfect opportunity to represent the British as an unsympathetic enemy. However, the powers that be in Hollywood ensured that no overtly anti-British sentiments made their way into this particular John Ford production from 1939. John E. O'Connor notes that *Drums Along the Mohawk's* production was 'fraught with worries about how to portray the British as an enemy' (2003: 37) because it was feared that:

> Germany [might] read a popular film that played up the long-forgotten hatred and resentments associated with the American Revolution as a sign that the alliance between the United States and Great Britain was perhaps not so secure. This conclusion would be less likely if, as in the film, Indians and American Tories were the enemy portrayed and no British officers were shown. (2003: 37)

Ford's film is an adaptation of Walter D. Edmonds' novel *Drums Along the Mohawk* (1997 [1936]). Edward Countryman's exercise in comparing the film to the novel catalogues a number of major changes, in particular the fact that 'the link between the Tories and the British, made explicit in the novel, is weakened almost to nonexistence in the film' (1986: 92). O'Connor indicates that the film's producer, Darryl F. Zanuck, insisted that 'we must not let ourselves be bound by the contents of the book – but simply retain the *spirit* [Zanuck's emphasis] of the book' when demanding a number of script re-writes (O'Connor 2008: 47). Clearly there is a lack of fidelity at work in this adaptation.

Drums Along the Mohawk's external scenes generally promote a pastoral, Eastern-inflected *mise-en-scène*. The painterly extreme long shots that detail Gil and Lana's journey to Mohawk Valley feature rolling green fields that are sandwiched between slow-running streams and dense, leafy forests. Lana even observes that 'it's the most beautiful country' she has ever seen. The film also possesses a celebratory finale wherein a series of shots depicting a multicultural band of victorious patriots, gathered together beneath the newly hoisted Stars and Stripes flag, effectively signal the birth of a united American nation. These two elements allow – indeed demand – the presence of a friendly Native American, Blue Black (Chief John Big Tree), who appears intermittently throughout the film. Blue Black is a somewhat stereotypical representation of an Indian: he is sombre, speaks in broken English and expresses a chauvinistic attitude towards Lana. And, as Countryman notes, by the end of the film Blue

Black has been 'reduced to the level of a comic sidekick' (1986: 95). *Drums Along the Mohawk* also features stereotypical representations of unfriendly Native Americans. These Indians are generally presented in crowded long shots that show them to be a homogenous and faceless mass of savage natives who are happy to do Caldwell's bidding.

Interestingly, Ford was able to briefly include allusions to British involvement in the attack on the fort at German Flats that occurs at the film's end. Two long shots show a couple of British soldiers crouched low in a wooded area, silently watching the attack from afar. However, Caldwell dominates these shots as a figure of authority: he is perched high on his horse and it is Caldwell who is issuing orders to the Indians. Later in the battle a brief extreme long shot reveals that the Reverend Rosenkrantz (Arthur Shields) has shot a British horse soldier whose proximity and relation to the main attack by the Indians remains vague. These few shots featuring British soldiers are quite literally 'blink and you will miss them' moments. Countryman concludes that *Drums Along the Mohawk*

> belongs to a cultural stream that has helped convince Americans that their Revolution has nothing in common with those of other peoples. By de-revolutionizing the Revolution even as it reconstructs it, the film has helped rob Americans of an appreciation of their past. (1986: 89)

With Britain and the USA growing ever closer during the Cold War years, Hollywood remained reluctant to produce any overtly contentious films about the Revolutionary War. But this reluctance might also be tied to the fact that – in the years following the Revolutionary War – America herself became a capitalist imperial power and, as such, producing films with a revolution-based theme would have been politically and ideologically counterintuitive. However, the Italian comic strip creators of *Captain Swing* – Giovanni Sinchetto, Dario Guzzon and Pietro Sartoris, who together were known as the EsseGesse collective – were not hampered by such cultural and political concerns.

The Influence of Italy

Western-themed comic strips have always been popular in Italy and the EsseGesse collective had already produced a Western-themed hit with a character called *Capitan Miki* in 1951. In 1966 the collective created *Il Comandante Mark* (aka *Kaptan Swing/Captain Swing*), which was set during the American War of Independence. Commercially successful in Italy, *Captain Swing* proved to be highly popular throughout Europe too, being translated into a number of different languages including French, Turkish and Greek. Marco Gremignai

(2010) has provided a concise overview of the original comic strip's narrative: during the Seven Years' War a young French boy, Mark, is orphaned and brought up by Indians. Growing into the swashbuckling agitator Captain Swing, Mark becomes the leader of an irregular squad of insurgent patriots who are determined to drive the British out of America. Accompanying Mark on his adventures are his fiancée Betty, the hulking Mister Bluff, the pessimistic Native American Gufo Triste and Mister Bluff's dog Flok. Gremignai indicates that new stories in the series were still appearing up until the year 2000 and reprints of old stories are still being published today. In the film *Captain Swing the Fearless*, Gufo Triste and Flok are renamed Sad Owl and Puik respectively, and these names will be employed for the remainder of this chapter. Başaran's film seemingly assumes that the viewer possesses some prior knowledge of the characters and their back-stories since Captain Swing and company are already embroiled in their fight against the British at the start of the film. It is worth noting that although Sad Owl is a Native American, he receives as much screen time and as much dialogue as the film's other major characters. This aspect of Başaran's film serves to distinguish it from typical Hollywood Westerns.

Captain Swing the Fearless' score also works to distance the film from Hollywood Westerns. Few popular Turkish films from this period had an original score composed for them. Turkish film producers would instead simply employ music appropriated from earlier films. For example, Yavuz Yalinkiliç's Turkish horror film *The Dead Don't Talk* (*Ölüler konusmaz ki*, 1970) features music borrowed from Roman Polanski's *Rosemary's Baby* (USA, 1968). It is telling that the most noticeable music used in *Captain Swing the Fearless* is taken from an Italian Western. The music in question – composed by Riz Ortolani – first appeared in Tonino Valerii's Italian Western *Day of Anger* (*I giorni dell'ira*, 1967), which starred Lee Van Cleef and Giuliano Gemma. Music from *Day of Anger* plays over *Captain Swing the Fearless'* front credits as well as being used liberally throughout the film. Ortolani's music is instantly recognizable as generic Italian Western soundtrack music and, as such, its jangling electric guitar sounds and blaring trumpets provide further evidence of the influence that Italian media productions had on Turkish filmmakers during this period.

The influence of contemporaneous Italian Westerns can also be felt in *Captain Swing the Fearless'* opening scene. The film begins with a squad of red-coats tormenting the dog Puik, who is tied to a stake. The redcoats are using the dog as a live target on which to practice their rifle shooting skills and when the acting Sergeant fails to hit Puik his troops indulge in an extended bout of manic cackling and guffawing that brings to mind the behaviour of the stereotypical Mexican villains that are often found in Italian Westerns. Captain Swing and Mister Bluff (Ali Sen) are passing by and they intervene in order to rescue Puik. What follows is a reasonably well-choreographed brawl that is reminiscent of

those seen in Italian Westerns starring Terence Hill (aka Mario Girotti) and
Bud Spencer (aka Carlo Pedersoli): Captain Swing possesses the athletic agility
and speed that is associated with Hill's characters, while Mister Bluff possesses
the superhuman brute strength that is associated with Spencer's characters, and
the pair soon vanquish the redcoats (Figure 2). However, things turn nasty
when Mister Bluff is betrayed and captured by the British. The British com-
mander is determined to know who is supplying the rebels with food and weap-
ons and Mister Bluff is duly tortured on a stretching rack. Mister Bluff bravely
tries to laugh off the torture but a series of medium close-up shots reveal that he
is really in extreme pain. Similarly, medium close-up shots of the British com-
mander allow his cruel and vindictive nature to be telegraphed via his facial
expressions. Mister Bluff is subsequently imprisoned and denied food before
seemingly being executed by a military firing squad. The intolerant British com-
mander – whose harsh character and malicious actions beg comparison to the
merciless *federale* officers encountered in Italian Westerns that are set during
the Mexican Revolution – orders that his body should be buried at the entrance
of the nearest village as a warning to other rebels. For the remainder of the film
the British commander is obsessive in his desire to track down and punish
Captain Swing and his fellow rebels, while Captain Swing is equally obsessive
in his desire to discover who betrayed Mister Bluff. This leads to a number of
scenes where Captain Swing and his fellow patriots directly engage in violent
fights with the British. At the film's end, the British commander sets a patriot
doctor's house ablaze in order to force Captain Swing and his companions to
emerge from their hiding place for one final violent confrontation. As such,
these scenes that detail bitter clashes between American patriots and British
soldiers represent something of a marked progression in terms of the way that
the Revolutionary War has been depicted on the cinema screen.

Figure 2: The hulking Mister Bluff intimidates another enemy (Captain Swing the Fearless).

Violent and bitter clashes notwithstanding, it should be noted that *Captain Swing the Fearless* is not a straight action film. The original Italian comic strip featured elements of comic relief that were usually supplied by Sad Owl or Mister Bluff and similarly humorous elements were incorporated into Başaran's filmed adaptation too. In keeping with the source material, the film's comic relief interludes would appear to draw upon the tradition of the Italian *commedia dell'arte*. Interestingly, Nezih Erdoğan observes that one of Turkey's theatre traditions – the *Orta Oyunu* – was 'largely inspired by the *commedia dell'arte*' (2006a: 257). This would seemingly indicate that Turkey has long been comfortable in looking towards Italy when seeking inspiration for entertainment forms and presumably accounts for the Turkish cinemagoers' easy appreciation of the type of sometimes quite farcical humour found in Başaran's film. Mel Gordon notes that within the *commedia dell'arte*, the *lazzi* were 'comic routines … [consisting of] … any discrete, or independent, comic and repeatable activity' (1983: 5). Gordon indicates that a number of *lazzi* revolved around food and eating: in these *lazzi* continually hungry characters were involved 'in a constant search for nourishment' that often resulted in them seemingly eating more than was humanly possible (1983: 21). Humorous set pieces that incorporate this comedic theme can be found throughout *Captain Swing the Fearless*. Both the skinny Native American Sad Owl and the hulking Mister Bluff are obsessed with food and eating, and Başaran's film features a running gag about how much or how little each of the characters might or might not be eating at particular moments in time. For example, at the film's start Mister Bluff expresses concern for Sad Owl who is supposed to be fasting for three days in solitary confinement in order to mark the passing of his grandfather. However, it is revealed that Sad Owl has in fact been secretly gorging himself for three days.

Again these two gluttonous characters serve to link the film to contemporaneous Italian comedy Westerns like Enzo Barboni's *They Call Me Trinity* (*Lo chiamavano Trinita*, 1970) in which characters played by Terence Hill and Bud Spencer indulge in similarly grotesque bouts of excessive eating. Interestingly, *Captain Swing the Fearless*' efforts to fuse Italian/Turkish comedic traditions with iconography associated with the Western genre find little favour with the American film reviewer Todd Stadtman. Unimpressed by the film's comedic content, Stadtman (2009) surmises that the source material is at fault before declaring that he finds nothing humorous about seeing Sad Owl and Mister Bluff 'greedily gnaw[ing] on a turkey leg while making a funny face'. Gordon also notes that many of the *commedia dell'arte's lazzi* were highly dependent upon athletic feats that involved tumbling, diving, handsprings and the like (1983: 9). These elements are also present within *Captain Swing the Fearless*' frenetic action scenes wherein Captain Swing shows off his athletic agility. *Captain Swing the Fearless*' physically vigorous action set pieces can be likened to the similarly staged action scenes that are found in contemporaneous Italian

Westerns starring notably athletic actors like Terence Hill, Giuliano Gemma and Alberto Dell'Acqua.

Although *Captain Swing the Fearless* is a film primarily concerned with American patriots fighting British redcoats, it does feature a subplot that sees Captain Swing and Sad Owl coming into conflict with pirates who have been paid to smuggle Mister Bluff's betrayer to Europe. In terms of the generic iconography that is readily associated with traditional Hollywood Westerns, the sudden appearance of the pirates in *Captain Swing the Fearless* undoubtedly represents a quite bizarre turn of events. However, Captain Swing battled with pirates from time to time in the original Italian comic strip and the inclusion of the pirates in Başaran's adaptation is another indication of the film's fidelity to its source material. The willingness to include apparently incongruous characters like the pirates, that ultimately served to maximize the original comic strip's (and hence the Turkish film's) potential to present exciting adventures, violent conflicts and heroic acts of derring-do, can also be found in the all-encompassing approach that Italy's popular film industry employed when it was producing historical adventure films during the late 1950s and the early 1960s. For example, in Giorgio Simonelli's curious historical adventure *Robin Hood and the Pirates* (*Robin Hood e i pirati*, Italy, 1960), Robin Hood (Lex Barker) manages to befriend a band of pirates who had previously kidnapped him and they in turn assist him in defeating a nefarious rival. The presence of incongruous pirate characters in Simonelli's film has been duly noted and criticized by purists. Christopher Wagstaff uses the words 'hybrid' and 'contamination' when assessing the content of a promotional synopsis that was used to market *Robin Hood and the Pirates*. He concludes that reading the synopsis would leave those who are familiar with traditional Robin Hood films 'shocked or moved to mirth' (1992: 252). Stadtman (2009) seemingly adopts a similar stance in relation to *Captain Swing the Fearless* when he observes 'what the pirates have to do with anything, I have no idea'.

A Yeşilçam Western

While the influence of Italy's popular cinema and culture looms large at times, *Captain Swing the Fearless* is first and foremost a Yeşilçam Western. Başaran's film possesses the kind of low-budget look and conspicuously post-synched sound design that is seemingly typical of most Yeşilçam films. One distinctly Turkish cultural element found in the film is the oriental-style dance routines that Betty (Gülgün Erdem) performs. Gürata observes that Turkish melodramas 'were produced and set in the cosmopolitan city of Istanbul, and thus tended to depict a modern ... environment' (2006: 251). The same would appear to be true of most Turkish popular films that had a contemporary setting. As such, the

costumes and sets – indeed the general sense of *mise-en-scène* – found in these films possess a noticeably European/Western look and feel. However, an element of local culture sometimes makes itself felt in Yeşilçam films from the 1960s and 1970s – regardless of their genre – in the form of scenes that feature female characters performing oriental dances. These dance sequences are not like the Bollywood equivalents that serve to act as spectacles that temporarily suspend their films' narratives. Instead, the dance sequences found in Yeşilçam films tend to have logical and unforced functions within their films' narratives, be it as nightclub performances or acts of seduction and the like. In keeping with the established conventions of Yeşilçam – and Turkish cinemagoers' expectations – *Captain Swing the Fearless* features two such dance routines. The first dance takes place as part of Betty's birthday celebrations, while the second dance is performed as a sign of Betty's devotion to Captain Swing. Savaş Arslan argues that Yeşilçam's filmmakers were essentially 'Turkifying' European and American media productions at this time (2011: 110). *Captain Swing the Fearless'* oriental dances are a clear manifestation of this Turkification process in action and they serve to further distinguish Başaran's Western from its Hollywood counterparts.

In assessing Turkish popular films from this period, consideration of – and allowances for – their low budgets must be made. Erdoğan notes that in order 'to meet a demand for 200 films a year' Turkey's popular cinema industry 'had to run at great speed' (2006b: 235). Since the films' budgets were typically very small, a particularly cost-conscious method of shooting was often adhered to. Erdoğan indicates that in order 'to save time and money, shot/reverse-shot and other point-of-view shots were avoided as much as possible' (2006b: 235). This practice, which meant that multiple camera set-ups and onerous editing duties could be avoided, frequently resulted in the films' diegetic conversations being framed within single – and often awkwardly blocked – shots. In contrast to some Yeşilçam films, *Captain Swing the Fearless* is a relatively sophisticated-looking production. For example, a number of interesting shot/reverse-shot set-ups are employed during the film's opening confrontation between Captain Swing, Mister Bluff and the redcoats. Similarly, some striking high-angled shots are present during Mister Bluff's torture scene. However, the inconsistent quality of the film's production design does serve to confirm that *Captain Swing the Fearless* is a Yeşilçam film. Budget constraints resulted in many of Turkey's popular films possessing a somewhat impoverished aesthetic look that stretched as far as their costume and set designs and it is clear that some of *Captain Swing the Fearless'* costumes and sets would be found lacking if judged by the standards of a typical contemporaneous Hollywood production. While acknowledging that the main characters' costumes are particularly well realized, Stadtman (2009) describes the film's British army uniforms as being 'gloriously absurd' before adding:

> I did some fruitless searching around to see if I could determine what the inspiration for this particular interpretation of period military attire was, but, whatever the case, the end result is that these soldiers look like a cross between overgrown elves and backup dancers in a grade school production of *The Nutcracker*.

Stadtman's assessment of the uniforms is completely valid, but their design and manufacture must be understood within their proper context. Erdoğan asserts that:

> When a Hollywood film shows a box, it says 'This is a box'. Yeşilçam, on the other hand, attempted to achieve the same statement but could not help saying 'This is supposed to be a box, but actually it is only an image which represents a box'. Yeşilçam was a hybrid cinema: it produced a cinematic discourse blending Hollywood-style realism with an unintentional Brechtian alienation effect. (2006b: 235)

This is plainly the case with *Captain Swing the Fearless'* British army uniforms, though it should be noted that they are actually fairly faithfully modelled on some of the British army uniforms seen in the original Italian comic strip. Ultimately, the film's army uniforms successfully signify 'eighteenth-century British soldier' to the viewer but the viewer remains acutely aware that budget constraints have resulted in a less than successful reproduction of a historically accurate uniform. The same applies to the crude model fort that is seen in the brief establishing shot which introduces a scene set at Captain Swing's secret hideout.

The Western and Cultural Distinction

The age in which American film reviewers felt compelled to routinely 'defend the Western genre as an institution against [Sergio] Leone's illegitimate revisionism and the wider developments it typified' (McClain 2010: 53) has long since passed. Todd Stadtman specializes in reviewing obscure and unusual popular world-cinema films, while professing an interest in observing how 'the familiar gets refracted, refined and/or re-imagined through the lenses of different filmmaking cultures' (2009). Hence he cannot be likened to those critics from the 1960s who consciously sought to dismiss Italian Westerns by highlighting their cultural distinctions and hybrid natures in wholly negative ways. However, it is interesting to note that Stadtman's familiarity with American history and closeness to American culture seemingly prompts him to raise questions regarding historical accuracy and generic purity when attempting to

determine the cinematic worth of Başaran's film. For Stadtman, *Captain Swing the Fearless* 'hold[s] up a funhouse mirror to a well-tread episode of American history' resulting in a 'strange depiction of my country's forefathers' struggle for independence', and he concludes that Başaran's film 'has precious little chance of ever being shown to a high school American history class'. Inevitably this approach results in *Captain Swing the Fearless* being indirectly flagged as an impure foreign Western, produced 'so very far from home' (Stadtman 2009), which in turn leads to the film's hybrid nature being judged in a less than positive way.

Captain Swing the Fearless is a Western that is culturally once removed from Hollywood. Based on an Italian comic strip, the film was produced by Turkish filmmakers whose endeavours were both influenced by popular Italian cinema and hampered by the Yeşilçam mode of production. The ensuing sense of generic and cultural dislocation might well result in a film whose general look, ambience and political ideology is unsettling to the more purist appreciators of traditional Hollywood Westerns. Nevertheless, the transcultural context in which Başaran's film was produced undoubtedly granted its makers a license to craft a Western that featured noticeably groundbreaking content. Any attendant aesthetic quirks or technical shortcomings must be viewed in context and they should not be allowed to obscure the narrative and representational innovations that the film contributed to the Western genre.

Conclusion

In the past few decades, just two films that focus upon the Revolutionary War have loomed large: Hugh Hudson's UK–Norway co-production *Revolution* (1985) and Roland Emmerich's *The Patriot*. Newman notes that Hudson's *Revolution* 'restored the balance' lacking in earlier Westerns that detail this historic period by finally foregrounding a 'good' Americans versus 'bad' British dynamic (1990: 4), and it is fair to say that Emmerich's *The Patriot* built upon *Revolution's* example. Both films could be called hybrid Westerns in as much as they were made by non-American directors and were funded wholly (*Revolution*) or partially (*The Patriot*) by non-American investors, but their employment of recognizable Hollywood personnel has allowed them to be loosely accepted as Hollywood fare. As such, both films have received critical attention, which has acknowledged the noticeably cruel and torturous nature of the British characters that they feature. Newman describes *Revolution's* key British officer, Sergeant Major Peasy (Donald Sutherland), as being 'corrupt' and 'sadistic' (1990: 4). The actions of *The Patriot's* equivalent hate figure, the British officer Colonel Tavington (Jason Isaacs), are particularly cruel and contemptible. O'Connor describes the despicable war crimes that Tavington and his men perform as

Figure 3: *The British commander sentences Mister Bluff* (Captain Swing the Fearless).

being 'more twentieth than eighteenth century – and more Nazi than British – in spirit' (2008: 57). However, *Captain Swing the Fearless* clearly introduced an explicit 'good' Americans versus 'bad' British dynamic to the Western genre 14 years before *Revolution* and 29 years before *The Patriot* (Figure 3). This Turkish adaptation of an Italian Western comic strip is a truly hybrid text that brings together cultural and cinematic traditions and influences of a distinctly non-Hollywood nature. The result is a film about the American War of Independence that successfully brings both difference and innovation to the Western genre. As such, the film is – in its own way – surely representative of the kind of 'fruitful cross-breedings' that Bazin highlighted and subsequently sought to defend. It is perhaps not surprising that *Captain Swing the Fearless'* profoundly impure character and determinedly non-Hollywood origins have resulted in the film being excluded from standard histories of the Western genre and wider discussions about American War of Independence films.

References

Arslan, Savaş (2011). *Cinema in Turkey: A New Critical History*. New York: Oxford University Press.

Barounis, Vassilis (2008). *Onar Films: Turkish Fantastic Cinema Guide*. Athens: Onar Films.

Bazin, André (2005 [1967]). 'In defense of mixed cinema', in *What Is Cinema?* Volume 1, essays selected and translated by Hugh Gray. London: University of California Press, pp. 53–75.

Countryman, Edward (1986). 'John Ford's *Drums Along the Mohawk*: the making of an American myth', in Susan Porter Benson, Stephen Brier and Roy

Rosenzweig (eds), *Presenting the Past: Essays on History and the Public*. Philadelphia: Temple University Press, pp. 87–102.

Edmonds, Walter D. (1997). *Drums Along the Mohawk* (1st edition 1936). New York: Syracuse University Press.

Eleftheriotis, Dimitris (2001). *Popular Cinemas of Europe: Studies of Texts, Contexts and Frameworks*. London: Continuum.

—— (2006). 'Turkish national cinema', in Dimitris Eleftheriotis and Gary Needham (eds), *Asian Cinemas: A Reader & Guide*. Edinburgh: Edinburgh University Press, pp. 220–8.

Erdoğan, Nezih (2006a). 'Mute bodies, disembodied voices: notes on sound in Turkish popular cinema', in Dimitris Eleftheriotis and Gary Needham (eds), *Asian Cinemas: A Reader & Guide*. Edinburgh: Edinburgh University Press, pp. 255–70 (first published in *Screen*, 43: 3, pp. 233–49).

—— (2006b). 'Narratives of resistance: national identity and ambivalence in the Turkish melodrama between 1965 and 1975', in Dimitris Eleftheriotis and Gary Needham (eds), *Asian Cinemas: A Reader & Guide*. Edinburgh: Edinburgh University Press, pp. 229–41 (first published in *Screen*, 39:3, pp. 257–71).

Everson, William K (1969). *A Pictorial History of the Western Film*. New York: The Citadel Press.

Frayling, Christopher (1981). *Spaghetti Westerns: Cowboys and Europeans from Karl May to Sergio Leone*. London: Routledge & Paul Kegan Ltd.

Garfield, Brian (1982). *Western Films: A Complete Guide*. New York: Rawson Associates.

Gordon, Mel (1983). *Lazzi: The Comic Routines of the Commedia dell'Arte*. New York: Performing Arts Journal Publications.

Gremignai, Marco (2010). 'Il Comandante Mark', *UBC Fumetti*, translated by Derrick De Candia. Available at http://www.ubcfumetti.com/mag/comdesc_en.htm, last accessed 2 August 2012.

Gürata, Ahmet (2006). 'Translating modernity: remakes in Turkish cinema', in Dimitris Eleftheriotis and Gary Needham (eds), *Asian Cinemas: A Reader & Guide*. Edinburgh: Edinburgh University Press, pp. 242–54.

Holsinger, M. Paul (1999). 'Drums Along the Mohawk', in M. Paul Holsinger (ed.), *War and American Popular Culture: An Historical Encyclopedia*. Westport, Connecticut: Greenwood Publishing Group, pp. 25–6.

Kara, Mesut (2008). 'Turkish Fantastic Cinema Part 2', extra feature on *Korkusuz Kaptan Swing* DVD. Athens: Onar Films.

McClain, William (2010). 'Western, Go Home! Sergio Leone and the "Death of the Western" in American Film Criticism', *Journal of Film and Video*, 62: 1–2, pp. 52–66.

Newman, Kim (1990). *Wild West Movies*. London: Bloomsbury Publishing.

O'Connor, John E. (2003). 'The white man's Indian: an institutional approach', in Peter C. Rollins and John E. O'Connor (eds), *Hollywood's Indian:*

The Portrayal of the Native America in Film. Lexington: University Press of Kentucky, pp. 27–38.

———— (2008). 'The American Revolution on the screen: *Drums Along the Mohawk* and *The Patriot*', in Peter C. Rollins and John E. O'Connor (eds), *Why We Fought: America's Wars in Film and History*. Lexington: University Press of Kentucky, pp. 42–62.

Simmon, Scott (2003). *The Invention of the Western Film*. Cambridge: Cambridge University Press.

Smith, Iain Robert (2008). '"Beam me up, Ömer": transnational media flow and the cultural politics of the Turkish *Star Trek* remake', *The Velvet Light Trap*, 61, pp. 3–13.

Stadtman, Todd (2009). 'Korkusuz Kaptan Swing', *Teleport City*, available at http://teleport-city.com/wordpress/?p=3101, last accessed 2 August 2012.

Tuska, John (1985). *The American West in Film: Critical Approaches to the Western*. Westport, Connecticut: Greenwood Press.

Wagstaff, Christopher (1992). 'A forkful of westerns: industry, audiences and the Italian western', in Richard Dyer and Ginette Vincendeau (eds), *Popular European Cinema*. London: Routledge, pp. 245–61.

PART III

LITERARY IMPURITIES

Adaptation by Degree: A Study of Vittorio De Sica's *Bicycle Thieves*

Matthew Harper

Shortly after the release of Vittorio De Sica's *Bicycle Thieves* (*Ladri di biciclette*, 1948) Luigi Bartolini, the author of the novel on which the film was based, complained that the film was a gross betrayal of his work and that it was not produced according to contract (Sitney 1995: 88–89). Bartolini's disapproval of the film became a prolonged public debate between him and Cesare Zavattini, the screenwriter who adapted the novel, with occasional volleys directed at De Sica. He wrote several letters to literary journals claiming that he had been wronged and that his book had been ruined because of De Sica and Zavattini's betrayals.[1] In his anger with the film, Bartolini specifically stated that he would 'prefer that everyone say the film had nothing to do with [his] book' (Moneti 1992a: 248). Zavattini concurred in this point and in a response he wrote:

> You may sustain, on the basis of the contract, that it should be stated in the opening credits that my story has been taken from, or inspired by, Luigi Bartolini's novel, even if the readers of your novel will think after seeing the film that you and I agreed to make fun of it. In fact, in the film, there is not one image from your book, and there is not even in the *soggetto* … If I had named my *soggetto* 'They stole a bicycle' nobody would have seen any sort of relationship with your book, for the simple reason that there is none.[2] (Zavattini 1988: 126)

There are two key elements to this statement. First, the obvious: Zavattini denied that the two stories had anything in common. Second, he also denied that his *soggetto* for the film had anything to do with the book. Usually, when

this passage is translated into English the Italian word *soggetto* becomes 'scenario', which is misleading, as the scenario specifically refers to the screenplay. A *soggetto* is definitely not a screenplay. The more correct translation for the term would be a film treatment which is the de facto first step in film production. The *soggetto* is usually shopped around for funding or, in some cases, a director.[3] Though it can vary in length, purpose and detail according to the author's needs and style, the *soggetto* often provides the major elements of the plot from beginning to end and offers character descriptions. In some cases (as is evident with Zavattini's work on *Bicycle Thieves*) multiple drafts are written in order to flesh out characters or refine the plot. Sometimes the *soggetto* becomes a short story in and of itself. As an element of film production, the *soggetto* is interestingly very literary and in some ways resembles the staging of a play in that it offers a type of direction for any future collaborators and it creates a situation wherein the film becomes an adaptation and interpretation of the *soggetto* itself, thus adding another layer to the adaptation of the source material. Zavattini's assertion that neither the pre-production *soggetti*, nor the film itself had anything to do with Bartolini's novel brings into question the nature of the relationship between the different texts. Is there something to Zavattini's denial to confirm that De Sica's film indeed stood on its own, or is he simply posturing in an attempt to distance himself from Bartolini and his accusations? An analysis of all the available texts shows that while Zavattini and De Sica radically altered Bartolini's novel, eviscerating it of many of its recognizable figures, base elements still remain in the form of characters, plot structure and thematic content. These elements clearly indicate a close relationship to the original text whereby Zavattini creates an adaptation by degree, with the evolution of each text pushing it, step by step, beyond the original.

A pragmatic approach to understanding the relationships between Zavattini's *soggetti*, Bartolini's novel and De Sica's film is provided by Genette's study of hypertextuality. Genette uses the terms hypotext and hypertext to categorize texts that have a relationship which unites them. The hypotext, of course, is the earlier document and the hypertext is any document related to it that follows (Genette 1997: 4). Any cinematic adaptation would, therefore, be a hypertext to the source from which it is drawn. It also follows that the *soggetto* for any literary adaptation by default becomes a hypertext to the original novel and in turn the final cut of the film becomes a hypertext of the *soggetto*, which now functions both as a hypertext and a hypotext.

Zavattini's *soggetti*, as they are the primary loci for the transformations that took place, offer a middle ground, a negotiating space that both connects to and breaks away from the novel. They reduce the story to its bare elements, transpose it into a different historical context and then allow enough interpretive space for De Sica to augment and transpose certain themes into the film. In short, the suppression of certain elements and the addition of others create a

situation in which the film is radically different from the source, but still owes its genesis to it. The reductive nature of Zavattini's *soggetti* is clear and will be discussed first. The transposition and extension of the theme(s) found in the film is somewhat more subtle and will be discussed later. Given that three of the four texts in question are relatively obscure and virtually unknown to most, it will be helpful to summarize them.

Bartolini's Ladri

Bartolini's *Ladri di biciclette* was published in 1946. Set in the immediate aftermath of the Second World War, when Italy was still under American occupation, the autobiographical book recounts Bartolini's attempts to recover a bicycle that was stolen right in front of him. The first person narrative reads rather quickly and, as De Sica stated, is rather colorful and picaresque (Nuzzi and Iemma 1997: 129). The narrator, motivated by the injustice of the robbery, is determined to retrieve the bicycle at all costs, not because he needs it to work (he used his less attractive spare to get around and then purchased another in case he was not able to find the stolen bicycle) but because he finds pleasure in the chase. The theft of the bicycle takes place in the first pages of the novel and is carried out by a team of thieves, two to distract and one to steal. His first course of action is to go to Piazza del Monte and search for it there, because that is where everything stolen in Rome (especially bicycles) ends up. While there, he sees and vividly describes all sorts of thieves who are openly camouflaging stolen bicycles, breaking them up into parts, repainting and reassembling stolen bicycles to be sold. He has a confrontation with a shop owner who refuses to show him a suspicious bicycle and a police officer is called to resolve it. Later, he returns to the area where the theft occurred, recognizes the thief and follows him to a street named Via Panico. A confrontation takes place, other thieves come to his aid and a policeman has to break up what nearly becomes a brawl. He then goes with the policeman to denounce the thief, but *en route* the officer convinces him that given the lack of evidence an official accusation will bring more trouble than good. The novel then takes a major digression as he reflects on another bicycle that was stolen from him some ten years earlier and how he recovered it. After the digression, he debates the idea of stealing a bicycle, but decides against it when he remembers that there is a brothel in Via Panico and he knows a prostitute who used to model for him that lives there. He sets up a meeting with her and she arranges for the return of the bicycle, which costs him a small sum for her mediation and the thieves' trouble.

Bartolini's novel presents the reader with an entertaining story of how he lost his bicycle and the adventures he went through to recover it. There are comical elements to it, and Bartolini proves to be a capable narrator. However, it is

difficult to classify the work as it does not enter into any of the major literary trends of the day. Though its setting could allow it to be seen as a neorealist novel, its expressive and at times ornate language prevents it from comfortably taking a place in that movement. The digressions and autobiographical nature of the novel locate it in a realm where diary or memoir come to mind, though it is unlikely that it was ever intended as such. Like Bartolini's other novels, *Ladri di biciclette* was not a great success, neither critically nor commercially. After its initial run had sold, the editor had no intention of producing a second printing. It won no awards, nor was it nominated for any. It is very likely that had De Sica and Zavattini not purchased the film rights to the book, it would have faded into obscurity.

Zavattini's First *Soggetto*

Zavattini first contacted Bartolini some time during the spring of 1947. As Bartolini recalls:

> Zavattini, one fine morning, called me and said that he had stayed up all night, taken by the pleasure of reading my 'wonderful' book, then he suggested that I send a copy of it to De Sica who also seemed to be taken intensely by the pleasure of reading, to the point that within a few days he offered to purchase the film rights. (Nuzzi and Iemma 1997: 128)

Subsequently in July of that same year, Bartolini sold the rights to Zavattini and De Sica for 100,000 lira. According to the contract, the two were free to use the story as they saw fit but were obligated to use the same title in the Italian release of the film.[4]

Upon the acquisition of the rights, Zavattini wrote an initial *soggetto* for De Sica.[5] This first *soggetto* alters the main protagonist from an artist with elevated tastes and ample resources, both temporal and financial, to a simple working man, a bill poster who lives in San Basilio, a suburb of Rome found at the extreme north-western edge of the city. The story begins with investigative reporters interviewing Antonio, a seemingly apolitical worker, about living conditions in his neighbourhood. As they leave they promise to publish the story. The theft of the bicycle occurs while Antonio is on a ladder hanging a poster. A brief chase ensues but ends in chaos with the whereabouts of the thief and bicycle unknown. Afterward, a policeman accompanies Antonio to the local station, where it is made clear that because of other, more serious crimes he will not receive any direct aid from them. Antonio returns home by bus, and tells his wife and son (Ciro) of the theft. Others suggest he go look in Piazza Vittorio or Porta Portese, and so he rises early the next morning with his son, who knows the bicycle better than anyone, to go and look for it. While searching

in Piazza Vittorio, a vendor yells at Ciro for handling some bicycle parts. He meets a paedophile who frightens him and then he runs to find his father. Antonio searches for the paedophile, finds him and accuses him of trying to seduce his son but others defend the paedophile saying he was only trying to console Ciro, who was crying. Frustrated, Antonio and Ciro leave for Porta Portese to purchase a replacement bicycle; this proves to be impossible, given their economic situation. Hearing their story, someone advises him to go to a woman who is in spiritual contact with Padre Pio and can likely help him. They go to the psychic, who tells Antonio that he will find the bicycle, but he must pray and have faith. Upset at each other and their situation, they go to a tavern to eat. Antonio buys some wine for Ciro and calculates their meager finances for the rest of the month, only to realize they will be short. They start looking in different bicycle shops and by chance Antonio sees the thief in Via Panico. They follow him but he ducks into a brothel to avoid them. One of the prostitutes is moved by their situation and tells them that she will get the bicycle back. They then follow her to a nearby warehouse, which is where the bicycle should be but it is not there. Dismayed, they return home. On the bus, a passenger complains loudly that Ciro's shoes soiled his slacks. Ciro begins to cry and, in the final images of the film, Antonio takes Ciro in his arms, gets off the bus and walks towards their apartment building. Ciro continues to cry and the disgruntled passenger yells after them.

The most radical changes take place in this first *soggetto* and it is here that a discussion of reduction and transposition must begin. Bartolini's artist/narrator becomes Antonio, an apolitical poster hanger, from whom a bicycle is stolen and, unless it is found, he will be forced to spend extra money on bus fares to get to and from the city. Antonio also has a son who helps him look for the bicycle, which may seem like a radical addition, however Bartolini's narrator has a daughter and refers to her on several occasions throughout the novel. Bartolini's Luciana becomes a reason to continue the search, nonetheless she is never present in the novel. It appears that the inclusion of Ciro in Zavattini's transposition of the novel is an amplification of the original character's role which functions as a means to give the theme of familial solidarity a more prominent place in the film.

The addition of the reporters at the beginning of the *soggetto* also presents an interesting transformation of the story. Their inclusion hints at the direction Zavattini desired for his cinema where facts would be discovered and reported, and in fact this *soggetto*, with its concise nature, reads very much like a newspaper article. It is very brief, succinct and primarily factual. Little time is spent on character development.

Many plot elements, characters and locations are eliminated in Zavattini's first *soggetto*. Zavattini's version is, by nature of its brevity, much more linear than Bartolini's as it eliminates the abundant digressions found in the original. Part of this linearity is inherent to the nature of the *soggetto* as practised by

Zavattini, which is fundamentally a summary or outline of the story and action. Perhaps the better term is a condensation. The *soggetto* abridges the novel, thereby creating a new text that stands on its own and is less directly related to its source material. It creates a type of independent synthesis of elements found in the source material and new elements created by Zavattini.

This concept of condensation as a means of reduction is evident in the first *soggetto*, which is the one most similar to Bartolini's novel. The most noticeable carry-overs from the novel to the *soggetti* are found in the encounters with the police, tracking the bicycle to Via Panico and the ensuing confrontation with the thief; and the prostitute as an intermediary between the victim and the thieves. Zavattini condenses the action of the novel by simplifying it to essentially two characters and their search for the bicycle. The condensation of the novel's action acts as a commentary to the original in that it highlights elements and details which are found in the original (descriptions of everyday life and situations, and references to the marginalized classes of society; thieves, prostitutes and the poor), thereby giving them a greater role in the narrative. Zavattini places a higher value on those aspects of Bartolini's story, which are more aligned with his positions on representing reality. He reduces the narrative to its essence by suppressing (eliminating) those details that detract from the everyday. Thus, the realistic elements which are present in Bartolini's novel, but not prominent or essential to its meaning, take centre stage in Zavattini's *soggetti*.

The *soggetto* also performs a function of proximization, which is to say that it updates the drama and the action in contemporary terms, thus bringing it closer to what the audience knows and experiences every day. Even though the gap between the publication of the book and the release of the film was only four years, a great deal had changed in Italy during that time. Bartolini's novel depicts a recently liberated Rome, still under the control of the Allies. He narrates in terms that are specific to a different time and its spirit. The pressing issues of 1946, though still not far away, were largely irrelevant to the everyday reality of the new protagonist, Antonio. The proximization is also in line with the direction that Zavattini wanted to push cinema, that is, to chronicle contemporary events and to show contemporary reality in the hope that the knowledge gained by spectators would spark a change in their actions and the way they related with their surroundings.[6] As compelling and moving as a story set in a specific historical moment could be, the temporal distance from the audience lessens any potential impact it could have on the present day.

Zavattini's Second *Soggetto*

The second and definitive *soggetto* was completed in April 1948, around the same time that the script was completed. It begins with a discussion of the value

of reporting everyday facts that replaces the scene with the reporters interviewing Antonio. A description of Antonio, who has recently taken a job as a poster hanger, follows. He and his wife live in Val Melaina with their son, Bruno. Antonio's wife had to hock her sheets in order to get his bicycle out of hock so her husband could work. He belongs to a leftist party but out of fairness he hangs posters for right-wing political parties as well. The family no longer lives in San Basilio but in Val Melaina, a fascist housing complex that was never finished. The previously anonymous voices of advice take the form of Antonio's friend, Baiocco, the sanitation worker who helps organize a search party to find the bicycle. From this point on the *soggetto* follows in its pertinent details the final version of the film, yet it is not identical, as some details from the first *soggetto* are omitted from the second but later find a place in the film. There is no paedophile in this version. There is also no mention of entering the brothel, and the final encounter with the thief has no specific location; this is the only version not to specify those details. The ending to the second *soggetto* is closer to the film's ending, in that Antonio unsuccessfully attempts to steal a bicycle, but it is also reminiscent of the first *soggetto* as father and son take a bus and, while they ride home, Bruno falls asleep on Antonio's shoulder as two passengers argue in the background.

One of the first notable changes in the second *soggetto* is the relocation of the family's home from San Basilio to Val Melaina, which adds layers to the story. Val Melaina is much farther from Rome than San Basilio. At the time it was literally in the countryside with miles of open fields between it and the city walls. The commute, without a personal means of transportation, was both very expensive and very time-consuming. Additionally, the housing complex was built by the Fascist regime, but left uncompleted. The subtle jab at the political predecessors who were unable to provide for the needs of the people and the implicit relationship to the current government's impotence becomes an important sub-theme throughout the film.

The second *soggetto* also presents a highly politicized Antonio who is deeply committed to the left but still hangs political posters for rival parties, when his job requires it. This is the only indication of Antonio's political affiliation in any of Zavattini's versions of the story. Bartolini discusses politics and at times harangues the government for its inefficiency and its willingness to employ reformed fascists, but he does not specify his position as being either left or right, only anti-fascist. De Sica's Antonio appears aloof and uninterested in politics, as is demonstrated by the scene in the neighbourhood club house where he is looking for Baiocco, and the first *soggetto* does not mention politics at all. Perhaps the reason for adding the details of Antonio's political affiliation and then later removing them in the film is found in the political climate during the spring of 1948.

The *soggetto* and screenplay were written during this politically-charged run-up to the general election. The Communists and Christian Democrats were

the prime contenders in a hotly contested battle for the government. Zavattini was a member of the Communist Party and as such wished to subtly promote his political ideals, hence the inclusion of party politics in the *soggetto*. De Sica was not politically active or vocal about politics. He was against placing references, even subtle ones, to political parties in the film. Sergio Leone, who was an assistant to De Sica (and also an extra in the film) recalls a story of being present in one of the writing sessions for the screenplay, during which Zavattini suggested that Antonio be shown with a copy of the Italian Communist Party's newspaper, *L'Unità*, in his hand as he leaves his house for his first morning of work:

> After a moment, Amidei[7] exploded with a 'God Dammit! What in the hell does *Unità* have to do with it! If anything, 'tà' only! There was a long pause of stubborn silence and then De Sica said, 'My good friends, I think there should be an apple, a red apple, one of those colourful, half red and half green ones, and as he leaves the house, he bites into this apple!' (Caldiron and De Sica 1997: 22)

Needless to say, Amidei quit working on the script shortly thereafter. The script was completed on 20 April 1948; two days later, the Christian Democrats soundly defeated the Communists in the general election. Zavattini did not get his way with the newspaper heading in the shot. Antonio and Bruno left the house that morning with *frittate* wrapped in nondescript paper.

Other differences from the first *soggetto* include more details regarding the theft of the bicycle. Two accomplices aid the thief in getting away, just as Bartolini wrote it. We find the addition of Baiocco, Antonio's friend who advises him in the initial search for the bicycle. The encounter with the paedophile, which takes significant room in the first *soggetto* and has a subtle role in the film, is omitted from the second *soggetto*. The psychic is presented as 'La Santona' and, despite her saintly name and appearance, is specifically referred to as a fraud by Zavattini. Additionally, Antonio and Bruno do not attempt to purchase a replacement bicycle, and there is no prostitute to mediate the return of the bicycle; instead, Antonio enters the brothel to apprehend the thief. The scene where Antonio strikes Bruno, they separate temporarily and Antonio fears Bruno has drowned is added and finally, instead of searching in vain and returning home without a bicycle, Antonio attempts to steal one, fails miserably, only to have Bruno witness the whole event.

One final, notable omission in the second *soggetto* is the investigative reporters interviewing Antonio, which is replaced by Zavattini's brief statement regarding the necessity to chronicle everyday facts about common people. If the first *soggetto* hinted at Zavattini's budding theories on cinema, then this is certainly the beginning of a formal development of them. It brings to mind Pierre Leprohon's observation that one of the lasting imprints of De Sica and Zavattini's

films was that they transformed the neorealist movement's focus from realistic narratives about the Resistance to one where everyday facts and stories of contemporary society assumed a privileged position in its discourse (Leprohon 1966: 37).

Thematic Transpositions

Another way of interpreting the relationship between Bartolini's novel and De Sica and Zavattini's texts is found in considering their respective themes. A thematic transposition is essentially a deliberate act of transformation where a change to the intended meaning is an explicit purpose of the transposition (Genette 1997: 214). An extension is an augmentation by massive addition that keeps within the stylistic boundaries already set. It extends the action and adds details that were previously not part of the hypotext (Genette 1997: 254). De Sica and Zavattini's versions of *Ladri* accomplish both of these functions by transforming the metaphorical significance of the bicycle (thematic transposition) and retaining some diaristic elements from the novel and extending their significance, both structurally and thematically.

Bartolini's novel is remarkably accurate in its vivid portrayal of Rome in the aftermath of the Second World War and its accompanying corruption, vice and crime. Through all of its digressions multiple commentaries crop up regarding prostitution, the hypocrisy of fascists turned republicans, the corruption of the police department and its complicity in perpetuating the social malaise carried over from the Fascist era. One could be confused as to whether or not a clear theme exists as the multiplicity of discourses obfuscates the overarching theme, to which Bartolini hints early on in an explicit reference to the bicycle and its importance:

> [A] poet, like me, has a true need for a bicycle, just as one needs bread. If bread is used to simply appease one's hunger, the bike is, for him, like a different type of bread: the bread of spiritual good; that spiritual good that I already know and can only be reached after you are away from the city, at least a dozen miles beyond the outskirts of the suburbs.[8] (Bartolini 1996: 33)

Although the value Bartolini assigns to the bicycle may seem somewhat superfluous and rather bourgeois in light of the apparent misery and hardship in which most of his fellow citizens find themselves, Bartolini's comparison of the bicycle with a spiritual good that is necessary for his wellbeing suggests that the search for it and ultimately its recovery will mean more than just having a bicycle for occasional pleasure rides out to the countryside. The metaphor, one

that Zavattini would appropriate, is the symbolic nature of the search, which Bartolini better explains in the final paragraphs of the book:

> I was so angry at myself for the importance I had attributed to finding (or rather redeeming) a bicycle, but I repeat that there is no subtler pleasure than that of finding something that was stolen or lost ... It is not a question of living to regain what was lost. You can find it once, twice, three times, like me, twice I managed to find the bike again. But the third time will come and I will find nothing. So it is, I repeat, for our entire existence; a constant running against the current, only to finally lose or die. A constant running against the current since childhood! ... We search for too many things before we die. And I will search for a friendly face and will only find that of Luciana [his daughter], if I ever find it: which would be, for my final agony, dying with the sun before my eyes.[9] (Bartolini 1996: 194)

Bartolini sees the search for the bicycle as the most important aspect of the story. It eclipses all other aspects of the narrative and gives a deeper purpose to the work, a reason for narrating such a banal, unimportant event. The search serves as a metaphor for life; an eternal search for that which is lost, be it the love of a mother, a child or a father, or the sense of community and belonging that one had at a certain point. At times the search turns out well, but other times it proves fruitless. Perhaps finding what was lost is not as important as the search itself.

The importance of the bicycle and the search for it is carried over into its cinematic counterpart as well, but with a different emphasis. Many critics have debated possible meanings and interpretations of the bicycle. Generally, the bicycle's value is intrinsically linked to the critic's interpretation of the film. For Millicent Marcus the bicycle is 'the emblem of all those cultural and material forces that determine the relationship [between father and son] from without' (Marcus 1986: 59). The bicycle is representative of patriarchal power and Antonio's ability to provide for his family. De Sica reiterates this by showing two scenes where Antonio carries first his wife and then his son on the handlebars. The bicycle allows Antonio to claim a traditional role in society, that of patriarch. It gives him purpose, community and identity. The search for the bicycle is a search for Antonio's self-worth.

In a similar vein of interpretation, Mark West offers some insightful thoughts about the bicycle and its meaning:

> The inflated importance of regaining the bicycle is a kind of inner reflection, projected from the deeps of Antonio's psyche, of an indeterminable fragment splintered off from the rest of his being, and striving to become

conscious. In this sense the bicycle becomes everything to Antonio, though it is nothing in itself ... Antonio's bicycle is valuable to him only because it promises to replace his feelings of despair and futility with a sense of purpose and meaning. (West 2000: 141)

The bicycle offers a chance to find fulfillment and function within normal, traditional societal roles.

Another possible interpretation of the bicycle's metaphorical meaning could be found in the name brand of the bicycle, Fides or faith. The search for it could be symbolic of modern man's loss of faith and search for it. In the context provided by the film, faith must be understood not in a religious but in a secular sense. The Latin word *fides* does not necessarily have the religious connotation that its modern derivatives 'faith' or '*fede*' have. The term 'losing faith', in this sense, does not exclusively, or even overtly, mean that the protagonist has lost any religious belief he may (or may not) have had prior to our meeting with him in the film. Judging by his remarks about his wife's 'little saints' and the prayers she offers to them, it would seem that he did not have much religious faith to begin with and therefore it would be more correct to say that Antonio has lost faith, trust or confidence in society and the institutions that are an inherent part of it. This is evident throughout the film. After Antonio gets the bicycle out of the pawn shop, his spirits are lifted, he has regained faith in the world. Government institutions have found him a job, he can plan to have dreams, to live again. As West notes, the bicycle does give his life meaning (West 2000: 146). He is able (albeit temporarily) to participate as a useful member of society. Without the bicycle he is worthless and his life has little purpose. Hence the urgency to find and regain the bicycle, for a life without faith, be it secular or religious, is a life without hope.

The abundance of available interpretations and meanings causes one to ask not what the bicycle represents, but what it can represent. In each of the interpretations provided, the recovery of the bicycle (or potential recovery) provides for a return to the fellowship and community that society offers. De Sica has said that all of his films are about the search for human solidarity but that solidarity is eternally fleeting because of mankind's egoism and lack of communication (Samuels 1972: 149–50). In Bartolini's novel, the protagonist is successful, not only in recovering the bicycle, but in finding solidarity as well, as the novel ends with him basking in his thoughts of his daughter's love. We could say that because he found the one he was able to find the other. Antonio, however, is unable to recover the bicycle and only experiences solidarity in fleeting moments throughout the film. Bartolini's successful search leads to the recovery of the bicycle and an implied return to solidarity. Antonio's failed search emphasizes the need for solidarity and the difficulty of finding it.

The progression from *Ladri di biciclette* the novel to *Ladri di biciclette* the film presents a complex relationship between the various texts. The film is not a

direct transformation of any single hypotext. Though it copies most closely the action of the final *soggetto*, certain elements from the original *soggetto* and the original novel are included as well, thus necessitating their inclusion as hypotexts. The film is not entirely faithful to any of its hypotexts. As has been demonstrated, the film has multiple hypertextual relationships with its various hypotexts. The *soggetti*, acting as both hypotexts and hypertexts, create a space of mediation between Bartolini's novel and De Sica's film. They bridge the gap between the two, allowing us to see the process by which Zavattini transposed, extended and condensed the original source material. Thus, it is essential to analyse *Ladri di biciclette* the film not as one text but as four. The *soggetti* stand alone as individual texts, but when viewed together they allow greater insight into what elements were privileged in the transformation of Bartolini's original work from a picaresque novel that only hints at deeper philosophical elements relative to humanity into the transcendent cinematic narration of modern man's search for solidarity. The film becomes a palimpsest to the source material, showing that it is always the culmination of its hypotexts and can be seen as a rearrangement or a reprioritization of them, but never a complete abandonment of them. Just as medieval scribes would scrape off the old text in order to reuse the vellum, but were unable to erase everything from the original, Zavattini and De Sica's adaptation of *Ladri di biclette* radically alters the original, but cannot claim independence from it as easily as Zavattini would have liked to believe. The faint impression of Bartolini's novel remains.

Notes

1 For a sample and discussion of the letters written by both sides, see Guglielmo Moneti's 'Ladri di biciclette' (1992a). Zavattini wrote several letters in response to Bartolini, all of which are available in *Una, cento, mille lettere* (1988).
2 All translations mine unless otherwise noted.
3 Many film and trade journals during that time, including *Cinema nuovo*, *Bianconero*, *Filmcritica* and *La rivista del cinema*, regularly published *soggetti* that screenwriters were interested in selling or that the editors of the journal felt would be provocative.
4 A legible facsimile of the original contract can be seen in Gordon (2008: 24).
5 Both *soggetti* can be found in Caldiron and De Sica (1997).
6 For a discussion on Zavattini's thoughts on the role of cinema in society, particularly with regard to what should be filmed and how, see Renato Barilli's entry on 'Evento' (78–85), Mino Argentieri's entries on 'Inchiesta' (104–7) and 'Neorealismo' (161–8) and Maurizio Grande's entry on 'Personaggio' (189–96) in Guglielmo (1992b).
7 The screenwriter Sergio Amidei worked with Zavattini and De Sica on the adaptation of *Bicycle Thieves*, but left the project at an early stage.
8 '.... *un poeta come me: che ha giustamente bisogno della bicicletta, come del pane. Se il pane gli serve per sfamarsi alla buona, la bicicletta rappresenta, per lui, come un altro*

pane: il pane del bene spirituale. Di quel bene spirituale che già conosco e che si raggiunge soltanto dopo che s'è lontani dalla città, almeno una dozzina di chilometri, oltre la periferia del suburbio.'

9 *'Ce n'era perfino tanta da sdegnarmi, con me stesso, per l'importanza da me attribuita al ritrovamento (anzi, al riscatto) d'una bicicletta: ma ripeto che non v'è gusto più sottile di quello del ritrovamento d'una cosa rubataci o smarrita . . . Non si tratta, vivendo che di ritrovare il perduto. Lo si può ritrovare una, due volte, tre, come io, per due volte, sono riuscito a ritrovare la bicicletta. Ma verrà la terza volta e ritroverò più nulla. Così è ripeto, di tutta l'esistenza. È un correre a ritroso, per finalmente perdere o morire. Un correre a ritroso fin dall'infanzia! . . . Si cercan fin troppe cose prima di morire. Ed io cercherò un volto amico e troverò soltanto quello di Luciana, se lo troverò: ché sarebbe, per i miei ultimi dolori, già un morire con il sole davanti agli occhi.'*

References

Bartolini, Luigi (1996). *Ladri di biciclette*. Milan: Mondadori.

Caldiron, Orio and Manuel De Sica (eds) (1997). *Ladri di Biciclette di Vittorio De Sica: Testimonianze, Interventi, Sopralluoghi*. Rome: Pantheon.

Genette, Gérard (1997). *Palimpsests: Literature in the Second Degree*, translated by Channa Newman and Claude Doubinsky. Lincoln: University of Nebraska Press.

Gordon, Robert (2008). *Bicycle Thieves (Ladri di biciclette)*. New York: BFI/ Palgrave Macmillan.

Leprohon, Pierre (1966). *Vittorio De Sica*. Paris: Seghers.

Marcus, Millicent Joy (1986). *Italian Film in the Light of Neorealism*. Princeton, NJ: Princeton University Press.

Moneti, Guglielmo (1992a). 'Ladri di biciclette', in Lino Micciché (ed.), *De Sica: autore, regista, attore*. Venice: Marsilio, pp. 247–75.

——— (ed.) (1992b). *Lessico zavattiniano: parole e idee su cinema e dintorni*. Venice: Marsilio.

Nuzzi, Paolo and Ottavio Iemma (eds) (1997). *De Sica & Zavattini: parliamo tanto di noi*. Rome: Riuniti.

Samuels, Charles (1972). *Encountering Directors*. New York: Putnam.

Sitney, P. Adams (1995). *Vital Crises in Italian Cinema: Iconography, Stylistics, Politics*. Austin: University of Texas Press.

West, Mark (2000). 'Holding Hands with a Bicycle Thief', in Howard Curle and Stephen Snyder (eds), *Vittorio De Sica: Contemporary Perspectives*. Toronto: University of Toronto Press, pp. 137–59.

Zavattini, Cesare (1988). *Una, cento, mille lettere*, edited by Silvana Cirillo. Milan: Bompiani.

The Supernatural from Page to Screen: Ambrose Bierce's and Robert Enrico's *An Occurrence at Owl Creek Bridge*[1]

Germán Gil-Curiel

I will only confess to you quite openly that, as I believe, all the horror and terror of which you speak has only occurred in your mind, and the external world of reality has had little share in it.

(E. T. A. Hoffmann 1993 [1816]: 52–3)

The relationship between film and literature – particularly the short story and, of course, the novel – is so close that it would be possible to argue that, from the moment that film turned narrative, literature came to live in it. Indeed, literature provided, on the one hand, the first framework within which film made sense, as storytelling in film was understood as an extension of literary narration. Woodrow Wilson allegedly said of *The Birth of a Nation* (D.W. Griffith, 1915) that it was 'history writ with lightning' (Lavender 2001), focusing on the realism of the medium and exalting the didactic possibilities of film.

But, on the other hand, the written word soon came to be construed not as complementary to the image, but as its very opposite. At the time that cinema was invented, literature was conceived as a means for the expression of the individual and the inner self, whereas cinema, as regards its partly industrial origins, came to be regarded as expressing a collective, social view, and crucially as being closely bound to the representation of reality, given its indexical and iconic nature. What François Brunet has said of photography is also applicable to cinema: ' ... it seemed to run counter to a literary enterprise that defined itself, at least partly, as the expansion of an individual imagination particularly

drawn to invisible truths' (Brunet 2009: 11). As put by Nobel Laureate Gabriel García Márquez when discussing adaptations of his literary works into films: 'the problem with cinema is that ... it is a mass creative process ... the writer is merely one cog in the huge machinery' (Taylor 2010: 162).[2] Although digital filmmaking has rendered obsolete the idea that film is bound to represent reality, and much digital video is now shot for the celebration of the individual, for most of the twentieth century the opposition between literature and cinema continued, with a general view of literature as the superior art and higher form of culture, and of film as an inferior, commercial and generally derivative, if not parasitic, form. In particular, the piece of literature on which a film was based came to be regarded as the 'original', and consequently as the standard whereby film was to be judged, a good film being the one that most faithfully followed its literary source. It was not until the 1990s that '... the fidelity imperative emerged as the arch-villain of adaptation studies, both because of its association with right-wing politics ... and because of its subjective impressionism' (Elliott 2003: 129). It was also around this time that Robert Stam's and others' questioning of originality and the role of the author, the basis of Mikhail Bakhtin's notions of dialogic exchange and the tenets of postmodernity more generally, allowed for the conceptualization of both a film based on a literary work and the literary work itself as of equal standing (Stam 1992).

One of the most important critics who have attempted to gain a better, nuanced understanding of the differences between these two modes of storytelling – namely, telling and showing (Hutcheon 2006) – is Karl Kroeber. In this chapter I test out Kroeber's views, outlined below, by contrasting and comparing the short story 'An Occurrence at Owl Creek Bridge' by Ambrose Bierce (1891) and an adaptation of it, the short film *An Occurrence at Owl Creek Bridge* (*La Rivière du hibou*) written and directed by Robert Enrico in 1962, with music by Henri Lanoë.

The Literary and the Cinematic Experience

In his *Make Believe in Film and Fiction*, Kroeber (2006) argues that literature is better suited for conveying interiority and subjectivity, and the film for external action. He contends that the cinematic and the literary oppose each other in such a way that they bring about diametrically different aesthetic experiences of subjectivity and consciousness, as well as contrasting perceptions of reality outside oneself. His main thesis has to do with the categories of space, time and perception, both in film and literature.

In film, according to Kroeber, space is all about distance. Reminiscent of Lacanian theories of the formation of the self through the 'mirror stage', distance, Kroeber contends, implies a spatial separation between the subject and the object, so cinema is a visual experience that takes place 'outside', suggesting

a radical distinction between the image on the screen and the viewer's mind: 'We literally cannot see anything except at some distance, and to see something is to recognize its separateness from us' (2006: 6). As regards time, film, he claims, is all about the present and the immediate, bringing one into direct and instantaneous involvement with the world depicted in its perpetual going forward, until the end of the film. He asserts sight is immediate, whereas language requires time. As for visual perception, Kroeber attributes to cinema, which he predominantly conceives of as an act of seeing, the capacity of getting the distinctive expansion and intensification of movements – for instance, thanks to the close-up – which the expression *larger than life*, often used to describe film images, accurately captures.

By contrast, Kroeber argues that the experience of reading takes place 'inside': 'We read for the meaning, not the perceptible actuality of the words on the page, and that meaning takes form entirely within our mind' (2006: 6). As for the perception of time in literature, written language needs more time to be apprehended, as opposed to the supposed immediacy of the visual mentioned above. And because the experience of reading is individual, it remains unaffected by the restraint of temporal sequences, allowing the narrator to create even timeless oneiric realities.[3] As regards perception, Kroeber evokes Mikhail Bakhtin's argument that as all words we share carry 'traces of earlier uses', there are in effect no 'original' words. The use of the same words throughout time entails what he defines as 'historical contaminations', which allows the language to continuously re-evaluate itself. He thus describes verbal storytelling language as ' . . . especially suited for subtle stimulation of changes in self-awareness' (Kroeber 2006: 7).

In sum, despite its high regard for literature on the basis of its ability to give, as it were, free reign to subjectivity, this perspective nonetheless holds that it is film that is better equipped to depict action, going beyond what painting could do before to suggest movement and to convey, in particular, the instant, and thus the aesthetic of modernity as the fleeting moment, in a more flexible, more fluid way than drama. This would seem to somehow echo the views that some filmmakers, especially those also devoted to writing theory, have had of cinema ' . . . as the art among arts, or at least as the most representative art of the century: better endowed than literature to transmit action, overcoming pictorial aporia as regards movement and the instant, and being more flexible and fluid than drama' (Aumont 2011: 153).[4]

Throughout my analysis of the short story and the film *An Occurrence at Owl Creek Bridge*, I focus on the different ways that the literary and cinematographic stories construct a psychic-supernatural reality, involving two planes of reality: what is 'objectively' happening, and the subjective reality of the main character, a reality that the audience is also able to share. I argue that, in a sense, and in line with arguments on the literary origins of cinema (Elliott 2003), the film

can be understood as embodying the aesthetics of the nineteenth-century supernatural literature that it draws from, concerned as it is with death – and with its rendition as a beautiful, beloved woman. It also seems to make the most of the magnification of movement and images in order to convey its narrative, seemingly providing evidence for Kroeber's view – although I argue here that so does literature, by different means. And in another sense, the film also crafts a supernatural world that violates all co-ordinates of time and space in the manner Kroeber ascribed to literature, with exclusively cinematic means. I conclude that while literature and cinema are certainly 'sisters' and complementary arts – rather than rivals – in the end the crucial role is that of the reader and/or the viewer, who authors his or her own story from the words or images afforded, as perception is in both cases highly subjective. In other words, cinema and literature, far from being two thoroughly differentiated aesthetic means of apprehending reality, constitute immersing experiences that impel viewers or readers to lose themselves within a rare event that takes place in their psychic dimension, just as in the incident of Peyton Farquhar, the main character in the story and film I am concerned with and to which we now turn.

Subverting Time in Literature and Film

'An Occurrence at Owl Creek Bridge' can be read as a metaphor of the unbearable, a speculation on the experience of agony just a moment before a dramatic death. Taking place during the American Civil War (from 12 April 1861 to 9 April 1865), the tale denounces the dehumanization of war and any 'civilized' method of extermination. Bierce's profoundly critical view turned to the political and historical reality of his country is simply devastating.

The plot for both tale and short film can be summarized as follows. Peyton Farquhar, the owner of a plantation and Confederate sympathizer, is about to be hung over the Owl Creek Bridge of the title, in Alabama (Figure 1). Those about to carry out the execution are soldiers of the Federal army. The reader will learn the reason later: a spy, passing himself off as a fellow Confederate sympathizer, has deceived him into believing that he could destroy the bridge occupied by the Unionists, with the objective of catching him. Mr Farquhar actually was a wealthy plantation owner, from a respected family in Alabama, a slave owner and, like other slave owners, a politician. However, by a seeming miracle, at the very moment the boards that sustain him are set loose so he will fall down and be hanged, the rope around his neck is broken and he falls into the river. He dives into the water and, after a huge effort of swimming to avoid being shot, he reaches the opposite shore and goes into the woods. Taken by a fit of euphoria at having so unexpectedly escaped and saved his life, he runs back home to hold his beloved wife in his arms. But at the supreme moment he is

Figure 1: The preparations of the man's execution (An Occurrence at Owl Creek Bridge).

reunited with her, his neck is broken on the weight of his body: the happy escape and return home have only taken place in his mind, a supreme act of imagination in only the few seconds that he was in agony over the Owl Creek Bridge.

Not only is the tale a masterpiece, but the short film it is based on – 30 minutes long – has been described as a 'classic short film' (Johnson 2004) in its own right. Directed by the late Robert Enrico, the film *An Occurrence at Owl Creek Bridge* was released in 1962, and won both the Golden Palm at the Cannes Film Festival in 1961 and the Academy Award for short film in 1964. The film begins with a still image that portrays a public warning 'prominently placed on a burnt tree trunk', which somehow synthesizes the director's outlook of amalgamating in his adaptation literature – a written text – with cinema – its actual image, in such a way that the viewer can *see* it and *read* it at the same time. The warning says: 'Order. Any civilian caught interfering with the railroad bridges tunnels or trains will be summarily hanged. The 4th of April, 1862' (Cooper & Dancyger 2005: 20).[5] We then hear drums, the cry of an owl, a bugle. We see the officer giving orders, feet marching, a sergeant carrying the rope with which the man will be hanged, and then the prisoner himself, in civilian clothes, standing at the edge of the bridge and struggling with what seems to be his very last moments. These first images already allow the viewer to understand the man's extreme situation. How is the escape conveyed in the tale, in such a way that it seems both possible and fantastic? And how, in turn, is this conveyed in images and sound, given that both Bierce's text and Enrico's short film are uncannily silent?[6] What does this say about perception, interiority and subjectivity? We must return, first, to the issue of time, then magnification of images and finally perception.

Real time and filmic time are of course not necessarily the same, even if film unfolds in time. As Jacques Aumont has put it: 'time in cinema, which is

mechanically identifiable as real time, is in fact quite different, because it is modulated dramatically and from that modulation it is rhythmically built (assembling elements of rhythm …)' (2011: 96). In relation to rhythm, the devastating conventional time alluded to by means of the 'ticking of his watch' (Bierce 1964: 52) echoes the beats of Farquhar's heart in extreme anguish, inexorably reminding him of the few seconds he still has to think about the safety of his loved ones. By means of the watch, Enrico's adaptation achieves a poignant cinematic recreation of that moment rhythmically – immediately after he is stripped of his watch by his executioners – when he is able to see his beloved wife in a dreamlike evocation, suddenly coming to his last call in slow motion, silent, smiling.

In both the written text and its adaptation, conventional perception of time and space collapses in that two realities – indeed two parallel occurrences – take place simultaneously, in a few seconds: the real time of the execution at the very moment the 'sergeant stepped aside' and the prisoner is hanged (Bierce 1964: 52) (Figure 2); and another, dreamlike reality, parallel to the execution, devoid of time and space, which constitutes Farquhar's escape from the Federal camp (Figure 3). This second occurrence takes place very close to the realm of the supernatural, in the victim's psyche and it is paradoxically the *real* story of both the tale and the short film. This psychic story in turn splits into two different layers of temporality during Peyton Farquhar's agony, once he has fallen 'straight downward through the bridge' (Bierce 1964: 53). First, a mental temporal line, which incorporates thoughts, analytical reflections, concepts and ideas; second, an unconscious pulse, which determines all kinds of extreme emotional states and instinctive reactions, which eventually annihilates the former, the 'intellectual part of his nature' (Bierce 1964: 54). For instance, the moment after he is hanged, 'ages later, it seemed to him', Payton's thought is

Figure 2: Real time of the execution: falling down into the void the instant before his death (An Occurrence at Owl Creek Bridge).

Figure 3: A dream-like reality: free fall into the water and escape (An Occurrence at Owl Creek Bridge).

able to register a strong physical pain upon his neck 'followed by a sense of suffocation'. But this then forces him only 'to feel', 'and feeling was torment' (Bierce 1964: 53–4). Then, instinct – the only means of surviving – allows him *to see*, 'as an idler might observe the feat of a juggler, without interest in the outcome', how his hands tried to untie themselves (Bierce 1964: 54). It is instinctive reactions that have taken over the intellectual ones. In his adaptation, Enrico resolves these mental and instinctive reactions through the cinematic sequence of the man in desperation under the water trying to free his throat and his hands, and getting rid of his boots. Neither the reader nor the viewer understands this double reality until the unexpected *dénouement*.

In short, the so-called 'presentness' attributed to cinema by Kroeber and others, which cinema can supposedly only surmount by means of devices such as flashbacks, flash-forwards, dissolves, image overlaps, distortions, colour filters and similar devices, simply does not hold here. Subjective time, in Enrico's film, is made present by the narrative itself. The aim is not to render surrealistic scenes of dream, but rather to make 'reality' uncanny. Enrico's short film is structured around a seemingly traditional linear narrative, although certain details indicate that all is not well. One instance is the strange immobility of the soldiers, which, in the light of the unexpected development, seems rather anomalous. Indeed, except for the four soldiers who are on the bridge, nobody moves on the camp: 'The company faced the bridge, staring stonily, motionless. The sentinels facing the banks of the stream might have been statues to adorn the bridge,' says the narrator (Bierce 1964: 51). Enrico shows us exactly that. Also, when the company fires, it is highly improbable that none of the soldiers would have hit their target; but at this stage of the tale and the film, it is by means of suggesting that the improbable indeed took place that disbelief is

avoided. Moreover, the cannon was fired three times, as his executioners were intent to kill Farquhar at all costs, something absolutely unbelievable when considered in retrospect.

Apart from presenting an apparently linear narrative that we later learn never took place in the objective reality, but subjectively, inside the victim's mind (and ours) as an alternative, atemporal, psychic reality, there is another way in which the film and the tale challenge conventional notions of temporality. Both start, so to speak, with the end. Following Poe's *Philosophy of Composition*: 'It is only with the *dénouement* constantly in view that we can give a plot its indispensable air of consequence, or causation, by making the incidents, and especially the tone at all points, tend to the development of the intention' (Poe 2006 [1846]: 543).

A great admirer of Edgar Allen Poe, Charles Baudelaire would remind us of Poe's seminal contribution as regards the structure of a work of art: 'All ideas, like obedient arrows, fly to the same goal' (1976a [1852]: 283). In the preamble of his translation of *The Raven*, Baudelaire emphasizes that: 'Everything, in a poem as in a novel, in a sonnet as in a *nouvelle*, must converge in the dénouement' (1976b [1859]: 343).

Michel Chion (2007) has argued that the climax of a film should be the culminating point of the dramatic progression, involving emotions, dramatization and intensity and it must therefore be located towards the end. After the climax, there can only be scenes of resolution. Bierce's tale is written, according to Poe's theory, pointing towards the *dénouement*. In other words, the linear temporal narrative is again subverted here by taking death, or the tale's and film's end, as the *starting point* of the narrative. The devastating meaning of the story only becomes clear to the reader or viewer in retrospect. Thus the argument that time in literature is not subject to actual restraints, but that time in cinema is, does not bear close scrutiny. Indeed, when discussing Enrico's short for its artistic merits, it is his ability to portray the subversion of time that most critics comment on:

> Jean Bofferty's crystalline cinematography pin-points the details of the soldiers unease, fright and desperation, while Henri Lanoe's [sic] music remains hauntingly uplifting. Yet, it is Enrico's simple direction that seems to echo so strongly after all of this time. For this film (which is virtually without dialogue but for a few words) offers viewers and filmmakers alike something that is so often missing in today's films: a clear, concise story wrapped in a composition of *striking images beating in time*. (Johnson 2004, my emphasis)

And if an earlier generation of critics that were conversant with literary conventions once thought literature was inherently superior and more effective,

the newer generations, accustomed to images, are starting to argue the opposite. In the words of blogger Alisa Hathaway:

> The elaborateness of the harrowing getaway makes us root for this man whose crimes are unclear. Having not read the original story, I can't imagine how the author builds this tension with nothing but text in his employ, when Enrico can tease us with sights, sounds, *and the defeat of time*. (2011, my emphasis)

With more bloggers joining film criticism academic debates on adaptation are bound to change.

Perception and Magnification

Recent research on the way images are processed in the brain has shown that perception is a complex matter. While visual perception is immediate, it takes place selectively, and some information is lost.[7] Moreover, regardless of its size, the meaning of a cinematographic image does not solely depend on the image itself, but also on the whole context that surrounds it. The magnification of movements that Kroeber attributed to cinema is thus, at least at the perception level, of a technical order. The impact of a close-up or a distorting lens will largely depend on the rest of the images in the narrative flow.

On the other hand, in literature, it is certainly possible to magnify movement, and indeed to magnify importance. In Bierce's tale, an essential component of the plot is the image – literarily speaking – of Farquhar's wife, that is, his wife as he remembers her. The presence of this character is essential in the story not only because of the strong emotional link with the main character, but also because she ultimately acts as a metaphor for the death that awaits him. In other words her image is magnified, looming large in all the scenes that take place after we first 'see' her, thanks to the narrative structure. What the viewer sees, as much as what the reader reads, is something tremendous in its simplicity: a woman and her husband, the man who is about to be executed, coming together again. During his very short agony, Mr Farquhar evokes his beloved wife three times: when he is about to be hanged, he thinks of his wife and children: 'My home, thank God, is as yet outside their lines; my wife and little ones are still beyond the invader's farthest advance' (Bierce 1964: 52); when, walking in the woods at night, he thinks again of his wife and children: 'By nightfall he was fatigued, footsore, famishing. The thought of his wife and children urged him on' (Bierce 1964: 57); and when he finally arrives home.

Let us now compare and contrast, in the short story and the film, the crucial scene in which the reunion between husband and wife eventually occurs and how this coincides with the man's last breath. In the literary text, the erotic

content is extremely subtle, only suggested through two moments in Farquhar's last *rendezvous* with Eros and Thanatos. One is a brief but powerful description of his wife's beauty and graceful figure when he is approaching his house:

> As he pushes open the gate and passes up the wide white walk, he sees a flutter of female garments; his wife, looking fresh and cool and sweet, steps down from the veranda to meet him. At the bottom of the steps she stands waiting, with a smile of ineffable joy, an attitude of matchless grace and dignity. And how beautiful she is! (Bierce 1964: 58)

The other, which connotes a strong but subtle eroticism, is when they are about to fall into each other's arms: 'He springs forward with extended arms. As he is about to clasp her he feels a stunning blow upon the back of his neck; a blinding white light blazes all about him with a sound like the shock of a cannon – then all is darkness and silence!' (Bierce 1964: 58).

Enrico's adaptation greatly benefits from this erotic vein of love and passion.[8] A highly emotional effect is achieved in the sequence which combines the man running with his arms outstretched towards his wife – indeed towards death – giving himself over to her; and she, moving towards him with her sweetest smile, the whole underscored by a piece of non-diegetic music. It is a piece for solo guitar that contrastingly celebrates the merging of love and life during the instant of Peyton Farquhar's agony. Its rather slow tempo provides the scene with a touch of painful melancholy through its delicate chords and simple structure. Its effect is so powerful that visually the man seems to be running to clasp his beloved 'with extended arms' (Bierce 1964: 58) in slow motion. At the end of the story, when the man has been hanged, the reader will learn that what Peyton Farquhar went through was nothing but his last recollections.

To sum up, what both literary and cinematic texts demonstrate is that, whether in reading or viewing, perception is not infallible, immediacy in both cases being relative and deceiving. Seeing an object requires a perspective, therefore any visualization of the object is fragmentary or partial, not thorough and complete. As Nietzsche famously argued, 'It is our needs that interpret the world; our drives and their For and Against. Every drive is a kind of lust to rule; each one has its perspective that it would like to compel all the other drives to accept as a norm' (quoted in McGowan 1991: 71). Making meaning through perception is a subjective operation that requires time for apprehension and interpretation.

Conclusion

In both the literary and the filmic versions of the tale, supernatural atmospheres correspond to a psychic experience. In the hands of both Bierce and Enrico, this

psychic reality becomes a supernatural dimension, where an escape from con-
ventional reality – as ephemeral as it may be – is possible. Unlike the reified
unworldly ghostly presences we can find in, for instance, the early Gothic novel
– which are more concrete or *real*, so to speak, than the material world and
whose effect ends the moment it shows itself – the internalized supernatural, as
seen in the tale 'An Occurrence at Owl Creek Bridge' and its cinematic adapta-
tion, has a far stronger impact due to its psychic dimension; that is, the fact that
the reader and the viewer are induced to create their own fears. In both litera-
ture and cinema this narrative stratagem is extremely effective in overcoming
conventional perceptions of time and space. In the words of Vallverdú, 'it seems
clear that … seeing is a visual as well as a cognitive process, and both domains,
the linguistic and the visual, are not always translatable into one another,
having instead a symbiotic relationship subordinated to a semantic of knowl-
edge' (2009: 107). According to Eisenstein, the cinematographic discourse is
based on the association of ideas, and these, in turn, on linguistic connections
(Aumont 2011: 43). Poetry is based on the transformation of given structures
into other structures, in the *becoming* of structures and of languages, in the
transmutation of languages into languages. In this respect, Aumont states that:
'The language of reality, based on signs, even if non-verbal, becomes verbal
language, and this translation is itself translated into another language, that of
the cinema, "written language of reality", language of the *imagined* reality'
(2011: 95).

To the extent that any reading of a literary text, as well as any glimpse of a
cinematographic image, entails an interpretation and an appropriation by the
reader/viewer, the act of reading or viewing is itself an adaptation of the source.
We all have our own readings, either of a film or a story. And what is the adap-
tation of a piece of literature if not a particular interpretation and appropriation
– in other words, an extremely active reading – of a text, a recreation of the
primary source echoing its spirit? In this process the association between word
and image is indissoluble, for any cinematographic adaptation, coming from a
piece of literature, becomes a written text in the shape of a script before becom-
ing a film. To conclude, I claim that the reader's and the viewer's imagination is
involved both in literature and cinema in equal measure, making the differ-
ences between the two media far less relevant than Kroeber and others con-
tend. In Ambrose Bierce's story, both cinema and literature successfully depict
the boundaries of the unbearable human condition.

Notes

1 I am grateful to Armida de la Garza for her feedback on an earlier version of this
 chapter.

2 García Márquez reportedly said he had written his *One Hundred Years of Solitude* (2007) 'against cinema' (Taylor 2010: 164).
3 A prime example of this would be Gérard de Nerval's 'Sylvie, Souvenirs du Valois'. As a labyrinth of time, in 'Sylvie', the amalgamation of cognition and imagination leads to a reality where action and descriptions fluctuate in a timeless dreamlike dimension, which gives the narrator access to a sort of innermost mysticism. This oneiric dimension becomes uncannily supernatural by means of dislocating time, which makes the logic of a linear narrative collapse. Those deep psychic regions are haunted by the memories of a bygone time, so that the past, inhabited by the dead – a number of *fantômes métaphysiques* (metaphysical ghosts) – becomes a vehicle for the re-apprehension of oneself (Nerval 1993 [1853]: 539).
4 All translations by the author, unless otherwise stated.
5 Except for the date, this sign comes from the short story. It seems that the film director added that date in order to historically contextualize the execution exactly at the middle point between the beginning (12 April 1861) and the end (9 April 1865) of the Civil War: 4 April 1862. (Although the sign is in the film, in the existing copies it is not clear enough because of film scratches and negative dirt.)
6 In fact, in the literary text Farquhar does not speak, but *thinks*. When thinking about his wife, the narrator observes that: ' ... these thoughts, *which have here to be set down in words*, were flashed into the doomed man's brain rather than evolved from it ...' (Bierce 1964: 52, my emphasis). With respect to the absence of words, silence connotes death, or at least Payton's instantaneous agony before dying. Jacques Attali, referring to his concept of noise and music in relation to social life, clearly identifies their opposite: '... life is noisy ... only death is silent' (Attali 2001: 11).
7 According to this experiment, in a picture showing a river, a goat on the left-hand side and four goats on the right-hand side, the understanding of both parts of the image is an immediate one. However, when the image depicts one goat on the left-hand side and, say, eight on the right, immediate perception does not in fact register this, and all that a viewer would be aware of would be 'many' goats (Vallverdú 2009: 106).
8 Another adaptation of Bierce's tale by Brian James Egen with the same title as the text (Egen 2006), forming part of the collection of adaptations *Ambrose Bierce: Civil War Stories*, dwells on the erotic side of the scene instead. Although he considers this image, twice consecutively, deeply eroticized, he neglects the children. However, he does not consider Farquhar's recollection of his family and home the moment before being executed.

References

Attali, Jacques (2001). *Bruits. Essai sur l'économie politique de la musique*. Paris: Fayard / PUF.
Aumont, Jacques (2011). *Les Théories des cinéastes*. Paris: Armand Colin.

Baudelaire, Charles (1976a [1852]). 'Edgar Allan Poe, sa vie et ses ouvrages', in *Baudelaire. Œuvres complètes*, Vol. II, edited by Claude Pichois. Paris: Bibliothèque de la Pléiade, pp. 249–88.

———— (1976b [1859]). La Genèse d'un poème [Préambule], in *Baudelaire. Œuvres complètes*, Vol. II, edited by Claude Pichois. Paris: Bibliothèque de la Pléiade, pp. 343–5.

Bierce, Ambrose (1964). 'An Occurrence at Owl Creek Bridge', *Ghost and Horror Stories of Ambrose Bierce*, selected and introduced by E. F. Bleiler. New York: Dover Publications, pp. 50–8.

Brunet, Francois (2009). *Photography and Literature*. London: Reaktion.

Chion, Michel (2007). *Ecrire un scénario: Edition définitive*. Paris: Cahiers du Cinéma.

Cooper, Pat and Ken Dancyger (2005). *Writing the Short Film*. London: Elsevier.

Elliott, K. (2003). *Rethinking the Novel/Film Debate*. Cambridge: Cambridge University Press.

Hathaway, Alisa. 'An Occurrance [sic] at Owl Creek Bridge', *Notes on Short Film*. Available at http://alisashortfilm.wordpress.com/tag/ambrose-bierce/, last accessed 25 August 2012.

Hoffmann, E. T. A. (1993 [1816]). 'Der Sandmann / The Sandman.' In Stanley Appelbaum (ed.), *Five Great German Short Stories / Fünf Deutsche Meister-Erzählungen*, translated by Stanley Appelbaum. New York: Dover Publications, pp. 36–103.

Hutcheon, Linda (2006). *A Theory of Adaptation*. London: Routledge.

Johnson, Jeff (2004). 'Twilight Zone: An Occurrence at Owl Creek', in *The Archive 100*. Available at http://shortfilmarchive.unlv.edu/catalog_archive100/1962_occurence01.html, last accessed 16 July 2013..

Kroeber, Karl (2006). *Make Believe in Film and Fiction: Visual vs. Verbal Storytelling*. London: Palgrave.

Lavender, Catherine (2001). 'D. W. Griffith, "The Birth of a Nation" (1915)'. Available at www.library.csi.cuny.edu/dept/history/lavender/birth.html, last accessed 25 August 2012.

McGowan, John (1991). *Postmodernism and its Critics*. Ithaca: Cornell University Press.

Nerval, Gérard de (1993 [1853]). 'Sylvie, Souvenirs du Valois', in *Gérard de Nerval. Œuvres complètes*, Vol. III, edited by Jean Guillaume and Claude Pichois. Paris: Bibliothèque de la Pléiade, pp. 537–79.

Poe, Edgar Allan (2006 [1846]). 'The Philosophy of Composition', in *The Portable Edgar Allan Poe*, edited by J. Gerald Kennedy. London: Penguin, pp. 543–54.

Stam, Robert (1992). *Subversive Pleasures: Bakhtin, Cultural Criticism, and Film*. Baltimore: The Johns Hopkins University Press.

Taylor, Clare (2010). 'García Márquez and Film', in Philip Swanson (ed.), *The Cambridge Companion to Gabriel García Márquez*. Cambridge: Cambridge University Press, pp. 160–78.

Vallverdú, Jordi (2009). *Bioética computacional (e-Biotecnología: simbiosis de valores)*. Madrid: Fondo de Cultura Económica de España.

PART IV

BORDER-CROSSING FILMS

Chapter 9

An Art in the Rough:
The Cinema of João
César Monteiro

Paulo Filipe Monteiro

The pure admire the pure, and live alone
...
How terrible the need for solitude:
That appetite for life so ravenous
A man's a beast prowling in his own house,
A beast with fangs, and out for his own blood
Until he finds the things he almost was
When the pure fury first raged in his head
And trees came closer with a denser shade.

(Theodore Roethke)

To discuss 'impure cinema' beyond a tautological framework requires discussing the different paths and strategies of impurity. This is why I have chosen to focus on a single and very singular auteur, João César Monteiro. His work is impure in many ways, yet at the same time it reminds us of how important it is to keep purity in mind when approaching impurity. Monteiro remains faithful to his drive towards both the pure and the impure, thus creating a tension between two chords that he plays admirably.

The modernist utopia of a pure medium, though stronger in other arts, was also present in the historical avant-garde films, but both filmmakers and thinkers soon broke away from it. As Deleuze (1986: 10) reminds us in a letter addressed to Serge Daney, cinema is the realm of imperfection, whereas television is perfect with all its aesthetic and noetic nullity. Cinema, Daney replies (1995: 145), is an impure art for it inevitably leans towards something other than itself, and its unexpected beauty emerges from the heterogeneous material

it collects. Cinematic beauty lies not in the things themselves but rather in the relationship they establish with the film, in what is *in between* them.

Within cinema, there is no need to argue that auteurs have always developed a number of strong connections with other arts, especially with painting and literature. Among the auteurs, the modernist ones have inherited a legacy derived from a tradition of dialogue and intertextuality between film and different arts and also between different media and sometimes between cultures. João César Monteiro is a modernist and auteurist filmmaker, and thus has a threefold justification for impurity.

Life and Work

Born in 1939 in central Portugal, João César Monteiro moved to Lisbon at the age of 15. When he was 21, after spending a few months in Paris, he came into contact for the first time with the new generation in Lisbon that was to change Portuguese cinema, including Paulo Rocha, Fernando Lopes and Seixas Santos. In 1963, he went to the London School of Film Technique with a scholarship from the Gulbenkian Foundation. However, he was not a good student, deeming the school to be full of 'imbeciles and incompetents'; he would later write that 'the English people are not born for cinema' (1974: 48).[1] By 1965, the new wave of Portuguese cinema had already produced its first films, and Monteiro had started to shoot his first fiction film, *He Goes Long Barefoot that Waits for Dead Men's Shoes* (*Quem espera por sapatos de defunto morre descalço*), but had to stop two days into the shoot due to lack of money (the film would be eventually completed in 1970). In 1969 he finally completed what is considered to be his first film, a splendid documentary about the Portuguese poet Sophia de Mello Breyner (*Sophia de Mello Breyner Andresen*). The other 20 films he directed were all fiction (eight of them short). He continued working until his death in 2003, aged 64.

Let us briefly sketch the main periods of his career. After his first documentary, he made two experimental fiction films; then, immediately after the 1974 revolution in Portugal, he shot a mixture of documentary and fiction which was as politically engaged as nearly all Portuguese films at the time. He then felt a strong urge, common to many artists in that period, to travel to the most isolated villages in Portugal in order to focus on popular roots and folk culture. He made several films based on traditional tales with a fictional character often appearing in the middle of a real rural scenery, though he also used hand-painted landscapes as background in his film *Silvestre* (1981), the adaptation of a Portuguese legend shot in a studio (Figure 1). Areal (2011: 246) calls this period of Monteiro's work 'medieval', as it is inspired both by courtly love and the picaresque tradition.

Figure 1: Silvestre *is the adaptation of a Portuguese legend shot in a studio.*

There followed one of his most singular films, *Hovering over Water* (À *flor do mar*, 1986), starring Laura Morante and Philip Spinelli, focusing on a woman who wants to start her life anew and goes through a kind of epiphany, signified by the light of the seaside. Monteiro himself enters a new phase after this film, which is dominated by his playing the main role in his fiction films. From this period dates the birth of the character João de Deus (John of God), a name which suggests the son of God, a Portuguese saint, or just any poor guy, an everyman or Joe Bloggs (Nagib 2011: 251). In *Recollections of the Yellow House* (*Recordações da Casa Amarela*, 1989), which won the Silver Lion award at the Venice Film Festival, he lives in a poor boarding house, is infested with lice and obsessed with two girls living in the same place; he ends up being beaten up and incarcerated in a mental institution from which he escapes through the sewage system to re-emerge with the appearance of Nosferatu. In *God's Comedy* (*A comédia de Deus*, 1995), João de Deus becomes the well-established manager of an ice-cream parlour and the creator of its ice-creams, selecting and teaching the young girls that come to work there. He occasionally falls in love with them and entices them to participate in carefully prepared erotic rituals. Once again he ends up incarcerated, this time in a hospital, after being attacked by the butcher father of one of the girls; when he returns to what used to be his love nest, he finds it has been totally destroyed and is full of pigeons and dirt. But in

The Spousals of God (*As Bodas de Deus*, 1998), João de Deus receives a suitcase full of money, becomes a baron and lives a life of grandeur until the woman he wins in a poker game runs away with the money; he is persecuted and locked up in the same mad-house as in *Recollections*. Because João de Deus is the protagonist of the three films, they are usually referred to as a trilogy, although Monteiro himself once added to the series the chaotic *The Hips of J.W.* (*Le Bassin de J.W.*, 1997) (Burdeau 2005: 436), in which he plays God fighting with Lucifer. Using texts from Strindberg's *Inferno*, he shares the character of João de Deus with the French actor Hugues Quester.

Three feature films are still to be mentioned: *The Last Dive* (*O último mergulho*, 1992), in which an old man meets a youth as he is about to commit suicide and takes him on a tour of Lisbon's popular festivities and *bas-fonds*, encouraging him to fall in love with his own daughter. In the year 2000, after an aborted project to adapt Sade to the screen, he turned to fairy tales with *Snow White* (*Branca de Neve*), but based on an unusual, perverse version of the story by Swiss author Robert Walser. This is Monteiro's most polemical film. From his very first fiction film he had used music without image or image without sound, but this time, after careful rehearsals and a few days of shooting, he decided to film with the camera lens covered. The result is a fascinating experience in which the cinema audience stares at a black screen and concentrates on the exquisite dialogue, accompanied by rare glimpses of grey clouds or, at the beginning, by the image of Walser's body lying on the snow where he died. Monteiro's last film is *Come and Go* (*Vai e vem*, 2003), in which he plays João Vuvu, a retired widower, who is seen either selecting girls to work as housemaids (whom he is willing to serve himself), or inside the noisy popular tram that takes him back and forth from his lodgings.

Arts within Cinema, Cinema within Arts, Happening

Monteiro's work is impure in the Bazinian sense, for his films are an endless dialogue with paintings, books, music and films. In an interview, he declared:

> Murnau is the filmmaker who impresses me the most. In the twentieth century, there is only another work that impresses me as much: that of Paul Klee. And that of Kafka. And that of Céline. Come to think of it, I'm easy to impress. Yet there are filmmakers I never cease to love. Renoir, Bergman, Mozart, Griffith, Mizoguchi, Vermeer, Lang, Camões, Rossellini, Webern, Hitchcock, Nicholas Ray, Montaigne! Others I've learned to love recently: Bresson, Dreyer, Mondrian … There's someone I love by correspondence and he's starving to death in rich Germany: Straub. (Monteiro 1974: 121)

If we are to consider Monteiro's connections with other arts, we should start with music. Often the music in his films is intradiegetic and played on site (he claimed he absolutely needed to have sound for his performance as an actor) and often a musical track corresponds exactly with the shot, as in the scene in *God's Comedy* where a girl, lying on top of an inflatable mattress, pretends to be swimming during all the seven minutes of Wagner's aria 'Death of Isolda'. But his idea was to have a rigorous and ironic *opposition* between music and image (Monteiro 1974: 218). He evoked the concept of 'point' in Webern and Stockhausen, which refers to an element that disrupts linear continuity and questions its ideology: 'modern cinema is the cinema of point' (105), an idea that could be applied to many self-reflexive devices in his films.

The relation with painting (Giotto, Piero della Francesca, Vermeer, Cézanne, Magritte and many others) is clear in some of his compositions, especially in the films *Silvestre, Hovering over the Water, God's Comedy, Lettera Amorosa* and *Come and Go* (Figure 2). But his films also have to do with sculpture and instal-lation. Drawing on the Portuguese cinema tradition, at least since the 1960s, of emphasizing the relationship between actors and space, Monteiro's scenes are set in clearly delimited buildings (often the protagonist's apartment) where he installs his unusual sculptures, such as the cornucopia of eggs used as a seat to soothe the indigestion of one of his female pupils; or the red inflatable mattress on top of a dining table for a swimming lesson (Figure 3); or the bath prepared with eight cans of milk, all found in what I consider to be his masterpiece, *God's Comedy*. They are inhabited sculptures of which the characters are the cause but also the effect, affected as they are by a kind of surrealistic bewilderment.

Most of Monteiro's scenes have only one shot: when this is over, the scene is over. Within the shot, the camera seldom moves. He thus secures the integrity (or 'purity') of the shot, even when 'impure' things happen in it. And we can feel the material existence of the shot because of its extended duration and

Figure 2: Final shot of Come and Go, *corresponding almost exactly to the painting 'The False Mirror', by Magritte.*

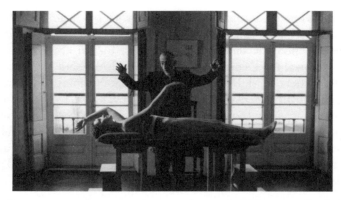

Figure 3: *Seven minutes of swimming lesson to the sound of Wagner, in* God's Comedy.

because of its sustained stillness, even if a character leaves the frame and later returns to it in a kind of choreography. Monteiro himself does this more than any other actors in his films. There is a strong sense of an adventure in his per-formance. As far back as 1969, in a provocative 'Self-interview' (1974: 115), Monteiro wrote: 'This is what I call working without a net: transforming the act of shooting into pure contingency' (Figure 4).

Rather than representation, he is devoted to the creation of an event that will not be repeated. One of his actors, Manuela de Freitas, has once described his way of improvising as an attempt to 'capture the living flesh of existence, to capture life live, as in theatre' (D'Allones 2004: 136). When a girl lying on the red inflatable mattress performs all the different swimming styles, while João de Deus conducts or follows her, her movements were not predetermined – and we can feel this. Things happen on the spur of the moment. This has to do with

Figure 4: *Cláudia Teixeira, in the role of Joaninha, pulls a lock of hair over her lips to make a moustache, as she improvises a scene with João César Monteiro in* God's Comedy.

happening but also with installation, in that it is a hybrid blend of performance and visual arts.

This performative drive draws Monteiro away from quotation and from the obsessive self-reflection of modernism. He chooses where to put the camera but then goes off on an adventure. Although deeply rooted in ethical and aesthetic principles, one feels that the centre of his work lies not behind but ahead, it is the sketch of something which is to come, but is still unknown. It is the cinema of someone who does not know and boldly moves forward into the uncharted. For instance, *God's Comedy* was shot in the chronological order of the scenes so that new ideas could be incorporated, changing the script and the work plan. Monteiro's cinema produces the exciting feeling that things are happening before our eyes and ears. He created unrepeatable events for the camera to record (which is one of the ways in which he is reminiscent of Artaud): scenes are carefully prepared but usually shot only once, very rarely in more than two takes. To quote Monteiro: 'Paraphrasing Rilke, I could say a film is not made of feelings, but of *experiences*, which means, following Blanchot who gives this term the precise meaning of the "contact with the being, the renewal of oneself through this contact"' (Nicolau 2005: 84).

Monteiro's cinema is not only the place where he is free: it is the place where he sets himself free. Portuguese director Jorge Silva Melo once commented:

> His work is uncommonly savage, something wild, for it is not the work of an innocent, but of someone who makes an effort to place himself in that position, nor is it the work of an ignorant, but instead a work that depends on the hypnotic unknowing of knowledge. (2005: 246)

The impurity of Monteiro's cinema also comes from a mixing of genres such as comedy, documentary, horror and home movies, as Lúcia Nagib astutely observed (2008: 6, 9; 2011: 238, 247). As Dudley Andrew recently wrote:

> In Bazin's day, the adult arts of fiction, theatre and painting provided subject matter that helped a very juvenile cinema mature. Today, having attained its status in university curricula, and on the Arts pages of news-papers and cultural journals, cinema's vitality, its necessary impurity now comes through contact with comic books, television, popular music, video games, and computer culture. (2010: 94)

Monteiro was ahead of his time in exploring some of these relations, yet his cinema still remains what Andrew describes, in Bazininan terms, as 'a cinema worthy of its past, to the extent that it maintains what might be best termed the cinematic ethos' (94).

High and Popular Culture

It is crucial to Monteiro (as it was to Nietzsche and to Artaud) to move outside high culture. We find high culture surprisingly mixed with popular culture, for example, in his dialogue, which combines a host of literary references (it is a vast *Philosophy in the Bedroom*) with coarse terms, proverbs, old sayings and roguish songs, in an *alchimie du verbe*, to use Rimbaud's expression. It is not just a combination of words, but of two cultures that are usually felt to be incompatible. This hybridism can also be seen in the comic dimension of his films. Humour is one of Monteiro's strengths as it offers a calming counterpoint to the excesses of bitterness, abjection, eroticism and the sublime. His humour is funny but can also be bitter and desperate. This Monteiro had inherited from popular traditions of Carnival as well as from the Portuguese film comedies of the 1930s and 1940s, and even more from burlesque traditions in general, as represented, for example, by Buster Keaton. This popular comic structure can be seen in his films in scenes that alternate different moods, like numbers in a music hall, as in *Come and Go*.

More than idiosyncratic, one could say, using a neologism, Monteiro is *idiosyncretic*, for he always promotes the fusion of opposing traditions, elements and moods – the sublime and the obscene, high literature and profane swearing, Wagner and popular music, lice and gods, tenderness and anger, performative and visual arts. As in the Camões sonnet used three times by Monteiro (once in *He Goes Long Barefoot . . .* and twice in *God's Comedy*), where we hear about the 'magic poison / that could transform my thoughts', he uses poisons in precise quantities so as to produce antidotes, *pharmakons*: the sublime neutralizes the obscene, the obscene makes the sublime even more sublime. His presence as an actor often results in scenes that are clumsy, vulnerable, embarrassing or even repulsive for some viewers. This is because he always tried to keep his art incomplete and a little rough. In *God's Comedy*, a girl is sitting on the toilet while reading aloud the aforementioned sonnet by Camões. Later she takes a ritual milk bath and then apologizes for having peed a bit in it; the character played by Monteiro answers: 'it's just the right dose, bitter and patriotic, that we were needing to reach perfection'. Francisco Oliveira (2005: 578) commented on Monteiro's 'fascination with the idea of scraps, offscourings, the accursed share, noticeable also in the way he litters his films . . . with prostitutes, beggars, bums, outsiders, immigrants from Eastern Europe and other pariahs.'

Unlike a Film

Abandoning literature at an early age (although his film scripts are remarkable and some have been published), Monteiro chose cinema as his language.

Yet, always provocative, he never let anyone or anything straitjacket him, not even cinema. He always wanted to be someone who came from the outside and remained outside. A former Portuguese critic turned award-winning filmmaker, Miguel Gomes (2005: 565) said that Monteiro showed 'a certain disrespect for cinema' for he violated most of its usual rules, thereby showing its relativity. One of his most faithful actresses, Manuela de Freitas, explains: 'Very often he destroyed the sets, rejected blockings and framings, undid lighting, decimated teams. "I don't want it. It looks like a film." This sentence contains all that Cinema was for him' (2005: 557). His former wife and long-time assistant Margarida Gil says:

> He always used to have a mental sketch of the film he was going to make: a first film, which was not the film as it exists. For it was necessary, almost invariably, that a sort of catastrophe should occur for him to arrive at what he was looking for: sometimes the actors were changed, sometimes the technicians. He had a sketch in his head and he waited for the rev-elation, for the miracle in the sense of Rossellini: 'One must wait for things to reveal themselves'. He suffered a lot while waiting for that. He was slow in finding the thing. And he was ruthless. The unnecessary should go ... João César makes a sketch of a film that turns into catastro-phe, and the real film [or sometimes the next, one should add] is born from that catastrophe. Like a hidden gem that one must find. (D'Allones 2004: 100–1)

The point is that Monteiro wanted to find the diamond but at the same time leave it somewhat in the rough. He conceived of artistic creation as a ritual crime; indeed, the trope of murder, a murder of which the author is simultane-ously the subject and the object, is recurrent in Monteiro, and it runs parallel to his drive to fuse public and private spheres. A murder, a ritual crime: it is up to us to call it pure or impure.

Monteiro wrote: 'One must want to do wrong in order to do absolutely right' (1974: 156). 'The act of filming draws on the awareness of a transgression. Filming is a violence of the gaze, a profanation of the real with the purpose of restoring an image of the sacred ... and this image can only be translated in terms of art, in that it presupposes a deeply playful creation, whose nature is deeply primitive and religious' (42).

A Search for Purity

When Monteiro talks about his work in terms of something primitive and sacred, as he often does, we arrive at what makes him such an original case.

The permanent tension between 'impurity' and a desperate need for 'purity' had been his personal driving force from his youth and it was also the result of retaining a modernist background. Indeed, in spite of the impurity derived from the dialogue between the muses, a yearning for the primitive, the sacred, the pure is not rare among modernists in other arts (though rarer in cinema). No great poet since Baudelaire has remained immune to the internal wound caused by civilization. The decadent tradition of the avant-gardes, starting with Wagner, was attracted by the hyper-refined but also by the primitive or barbarian. Mallarmé, who urged us 'to give a purer sense to the word of the tribe', spoke endlessly of a 'somewhere', or là-bas, that could seal that wound (apud Merquior 1975: 67). As Rimbaud wrote, 'La vraie vie est ailleurs' ('real life is elsewhere'). Therefore, the spirit of modernism, at least in poetry and music, was an epic of the negative, the wreckage of a pure and sacred vision in a self-destructive discourse.

In the ascetic Monteiro, who kept rediscovering and transforming himself through loss (his character João de Deus always found himself in the position of an outlaw, with no father, no mother, no women, no money), there is a clear nostalgia for an original state of purity, which poverty sometimes comes close to. His art, again revealing its modernist affiliation, aims for an ontology and Gnostic mystery. One should note there is a presence, one could say a miraculous presence, of the supernatural within the natural. Thus there is a constant, natural sacredness of the profane and a profanation of the sacred. One should try not to profane the real, said Monteiro (Silva 1992: 26), who constantly profaned the sacred.[2]

Actor Luís Miguel Cintra concluded, after starring in He Goes Long Barefoot that Waits for Dead Men's Shoes, that cinema 'always talks of innocence, there is always a nostalgia for some desired peace, a vital drive for purity is always violently exposed' (Nicolau 2005: 547). Sometimes this pure origin is found in nature, especially in the films Monteiro shot in north-eastern Portugal, but it is present even in his urban films (where some of his main characters, like João de Deus, have a connection to agriculture and the land). Monteiro's interest in the Swiss author Robert Walser's recreation of the story of Snow White (a name of superlative purity) has everything to do with this search for a whiteness that cannot be innocent, but instead is created within culture, with rigour, hardship and solitude.

The power of an ascetic man grows as his pleasure diminishes. Monteiro chose to live in great austerity, an ascetic life. His films sometimes have a pathetic or burlesque version of mysticism, always aspiring to sainthood, deviant though this might be. There is a Christ-like dimension to some of his characters, especially those he played himself. And in all his films this asceticism is imbued with a sense of the eternal, as in the Bresson films he so admired.

In order to reach purity one must submit oneself to ritual rules that progres-sively tear one apart from the profane world in order to approach the sacred without danger. In Monteiro's films, especially in the *God's* trilogy, many motifs have to do with this mystical route: barbershops, showers, private baths, public baths, milk baths, leaving ordinary clothes behind, putting on new clothes and so on.

Ariadne

The poems Monteiro published in 1959 when he was 20 constantly alternate between sordidness and epiphany. The divine emerges from the filth by means of a purgatory of redeeming abasements. He cultivated an oscillation between abjection and purity, as though immersing himself in rubbish was the best way of attaining a state of exhaustion and simplicity in which radiant love again becomes possible, unblemished, urgent.

> The louse in your blue belly paraded
> Whistling a pacified song
> And noticing me, who listened in astonishment,
> It yelled gently as a gentle pope
> – Thanks disgusting comrade
> This way, horizontal and easy
> My destiny will be infallible and divine
>
> (Monteiro 1959: 10)

This trend persisted when he decided his language was cinema: 'I didn't care at all to do bullshit, so long as it was my own shit', he said in an interview (Nicolau 2005: 25). The point is that he needed impurity in order to break conventions, as the only way to attain purity. When the protagonist of *Recollections of the Yellow House* emerges from the ground as Nosferatu, we are reminded of the duplicity of men who during the night turn into vampires and werewolves. 'Night bird, almost an owl who compares himself to Nosferatu, he goes in search of light like suicidal insects' (Melo 2005: 245): the clear light of Piero della Francesca, present in many of Monteiro's films. But this luminosity is impossible to attain, Monteiro said: 'The morning presence is not for us; nor the presence of some golden gods ...' (Nicolau 2005: 80). Another Portuguese director, Seixas Santos, used to tell Monteiro that he had an attraction to the abyss (Nicolau 2005: 232). But there is the abyss that goes down and the one that ascends.

At one point, the protagonist in *God's Comedy* exclaims: 'We are not looking for the truth, we're looking for our Ariadne. And in what conditions, so help us God!' Beauty itself disturbs and saddens those who know where it comes from,

and how it comes to be. Day to day life is made of disaggregation in which mad-ness sleeps, or awakens. As Walser makes the Prince in *Snow White* say:

> What I see is sweet and charming just to look at. It is holy to the sense that captures the image in its fine network. For the spirit who knows the past, it is ugly as a stream of turbid and muddy water. Oh, it is a double vision, sweet and mean, worrying and enchanting.

In *The Last Dive*, Monteiro used the music of Bach played by Glenn Gould, 'because it's an ascensional music' (Silva 1992: 27).

> This film is constructed in a spiral. The spiral is, in a way, the line of vertigo, of swirl. It's a baroque line *par excellence*. It has no beginning and no end. It's like a feminine bush that unfolds, and I'm keen on those things. It's like Ariadne's thread. The bush itself is not so interesting to me. It interests me as Ariadne's thread. (27)

There is something baroque in Monteiro's attitude, in his fusion of elements, in his laughter. Baroque, yet against mannerism and decorativism which he con-sidered a crisis of the form (Silva 1992: 27). But his upward drive has a lot to do with romanticism. In a journal he kept in 1999 (Monteiro 1999: 218) he speaks of his romantic side. As the critic Bénard da Costa stated on the day Monteiro died, his films are 'astonishingly romantic works, and also a subversion inside romanticism. There is a fascination with beauty that goes to the final limit. The beauty of Monteiro's work lies in this ability to find in images the possibility of accessing a higher order' (2003: 36). In Monteiro's own words (Câmara 1999: 32), 'There is a stubbornness in understanding love as something absolute. Being absolute, it is impossible. We remain with the idea.' He often said, and again I quote (Monteiro 2005: 445): 'The object of love is not there. In this sense, I think I'm close to Godard, who said in a recent film: "I am the one who loves". He is the amorous agent, he is active. But if there is no object, that's not my fault.'

Conclusion

It is not easy to understand and accept Monteiro's proposal that combines such different and often contradictory elements: or rather, not contradictory, for there is no dialectic synthesis and the elements remain in antagonism within a single piece. In Monteiro's work, there is a continuous, restless travelling back and forth between heaven and hell. The title of his masterpiece, *God's Comedy*, echoes Dante's *Divine Comedy*; and indeed, the various Dantean cycles are re-enacted by Monteiro in this and other films. From hell to heaven, there is a

Figure 5: The Spousals of God: *Monteiro scooping out a pomegranate.*

continuous shuttling back and forth, restlessly. One of the main characteristics of his cinema is the experience of different dimensions simultaneously as if a super-Monteiro had the capacity and the right to edit the set of frames in which he develops his work and his self.

He comes and goes between the Dionysian and the Apollonian: Dionysian moments lead to Apollonian visions, but he wants to make sure that nothing has just a formal appearance, that beauty is always under threat, and that out of something pure will emerge something impure, as when he removes pubic hair from the milk bath, or when we see Robert Walser's dead body lying on the vast expanse of the white Swiss snow. Beauty carries some impurity in it, some poverty, an apparent neglect, a bit of brutality. '*Le vrai film est ailleurs*' ('the real film is elsewhere'), he wrote (1974: 129). Like the actor–director Erich von Stroheim, whose poster appears in *Recollections of the Yellow House*, Monteiro felt a deep need to sully art in order to ensure its existence as art (Figure 5). He preferred incompleteness, things disrupted by very different things. This discontinuity is one of the characteristics of modernism. In Monteiro we can say that modernism spreads inside romanticism – something made possible by the importance of the image in both and in Monteiro (with the image being the great bridge linking realism to the romantic and the modernist poetics). As in the sentence he took from the eighteenth-century Brazilian-Portuguese philosopher, Matias Ayres: 'All art includes a little roughness.'[3]

Notes

1 All translations by the author, unless otherwise stated.
2 It is worth noting that 20 years earlier, when writing about a Manoel de Oliveira film, Monteiro had thought differently: 'Filming is a violence of the gaze, a profanation of the real' (republished in Monteiro 1974: 42).
3 In Portuguese, '*Toda a arte leva em si um pouco de rudeza*'. Monteiro uses this sentence in *God's Comedy* as well as in an interview (Silva 1992: 26).

References

Andrew, Dudley (2010). *What Cinema Is! Bazin's Quest and its Charge*. Chichester: Wiley-Blackwell.

Areal, Leonor (2011). *Cinema Português: Um País Imaginado*, vol. II. Lisbon: Edições 70.

Burdeau, Emmanuel (2005). 'Entrevista a João César Monteiro', interview with João César Monteiro, in João Nicolau (ed.), *João César Monteiro*. Lisbon: Cinemateca Portuguesa (original: *Cahiers du Cinéma*, 541, December 1999).

Câmara, Vasco (1999). 'João de Deus desfez-se na luz', *Público*, 20 May, p. 32.

Costa, Bénard da (2003). 'Um dos grandes cineastas mundiais', *Público*, 4 February, p. 36.

D'Allones, Fabrice Revault (2004). *Pour João César Monteiro: 'Contre tous les Feux, le Feu, mon Feu'*. Crisnée: Yellow Now.

Daney, Serge (1995). *Lo Sguardo Ostinato*. Milan: Il Castoro.

Deleuze, Gilles (1986). 'Optimisme, pessimisme et voyage: Lettre à Serge Daney', preface to Serge Daney, *Ciné Journal*. Paris: Cahiers du Cinéma.

Freitas, Manuela de (2005). 'A César', in João Nicolau (ed.), *João César Monteiro*. Lisbon: Cinemateca Portuguesa, pp. 556–8.

Gomes, Miguel (2005). 'Untitled', in João Nicolau (ed.), *João César Monteiro*. Lisbon: Cinemateca Portuguesa, pp. 561–5.

Melo, Jorge Silva (2005). 'Sem saber', in João Nicolau (ed.), *João César Monteiro*. Lisbon: Cinemateca Portuguesa, pp. 241–6.

Merquior, José Guilherme (1975). *A Estética de Lévi-Strauss*. Rio de Janeiro: Tempo Brasileiro.

Monteiro, João César (1959). *Corpo Submerso*. Lisbon: author's edition.

—— (1974). *Morituri te Salutant: Os que Vão Morrer Saúdam-te*. Lisbon: & etc.

—— (1999). *Uma Semana noutra Cidade: Diário Parisiense*. Lisbon: & etc.

Nagib, Lúcia (2008). 'João César Monteiro e a comédia do autor'. *Trópico*, http://p.php.uol.com.br/tropico/html/textos/2391,1.shl, 20 May 2008 (last accessed 28 March 2013).

—— (2011). *World Cinema and the Ethics of Realism*. New York/London: Continuum.

Nicolau, João (ed.) (2005). *João César Monteiro*. Lisbon: Cinemateca Portuguesa.

Oliveira, Francisco (2005). 'Entre perversão e gozo: César Monteiro (vertiginoso)', in João Nicolau (ed.), *João César Monteiro*. Lisbon: Cinemateca Portuguesa, pp. 576–80.

Silva, Rodrigues da (1992). 'O sagrado e o profano: O Último Mergulho', interview with João César Monteiro, *Jornal de Letras, Artes e Ideias*, 22 September.

Chapter 10

Relational Subjectivity, Impure Voice: The Video Essays of Agnès Varda, Bingöl Elmas and Kathy High

Brenda Hollweg

Questions of impurity have always featured in the discussion of an art form that is central to the focus of this article: the personal essay. Evolving from a long, albeit discrete literary tradition of essay writing, which can be traced back as far as Seneca and Plutarch in classical antiquity, the personal essay was first perfected in the work of Michel de Montaigne. His *Essais* (1580–95), a collection of 107 short subjective treatments of a given topic, can be seen as the template for all later forms of personalized essayistic writing. From the late eighteenth century to the inter-war years of the twentieth century, the form thrived with the familiar English essay of William Hazlitt, Charles Lamb, Robert Stevenson, George Orwell or Virginia Woolf, and has become so ubiquitous again in contemporary Anglophone literature that US-American writer Patricia Hampl, a few years ago, called the personal essay the 'signature genre of the day' (cited in Lopate 1998: x).

The personal essay is a generic border-crosser *par excellence*: it 'may take a variety of forms (from narration to description to autobiography) and can reflect any number of moods (from critical to reflective to whimsical)' (Lester 1996: ix). For Claire de Obaldia (1996) the personal essay is a genre that is *in potentia*, borrowing freely from other seemingly more stable genres. It can 'turn up in the costumes of personal memoir, humorous sketch, diatribe, speech, prose poem, vignette, philosophical treatise; in performance pieces, comic books and on the radio,' writes Phillip Lopate (1997: ix), the form's foremost critic and practitioner. This impurity of the personal essay has caused writers to

almost ritualistically invoke the difficulty or near-impossibility of defining it as a genre. As Michael Renov (2004) and Laura Rascaroli (2009) in their respective studies on the 'essayistic' and 'subjective cinema' have argued, however, 'we must resist the temptation to over-theorize the form, or even worse, to crystallize it into a genre' (Rascaroli 2009: 39). Rather, these authors suggest, we should look at the first-person essay as a *mode* of thinking and being, characterized by a personalized, self-reflexive voice, an open, experimental mode of engagement and radical questioning of objective and fixed viewpoints on the world.

Although this particular essayistic mode has been present in other media for quite a while, it seems to have picked up momentum again over the last three decades. What once used to signify the work of only a few cine-essayists such as Chris Marker, Jean-Luc Godard, Jonas Mekas or Harun Farocki, has now increasingly been taken up in a variety of different art practices. In the fields of photography and time-based digital media, for instance, personalized forms of visual expression have produced hybrid forms such as the 'photo-essay', 'web-essay' or 'electronic essay'. It is, as Phillip Lopate argued, speaking in the context of the literary essay, as if personal essays have begun to 'bleed' into other, more traditionally impersonal art forms, because their 'authors now feel emboldened (or compelled) to appeal to their own experience as testimony, before launching into their main argument' (1998: x). Documentary filmmakers and those working in an experimental or avant-garde film tradition (Trinh T. Minh-ha, Barbara Hammer, Albertina Carri or Angela Melitopoulos) have embraced the personalized voice as a rhetorical means for socio-political critique.

Personal *video* essays in particular enjoy growing popularity amongst artists and filmmakers. Their popularity cannot only be attributed to the advancement in digital technologies, which have made filming overall easier and more affordable. Personal *video essays* share the literary essay's generic impurity. They come in many different forms – cine-travelogues, video confessions, cine-poems, philosophical meditations or essayistic 'mockumentaries' – and are often also transnational and multicultural in approach and subject matter. They typically cross-reference other art practices like film and photography (Marker, Godard), dance and performance (Trinh), opera (Godard), painting (Ursula Biemann) or various digital media (Farocki, Marker, Biemann). Video essays also mimic practices known from other (more academic) disciplines and art forms, such as visual anthropology, visual sociology, ethnographic research or investigative journalism. They incorporate elements of the traditional documentary, such as face-to-face interviews, a certain investigative spirit or an emphasis on providing visual/photographic evidence. Due to their openness, however, personal video *essays* also allow for a broader spectrum of personalized, self-reflexive and essentially political commentary. The video pieces of Shelly Silver, Sean Snyder,

Elisabeth Subrin, Deborah Stratman, Ursula Biemann, Hito Steyerl and a whole generation of young (female) video artists are cases in point.

Furthermore, the search for knowledge or new insights – typical of any form of documentary filmmaking – in the personal essay is not a search for objectivity and 'truth' but possibility. The essayistic as a mode of thinking and being acknowledges the relational and the less visible moments of human existence which are nevertheless capable of being experienced. 'Objectivity', 'authority', 'truth' become questionable concepts in the essayist's attempt 'to work out some reasoned line of discourse on a problem' (Lopate 1992: 19). Knowledge or practical wisdom gained from what one has observed, encountered or undergone is presented as temporary, contingent and partial. 'Instead of a transcendental subject of vision', personal video essays 'enact the details of a particularized, partialized subjectivity' (Russell 1999: 295). In a poststructuralist gesture, the existence of axioms is met with suspicion and process is emphasized.

My focus here is on this personalized, questioning voice of the essayist. As it constitutes the 'genre', it needs further conceptualization and elaboration. At first, I link this voice to the philosophical writings of Italian feminist Adriana Cavarero. Then, I advance to show how the relational quality of the essayist's voice accounts for the inherent impurity of the personal essay on a communicative level. For this purpose, I draw on the essayistic work of the contemporary filmmakers Agnès Varda (France/Belgium), Bingöl Elmas (Turkey) and Kathy High (USA), whose video pieces – at least the ones under discussion here – foreground the self as a privileged site of knowledge. Both Varda's and Elmas' video essays are also cine-travelogues; they take us on geographical journeys through different regions of France and Turkey, respectively. All three video essays perform a journey of the mind, tracking their authors' thoughts and personal experiences as they try 'to work out some mental knot, however various in its strands' (Lopate 1992: 19). Oscillating between fact and fiction, narration and exposition, reason and emotion, the abstract and the concrete, confession and self-stylization, these video essays are not only generically hybrid; they also celebrate the personal voice as ontologically 'impure', that is, as the effect of a relational subjectivity.

When I speak of 'voice' here, I do not mean 'voice-over' but the author-essayist's unique vision or perspective as expressed in the video-text as a whole and through which 'experience or information will be filtered, perhaps distorted, perhaps questioned' (Brown 1994: 5). Behind this vision or perspective is a self – the author, essayist or enunciator of the film – whose on-screen identity is the effect of a multiplicity of actions and gestures, minute verbal and non-verbal performances, employed by the essayist to experiment with the world, explore alternatives and discover herself and the role she plays in this world anew. The self as performance, writes Catherine Russell, renders 'the subject "in history" [as] destabilized and incoherent, a site of discursive pressures and articulations' (1999: 276). In the essay, this subject is also presented as

open, non-unified or incomplete, typically asking for response and self-affirmation from others.

In her writings – *Relating Narratives* (2000), 'Who Engenders Politics?' (2002) or *For More Than One Voice* (2005), among others – Adriana Cavarero develops a relational ontology that poses the corporeal self as unique or 'insubstitutable' and only recognizable to itself as such in the narratives it longs to hear from an 'other' or 'others'. A person's uniqueness, she writes, stressing the performative and specular qualities of human subjectivity, 'does not pertain to a substance, much less to an inner, internal, interior, deep, hidden substance. Uniqueness is always exposed, external, visible, and manifest. It is the elemental reality of the face-to-face' (2002: 95). Each person's 'who-ness', Cavarero argues with reference to Hannah Arendt, is not separate but 'from its birth' intricately and enigmatically entwined with the 'what' of politics or common identities (2002: 100). Put simply, we are to a large extent who/what other voices produce and effect in us. As human beings, Cavarero stresses, we are always vulnerable to the gaze, tale, narrative or actions of others; only through or in relation to them do we gain a sense of our own unique, corporeal self.

At the heart of the personal essay's textual desire to attach itself to other forms, to mix and mingle elements of different genres, can be found a communicative set-up that is the product of a relational activity: a 'reciprocal communication of voices' (Cavarero 2005: 197) which stresses the relational aspects of human existence and within the constitution of the self. It is this latter form of impurity in the sense of an impure voice, I argue here, that allows the essayist to use the medium of documentary film both as 'a vehicle for experiments in self-discovery' (Oates 1991: ix) and a platform for broader socio-political interventions. As Varda, Elmas and High take up their shifting and multi-layered roles as essayists, they are seen to engage in relational activities with objects and people they encounter on their journeys. In the following, particular attention is paid to episodes and scenes that encourage the audience to relate and enter into a dialogue with the filmmaker and her material. These are moments or 'modes of intelligibility' (Rancière 2009: 117) that are – in a political sense – important, as they show the essayist-filmmaker reaching out to others, her imagined or desired community of viewers. In my analysis of the video essays I focus on scenes that emphasize the relational approach to the world that characterizes the essayist and her specific mode of thinking and being; scenes that create an intimate space of visual and verbal exchange which is not limited to the production's *deixis* but may also connect essayist and viewer; and scenes in which strategies such as direct camera address or an extra-diegetic gaze are employed to position the spectator as the essayist-enunciator's imagined, imaginary or ideal 'other'. Here, meaning is constantly being produced from a wish to address the 'other'/ 'others', while the subject becomes an agent in the construction of new forms of shared experience and knowledge.

Framing Self-disclosure: Agnès Varda's *The Gleaners & I*

With Agnès Varda we encounter a filmmaker who – like Godard or Marker – never stayed within the confines of a single genre, format or language. A member of the Left Bank Group and an important figure in the development of the French New Wave, Varda has worked in France and the United States and made short films, feature films, documentaries and a musical. For many, she personifies 'the eccentric bohemian matriarch' (Romney 2009); she is known for her flair for spectacle and has always kept a close relationship with her audience – both on- and off-screen.[1]

The Gleaners & I (*Les Glaneurs et la glaneuse*),[2] which won the Méliès Prize for Best French Film of 2000, marked Varda's return to the documentary format. Through interviews with people from different regions in France, locals and tourists, we are introduced to various modes of foraging, rummaging and scavenging. We watch people gleaning potatoes that have been left on the fields to rot; we observe them gathering windfall or picking fruits (grapes or apples) from trees and bushes. In Paris, we meet a biology student who has made a habit out of eating the leftovers from market stalls; we also see people living on the margins of society fix and recycle 'white goods' (domestic appliances like washing machines and fridges) – people who, through their words but also their attitude and lifestyle, personify a critique of capitalism and consumer societies. In fact, gleaning is soon developed into a broader discourse that can be manifested through diverse institutionalized forms of language. We hear about the etymology of the term and the significance of gleaning as a motif in French art history. A Professor of French Law is seen standing in his robe on a field of cabbages, while quoting article R-26.10 from the French penal code to us. From his citations we learn that gleaning complies with the law in France and that the practice was first legalized in an edict of 2 November 1554, which allowed the poor, the wretched and the deprived to enter the fields once harvesting was over.

Gleaning is also coded, however, as a way of knowing that is grounded in personal experience, in active and hands-on participation. Interested in the most ordinary and concrete, Varda records with fascination the shrivelling potatoes or the wet, mouldy patches on her ceiling at home. In another scene, she is sitting on the passenger side of her car, filming lorries with her hand-held DV camera through the windscreen. Using the fingers of her left hand as a framing device for each passing vehicle, Varda can be seen to literally 'grasp' the world. Her repeated attempts to capture the visceral and the material in close-up shots suggest a desire for proximity and for a haptical and corporeal approach to the world.

It is the 'hum of perpetual noticing' (Ozick 1998: xx) that propels the filmmaker forward. In another sequence of shots, nearly halfway through the film,

we accompany Varda on her drive through an urban area, when a sign on the storage hall of an 'antiques' seller suddenly catches her attention. In the same 'methodically unmethodical' way[3] with which she at other times gleans objects from the fields or the streets in Paris, she pulls up her car and – purely led by curiosity – enters the shop. Minutes later we observe her stumble upon a painting that combines Jules Breton's female peasant (*The Gleaner*, 1877) with Jean-François Millet's depiction of gleaners in rural nineteenth-century France (*The Gleaners*, 1857). 'Honest, this is no movie-trick,'[4] she confides in us, as her voice-over self-reflexively yet unreliably performs a double-act of both revealing and concealing the 'truth': 'we really did find these Glaneuses purely by chance'. The objects, impressions and incidents Varda collects over the course of the video essay form 'figures' in Donna Haraway's sense of 'material-semiotic nodes or knots in which diverse bodies and meanings coshape one another' (2008: 4). They represent relational objects, as they 'collect the people through their invitation to inhabit the corporeal story told in their lineaments' (4). 'The painting had called to us because it belonged here in this film,' Varda comments as she leaves the storage space and secures the painting in the car. Once more, it seems as if the object has found the essayist rather than vice versa, expressing important parts of her own subjectivity and desires.

As much as *The Gleaners & I* is a documentary about wastefulness and its alternatives, collecting and recycling, as much as it focuses on the forgotten and marginalized, it is also and most importantly an imaginative and multilayered self-portrait. Varda shares the gleaners' desire to re-ascribe value to things that are thought to be useless or to lack in market value, such as the heart-shaped potatoes of different sizes which do not comply with EU food regulation standards and which she picks up and carries home, or the clock without hands that reflects her own desire for eternal time (Figure 1).

Figure 1: In her desire to escape time the filmmaker is addressing us (Film still: courtesy of Agnès Varda).

What distinguishes Varda's video essay from 'purer' forms of documentary filmmaking is the weight afforded to her authorial presence which is bound up with an embodied enunciator, positioning her in different roles as filmmaker, essayist, journalist, ethnographer, art historian or artist/creative force. Right from the beginning, she creates her own modernized, Varda-esque version of a *glaneuse*. She poses in a *tableau vivant* as Breton's idealized figure of the female peasant, balancing a bundle of wheat on her shoulder. With this gender-critical gesture Varda wryly nods toward her art-historical training, positioning herself vis-à-vis an entire tradition of male European artists (Bonner 2001). A second later, however, she drops the bundle of wheat and holds up her new digital video camera instead. She is stylizing herself as a *glaneuse* of images, incidents and life-stories, stressing the importance of her camera as *cinéstylo* ('cinepen'), which supports her idea of film as *cinécriture*, 'implying a sort of writing with, rather than for, the filmed image' (Kehr 2008).

As we catch her musing, contemplating, ruminating on representations of gleaning in art history, Varda performs an intellectual attitude, a mental strolling or g/*flânerie*, that corresponds 'to the literary essay's trial-and-error character, the approach of "luck and play" that is encapsulated in the word *essay, to try* itself' (Hesler 2009: 198). In the video essayist, the two figures of the *glaneuse* and the *flâneuse* – one evolving from a visual, the other from a literary tradition – merge, fertilize each other and contribute to the impurity of the essayist's voice. Taking up a typical essayistic trope, *The Gleaners & I* as self-portrait is also a meditation on the passing of time and the process of aging. Research on Varda has stressed her recurrent concern with temporality and death.[5] Her heart-shaped potatoes, which soon start to mould and crinkle, encapsulate her own subjective state of being at the age of 72: a body in decay – a fact that can no longer be denied. At one point, we observe the essayist filming her freckled, wrinkled left hand in several extreme close-up shots; at another, we accompany her to her bedroom and become participants of an intimate moment in which she exposes the grey roots of her dyed hair to us. Making use of blurred shots and low-key lighting, the camera draws us closer into the scene. Although Varda, at first, seems to be fending off this intrusion into her private sphere (her left hand appears to attempt to cover the camera lens), the following close-ups of her head and face show her gazing at the camera; she is directly addressing the spectator, before she is eventually seen to disclose and, 'in an adept feminist move, [to] revalue the physical signs of age that society chooses to malign' (Bonner 2001).

Varda here recuperates a strategy of *intimacy* that is usually absent from documentary film, but has been part of the literary essay since its beginnings in the Renaissance and accounts for its ongoing appeal.[6] In *The Art of the Personal Essay*, Phillip Lopate mentions the 'conversational dynamic – the desire for contact' that is ingrained in the essay 'and serves to establish a quick emotional

intimacy with the audience' (1994: xxv). For Edward Hoagland, the essayist acts like an intimate friend, a *confidant* and equal; he writes: 'If you know the anguish, joy, and bravery somebody has experienced, you can also share their episodes of shame and indigestion' (1999: xix). In *The Gleaners & I*, acts of self-disclosure resemble 'disquieting confessions' (Bonner 2001); they are neither purely performed for reasons of narcissism nor self-scrutiny. Rather, they point to a feminist understanding of a 'woman *who* is here, in flesh and blood, with a face, a name, a story, a voice, whose uniqueness is exposed and shared by others, men and women in the vulnerable context of human, material and transient life' (Bertolino 2008: 133). The gaze directed at the spectator visualizes the essayist's longing to be discovered in her uniqueness, understood and created anew. Essayistic 'I', camera eye and spectator stand in a mutually constitutive and metonymical relation to each other. The essayist's voice or display of self is impure in so far as it is also always something given to her from an 'other' – the spectator – whom she 'invites', that is, positions cinematographically, to share in her perceptions and experiences.

Epistolary Intimacy: Bingöl Elmas' *My Letter to Pippa*

Varda's *The Gleaners & I* is a video essay dominated by an open, experimental, self-reflexive and essentially playful approach to the world. Bingöl Elmas' *My Letter to Pippa* (*Pippa 'ya Mektubum*, 2010), on the other hand, exemplifies a production that is more situated in the tradition of news reports and journalistic investigations, in which the essayistic voice is less pronounced. The film retains, however, a relational mode of artistic experience that envisages the audience as a community. A key role in the construction of this relationality is played by the conceit of a fictive letter the author writes to the late Italian artist Pippa Bacca. The epistle as a communicative device allows the author to address and engage with the viewer on a collective level. *My Letter to Pippa* – which was co-produced by Patrice Barrat and ARTE France and broadcast on the European channel in 2010 – was embedded in a broader series on 'The Other Turkey'. The programme set out 'to question the clichés and realities of Turkey, to renew the terms of the debate on its identity and its entry into the European Union, and to engage with profound and surprising propositions from Turkish film-makers'.[7]

In her film, Elmas takes the viewer from Istanbul on a 1,500-kilometre journey through Turkey. She hops on and off long-haul transporters, cars and smaller motorized vehicles, hitchhiking her way eastwards into more rural and remote areas, right across to the Syrian border. Her journey is motivated by the intention to retrace the steps of and relate to Italian artist Pippa Bacca who, two years earlier, left her hometown Milan to hitchhike all the way to Jerusalem. Bacca's

aim was to promote world peace and trust and she travelled as a 'bride for peace', wearing a white wedding dress. As we learn from a montage of archival footage – initially broadcast on Turkish television – Bacca's project and performance ended tragically. On 31 March 2008, she was found raped and murdered near Gebze, 65 kilometre east of Istanbul. In mournful homage to the Italian artist, the Turkish filmmaker Elmas – who is 32 at the time of filming and was born in the same year as Bacca – continues the journey of the deceased woman. She wears, however, a black wedding dress onto which women of her Istanbul community have sewn and stitched symbolic messages of female solidarity, good-luck wishes (the 'courage of Antigone') and feminist warnings (Figure 2).

In her (partial) reproduction of Bacca's performance, Elmas follows a current trend in the art world – that of 'postproduction'– which sees an ever-increasing number of artists 'insert their own work into that of others' and thereby 'contribute to the eradication of the traditional distinction between production and consumption, creation and copy, readymade and original work' (Bourriaud 2002b: 13). With her own performance and film, Elmas wishes to draw attention to Bacca's case (and that of other women in the past), whose violent and unatoned death was met by public disinterest. We see Elmas engage her (exclusively) male drivers – businessmen, professionals from the tourist industry, shop owners or farmers – in conversations about Bacca's death and her own role as a woman travelling alone as a hitchhiker. Placed in the intimate space of a car or a lorry's front cabin, Elmas films her interview partners as well as herself with a handheld DV camera. Her edited material draws a picture of Turkish masculinity that is as much cliché-ridden as it is diverse. Elmas' interview footage reveals the derogatory attitude of many Turkish men towards women, including their

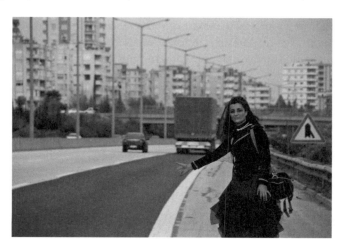

Figure 2: Elmas hitchhiking her way to the Syrian border, in My Letter to Pippa *(Photograph: Şirin Bahar Demirel).*

wives, and highlights both the normalization of violence against women and the dismissal of the right to female self-determination. The drivers are shown to compare the female hitchhiker to a prostitute and, repeatedly, Elmas has to fend off their verbal sexual advances. Questions arise about gender and culture, male domination and the discourse of rape in twentieth-century Turkey, and the role of female solidarity as a possible strategy of resistance.

While a probing, investigative spirit dominates Elmas' interviews with Turkish men, the inclusion of the letter opens up the production to the essayistic mode, to critical reflection and a more personalized and relational approach to both her subject of inquiry and her audience. Positioned at the beginning, middle and end of the film, the letter – addressed to the absent Bacca but read to the viewer – has a disruptive function, supporting Elmas in her effort to dismantle traditional assumptions about gender-specific roles in Turkish culture. A private and intimate form of address, the letter is also an expression of Elmas' desire for identification – a desire to know who Bacca was, what she experienced and how she must have felt when she met her perpetrators. The letter allows the enunciator to initiate a soliloquy, since the addressee is already deceased. As such the epistolary form produces what Hamid Naficy, in his work of exilic and diasporic cinema, understands to be 'an illusion of the other's presence that hovers in the [film] text's interstices' (2001: 5). In My Letter to Pippa this presence connotes violence against women and thus works as a connecting thread between the private and the public, Elmas' deeply personal concerns and larger feminist politics.

As we follow the filmmaker travelling in Pippa Bacca's footsteps, we become engaged in the production of Elmas' journey which generates ambivalence. Elmas' desire to situate herself as a Turkish citizen within her culture on the one hand, and her increasing feelings of alienation as a modern woman in the presence of her fellow countrymen, on the other, is inscribed in a peculiar back-and-forth movement, her alternating presence in and/or absence from the film: she is seen in front of and behind the camera, entering and leaving the diverse vehicles, trying to both identify with and distance herself from the 'presence' of Pippa Bacca, the film team, the places that she travels to and the men whom she meets on her way. The first-person plural 'we', with which Bingöl addresses Pippa in the letter, further underpins her desire to include other women in her epistolary address, in the first instance those among her audience. The use of the inclusive pronoun also expresses her wish to see her audience take up a position as collaborators, possibly even co-authors of her letter.

Unspoken Companionship: Kathy High's *Animal Attraction*

A reciprocity of voices of a different kind, namely between human and non-human animals in the contentious realm of telepathy, is at the centre of Kathy

High's *Animal Attraction* (2001). Once again, we are made aware of our exposed-ness and the importance of the 'other'/ 'others' in the constitution of the self. Shot over a period of three years, the video essay starts out with a sequence of images that introduce the spectator to High, her home and her troublesome cat Ernie. This sequence foregrounds the individual life story or the first-person account as a privileged site of female authority. At the suggestion of a friend, High phones Dawn Hayman who specializes in telepathic communication with animals. She eventually meets Hayman at Spring Farm in Clinton, NY, an animal sanctuary, nature preserve and animal communication centre.

Like Varda and Elmas, High is present throughout the film – alternately behind and in front of the camera, both participating in and withdrawing from the scene. Her voice-over oscillates between admiration and scepticism with regard to Hayman's practice and is interwoven with self-reflexive remarks. A number of communicative situations are set up to strengthen the relational quality that characterizes, on the one hand, Hayman's interaction with the farm animals and even animal patients on the phone and, on the other, High's encounters with Hayman and 'the magic animal kingdom' of Spring Farm. Diverse voices emerge from this complex set-up and competing claims for authority are made.

We are introduced to Hayman's 'miracle transformations of animal behaviour' through interviews with friends of the Spring Farm community. These third-person accounts centre on Hayman's communicative skills and describe her as a person with an almost mythical aura. Later we meet Hayman in person and listen to her tales of the late horse Detesta who is her 'spiritual guide' and provides her with 'bits of wisdom' on a daily basis. We hear about the exceptional cat Sonia Pia who negotiated her alpha position as mice-catcher on the farm in personal conversations with Hayman; we listen to her stories of George Kigercat who inspired the design of one of the farm halls (later named after him) and learn that Gulliver, the llama, can 'resonate faster' than other animals. Hayman emerges as a talented storyteller but also as someone whose attempts to read her animals' mental states, to speak like a ventriloquist for them and to impose human intentionality upon them[8] constitute an extreme case of anthropomorphism. This 'irresistible taboo' that marks our relations to the animal world serves a particular human desire to relate and understand the 'other' but also to potentially control and predict the 'other' as animal (Daston and Mitman 2005: 1).

In her video essay, High employs humour as a device to undermine Hayman's authoritative readings of the animal world and to support her own deeply sceptical voice. Hayman's interpretations are also given as off-screen voice-over and juxtaposed with images of horses nibbling on film equipment or llamas and goats staring at camera lenses, contesting any deeper meaning assigned to their behaviour by the animal communicator. In a short on-screen performance,

High herself is seen to 'telepathically' communicate with a duck – but, as sub-titles reveal, without success. Hayman, however, is not dismissed as delusional or a hoax. Her reputation remains intact and the positive effects of her work are valued, for instance promoting mutual respect and equality between the spe-cies. This becomes obvious in scenes of workshop sessions at Spring Farm, in which the participants are seen in close proximity with an animal of their choice. Both human and non-human animals mimic each other's body lan-guage or move in synchronicity, seemingly in an effort to connect. Unlike Hayman's eloquent interpretations, these scenes invite us to witness – with High – moments of unspeaking companionship between the species.

In one scene, a workshop participant is reading out his notes taken during a 'telepathic encounter' with a Rottweiler cross-breed. The story, written by the man but told from the first-person perspective of the dog, is a tale marked by misunderstanding, emotional neglect and cruelty. Halfway through his reading the participant begins to cry. His emotional response indicates that the animal's story may also illuminate aspects of his own experience, desires or fantasies. The viewer who witnesses this intimate scene starts to wonder whose story is being narrated (and by whom). The male subject at the centre of this scene represents Cavarero's expressive and relational self, 'whose reality is in so far symptomatically external as it is entrusted to the gaze, or the tale, of another' (2000: 41). Everyone, she writes, 'looks for that unity of their own identity in the story (narrated by others or by herself), which far from having a substantial reality, belongs only to desire' (41). Here, this other is, strangely enough, a dog. It is, however, precisely his 'otherness' – both as belonging to a different species and as a space of projection for the human self – that brings the imaginative and imaginary aspects of subject constitution to the fore and permits the participant to recognize his own unique, corporeal and vulnerable self.

Despite the obvious wish of the man to tap into the animal's alleged 'biogra-phy' and connect with the dog on the basis of a core similarity, their stories are different and non-congruent. We are reminded of High's own situation with her troubled cat whose behaviour remains incomprehensible: 'I really wanted to talk to Ernie, I want him to explain what he needs – otherwise, I am afraid, he just remains a troubled cat', we hear her say. With this 'otherwise', however, High admits to 'a non-reductive relation to alterity' (Cooper 2010: 58), in which the other will never be 'an entity that could be known fully, and therefore contained or constrained by the sentient, perceiving subject' (58).

The difficulties of living out such ethics, particularly in our relations to ani-mals, are played out in *Animal Attraction*. As much as the sceptical essayist renounces Hayman's method, one part of her also yearns for this 'sacred place where all things are believed'; one part of her wants to believe in the sameness beneath the difference and sustain the 'moments of belief' that she experiences on her visits at Spring Farm, as they are also 'moments of possibility'. Towards

Figure 3: Interspecies co-authorship? High's telepathic skills are challenged, in Animal Attraction *(film still: courtesy of Kathy High).*

the end of the film, we see High follow one of the llamas with her camera; the animal's thoughts are given as subtitles (Figure 3). The desired moment to tele-pathically connect with an animal seems to be here at last. If only for a few seconds, High reminds us of Dziga Vertov's 'fiercely argued theory for the tran-scendent power of documentary film, not only to record society but to see and imagine it differently than deemed possible by mere human beings' (Aufderheide 2007: 42). At the same time it remains, however, obvious that her 'telepathic' moment is the effect of cinematographic elements, which exposes the medium of film as exactly that: a space of projection, imagination and the imaginary.

Animal Attraction concludes with three short films: *The Intelligence of a Dog*, a film by Ernie, *A Day of a Barn Cat*, made by Sonia Pia, and *Grass*, directed by Gulliver. Ernie is also mentioned as the assistant director of *Animal Attraction*. By crediting her animal others as co-producers of her work, the filmmaker pays homage to Hayman, albeit in a tongue-in-cheek fashion. Given High's difficult life situation at the time the film was made – in the concluding part we learn that she lost her father and experienced the break-up of a long-term relation-ship – these animal-collaborators not only constitute for High 'the one part of nature that is still within my grasp', but also function as her source of inspira-tion and creativity.

Conclusion

In 2010, UNICEF posted a series of 'photo-essays' on their website. The small, informative documents of journalistic work shown under this rubric are clearly not essays as understood in this article. However, the rationale behind this

choice of terminology may have to do with what essays – and personal essays in particular – *do*: they are 'an expression of the human voice addressing an imagined audience, seeking to shift opinion, to influence judgment, to appeal to another in his or her common humanity' (Oates 1991: xvii). For the same purpose, these three video essays position the spectator in such a way that authorial subjectivity can be experienced as relational and thus impure, as something that does not only happen for someone but also always with someone else in the sense of *poiesis* or *co-poiesis* rather than *poetics* (Ettinger 2005). The author's voice and the spectator's 'reading' can be seen as the result of a co-emergence, in which both the self and the reader co-perform, with the potential to recognize and/or the risk to misrecognize each other in the other. This co-production between essayist and viewer is never fully harmonious but also marked by difference. The essayist, writes Juanita Rodgers Comfort in the context of the literary essay, asks us 'to understand how we can connect' but also 'how we can be distinct, at the same time'. The form 'opens a space for continuity and discontinuity to coexist, in order to help us to navigate the territory that a writer [or filmmaker] claims to inhabit' (Comfort 2002: 136).

On the one hand, these video essays point to the precariousness of human life, its constant state of exposure and vulnerability; on the other, they also offer – in their intimate, self-disclosing and dialogic moments – modest possibilities for 'learning how best to handle this constant and necessary exposure' (Butler 2001: 24). As such, they represent variants of what Nicolas Bourriaud (2002a) called 'microtopian' art.[9] In his analysis of Varda's *The Gleaners & I*, Homay King argues that 'it would be a mistake' to let the melancholic aspects of Varda's subject (loss, death, the transience of time) 'distract from an equally important note the film sounds, which has to do with beginnings, becoming, and the possibility of the new' (2007: 426).[10] After all, Varda's heart-shaped potatoes do not only start to crinkle and mould; they also grow roots.

The possibility of the new gives value to Varda's gleaning activities, Elmas' epistolary address and High's telepathic moments as creative processes with a transformative function. This process bears the potential to give something that is invisible, marginalized, forgotten or designated as useless a new, meaningful existence. In creating the space for these moments or feelings to happen and to be shared lies an important political and ethical function of the personal essay in general and these video essays by women in particular.

Notes

1 In interviews, Varda has repeatedly stressed how important the audience is for the way she works (Romney 2009); see also Anderson 2001. The pleasure seems to be reciprocal: audiences have regularly applauded her at the end of a

screening and expressed their feelings of gratitude; enthusiastic mail has been generated (Callenbach 2002: 46). To keep the connection intimate and 'authentic', Varda sells her DVDs from her own shop in the Rue Daguerre in Paris, where she lives. Varda has self-ironically commented on this: 'It's like buying tomatoes directly from the farmer' (Romney 2009).

2 In 2002, a sequel to the film, *The Gleaners & I: Two Years Later* (*Les glaneurs et la glaneuse ... deux ans après*) was released, in which Varda revisits many of the characters who feature in *The Gleaners & I*.

3 This approach is often taken as a defining criterion of the essay; most prominently theorized by Theodor W. Adorno (1954–58) and György Lukács (1910).

4 The translation of this and subsequent passages are drawn from the film's English subtitles.

5 See Hesler 2009; Cruickshank 2007; King 2007; Bonner 2001; Biró and Portuges 1997.

6 See in this context, for example, Renov's typology of more recent 'video confessions' (2004: 191–215).

7 The quote was taken from a no longer existing website once available at http://www.otherturkey.tv/intention.php; last accessed on 30 May 2011.

8 This wish has repeatedly been described in literature on anthropomorphism (Siegel 2005: 216). At the beginning of the film, High's wish to penetrate Ernie's mind, to see (and thus understand) what causes his irritable behaviour, is inscribed in the way the camera scans his face in extreme close-ups, as if in search of an answer. Close-up shots of animal faces abound in *Animal Attraction*, reflecting the central position the face has in human interaction. Ernie often looks directly at the camera; it is an enigmatic look which – to a human viewer – suggests self-confidence but also unpredictability.

9 In *Relational Aesthetics*, Bourriaud claims that 'the role of artworks is no longer to form imaginary and utopian realities, but to actually be ways of living and models of action within the existing real, whatever scale chosen by the artist' (2002a: 13).

10 Homay King (2007: 426) links this thought correctly to Hannah Arendt's concept of 'natality'.

References

Adorno, Theodor W. (1991). 'The Essay as Form [1954–58]', in Rolf Tiedemann (ed.), *Notes on Literature*, vol. 1, translated by Shierry Weber Nicholsen. New York: Columbia University Press, pp. 3–23.

Anderson, Melissa (2001). 'The Modest Gesture of the Filmmaker: An Interview with Agnès Varda', *Cineaste* 26: 4, pp. 24–7.

Aufderheide, Patricia (2007). *Documentary Film: A Very Short Introduction*. Oxford: Oxford University Press.

Bertolino, Elisabetta (2008). 'Beyond Ontology and Sexual Difference: An Interview with the Italian Feminist Philosopher Adriana Cavarero', *Differences: A Journal of Feminist Cultural Studies* 19: 1, pp. 128–67.

Biró, Yvette and Catherine Portuges (1997). 'Caryatids of time: temporality in the cinema of Agnès Varda', *Performing Arts Journal* 19: 3, pp. 1–10.

Bonner, Virginia (2001). 'Beautiful Trash: Agnès Varda's Les glaneurs et la glaneuse', *Senses of Cinema* 45, 30 May. Available at http://www.sensesofcinema.com/2007/feature-articles/glaneurs-et-glaneuse/, last accessed 4 August 2012.

Bourriaud, Nicholas (2002a). *Relational Aesthetics*. Dijon: Les presses du réel.

——— (2002b). *Postproduction: Culture As Screenplay: How Art Reprograms The World*, second edition. New York: Lukas & Sternberg. Also available at http://www9.georgetown.edu/faculty/irvinem/theory/Bourriaud-Postproduction2.pdf.

Brown, Rosellen (ed.) (1994). *Ploughshares Fall 1994: Intimate Exile* (Ploughshares Series). Cambridge: Emerson College.

Butler, Judith (2001). 'Giving an account of oneself', *Diacritics* 31: 4, pp. 22–40.

Callenbach, Ernest (2002). 'The gleaners and I (Les glaneurs et la glaneuse)', *Film Quarterly* 56: 2, pp. 46–9.

Cavarero, Adriana (2000). *Relating Narratives: Storytelling and Selfhood*, translated and introduced by Paul A. Kottman. London/New York: Routledge.

——— (2002). 'Who engenders politics?', in Graziella Parati and Rebecca West (eds), *Italian Feminist Theory and Practice: Equality and Sexual Difference*. Madison Teaneck: Fairleigh Dickinson Press/London: Associated University Presses, pp. 89–103.

——— (2005). *For More Than One Voice: Toward a Philosophy of Vocal Expression*, translated by Paul A. Kottman. Stanford, CA: Stanford University Press.

Comfort, Juanita Rodgers (2002). 'The essay matters because the *essayist* matters: personal disclosures and the enactment of ethos in essays by black feminist writers', in Frederick J. Antczak, Cinda Coggins and Geoffrey D. Klinger (eds), *Professing Rhetoric: Selected Papers from the 2000 Rhetoric Society of America Conference*. Mawah, NJ: Lawrence Erlbaum Associates, pp. 130–6.

Cooper, Sarah (2010). 'Looking back, looking onwards: selflessness, ethics, and French documentary', *Studies in French Cinema* 10: 1, pp. 57–68.

Cruickshank, Ruth (2007). 'The work of art in the age of global consumption: Agnès Varda's Les Glaneurs et la Glaneuse', *L'Esprit Créateur* 47: 3, pp. 119–32.

Daston, Lourraine and Gregg Mittman (2005). *Thinking with Animals: New Perspectives on Anthropomorphism*. New York: Columbia University Press.

Ettinger, Bracha (2005). 'Copoeisis', *Ephemera: Theory and Politics in Organization* 5: X, pp. 703–13.

Haraway, Donna J. (2008). *When Species Meet*. Minneapolis: University of Minnesota Press.

Hesler, Jacob (2009). 'Playing with death: the aesthetics of gleaning in Agnès Varda's *Les Glaneurs et la Glaneuse*', in Jane Tormey and Gillian Whiteley (eds), *Telling Stories: Countering Narrative in Art, Theory and Film*. Newcastle: Cambridge Scholars Publishing, pp. 193–9.

Hoagland, Edward (ed.) (1999). *The Best American Essays*. Boston/New York: Houghton Mifflin.

Kehr, Dave (2008). '4 by Agnès Varda.' *The New York Times*, 22 January. Available at http://www.nytimes.com/2008/01/22/movies/22dvds.html?ref= movies, last accessed 4 August 2012.

King, Homay (2007). 'Matter, time, and the digital', *Quarterly Review of Film and Video* 24, pp. 421–9.

Lester, James D. (1996). *Diverse Identities: Classic Multicultural Essays*. Lincolnwood, IL: NTC Publishing Group.

Lopate, Phillip (1992). 'In search of the centaur: the essay-film', *The Threepenny Review* 48 (Winter), pp. 19–22.

——— (1994). *The Art of the Personal Essay*. New York: Doubleday.

——— (ed.) (1997). *The Anchor Essay Annual – The Best of 1997*. New York: Doubleday/Anchor Books.

——— (ed.) (1998). *The Anchor Essay Annual – The Best of 1998*. New York: Doubleday/Anchor Books.

Lukács, György (1978 [1910]). 'On the nature and form of the essay: a letter to Leo Popper', in *Soul and Form*. Cambridge, MA: MIT Press, p. 2.

Naficy, Hamid (2001). *An Accented Cinema: Exilic and Diasporic Filmmaking*. Woodstock: Princeton University Press.

Oates, Joyce Carol (ed.) (1991). *The Best American Essays 1991*. Boston/New York: Houghton Mifflin.

Obaldia, Claire De (1996). *The Essayistic Spirit: Literature, Modern Criticism, and the Essay*. Oxford: Clarendon Press.

Ozick, Cynthia (ed.) (1998). *The Best American Essays 1998*. Boston/New York: Houghton Mifflin.

Rancière, Jacques (2009). 'A few remarks on the method of Jacques Rancière', *parallax* 15: 3, pp. 114–23.

Rascaroli, Laura (2009). *The Personal Camera: Subjective Cinema and the Essay Film*. London: Wallflower Press.

Renov, Michael (2004). *The Subject of Documentary*. Minneapolis: The University of Minnesota Press.

Romney, Jonathan (2009). 'Step into my office: Agnès Varda's new career as an installation artist', *The Independent*, 4 October. Available at http://www.inde-

pendent.co.uk/arts-entertainment/art/features/step-into-my-office-agne-graves-vardas-new-career-as-an-installation-artist-1796261.html, last accessed 4 August 2012.

Russell, Catherine (1999). *Experimental Ethnography: The Work of Film in the Age of Video*. Durham, NC/London: Duke University Press.

Siegel, Sarita (2005). 'Reflections on anthropomorphism in *The Disenchanted Forest*', in Lorraine Daston and Gregg Mitman, *Thinking with Animals: New Perspectives on Anthropomorphism*. New York: Columbia University Press, pp. 196–222.

Jia Zhangke's Cinema and Chinese Garden Architecture[1]

Cecília Mello

This chapter proposes an analysis of director Jia Zhangke's films *The World* (*Shi Jie*, 2004) and *Cry Me a River* (*Heshang de Aiqing*, 2008) from the point of view of their spatial practice, leading to a reflection on cinema's impurity through its affinity with architecture, and more specifically with Chinese garden architecture.[2] Both *The World* and *Cry Me a River* take place in garden-like spaces within cities, respectively the World Park, located in the outskirts of Beijing, and the city of Suzhou, the so-called Venice of the East, whose classical gardens are listed as one of Unesco's World Heritage Sites. As I will argue, these films promote a form of spatial practice akin to that invited by a Chinese garden, where dislocation through space creates a series of views and a series of emotions in the visitor/tourist/viewer, interconnecting an external and an internal landscape.

The first part of the chapter will introduce some ideas regarding Jia Zhangke's work and the spatial relationship between film and gardens, including a brief summary of the history and the main defining features of a classical Chinese garden. The second part will focus on *The World*'s spatial organization in relation to two imperial gardens, built during the Qing dynasty, leading to a reflection on the rapport between gardens and the history of China, both ancient and recent. The third part, dedicated to *Cry Me a River*, will investigate the idea of film as promoting an emotional mapping of a garden-city, loaded with subjective and collective memories.

Cinema, Architecture, Gardens

Jia Zhangke can be described as an itinerant director. A brief look at his filmography, from his first feature film *Xiao Wu*, made in 1997 in his hometown of

Fenyang in Shanxi Province in mainland China, to his last film (to date) *I Wish I Knew* (*Hai Shang Chuan Qi*, 2010), dedicated to memories connected to the city of Shanghai, reveals a penchant for dislocation, mobility, transience. Jia has made films in different parts of his country, from the capital Beijing (*One Day in Beijing/You Yi Tian, Zai Beijing*, 1994; *Xiao Shan Going Home/Xiao Shan Hui Jia*, 1995; *The World*) to the county-level cities of Fenyang and Datong in Shanxi (*Xiao Wu*; *Platform/Zhantai*, 2000; *In Public/Gonggong Changsuo*, 2001; *Unknown Pleasures/Ren Xiaoyao*, 2002; *Useless/Wu Yong*, 2007); from Chendu in Sichuan (*24 City/Ershisi Cheng Ji*, 2008) to Feng Jie in the Three Gorges (*Still Life/San Xia Hao Ren*, 2006; *East/Dong*, 2006); and from Guangzhou (*Useless*) to Suzhou (*Cry Me a River*). Writing in the *Cahiers du Cinéma* in 2004, Jia referred to his errant nature by drawing a revealing if loose parallel: 'In the past, Chinese poets had the habit of composing poems on the road. In a similar vein, I very much love travelling, going to small towns or unknown villages' (2004: 22).

This itinerant quality seems to impregnate the mobile drive of Jia's characters. His films feature drifters through the urban space, epitomized by the character Xiao Wu in the eponymous film; travelling artists such as those in the theatre troupe in *Platform*; internal migrants from the so-called Chinese 'floating generation', who travel from distant provinces to big cities in search of work, as seen in *The World* and *Still Life*; as well as those moved by an unfulfilled desire to leave, such as the characters in *Unknown Pleasures*. Giving this question a social stance in the context of contemporary China's transformation, Zhang Zhen links Jia's own migrations to that of his characters in her introduction to *The Urban Generation*: 'Jia's firsthand experience (as opposed to ethnographic "fieldwork") as a migrant urban subject … have compelled him to place the "migrant-artisan" at the center stage of his cinema. As a result Jia has been called, admiringly, the "migrant-worker director" (*mingongdaoyan*)' (2007: 16).

As well as reflecting on the level of geography and the fable, the director's migrant nature has also come to define the mobile drive of his cinematic style, and this is perhaps the key to Jia's innovative filmmaking. In an irrefutable demonstration of the organic link between form and content, his films articulate the tension between mobility and immobility, time and space, old and new, past and future, and yet remain firmly rooted in the soil of contemporary China. Antony Fiant suggests that his work is structured upon a double questioning, dedicated to both China and cinema itself (2009: 14). Drawing from his master Hou Hsiao-hsien, whose *The Boys from Fengkuei* (*Feng Gui Laide Ren*, 1983) was referenced in *Still Life* and *The World* (Chinese version), as well as from Robert Bresson, Vittorio De Sica, Yasujiro Ozu, Chen Kaige and many others, Jia seems nevertheless to be the director of today, making films which work as a diagnosis of our times. He is also the most prominent director of a whole generation to emerge in 1990s China, the so-called 'urban generation' or 'sixth generation of

Chinese cinema', whose urban films contrasted with the epic grandeur of the 'fifth generation' landscape cinema.[3]

Jia's acute observation of the effects of China's economic reforms on the real urban spaces of the country and its people seems in tune with contemporary film theory's increased preoccupation with notions of space, mobility and the relationship between cinema and the city. Within the multiplicity of studies that have emerged in recent years, dedicated to single cities, urban directors, urban genres, as well as issues concerning modernity, cosmopolitanism and post-colonialism, the writings of Giuliana Bruno are specially original and inspiring given their broad-reaching and multidisciplinary scope. In her monumental *Atlas of Emotion* (2007a [2002]), Bruno highlights cinema's ability to set into motion an emotional journey through multiple spaces. She evokes Michel de Certeau's well-known phrase 'every story is a travel story – a spatial practice' to suggest that 'film is the ultimate travel story. Film narratives generated by a place, and often shot on location, transport us to a site' (1997: 46). Film viewing is thus, in Bruno's terms, 'an imaginary form of *flânerie*' (2007a: 16).

My take on Jia's garden-films espouses Bruno's contention of cinema as a spatial art, or at least one which is as much spatial as it is temporal. In thinking of space, I take it to be defined by its dynamic characteristics and by movement, distinct from the idea of representation or of a static moment in time with which it is usually associated. Doreen Massey, drawing on Henri Lefebvre's idea of space as product, argues for a conceptualization of space that incorporates this principle by suggesting that 'no spaces are stable, given for all time; all spaces are transitory and one of the most crucial things about spatiality ... is that it is always being made. The mobility of the cities is a hyperversion of spatiality in general' (1999: 231). From this premise that sees the cinematographic experience as promoting a journey through spaces, I endeavour to look at *The World* and *Cry Me a River* as spatial practices, departing from a real space and resulting in a new one, the filmic space, woven from the urban/garden sites/ sights and sounds in movement, and through which the characters and the viewers travel and feel.

Giuliana Bruno draws some of the initial questions explored in her *Atlas of Emotion* from Sergei Eisenstein's essay 'Montage and Architecture' (2010 [1938]), in which he reflects on the apparent paradox of the immobility of the film spectator, confronted with different fragments of the real space, filmed from different angles and brought together in the editing. What Eisenstein goes on to do is establish a parallel between the immobile cinema spectator faced with the mobility of film, and the mobile spectator of architecture, who traverses an immobile site. Both types of spectators have in common the experience of moving through spaces, and the consumer of the architectural space would be the prototype of the film spectator (Bruno 2007a: 56). Therefore, Eisenstein brings to the fore the importance of the mobile dimension of the apparently

immobile gaze of the film spectator, approximating cinema and architecture from the point of view of their spatial journey.

To speak of the visual sense as possessing a mobile quality is in consonance with a dynamic understanding of space. One can look at a map, a spatial representation, but space is only there when one traverses it, practices it (Lefebvre 1991; de Certeau 1984). Therefore, in film, space must be understood not as a static representation but as a mobile element, in constant mutation. This notion of spatial practice becomes clear when one thinks of the movement through a building, an architectural site, a city, a park, a garden. Eisenstein indeed builds his aforementioned essay on explorations of the Acropolis in Athens, conceived to be viewed from different angles and explored on foot, through various possible trajectories. This observation can be applied to landscape architecture in general, which creates spaces to be experimented through movement, through passage.

Giuliana Bruno has written on how, from the eighteenth century onwards, the idea of motion became more clearly linked with emotion within Western garden theory, and on how the garden became a 'privileged locus in this pursuit of emotive space':

> A memory theater of sensual pleasures, the garden was an exterior that put the spectator in touch with inner space. As one moved through the space of the garden, a constant double movement connected external to internal topographies. The garden was thus an outside turned into an inside, but it was also the projection of an inner world onto the outer geography. In a sensuous mobilization, the exterior of the landscape was transformed into an interior map – the landscape within us – as this inner map was itself culturally mobilized. (2007b: 24–5)

My intention is to look at how Chinese classical gardens from the Ming and Qing dynasties are structured in a way that offers the visitor a proto-cinematic experience, and at how *The World* and *Cry Me a River* incorporate this specific Chinese experience of space in their style. There are myriad types of Chinese gardens, varying geographically and in time, but they share some basic characteristics which I will broadly sketch here. As Lou Qingxi explains, the origins of the Chinese classical garden can be traced back to the country's ancient period. There are records of Chinese landscape architecture as early as the Shang Dynasty (1600–1046 BC), but it was not until the Qin and Han Dynasties (221 BC–AD 220) that the more specific practice of garden architecture originated. It reached its apogee during the Ming (1368–1644) and Qing (1644–1911) Dynasties, allied with important developments in the art of painting and accompanied by the first treatises on garden architecture (Lou 2003: 21).

One of the most distinguishing features of Chinese garden architecture is its conceptual nature. According to Lou, 'the hills, lakes, plants and buildings, and the spaces formed between them, create not only a material surrounding but also a spiritual atmosphere' (2003: 3–4). The two main elements in both Chinese landscape painting and garden architecture, the mountain (*shan*) and the water (*shui*), refer, according to the Confucian tradition, to the human attributes of benevolence and knowledge. Therefore, to build hills and lakes in a garden is to aspire to these attributes. Different plants such as the lotus and its flower, the pine, the plum tree and the bamboo are loaded with symbolic value and occupy a special place in Chinese gardens. Designers thus pursue the symbolic and the picturesque when building lakes, hills, paths, promenades and pavilions. They also take into account the two different modes of appreciating a Chinese garden: the static mode and the dynamic mode (Lou 2003: 125). For the first one there are strategically located buildings from where either a section of the garden or its entirety can be admired, allowing the visitor time to sit down and enjoy the view. The dynamic mode, which is the predominant one, follows routes that can be meandering – going up and down, from building to building, from mountain to lake, through corridors and windows that frame different views, with the landscape scrolling in front of the visitor as in a painting. As Pang Laikwan puts it,

> Just as the experience of reading traditional Chinese paintings is conditioned by the movements of the viewers' eyes, movement in space is also essential to the aesthetics of traditional Chinese gardens. A core aesthetic principle of the Chinese garden is the orchestration of constantly changing images created by the walking subject. (2006: 6)

This architectural promenade that sets in motion a series of picturesque views is enhanced by the sounds of birds and insects, by the smell of flowers, by the leaves brushing on the skin, by the different pavement designs aimed at producing tactile pleasure, all combined into an intense synaesthesia, in which the movement of the body and the movement of the mind work as a combined experience.

The relationship between Chinese garden architecture and cinema gains a new level of significance within China's early film scene. As Pang explains, research by Chinese film historians has revealed that the earliest film screenings in Chinese cities were held in a variety of places, including public gardens, and most commonly inside teahouses located in gardens. Pang investigates how this public space influenced and was influenced by cinema (2006: 3), and how the real movement of the walking subject was gradually replaced by imaginary movement: 'As if to catch up with the accelerated speed of capitalist life, the new garden experience had to pick up the pace, but it achieved this by replacing

bodily movement with various forms of visual entertainment, including motion pictures' (6). It is revealing to see how the ancient art of Chinese garden architecture and the nascent art of cinema crossed paths in the early years of the twentieth century, as if in confirmation of the affinity between what I have tried to establish as a Chinese proto-cinematic experience and the moving image. This affinity between the garden and the cinema is at the core of Jia Zhangke's first government-approved film, co-produced by the Shanghai Film Studio and released in China in 2004: *The World*.

The World: Gardens and History

Jason McGrath writes that, despite fears that Jia Zhangke's first government-approved film would have suffered at the hands of domestic censorship, 'the thematic consistency between *The World* and Jia's "independent" works has largely exonerated the director of the charge of compromising his vision' (2007: 107). It must be noted, however, that the film has two different versions, one Chinese (100 min.) and one international (140 min.). The shorter and slightly more linear version of *The World* was an intentional, albeit unsuccessful, attempt at reaching a larger audience in China. The following comments refer to both versions unless indicated otherwise.

 The World is Jia's second feature film shot entirely in digital (after *Unknown Pleasures*) by his long-time collaborator Yu Lik-wai. The film, structured in tableau-style with the use of intertitles, is complemented by sequences of flash animation motivated by text messages, exchanged with frequency by the characters. The director comments on how this 'digital ambience' served as a guiding force behind the film:

> Formally, I have tried to create a digital ambience at all levels: HD, flash animation, SMS, electronic music, etc. From the point of view of the narrative I aimed for a web structure. Instead of following one character in a linear fashion, I wanted to follow several characters, navigating from one to the other, from one's time to another's, just as we do online. (Jia 2005: 34)

The characters followed by Jia are the park workers Zhao Tao (Zhao Tao, the director's muse since *Platform*), her boyfriend Chen Taisheng (Chen Taisheng), Erxiao (Ji Shuai), Wei (Jing Jue), Niu (Jiang Zhongwei), Anna (Alla Chtcherbarkova), as well as Qun (Huang Yiqun), who runs a clothes factory, and Chen's hometown friends Sanlai (Wang Hongwei) and Chen Zhijung, nicknamed Erguniang (Little Sister), who came from Fenyang to Beijing to work in construction. True to the director's aforementioned statement,

The World unfolds as a web, suggesting a multiplicity of trajectories within the space of the World Park. Apart from the explicit reference to the Internet as a formal and narrative influence, I will attempt to approach the film's spatial practice from the point of view of its affinity with the multiplicity of trajectories also present in any Chinese garden, which too unfolds as a web, linked by paths, promenades and bridges. The fact that the film was shot almost entirely inside the Beijing World Park (*Beijing Shijie Gongyuan*, the Chinese word *gongyuan* meaning both public park and public garden), located in the outskirts of the capital and where a number of internal and foreign immigrants live and work, informs this choice of approach, in both formal and historical terms, a point to which I will return.[4]

What kind of space is the World Park? A neon sign glimpsed at some point in the film sums up its bold promise: 'Give us a day and we will show you the world.' The park is indeed an 'Epcot Center' of sorts, but while its American counterpart has 11 country pavilions the Beijing World Park boasts an impressive 106 reproductions of famous monuments in the five continents, scaled-down to 1/3 of their real size (Figure 1). There, the tourist can wander through the Taj Mahal, Big Ben, the Eiffel Tower, the Leaning Tower of Pisa, as well as gardens in different styles and reproductions of famous sculptures. In order to see the world the visitor can take a monorail, largely incorporated by Jia in his film to cross the park from pavilion to pavilion (Figure 2). Zhao, for instance, is seen inside the monorail in three sequences, travelling from country to country and talking on her mobile phone. In the first, she is dressed in Indian attire, following the dance performance which opened the film. The monorail's welcome announcement plays on the soundtrack and through the window it is

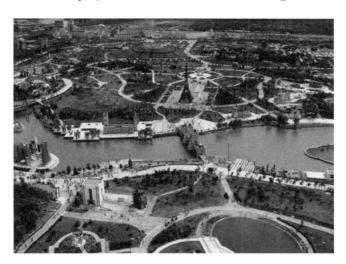

Figure 1: Aerial view of the Beijing World Park.

Figure 2: See the world by monorail without leaving Beijing, in The World.

possible to see the Eiffel Tower. Zhao answers her phone and says that she is on her way to India, reinforcing the notion of a world at one's reach. An exterior shot then reveals the monorail passing through from left to right, and Zhao waving to Erxiao from the window, followed by a tilt and pan downwards to reveal a group of security men carrying water-cooler bottles and crossing the Sahara desert, with the backdrop of the Egyptian Pyramids. The website address of the park (albeit an incorrect one)[5] and the phrase 'See the world without ever leaving Beijing' are then superimposed over the image of the pyramids, and a final cut reveals the park from a distance, a big lake occupying the foreground of the shot. The director's name and the film's title are superimposed over this image.

In this sequence it is possible to observe the type of spatial organization employed by Jia throughout the film: he shifts from the moving perspective of the monorail, lifted above the ground, to the ground-level perspective of Erxiao and the other workers crossing the desert, and finally to an establishing shot of the park. The monorail, which as explained by the ubiquitous announcement circles the park in 15 minutes, is also seen profusely in establishing shots of the park, travelling by in the distance. The presence of this device as a guiding path through the park/garden, complemented by the announcements which rein-force the touristy nature of the ride, relates to the peculiar structure of a corridor in Chinese gardens, which serves as a way of interlinking buildings, separating environments and accentuating the scenery by providing different perspectives to the visitor. The longest of these structures can be found in the last imperial garden built in China, the Summer Palace (Yihe Yuan), one of the greatest examples of Chinese Garden Architecture, located in the suburbs of Beijing (Figure 3). Its construction started in 1750 by order of Emperor Qianlong (1735–1799), and continued throughout the Qing Dynasty, being revived after its destruction by the Anglo-French allied forces in the nineteenth century by

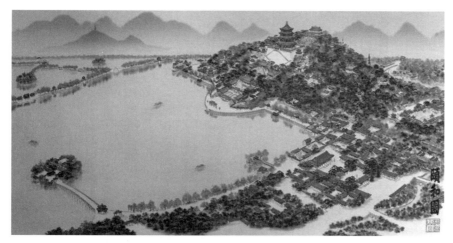

Figure 3: The Summer Palace in Beijing: China's last imperial garden.

Empress Cixi. The garden occupies over 700 acres, and there are around 3,000 different buildings carefully placed around its extension. The Summer Palace is an open space which offers a series of possible trajectories through squares, pavilions, temples, hills and bridges. The Long Corridor, also known as the Long Promenade (Chang Lang), guides the multiplicity of possible trajectories within the garden and extends for 728 metres. In its central part it spreads into four octagonal pavilions which symbolize the four seasons, bringing a temporal dimension to this architectural structure.

Here, the mobile spectator of architecture and the immobile film spectator share, to use Bruno's terms, the same mobile dynamics of site-seeing, becoming a voyager, an itinerant being who traverses a space. Furthermore, the Long Corridor at the Summer Palace contains a peculiarity which brings it even closer to a proto-cinematic experience: its beams and roof are covered with over 14,000 different pictures, painted inside semicircles and on different levels, which enhance the impression of depth. Some are reproductions of scenes from South China, painted by a group of artists commissioned by Emperor Qianlong to travel the country and bring him back its views. Others are images of flowers, fishes and birds. Particularly striking are the series of legends, folk tales and classical Chinese novels represented by these paintings, which offer themselves to be read as a narrative. The immobility of each 'frame' gains mobility through the visitor's dislocation, and as in cinema it is the sum of still frames that gives sense to them. But the 'editing' here does not result from the editor's action or the running projector, but from the movement of the spectator's body, a travelling body (Figure 4).

In *The World*, there are recurrent images of 'travelling bodies' inside various corridors, followed by the camera in a dolly-in or -out movement. Most

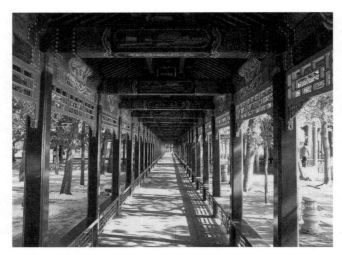

Figure 4: The Long Corridor crosses the Summer Palace and offers a proto-cinematic experience to the travelling visitor.

prominently, this mobile camera traverses the basement of the park's theatre, which serves as a massive dressing room for all the performers, interlinked by what appears to be a maze of corridors. The film opens with a long take of three minutes of Zhao moving along one of these corridors, looking for someone to lend her a plaster before going onstage. At least another six corridors will be tracked by the camera in the film, both inside the park and in external locations, such as the hotel in which Zhao and Chen meet and a karaoke bar. It is, however, the monorail which most resembles the 'long corridor' inside the Beijing World Park, guiding the visitors through the space, linking places and opening up views. Another device incorporated by the film's spatial practice in three different sequences is the lift inside the park's Eiffel Tower. In the first, Chen travels to the top floor, and from its vantage point the camera pans to a bird's-eye view of the park, dwelling on it. Inside the lift we learn the exact height of the tower: 108 metres. In a later sequence, Zhao takes the same lift and the recurrent announcement suggests: 'We hope this panoramic view will heighten your knowledge of the world.' Cars and buses are also employed by Jia in *The World* to convey varied views of the park, or to heighten the spectator's knowledge of it. Yet the director often shifts from a voyeur position to a street-level view of the park, especially by following groups of visitors on the ground, walking through, taking pictures and enjoying this off-scale world.

The profusion of vehicles in the film is related to one of its main themes, that is, the dichotomy between mobility and immobility, epitomized by the desire to contain the world in one space, and by the opposite dream of going abroad. Some characters indeed manage to travel to other countries: Zhao's ex-boyfriend

takes the train to Mongolia, Qun's French visa application is successful and the Russian immigrant Anna fulfils her dream of going to Ulan Bator, having had to work as a prostitute to save money, after her passport was apprehended upon her arrival in China.[6] Others, however, have never even seen a passport in their lives. There is no more symbolic presence, therefore, than that of the airplane, which features in two crucial sequences of *The World*. In the first, Zhao, dressed as an air stewardess, kisses Chen inside a static airplane, one of the park's features aimed at reproducing the experience and the 'profound beauty of air travel', as the announcement once again explains. The aircraft, which 'before retiring has linked China with the rest of the world for a long period of time', has been 'preserved in its original appearance', now firmly anchored on the ground, working as a visual sign of the mobility-immobility dichotomy. The park, therefore, not only contains the world but also reproduces the experience of mobility, forfeiting the need for the real journey. Curiously, the airplane resonates with another vehicle, a stunning Marble Boat stationed in the lake inside the Summer Palace.[7]

The tension between mobility and immobility is also felt in the second sequence of the film featuring an airplane, only this time one that actually flies: Zhao and Erguniang meet in a vast construction site, standing on the top of an unfinished high-rise, in a garden of sorts of armed concrete and rods. As they talk, an airplane crosses the sky and they exchange the following dialogue:

> Erguniang: Who flies on those planes?
> Zhao: Who knows. I don't know anybody who has ever been on a plane.

Zhang Yingjin links the recurrent motif of the airplane – as well as those references to having or not having a passport – to 'the migrant workers' frustrated desires and imagined freedom' (2010: 88). Zhao, for instance, had expressed to Anna how she envied her for having the opportunity to travel abroad. This desire to go beyond China's borders can be seen as a symptom of the country's unprecedented opening up towards the world initiated with Deng Xiaoping's Era of Reforms (*Gaige Kaifang*, 1978–1992). The effects of China's move towards market economy were felt with intensity in the urban spaces of the country, and Jia's work, as he has acknowledged in several interviews and essays in the past decade (see for instance Berry 2009; Fiant 2009; Jia 2009), is moved by an urgent desire to film disappearance, to register and to preserve – through cinema's unique recording ability – an ephemeral cityscape.[8]

The existence of a park such as Beijing World Park, however, points towards China's past as a millenary wall-building Empire, which prized its isolation from the rest of the world in place of the expansionist attitude behind other imperial forces in history. Testament to this defining trait of the Chinese Empire,

extraordinarily depicted by Jia in his film, is another Qing Dynasty garden called Yuan Ming Yuan, also known as the Old Summer Palace or the 'garden of gardens', which was burned down by the Anglo-French forces in 1860 during the Second Opium War. This garden, which impelled Victor Hugo to write 'even all the treasures of all our cathedrals do not compare to this sumptuous and magnificent museum of the East' (1861),[9] brought together architectural characteristics of the Han, Mongolian and Tibetan ethnic groups and reproduced landscapes from different areas of the country. The Yuan Ming Yuan, which while standing served as the official residence of the Qing Dynasty Emperors outside the Forbidden City, was formed by over 150 different landscapes, little gardens within one garden, like a museum of the art of garden design. It also referenced Western architecture by including a group of European-style buildings, designed by Jesuits Giuseppe Castiglione and Michel Benoist by order of Emperor Qianlong. Such a garden made of gardens reproducing different parts of the world can be adequately described as an instance of heterotopia, defined by Michel Foucault (1986) as a space which contains all other spaces. Foucault actually includes all gardens – as well as the theatre and the cinema – as instances of heterotopia:

> *Third principle.* The heterotopia is capable of juxtaposing in a single real place several spaces, several sites that are in themselves incompatible. Thus it is that the theater brings onto the rectangle of the stage, one after the other, a whole series of places that are foreign to one another; thus it is that the cinema is a very odd rectangular room, at the end of which, on a two-dimensional screen, one sees the projection of a three-dimensional space; but perhaps the oldest example of these heterotopias that take the form of contradictory sites is the garden. We must not forget that in the Orient the garden, an astonishing creation that is now a thousand years old, had very deep and seemingly superimposed meanings. The traditional garden of the Persians was a sacred space that was supposed to bring together inside its rectangle four parts representing the four parts of the world ... The garden is the smallest parcel of the world and then it is the totality of the world. (1986: 25–6)

It is so that Yuan Ming Yuan's distinctive quality, mirrored by the Beijing World Park, can be seen as an exaggeration of what Foucault has defined as a heterotopic desire: to bring the world to China, rather than to see or conquer the world (Figure 5). Here, Mongolia, landlocked between China and Russia, acquires a special significance in the face of the Great Wall built by the Chinese to protect their territory from invasion. In *The World*, Zhao's ex-boyfriend takes a train to Mongolia, and Anna manages to board a plane to Ulan Bator. But in the Chinese version of the film the city seems more unreachable, for Anna is

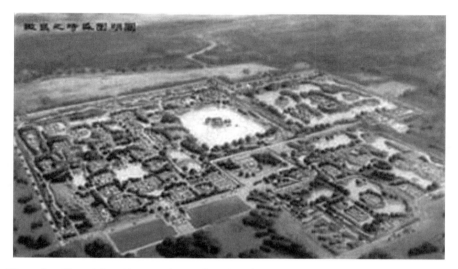

Figure 5: Yuan Ming Yuan *or the 'garden of gardens': a heterotopic desire to bring the world to China.*

not seen inside the plane. Ulan Bator exists only in one intertitle, on the television weather broadcast and in a song. The intertitle – Ulan Bator Night – appears significantly at the end of a sequence in which the park workers joke around with a pair of binoculars: 'Doesn't Niu look like Columbus?', says his girlfriend Wei, and the group runs out into the night to admire the city from a roof terrace, to shouts of 'climb to the top to see the new world'. Zhao is then seen on her own, wearing a Russian hat and looking through the binoculars at Beijing, but as the camera pans right into the city's skyline the words 'Ulan Bator Night' appear superimposed, as if she could see Mongolia in the distance, beyond the Great Wall.

'Ulan Bator Night' ('Ulaanbaataryn Udesh') is in fact the name of a Mongolian romantic song. It is first heard in its Mongolian version as sung briefly by Anna to Zhao over a drink at the park's restaurant. Anna sees the weather forecast on the television, picks up the name Ulan Bator amidst the Mandarin she cannot understand and tells Zhao, in Russian, how she dreams of going there to meet her sister. She then sings 'Ulan Bator Night' to her friend, significantly finding a way to connect her Russian (incomprehensible to Zhao) and Zhao's Chinese (incomprehensible to her) through something which comes from between the two, that is, a Mongolian song. This is followed by a long take of the two friends travelling in an open-roof vehicle through the park at night. In the international version of *The World* the song is then heard instrumentally, but in the Chinese version it is the Mandarin translation which plays in the soundtrack.

Within the context of this analysis, it could be argued that the Mandarin translation of a Mongolian song reconfirms the Chinese habit of taking foreign things and turning them Chinese. This is explicit in the desire to bring the world to China by copying monuments, historical sites, as well as designer clothes and accessories, as seen in Qun's clothes' factory, specializing in faking designer labels. One of the triumphs of *The World* is therefore to introduce a historical dimension to the contemporary issue of mobility and immobility pervading the characters' lives, in a moment when the China of Great Walls and Forbidden Cities opens up to the world. And it achieves this through a sophisticated spatial organization akin to Chinese garden architecture, epitomized by the imperial gardens Yihe Yuan and Yuan Ming Yuan, and by a contemporary equivalent, the Beijing World Park.

Cry Me a River: Gardens and Memory

If in *The World* Jia achieves an insightful diagnosis of China's contemporary reforms and its imperial past, in *Cry Me a River*, vaguely inspired by Fei Mu's 1948 classic *Spring in a Small Town* (*Xiaocheng zhi chun*), he introduces the dimension of memory as both a spatial and temporal phenomenon, and as both a subjective and collective experience. *Cry Me a River*, whose original title in Mandarin translates as 'river of love', is a 20-minute film shot in the city of Suzhou, where old friends Ma Qiang (Guo Xiaodong), Zhou Qi (Zhao Tao), Tang Xiaonian (Wang Hongwei) and Bai Yu (Hao Lei) reunite for a dinner in honour of their university teacher, ten years after graduation. Throughout the film, it becomes increasingly clear that the four friends were once two couples, now estranged and leading separate lives with new partners.

As mentioned in the beginning of this chapter, the garden-city of Suzhou is one of China's main tourist destinations, renowned for its picturesque canals – which supposedly reminded Marco Polo of his hometown – and its classical gardens from the Song, Yuan, Ming and Qing dynasties. This unique location was by no means a random choice, and it plays an important role in the construction of a filmic space conductive of memories as connected to space and movement. On one level, it is the trip back to Suzhou that reawakens subjective memories in the four characters. Apart from the bachelor Ma Qiang, who still lives there and teaches at the university, the other three friends – all married with children – have travelled from other parts of China to attend the event: Zhou Qi from Shenzhen, Tang Xiaonian from Nanjing and Bai Yu from Hefei. Ultimately, though, it is the cinematic journey *through* Suzhou that will function as a conveyor of memory on more than one level, as the following comments will attempt to demonstrate.

In *Public Intimacy: Architecture and the Visual Arts*, Giuliana Bruno refers to film as an 'art of memory': 'In its memory theater, the spectator-passenger, sent on an architectural journey, endlessly retraces the itineraries of a geographically localized discourse that sets memory in place and reads memories as places. As this architectural art of memory, filmic site-seeing ... embodies a particular mobile art of mapping: an *emotional* mapping' (2007b: 23–4). In *Cry Me a River*, Jia Zhangke, assisted by elements of Chinese garden architecture such as pavilions, lakes, paths and prominently the city's canals, draws an 'emotional mapping' of Suzhou through a sort of filmic site-seeing. It is thus that a film which deals with remembrance and the passing of *time* promotes an 'architectural journey' through a specific *place* – the garden-city of Suzhou – which works as a vehicle for memory. This journey therefore highlights memory's spatial dimension, for as Edward Casey suggests, embodiment is a necessary condition of remembering, and embodiment points towards a place: 'as embodied existence opens onto place, indeed *takes place in place* and nowhere else, so our memory of what we experience in place is likewise place-specific' (2000: 182). Memory is thus a point of connection between the event remembered, the person remembering it and the place of the remembered.

Cry Me a River unfolds in 19 shots and eight main sequences, alternating from Ma Qiang's flat, the university, two different garden pavilions and the city's canals. The first half of the film sets the tone for the two final sequences, in which the former couples each go a different way and share an intimate conversation. The film opens with two shots of Ma and Tang playing basketball under the watchful eyes of Zhou and Bai. The courtyard is surrounded by trees and in the distance it is possible to glimpse Huqiu Tower (aka Yunyan Pagoda) sticking out from Tiger Hill, one of Suzhou's main tourist attractions. A faint classical Chinese tune can be heard in the distance, complementing an ambience which points not only to the characters' shared past but also to the country's own past and cultural heritage.

The four friends are next seen inside Ma's flat, taking turns to check their eyesight with an optometrist poster. As Ma and Zhou leave the room, Tang and Bai chat about the journey to Suzhou:

> *Bai*: How did you come?
> *Tang*: High-speed train.
> *Bai*: Your driver didn't bring you?
> *Tang*: It only takes two hours.
> *Bai*: Two hours? From Nanjing to here? Not four hours?
> *Tang*: You still remember that!
> *Bai*: I have a good memory.

From this brief dialogue, it becomes clear that certain things have changed since the two were in college together: trains, for one, are now twice as fast as

they once were. Tang has become a rich man, and might even have his own driver. And the two are not as close as they once were. Bai's final retort – 'I have a good memory' – also relates to and anticipates the film's main motif. Outside the flat, in the communal balcony which links the different apartments, Ma washes his hair in a sink, with Zhou observing from a distance. She finally approaches him and folds his jacket's hood to prevent it from getting wet. Here, it is her gesture, rather than dialogue, which reveals their previous intimacy, lost with the years.

The third sequence consists of a tracking shot of the four friends walking along one of the city's canals, taken most probably from a boat moving at a similar pace. A faint Chinese classical tune once again plays in the distance, fusing in the soundtrack with the sound of running water. Three shots will then convey the dinner scene, which happens inside a garden pavilion built over a lake. The pavilion is an ornamental building opening towards the landscape and framing its views, and its architectural peculiarities are incorporated by Jia Zhangke into the film in an original way. The first shot, for instance, is a static long take framed by what appears to be a small glass window inside the pavilion opening towards the dinner table. It has an intricate layout of frames (the camera's, the smaller window in the foreground and the door in the background opening up to the garden), the water outside and the silk curtains inside complementing an atmosphere of recollection. The next two shots of the dinner scene are taken from outside the pavilion. The first one shows the dinner guests through the window, tracking from right to left to reveal two Kun opera singers in traditional clothes, performing on the deck which extends over the lake. In the distance, the sights and sounds of running traffic work as a reminder that gardens are essentially an urban space, located within or just outside cities, and functioning as a bridge between the city and the countryside. A third shot then reveals a complete picture, the pavilion adorned with lights, the musicians, singers and diners all in frame, with the intricate architecture of the roof sculpting the night sky and the film's frame.

After dinner, the friends return to their old college to play mah-jong, and their conversation revolves around getting old, their kids and generational differences. Finally, the three final sequences will reveal how the movement through the city in a boat and through the garden sets in motion the landscape within the characters, reawakening their memories which are still in the present and contained in that space. To introduce this 'architectural journey', Jia weaves four shots of Ma, Zhou, Tang and Bai travelling down one of the city's canals inside a traditional boat, in complete silence. Together, these shots make for a harmonious composition, starting with a frontal view of their boat in movement, as seen from another boat also travelling down the canal. This cuts to a much closer shot in which the boat's ornate roof coincides with the film edge, framing the four friends who are absently staring at the distance. With a

break of the axis the next shot brings what could be a subjective point of view from inside the boat, with a frontal view of the canal and of the rain which disturbs its surface. Finally, another shot shows the group from the back of the boat, only with a different canal in front of them, completing a 180-degree depiction of this introspective boat trip. As they are silent, it is in fact the style of the film which emphasizes the idea of a journey evoking subjective memories. The temporal element is contained in the movement of the water which makes up the streets of Suzhou, in what could be read as a reference to the Confucian kinship between the passage of time and the flowing of water. Yet it is the experience of dislocation through space which seems loaded with memories and emotions.

This is corroborated by the two final sequences of *Cry Me a River*. The first couple, Ma and Zhou, stay in the boat travelling down the canal. Their dialogue is conveyed by a long take of over two minutes, with the camera pans replacing the cuts of a conventional shot/reverse-shot structure. Zhou tells Ma that she sometimes wonders how he spends his evenings. He in turn tells her: 'I'm with you every day. In the ten years since we graduated you are the one I dream of.' Elsewhere, Tang and Bai walk through one of Suzhou's famous gardens (Figure 6). They come down a path towards a lake and sit inside a pavilion, once again used by Jia as a means of reframing his characters in a picturesque way. They share a moment of intimacy and open up about their marital frustrations. The element of water is yet again present, but here the placidity of the garden lake is only disturbed by a rock which Tang throws into it, producing a series of ripples which reverberate for almost one minute. The final shot of the film reveals the

Figure 6: Gardens and memories in Cry Me a River.

group once again inside the boat travelling down the canal. 'Love Song 1990' by Taiwanese pop singer Luo Dayou then plays over the credits.

It is interesting to notice how for the first time Jia Zhangke focuses on middle-class characters, now leading comfortable lives and travelling for leisure rather than in search of work. Throughout the dinner in honour of Professor Ji, organized and sponsored by a certain Mr Chen, it transpires that the four friends were once idealist students who wrote poetry and edited a magazine called *This Generation*. Mr Chen comments on how he remembers the magazine – which only had one number – and quotes from Tang's editorial which read 'the end of *This Generation* does not mean the fall of our generation'. He complements the recollection by saying he was in college in Wuhan in the 1990s, and that he too was a 'hot-blooded young man'. Now he is in business and no longer hot-blooded, but claims to have a good heart. As mentioned before, the film deals with the issue of getting old and with frustration on a personal level. However, it becomes increasingly clear that it also touches on the passing of the dreams of a whole generation, which were suppressed and replaced by today's material ambitions. Tang is now a rich man, most of them are married with kids, they no longer write poetry and, despite what the magazine's editorial proclaimed, their generation also seems to have fallen under the sway of the imperatives of money and social conventions.

Cry Me a River therefore tackles not only personal but also collective memories and frustrations. And it goes beyond that by putting the garden-city of Suzhou at the centre of this spatial and temporal journey, back to a time when dreams were still possible. Suzhou appears as a symbol of lost loves, lost ideals, lost poetry, lost dreams and ultimately a lost past, not only of four friends or of a generation but of a whole country. Its millenary gardens, pagodas, pavilions, canals, as well as the Kun opera singers and the classical tunes heard in the distance, all seem to point to China's past, suppressed by years of a regime which insisted on restarting history and on never looking back. And so it is that the journey undertaken by these friends to a place like Suzhou, where the past is still very much present, not only reawakens love memories but also their youthful political dreams. What the film ultimately seems to suggest, through its emotional remapping of Suzhou, is that China's new generation of ambitious businessmen risk losing touch with its cultural heritage, or that financial ambition, perhaps as much as political oppression, is incompatible with utopia.

To conclude, I would say that these instances of filmic psychogeography reveal cinema's impurity through the close parentage with the art of architecture, and in the specific cases of *The World* and *Cry Me a River* with the art of Chinese garden architecture. By leaning on gardens, a heterotopic combination of natural world and human creation somewhere between the city and the countryside, director Jia manages to remap Suzhou, Beijing and the 'whole world' from the point of view of his characters' memories and emotions, who

traverse and contemplate a real space, reworked into the filmic space. I believe the focus on this culturally-specific instance of impurity is helpful to an understanding of these films from a historical, spatial and memorial perspective. And it also works as a testament to director Jia's urgent and poignant reflections on his country's – and on cinema's – present, future and past.

Notes

1 Research for this chapter was funded by FAPESP (São Paulo Research Foundation), Brazil.
2 The pinyin romanization system has been used throughout the chapter, with the exception of Hou Hsiao-hsien (Wade-Giles romanization, in use in Taiwan), Pang Laikwan and Yu Lik-wai (Jyutping romanization, in use in Hong Kong for Cantonese). The Chinese norm of placing the surname before the name has been kept, abbreviated to the surname in future references. The first two given names (except Hou's and Yu's) have been spelt without a hyphen.
3 Zhang Zhen contests this and proposes that 'the appearance in the late 1990s of Jia Zhanke and his films *Xiao Shan Going Home* (1995), *Xiao Wu* (1997), and *Platform* (2000) inaugurated a different phase in the independent movement that effectively ended the era of the Sixth Generation' (2007: 15).
4 Another park, located in Shenzhen and called Window of the World (Shi Jie Zhi Chuang), was also used as location in the filming of *The World*.
5 The correct website is www.beijingworldpark.com.cn and not www.worldpark.com.
6 In the Chinese version Anna's passport apprehension by her Russian 'agent' is not shown, neither is the scene in which she sits on a plane to Ulan Bator.
7 The use of immobile vehicles is recurrent in Jia's cinema, as Michael Berry points out in *Jia Zhangke's 'Hometown Trilogy'* (2009: 116).
8 I explore this peculiarity of Jia's cinema in my forthcoming book *Movement and Urban Spaces in Contemporary World Cinema*.
9 Victor Hugo never saw the actual garden, but the incursion by troops of his country into China and the subsequent destruction of the garden impelled him to write a letter of protest.

References

Beijing World Park (Beijing Shi Jie Gong Yuan). Available online at http://www.beijingworldpark.com.cn/ (last accessed on 13 August 2012).
Berry, Michael (2009). *Xiao Wu/Platform/Unknown Pleasures: Jia Zhangke's 'Hometown Trilogy'*. London: BFI-Palgrave Macmillan.
Bruno, Giuliana (1997). 'City Views: The Voyage of Film Images', in David B. Clarke (ed.), *The Cinematic City*. London: Routledge, pp. 46–58.

—— (2007a [2002]). *Atlas of Emotion: Journeys in Art, Architecture and Film*. New York: Verso.

—— (2007b). *Public Intimacy: Architecture and the Visual Arts*. Cambridge, Mass./London: The MIT Press.

Certeau, Michel De (1984). *The Practice of Everyday Life*. Berkeley: University of California Press.

Eisenstein, Sergei (2010 [1938]). *Towards a Theory of Montage:* vol. 2, edited by Michael Glenny and Richard Taylor. London: I.B.Tauris.

Fiant, Antony (2009). *Le cinéma de Jia Zhang-ke: No future (made) in China*. Rennes: Presses universitaires de Rennes.

Foucault, Michel (1986). 'Of Other Spaces', *Diacritics* 16, pp. 22–7.

Hugo, Victor (1861). 'Lettre au capitaine Butler'. Available at http://www.monde-diplomatique.fr/2004/10/HUGO/11563, last accessed 13 August 2012.

Jia, Zhangke (2004). 'Paroles de Jia Zhangke: Les trois révolutions du numérique', *Cahiers du Cinéma* 586, January, pp. 20–4.

—— (2005), 'Entretien avec Jia Zhang-ke: Ce temps-là a disparu', *Cahiers du Cinéma* 602, June, pp. 33–4.

—— (2009). *Jia Xiang 1996–2008*. Beijing: Peking University Press.

Lefebvre, Henri (1991). *The Production of Space*, translated by Donald Nicholson-Smith. Oxford: Blackwell.

Lou, Qingxi (2003). *Chinese Gardens*, translated by Zhang Lei and Yu Hong. Beijing: China Intercontinental Press.

Massey, Doreen and Lury, Karen (1999). 'Making Connections', *Screen* 40: 3, pp. 229–38.

McGrath, Jason (2007). 'The Independent Cinema of Jia Zhangke: From Postsocialist Realism to a Transnational Aesthetic', in Zhang Zhen (ed.), *The Urban Generation: Chinese Cinema and Society at the Turn of the Twenty-first Century*. Durham/London: Duke University Press.

Pang, Laikwan (2006). 'Walking into and out of the Spectacle: China's Earliest Film Scene', *Screen* 47: 1, pp. 66–80.

Window of the World (Shi Jie Zhi Chuang). Available at http://www.szwwco.com/, last accessed on 13 August 2012.

Yuan Ming Yuan Park (Yuan Ming Yuan). Available at http://www.yuanmingyuanpark.com/, last accessed 13 August 2012.

Zhang, Yingjin (2010). *Cinema, Space and Polylocality in a Globalizing China*. Honolulu: University of Hawaii Press.

Zhang, Zhen (2007). 'Introduction: Bearing Witness: Chinese Urban Cinema in the Era of "Transformation"', in Zhang Zhen (ed.), *The Urban Generation: Chinese Cinema and Society at the Turn of the Twenty-first Century*. Durham/London: Duke University Press.

Chapter 12

Amidst Landscapes of Mobility: The Embodied Turn in Contemporary Chinese Cinema[1]

Haiping Yan

China is in the midst of an intensifying movement of urbanization. As miles and miles of new cities are being built over different regions of the country, massive migrations from rural areas and across urban China are increasing in speed and scope, re-drawing the physiognomy of the land and patterns of relations among its inhabitants. Registering crucial social changes occurring in the life-world, such a re-drawing has also been fuelling many kinds of innovation in the realms of the arts. In analysing two Chinese films produced in the first decade of the twenty-first century, this chapter traces the specific ways in which these films leverage and reassign the functions of various tropes of being mobile in the world across established media in cultural production without caving into but, rather, remaining at odds with the logic of global capital and its 'liquidating' motions of spectacle industry (Benjamin 1992: 221–2). The chapter offers a further argument on how a distinct aesthetic arises therein, intimating what may be called an 'embodied' intermedial turn in contemporary Chinese cinema involving critical implications for the making of the arts and its possible efficacy.

The City Openings: *Shanghai Trilogy*

As one of the cities emblematic of urban China and China's urbanization, Shanghai has long been engaged by contemporary artists as a primary site for aesthetic innovations. Filmmakers since the 1990s in particular have traversed

the actual city and rendered its multifaceted existence into a field where tropes of being mobile arise in competition to display their ingenuities. *Shanghai Trilogy*, directed by Peng Xiaolian, and comprising *Shanghai Women* (*Jiazhuang men ganjue*, 2002), *Shanghai Story* (*Meili Shanghai*, 2004) and *Shanghai Rumba* (*Shanghai Lunba*, 2006), provides an entry for my discussion. The first film of the trilogy, *Shanghai Women*, features a clear-eyed schoolgirl named Ah Xia (meaning 'morning dew') and Mama (Ah Xia's mother), a soft-voiced school teacher. As Mama manages to break away from her first husband, Ah Xia's biological father, along with his saga of extramarital affairs, Ah Xia struggles through much of the painful confusion both inside her and the world around her. After Mama's second marriage of convenience breaks down, the two women begin a search to actively relocate themselves in the city. The film ends when Mama and Ah Xia find a room of their own, paid for with Mama's modest salary and the settlement fees that the court ruled as a result of her divorce from her first husband.

The film is a cinematic adaptation of *Turning Seventeen*, an award-winning short fiction authored by Xu Minxia, one of the 'new literary talents' of the 'post-1980s generation' in Shanghai (Xu 2000, 2006). Comprised of a first-person narrative, the text delineates its title character's psychological maturation, starting with a crisis precipitated by a moment of loss and ending with a crystallized sense of re-relating to the social forces in her world. Rendered with intricate nuances, the work nonetheless can be seen as a conventional instance of *Bildungsroman* literature in a feminine mould, constitutively gendered even in the most acute moments of its striving to transcend the pain of 'lack' caused by the departure of the father, a condition predetermined by the assumption of the 'blissful' nature of heterosexual marriage and parentage. In the final paragraph of the text, the first-person narrative reaches the point of individuation for the title character with contemplation on whether 'I will attend his funeral if father dies'. The answer that ends this female *Bildungsroman* is '... and I will'. A gesture of moving beyond the need for the presence of the biological father, it is laden with implications that female dependency is curable only through a 'mature' reconciliation with the given in the shape of an enhancement of the capability of accepting its structural condition: 'Happiness is not going to actualize itself just because of my wish' (Xu 2006: 114–20). Ostensibly, *Shanghai Women* remains framed in such a structure of pain at work in the text. Its cinematic rendition however is doubled by a visual mobilization of a constellation of architectural entities existent in the city of Shanghai. That such a doubling engenders a 'built environment' of sorts calls for critical attention, as does its ways of activating the energies concealed within the literary text and/or vibrant beyond its textual limits.

This 'built environment' is first of all enacted with three settings of urban domesticity, the graphic materiality of which does not appear in the textual

flow of the story. Of the 94-minute span of the film, approximately one-third consists of scenes shot in residential units. The first occurs in the apartment that Ah Xia considers as 'natural home' with her biological parents. Its textural environment, registered in such details as floral wallpaper, framed prints of oil paintings on the wall, stylish curtains and furniture, indicates the status of an affluent family in accordance with contemporary fashion. The end of this scene sends Mama and Ah Xia out onto the street, and leads them into the second domestic site where Mama's mother lives in a crowded and run-down building. With its stone-framed doorway, this building is representative of a feature architecture – characteristic of 1890s Shanghai in particular – with its European-designated concessions, suggesting a physical articulation of the existence of certain Chinese urbanites dating back to that era or the idea of such urbanity surviving the often war-torn years of modern Chinese history. This is where the old residents of Shanghai amid its present new cosmopolitanization find themselves in relatively declining economic conditions. Old Mother shelters Mama and Ah Xia but only for a short while, for the place is to be inherited by Mama's young brother, the family's male heir who is about to get married. Mama brings Ah Xia into a third domestic site by virtue of her marriage with Old Lee, a hard-working man whose wife died of an illness while leaving him a teenage son. The limited physical size of Old Lee's apartment with its similarly constrained mindset for what constitutes life affords 'a family of four' a measure of stability with little else. Mama's attempt to bring a feeling of care into the site only exasperates the sense of its physical limits and triggers a confrontation between Ah Xia and Old Lee, speeding up the breakdown of the arrangement.

Distinct in terms of their indexed economic status, these three interiors enunciate themselves as exponents of a Chinese 'middle class' historically evolved, and culturally imaged, in relation to the city of Shanghai. Some critics try to examine how these interiorities in *Shanghai Trilogy* are filmed with an acute awareness of specific, distinct Shanghai attributes. Others suggest that such awareness informs the viewers about how 'Shanghai' looks through Peng Xiaolian's fascination with the life – or the idea of the life – of a Chinese middle class specific to the history of Shanghai, be it imaginary or actual, aborted or otherwise, a temporal past that is also an ideologically specific trope for the present Chinese society in change. For the purposes of the discussion here, suffice it to note that the domesticity of a Shanghai middle class in the film designates a condition of interior stasis and a state of being etiolated, as well as an impetus to open up onto the outside. Peng Xiaolian's cinematic lens often seems an usher that does more than follow Mama and Ah Xia out of those domestic sites that variably fail them. Instead of leading towards and culminating in a closure similar to 'the state of maturity' governed by a developmental *telos* in a *Bildungsroman* tale, the camera actively rides on such an impetus to engage the streets outside, effecting significations in contrast with the tension-ridden

interior scenes, displacing the centrality of the structure of lack if not dispersing its operation in the process of employing it.

One example among many can be found in the scene after Mama refuses to be part of a gendered, exploitative establishment and walks out of the apartment taking Ah Xia with her. The camera follows the women and takes on an enlivened dynamic, striking open a prolonged moment with a long shot of a street space filled with various motions. Ah Xia, having taken leave of all the given definitions of her life, now pushes her bicycle laden with motley utensils, walking with her mother right into the crowds of people, cars, trucks and bicycles. Contrary to the scene of crisis in interiors of stillness, Ah Xia moves on the city streets in broad day light with supple and activating strength. A wash-basin falls from her bicycle. Ah Xia stops. A truck speeds by and runs over the wash-basin. Mama walks over, picks up the battered object, and scrutinizes it as if scrutinizing an eliminated life. Ah Xia joins her. The two stand on the sideway and gaze at the wash-basin, static when all around them is moving, until the object un-conceals itself, as it were, as a revelation of some sorts about the nature of what they have left behind: Mama and Ah Xia burst into laughter, take a look at each other and move on. The scene that follows 'Granny's lecture' is another example. On the pavement outside the studio where Mama and Old Lee have just taken their wedding photo, Ah Xia stops Mama. Facing a high volume of traffic speeding by, she initiates a delicate exchange on questions about 'leaving father', 'marrying again' and the 'feelings' involved therein. Mama answers all the questions gently but directly. The two women, again, simply move on. The moments normally considered as the most private are filmed in such a way that they intersect and merge with the most public streets, leading to a series of long shots and close-ups, tracing a mobile Ah Xia in a fluid environment, with Mama, schoolmates and neighbourhood teens, or alone, a presence of not only contemplation but active assertion in the sound and fury of the city. A further example can be seen in Ah Xia's confrontation with Old Lee and its ramifications. The incident is triggered when Old Lee sees the monthly water bill and flies into a rage: for him, Mama and Ah Xia are wasteful; for Ah Xia, who is weary of his imposing his authority – predicated upon his ownership of the property where they all live – upon the family members, this is the last straw. In the midst of a confused and disturbing exchange, Mama and Ah Xia hit the streets, getting into a taxi with no idea where to go. A cooling-down Old Lee runs after them and, thinking that his 'frugality' is the issue, tries to make up for it by paying the taxi driver a roll of money. Mama pauses. She knows that she and Ah Xia can have only one place to go (her aged mother's) which is no place for them: 'Old Lee's life is not easy, alone and with a child.' Ah Xia replies: 'You can decide not to live with my father, why cannot I decide not to return to the Lees place?' The camera takes the cue of this enunciation by making a long shot of the actual city at night wherein the taxi moves into its

depth, a dynamic measurement of an otherwise repressed impulse for human equality in motion and beyond the limits of economic ownership. The city that lives at night with flickering street lights in rain, framed with a deep focus, hereby constitutes a palpable space that carries, enables and sustains human mobility, as an intermedially 'built environment' that is an embodied opening for social possibilities

One might caution oneself here against possible predilections to privilege the cinematic as a distinct medium with the inherent capability of mobilizing 'energies of reality' beyond the limits of established modes or genres of representational visibility. In the wake of post-structuralist movements over the past decades, where indistinctness of modes and genres arises as a problem of complicity in relation to the flattening motion of the global capital (Krauss 2000), such predilection can be a version of retreat to the laws of genres in the bygone 'age of purity'. *Shanghai Women*, however, jars any such attempt to evade the contemporary moment. Its cinematic apparatus engages architectural entities of the actual city in such a way that it foregrounds an inherent intermediality in the cinematic environment so built, with a distinct material texture and humanly-inhabited ethos. While the interiorities in the film are all constructed sites for film shooting and can be considered as artefacts, the lanes where those interiorities are indexed as being located are real architectural entities of the city where people reside. Granny's second-floor flat, for instance, is filmed in a location administrated by the Shanghai Film Studio and the Cinema–TV Corporation of Shanghai. The lane that situates the flat in the film, by contrast, is in a residential area in Hongkou District designated for preservation due to the historical value of its architecture. Such a lane and other similar entities leveraged in the film, one may argue, registers a feature of the 'built environment' evocative of the living organs of the city. The building that supposedly holds Old Lee's apartment is another actual architectural entity in Hongkou District, styled with a touch of early modern Italian architectonics particularly in the shape of its long hallways with their vaulted ceilings. After showing how Old Lee's apartment assures a social order and depletes the humanity ordered therein, driving Mama and Ah Xia out of it, the camera cuts to a shot of Old Lee running after them. The long hallway that he runs through is the actual hallway of this Italian residential building, so filmed to reveal a different space leading to the open streets. While Granny's flat is both the most empathetic and repressive, where Mama is recognized but only as an unwise failure and Ah Xia an innocent victim, the lane that is indicated as its immediate exterior is part of an actual residence of ordinary Shanghai people, complex and fluid, charged with relations of differential implications. The filming links the artefacts (the made-up interiors) and the actual openings (the lanes or buildings where Shanghai residents live and the street sites where the public life transpires) with deft ease, thereby constituting an intermedial motion that generates

an inherently differential and hence always changeable environment. The architectural constellation of a live Shanghai, in other words, carries the centre of gravity at work therein, at once cinematically open, humanly inhabited and materially grounded. The actual streets and public sites employed throughout *Shanghai Women* ground such intermedial openings of the city in the film. It is in such a humanly inhabited material environment set and built in cinematic motion, in short, that Ah Xia and her mobile relationship to others around her reveals a dynamic strength, turning herself into a figure and exponent of the very mobility and differentiality of the city itself and as an embodied environment on screen. I posit such an intermedial filming-cum-moving as an 'embodied turn', an aesthetic signature of *Shanghai Women* and the *Shanghai Trilogy* as a whole.

Its effectiveness shows in particularly brilliant moments in the film. Here is an example: After Ah Xia fails to keep her agony private when Mama discovers her diaries, she attacks Mama in anger. Mama leaves the room. Ah Xia is in a state of pure rage. Granny's voice disclosing that Mama is on her way to remarry Ah Xia's biological father to give her 'back' to her 'original' family: 'I have asked her to remarry him, for you, you child!' The camera produces a close-up of Old Mother's suffering face, shifts to a close-up of Ah Xia's eyes filled with tears and, then, with a crane move, shifts toward and beyond the window of the room which is the constructed set for film shooting. The camera moves further downward to capture a lane in a neighbourhood, part of the feature architecture of urban Shanghai which dates from the 1890s, and then onwards to engage a street of the kind which exists and operates all over the body of the actual city, thereby ingesting and issuing a materially embodied cinematic environment with the longest articulation in the film of a mobile Ah Xia. Here in the view is a young woman's resilient body in motion, riding on her bicycle through long and short streets as if enacting a telescoping of the possible patterns of being human and modes of human relations in the making, leaving her bodily prints on the city as much as bringing its material entirety into a cognitive focus for reflection in transformation. As the camera finally slows down at an actual bus stop, one of the millions in Shanghai, Ah Xia, after overtaking a bus that carries a full load of passengers including Mama, is filmed waiting there for the bus to arrive when Mama steps out. She resolutely puts a stop to Mama's attempted 'return' to the point where they have parted with their battered wash-bin. As traffic passes and speeds by in front of them, Ah Xia and Mama stand, again, on one of these many hundreds of streets that comprise the body of Shanghai, where the first Chinese women's newspaper opened its office, the first women's school opened its classes, the first women's urban performing arts troupe opened its evening shows and the first women's association opened its congregations and rallies in the modern history of a transforming China. *Shanghai Women*, in this sense, is an architecturally endowed, cinematic refiguration of the city with

its layered history and changing dynamics. Streets short or long, winding lanes of residential units, corners or walkways, small shops or department stores and various malls, buses, bus stops, playgrounds and crossroads, these sites are chosen for their ordinary actuality in the city and filmed as active exponents of a cinematic environment, functioning as material carriers of an environmental history, gaining the status of a multiple, variable body.

Such use of the cinematic environment as a variously embodied multiple has a built-in Brechtian *gestus*: a play of intermedial engagement between the constructed artefacts and the architectural entities in daily human use, turning the city on the screen into an abode of the urban mobile, a body social always in a process of being made and remade. It is indeed striking that these actual public sites, ingested in *Shanghai Women*, are such grounded openings for life to establish itself as well as to begin again, beyond crisis of various kinds. The taxi scene at night, for instance, is grounding as it is evocative in its delivery. Shanghai in Peng Xiaolian's films is never implicated with danger for women, even in its darkest hours, as it rests in the materially-grounded reliability of these streets, schoolyards, hospitals, bus stations and other routes, all of which is textured with residential neighbourhoods of differential and shifting kinds. At the same time, such a ground of reliability is constitutively inflected into a fluid force-field, wherein daily decisions for change are being made by and amongst the most ordinary people, such as Ah Xia and Mama. At another point, Ah Xia is filmed wandering across the metropolis to arrive at the banks of the Suzhou, the mother river of the city since its configuration in the nineteenth century. She contemplates this locale, the sedimented specificity of which turns into an animated environment for the newly arrived and activated in the city through the gaze of her clear eyes. Meanwhile, the centuries-old locale looks back at Ah Xia as if an opening for connection coming from the depth of time, an extending aid with which Ah Xia reforges her way of belonging and her way of becoming. Such highly indicative moments organize the film's unfolding process. Significantly, it is also at the bank of Suzhou River toward the end of the film that Ah Xia shares with Mama a moment of mutual comprehension, a moment that seems to last only a second but feels as long as Shanghai's history of 'being modern'. Mama for the first time lets her tears be seen by Ah Xia, as she ends her last few minutes of 'being 17'. This renders the content of her life over these tender years into a glimpse of intelligibility for the first time to Mama: the two women have lived in a way distinct from, albeit conditioned by, the norms and social codifications of the junior and the parental, therefore never following the order of the normalized and its hierarchy to the exclusion of their differentially-shared sense of equality in their relation. Entirely beyond or rendering irrelevant the structure of the pain of the daughterly lack in the female *Bildungsroman*, the film logically comes to its ending via a scene where Ah Xia, holding Mama's shoulders with her long and comforting arms, bids her: 'Don't cry, Mama. Look,

that is a steamship!', 'That is a tugboat'; Mama cleans her tears, holding Ah Xia
in return but with a 'motherly' though differentiating *gestus*: 'that is not a steam-
ship at all'. Ah Xia takes the cue in her own way: 'Mama, let's go home': an
irreducibly differential embodiment of human mutuality. The camera cuts to
the final scene of the film, a room of their own. Ah Xia and Mama are making
arrangements in the room, transforming the room into a work of art. On the
one hand, this room is a constructed site for shooting, indicated to be located
on the third floor of a crowded building in a crowded neighbourhood in the old
style of Shanghai residential units and replicating Granny's place, and is
inscribed by a sense of domesticity: the floral wallpaper and curtains marking it
as an apartment in contemporary fashion, with an addition of a bundle of fresh
flowers in a small vase. Meanwhile, the room is so filmed to be linked with an
intersecting location between a busy street and the bank of the busier Suzhou
River; the actuality of the latter is rendered in a POV-shot from the open bal-
cony of the room, indexing itself as a passage all the way up to the sky and a
connection with the streets and the river water all the way down. The sound-
track floods the room as if flowing through the scene in the film, with all kinds
of street sounds resonating around and recorded at the bank of the Suzhou
River. Otherwise a mirror image of the 'original home' shot in the constructed
site in the 'divorce scene', this made-up 'room of one's own' in plenitude is
interceded with an active mediation of a long shot and a close-up of the rough,
firm and winding bank of Suzhou River crisscrossing the city. This is the ground-
ing signature of Shanghai and its embodied architectonics sustaining the major-
ity of its inhabitants over long and variable periods of Chinese urban history. Its
physiognomic presence, charged with the specific architectonics of a body
social, is hereby intimated as that of the ordinary urban Chinese and their daily
praxis, over time and across space, in making and remaking their relations to
the world around them and to themselves, in their ways of being mobile and
becoming embodied exponents as intermedial openings of the city of Shanghai
itself. So intermedially open and embodied, *Shanghai Women* is an environment
where the traces of normally unnoticed happenings show the dynamics of their
human inhabitants and their potential for social change, as loci of enabling
mutuality rooted in difference, central to the quick of the life in the city and its
inhabitants since the early nineteenth century and still as it continues into the
present day.[2]

Amidst Great Migrations: *Still Life*

Such intermedial mobilization of a cinematic environment takes on a drasti-
cally enlarged scope in *Still Life*, a film of epic proportions produced in 2006 and
directed by Jia Zhangke. *Still Life* similarly traces the figure of being mobile in

relation to 'the city', and grounds such mobility with a humanly inhabited and distinctive architecture. Significantly, the centre of gravity in such grounding moves away from the sense of reliability of the buildings or architectural entities at work in *Shanghai Women*. In *Still Life*, the material exponents of the 'built environment' in the lifeworld are in the midst of being literally uprooted and demolished on a massive scale, whereby a different grounding in contrast to that of *Shanghai Women* transpires, constituting an important event in the emergence of the embodied intermedial turn in contemporary Chinese cinema.

The film opens with a pan across a steamboat coming to the Three Gorges region – an actual place near the metropolis of Chongqing, in Sichuan Province, China's heartland – carrying a full load of passengers, mostly male migrant workers in search of jobs. A series of medium to extreme close-ups delineates their various body configurations and facial features, as if in a mobile painting or an extending panoramic photograph, thereby bringing into focus an image-constellation indicative of what has become part and parcel of the largest human migration in modern Chinese history. The camera's focal point finally centres on Han Sanming, the leading character in the film, sitting at the rear of the steamboat with one bundle of luggage on his knees: brownish, sturdy, rugged, quiet, a migrant in the thick of labour mobility. Another cut shows a gang of young males of obscure identities coercing him to pay for a trick-performance by a 'magician' who turns white paper into Euros and from Euros to RMB bills while proclaiming that 'people are drifting on water and everyone depends on the US dollar'. The ringleader, also the youngest of all, takes Han's luggage and threatens him when he finds nothing valuable after a search. Han springs open his hand-knife to put the youngster at a distance, turns and disappears. The camera chases him out of the room and off the steamboat, captures him again as he walks, slowly, on the steps of a long and broad stairway made of boulder strips, the signature of the paths made across the region. A slower pan follows to show the stairway leading to the old gate of a city up on the hills, and a Han Sanming who walks one step after another, on the stairway hewed from stone, up the hill, towards the city.

Such an opening suggests a film about a migrant and his dangerous journey to a place inscribed with a regional style of Chinese architecture that has endured through time, whatever the specific content of this journey may be. When one approaches *Still Life* at the level of its expressive narrative or genre designation, this is indeed the case. As the narrative would have it, Han Sanming, distinguished from others landing here for random jobs, holds the home address of a woman from this area, his ex-wife who left him with their newborn daughter 16 years ago. He manages to locate the birthplace of his ex-wife only to discover a flooded river there. 'People who lived here have long been relocated and all moved away,' a local motorcyclist tells him. Han heads for the government

office for information only to find a broken-down computer system in the office and anxious crowds in the hallways, caught in confused arguments. He decides to take up residence in a small inn. The Chinese character for 'cigarette' appears on the screen, and a continuity cut shows Han Sanming handing the inn owner a cigarette of a Chinese brand popular in the early 1980s, a token of goodwill for social bonding and possible help in return. The camera pulls back, revealing the location as the elderly owner's bedroom-cum-office, with an old television set running a Hong Kong television drama about the underworld in Hong Kong, a hit back in the 1980s. Glued to the television screen is the third man in the room, who is none other than the youngest member of the gang on the steamboat from whom Han Sanming escaped. Presenting himself as 'Little Ma' and mimicking the style of the charismatic but tragically flawed gangster star in the Hong Kong TV drama series, he proclaims that this area is his territory and under his command. Ignoring the film on television, Han acknowledges Little Ma by also offering him a cigarette. Little Ma lights it up with a scrap of Chinese newspaper in the same way the mafia boss does, mimicking the air of the rich and powerful (except in the Hong Kong TV drama, it is with a $100 bill that the mafia head lights his cigar). A world characterized by a malfunctioning system of official information, and threatened by dispersing communities, is hereby indicated as a breeding ground for the displaced of all sorts who feed on misidentifications with simulations of unregulated wealth and power, coded in American cash, Euros and RMB bills. All seems caught in a flux where the logic of the cash nexus threatens to prevail. When Han Sanming reaches a pier along the river bank and finds Old Ma, the elder brother of his ex-wife and the master of a cargo ferry, Old Ma turns out to be totally indifferent to Han's attachment to his ex-wife. The elder brother makes clear that he cares nothing for this business of sentiment, while one of his employees, a youngster much like Little Ma, whose head is wrapped with blood-oozing gauze indicating violent fights, dashes at Han for another clash. Departing, Han offers two bottles of wine he brought from Shanxi Province, his home, a culturally specific gesture to convey his sense of Old Ma as a family. He receives rejection. The Chinese character of 'wine' appears on and goes off from the screen. While it remains unknown until later in the film that Old Ma has made his sister the wife of another ferry master as a payment for the debt he owns, it is clear here that vehicles for communication such as 'home-made wine' and 'China-made cigarette' commonly used by ordinary Chinese, particularly those from the rural regions, no longer function in this city in transition. The sense of opening and resting in the dynamics of a humanly inhabited material sphere and its environmental reliability, at work in *Shanghai Women*, hereby disappears. One sees instead a city of jungles, as the condition for a male-centered *Bildungsroman* or masculine heroism to unfold. The rest of the film, one might anticipate along this line of cinematic narrative or expressive genre, should be comprised of the strength or ingenuities shown

by Han Sanming in his way of surviving or handling such a jungle. Finally he should come out from the other end as it were in the fashion of a good Hollywood movie, as the winner of the situation while being rewarded with regaining the woman he loved and lost.

Still Life though is demonstratively outside the genre of masculine individuation or heroism, be it Hollywoodian or other kinds. In terms of its cognitive structure and cinematic making, as the director himself suggests and more critics argue, the film is something extremely close to a documentary of a land in radical change, an ambitious attempt to take a measure of the mutation of China's physiognomies in the regions – with the city of Chongqing at its heart – deployed for the Three Gorges Dam Project, a grand engineering project emblematic of China's drive for modernity, the conception of which can be traced back to the first decades of the twentieth century. The project has been championed by all the leading political figures from Sun Zhongshan in 1919 to Mao Zedong, Zhou Enlai and Deng Xiaoping throughout PRC history and, after intense debates over the decades, was finally approved by the People's Congress in 1992.[3] Once accomplished, as far as the plan goes, the project is to revolutionize China's systems of flood control, production of hydropower and shipping, with immense economic gains. As history would have it, the first phase of such gains by necessity results in architectural demolition and human migrations that affect 1.4 million people within Chongqing alone and more from 20 districts, municipalities and counties extending into and across part of Hubei Province.[4] As multitudes are displaced, the social patterns of their lives are dislodged; so are the textures of their relational existences. Fengjie, one of the ancient cities established in the Han Dynasty (25 BC) in the eastern part of the urban center of south-west China comparable to today's Chongqing metropolis, which has become over some 2,000 years a nerve node in classical Chinese literature, architecture and historiography,[5] is required to disappear in two years to make way for the implementation of the Three Gorges Dam Project. It was a carefully-deliberated decision on the part of the director to film this 'Han Sanming story' in Fengjie, the actual 'old city up on the hills', and in its surrounding area, when its intricately layered architecture-cum-environment is being decomposed as part and parcel of its recomposing. Approximately 108 minutes long, *Still Life* traces the conditions of the city of Fengjie in a process of displacement, recording perhaps the most radical instance of city in the making-cum-unmaking, fraught with tensions, conflicts and social re-valuations.

Han Sanming, the cinematic figure of a migrant coal miner coming from Shanxi Province all the way to the city of Fengjie, in this sense, serves as an indexical element that sizes up this human-made project to bring it into a focus with which it can be rendered comprehensible on an individual level: the birthplace of his ex-wife Yaomei is in an actual area designated for Phase One of the Dam Project, already underwater as scheduled by the time Han arrives.

The government office he visits for contact information is in charge of building demolition and resident relocation. The small inn where he resides is in the area marked for Phase Three of the Dam Project. Named as 'Guest House of the Great Tang People',[6] it suggests a dwelling that insists on its ancient history (since the Tang Dynasty) and claims to such a long history as it caters to travellers cognizant of their transitory state of being, just as its own imminent vanishing. All these graphic details and more are delivered in the filming with a documentary care for factual accuracy, as if establishing a record of visual evidence for a human eye, located in and mediated by the body of a mobile Han Sanming. When he finally learns the whereabouts of his ex-wife's elder brother and walks through the chaotic streets of Fengjie towards the bank of the Yangtze River, the camera takes a long shot from his back that frames his moving body with a growing field of discontinuity in the making. Under his feet and all around him are piles of debris in the wake of demolished and half-demolished buildings of various structures, periods, functions and aesthetics, the increasing scale of which is measured by a receding human figure, an often used and effective device in the documentary genre.

The environmental demolishing in operation is so convincingly filmed that Fengjie, as an actual site, appears not only to be caught in but also becomes itself a process of social unravelling, a cash nexus in flux that shuns impulses for mutually enabling relations or relational possibilities. Fengjie is thereby endowed through the sequence with a connotation indicative of the troubling nature of a city as an organized public disorder that offers no formative energies. A site of productive demolition inherent to and required by a grand design of economic development-cum-systematic modernization, in short, the city as an idea and function of the production of modern life is turned into a questionable force-field or a field of questions itself, fundamentally destabilizing in its momentum and momentously threatening to all lives involved. The magnitude of such productive decomposing as part of a still larger recomposing, carefully filmed with a documentary bent on an objective rendition of the world (Jia 2006), looms so large on the screen that it dwarfs Han Sanming, the human figure whose presence therein serves to measure or reveal the massiveness of such phenomena. Indeed, the momentum of this process not only threatens to liquidate what Han Sanming searches for before he can possibly reach it, but seems to further require the annihilation of the kind of human beings like him.

One may note here that *Still Life* has a different title in Chinese, *Good Persons of the Three Gorges Region* (*Sanxia haoren*). It is under this title that the film was released, and is known, in China and Chinese-language contexts. The question of titles in translation aside for the moment, *Good Persons of the Three Gorges Region* is a deliberate echo of *The Good Person of Szechwan*, one of the masterpieces by Bertolt Brecht, arguably the twentieth century's most important dramatist, and suggests a self-consciously structural engagement with the world of

the real in the film similar to that of its evoked German drama. Much like Brecht's Shen Te, Han Sanming, the 'good person', does not seem likely to survive the flux of organized disorder, its inherent indifference towards human attachment beyond the code of the cash nexus and its corruption of humanity to the core. The world in and as such a structured flux is no place for a 'good person' to be. Shen Te has to mask herself as her cousin Shui Ta to deal with the business of the real on its own terms, and is therefore caught in the danger of becoming indistinguishable from the forces that are fundamentally alien to her.

Given Brecht's Marxist persuasion, or taking it as a cue in understanding the Brechtian logic, one might infer that the way of overcoming such a predicament is a structural revolution (Anderson 1984). One could argue that it is with a desire for such a revolution that Brecht sets his drama in a mythological place called Szechwan in China, whose significance in Brecht's imagination is defined by contemporary critics as 'Brecht's China dimension', involving an alienation effect and a Hegelian-Marxist revolutionary dialectic (Jameson 1998). For the Chinese filmmaker and his Chinese audiences, 'Szechwan' marks out a real place in China. Spelled as 'Sichuan' today, it is the largest province in south-west China and its centrepiece is the Three Gorges Region.[7] *Good Persons of the Three Gorges Region*, otherwise titled *Still Life* in English, focuses on and unfolds 'some place elsewhere' in Brecht's dramatic vision with an acute self-awareness of its present actuality in the thick of the lifeworld so focused. 'Elsewhere' is the constitution of the here and now. While this place of actuality is cinematically indexed at one level as human alienation and a cash nexus in flux, Brecht's drama of alienation-effect is firmly engaged insofar as its implied (and later developed and rendered explicit) dialectical logic is to be distinctively refunctioned. Han Sanming does not split into a destiny of a binary comprised of positive versus negative as 'the good person' in Brecht's drama splits herself into the two figures of Shen Te versus Shui Ta. Such a 'split being', if construed in the logic of the dialectic leading towards the plenitude of human mutuality or sublimation in a temporal beyond, seems likely or can only resolve to assert its unalienable 'authentic self' in the present as a tragic-cum-sacrificial act, a self-aware passion in history.[8] Intimately evoking such a passion as found in the dialectical drama, *Still Life* complicates its own documentary impetus and exceeds the binary of the dialectical logic by bringing forth a turning of events leveraged on the figure of the quiet migrant worker as its mobile centre of gravity. Han Sanming finds his way of remaining a 'good person' in the here and now of the present city while continuing his search, travelling through, tracing and inhabiting every inch of the land in its critical moment of transition. He takes a job demolishing buildings as it is the only business in town at the moment and, along with other migrant workers on the sites, works day in and day out while becoming an enduring human texture inherent in this particular

instance of a generalizable process of productive destruction in modern times. A Han Sanming, stripped to the waist with muscles shown, exerting himself at work amid piles of debris while sustaining himself in a world of flux, punctuated by a Han Sanming in his dark blue work clothes searching through the city and the region for the long-disappeared indispensables in his life, amount to a presence that takes place in more than one-third of the film's duration, variably framed by a broad flowing river and a modulating range of mountains. Here in the shifting frames of the cinematic view we have a human body that works and moves on earth, across the river and through or around the mountains and the cities cradled therein, until he turns himself into an exponent of earth, river and mountains, opening up a humanly inhabited environment in motion that grounds all the elements encountered therein, including the extensive piles of debris. A force-field and a cognitive point of view, the Han Sanming body in motion evokes the 'built environment' and its reliability featured by a specific architectonics in *Shanghai Women*, but with a humanly-embodied physiognomy, the substantive simplicity of which only intensifies its rich and largely obscure implications. This, I argue, is where in *Still Life* the intended documentary turns into a profoundly intermedial artwork, thereby giving rise to an embodied aesthetic that grounds the cinematic signification. Such intermediality involves an active engagement with the drama of the dialectic a la the Brechtian Marxism and his *The Good Person of Szechwan*, while being inherently free from the latter's organizing binary, hidden or overt, as a registry of a vital moment of innovation in contemporary Chinese cinema and cultural production.

The fact that such a human body of mobility has shifting boundaries can be a feature of cultural products and production in general. The particularity of such shifting fluidity in Hang Sanming and *Still Life* lies in the ways in which its overall configuration employs multiple media across the boundaries between human faculties and technological devices, cinematic screen and real lifeworld, figures of a cinematic world and actual members of a society, and unfolds an intermedial movement of epic proportion which is only measurable by the scope, at once documented and evoked, of the Three Gorges Dam Project, the Three Gorges Region and the heartland of China amid conflict-ridden momentums of modernization. Han Sanming the migrant worker is indexically mobilized through a deployment of hand-held shots, jump-cuts, tracking shots, deep-focus shots and other operations of a subjective camera at a level of sensitive sophistication that has not been assuredly reached by filmmakers in China until the last decades of the twentieth century. More striking is the ways with which the Han Sanming body in mobility is so designated as to include high-tech features of the twenty-first century. In a subtly rendered scene, for instance, Han Sanming treats Little Ma to a drink, after Han rescues the youngster who is badly beaten by those unidentifiables from his world. One learns of the life of a roving local teenager, turning 18, with a heart not at all set on the logic of

cash nexus in the underworld. The other learns of the life of a coal miner from Shanxi, a faraway land up in the north, with a mind that firmly keeps the memories of the past while focusing on the present living. Han's ex-wife 'baby-sister' was abducted by a human trader from here and sold to him there, across three provinces. She shared her sorrows with her empathetic 'Shanxi husband' and found a way of returning to the heartland with their daughter. Han Sanming hopes to know how they are managing in their life, here and now. Little Ma and Han Sanming become brothers and, significantly, exchange their cellphone numbers, an icon of the technological highway of a new century for human connections.

These connections operative with mobile phones or other technologies are shown to be socially made but not as forces exterior to the composition of those who make or use them. When Han Sanming's cell phone receives a signal from Little Ma, it begins to ring a musical piece, which is the melody of the theme song from a popular television drama series titled *Yearnings* (*Ke Wang*, Lu Xiaowei, 1990). Produced in the 1980s and broadcast in 1990, this series tells the stories of two families spanning the periods of the 1950s and the 1960s including in particular the Cultural Revolution (1966–1976), with reflective attachment and critical affirmation. This was the first fully-fledged popular teledrama in the histories of Chinese dramatic art and television industry. The song is titled 'Blessing Good People':

How many things past
as if still just yesterday
how many friends one had
as if still nearby
Once feeling truly and deeply
now encounters it, real or unreal?
raising our glasses, wishing the good persons travel safely
close and distant
all are in connection
such feelings of caring
are the heat of this world ...

Little Ma's cellphone, in turn, plays the melody of the theme song of another similarly popular television drama series in the 1980s, *The Bund*, about a young man who tries but fails to make it in the world of Shanghai mafia in the 1930s (Zhao 1980): 'Flowing waters / pounding waters / the river waves run towards infinity / it surges through our lives / it carries away our woes ...'

The structures of feelings registered in these two television drama series are historically significant, so are their workings with Han Sanming and Little Ma in the present through their mobile phones. *Yearnings* intimates how mutually

enabling human relations constitute the quick of life and the core of society during the years of PRC history, in spite of all the disasters and tragedies occurred therein. A spirit of human mutuality, or an impulse of socialist utopia as some put it, animates *Yearnings*. While the heartland of China is caught in a decomposing and recomposing frenzy of a post-socialist nature, it bespeaks of Han Sanming in such present not as a token of or a sentimental longing for a bygone collectivity or plenitude, but as a personal voice of the indispensables that stay alive in the body of his social, emotional and physical constitution, something like an embodied impetus or a bio-ethos in live motions. After all, Han Sanming, either the character in the film or the performer as a member of Chinese society, is one of the post-70s generations born at the end of the actual history depicted in *Yearnings*, and both are inherently communicative with and actively different from what is registered in *Yearnings* and its musical motif in the film.

In a similar way, the other parallel line of *Still Life* traces how Shen Hong, a woman from the city of Taiyuan in the north, is looking for her husband at an abandoned, formerly state-owned factory. The unspoken truth throughout all of her efforts is that the man has been with 'another woman', who is the current owner of the sold and privatized factory where he used to work. Shen Hong, walking across the Three Gorges Region along the Yangtze River with a bottle of cold water in hand, haunts the land like a voice that cannot be heard, until the theme song of another film dated in 1980 arises. Titled 'When Leaves Turn Red on the Mountains', this song and film about an ethic of care beyond desires of possession and ownership historically attributed to an ideal PRC, befits Shen Hong and works in the quick of her life amidst a historical fluidity. Her episode in *Still Life* ends with her leaving behind the socially given while moving east, with an unarticulated and anticipatory contemplation of the unknown.

Such structure of feelings, palpable as an embodied impetus of a bio-ethos in Han Sanming and Shen Hong, is made poignantly tangible when the film delineates how constitutively unavailable it is for Little Ma in his life. In the scene where Han Sanming and Little Ma become brothers over drinks, Little Ma listens to the story of Han Sanming but cannot hear it. He tries to grasp such live content by using what is available to him, namely, the cant of commercial cinema circulating on a global market via Hong Kong and Taiwan brandings and penetrating via the multiplying tele-routes the remotest corners of the world, including his, and defines such a bio-ethos of the Han Sanming story as something 'nostalgic'. 'We are too nostalgic,' comments Little Ma, with exaggerated gestures mimicking the stars in films of mafia bosses. Han Sanming asks with a smile: 'Where have you gotten this big word, "nostalgia"?' and, without waiting for Little Ma's answer, he adds the single longest sentence he utters in the film: 'one's own matters, no way to just forget about it'. Though linked by their cells representing the technologies of the present, the 'two brothers' cannot bring together their structures of feelings or bio-ethos which remain

apart in the midst of their intimate encounter. Their cell link is as fragile as it is indicative of the acute and layered rupture, both material and psychic, between past and present, and between their respective lives in the thick of a historical flux. Charging around as a head of a small gangster ring under the instructions of some men of power whose identity is obscure, Little Ma one day vanishes. Han Sanming rings Little Ma's cell phone. A melody arises, the theme song of *The Bund*, muffled. Han Sanming walks in the direction of the sound and stops at a pile of debris: the music continues, here and now. Han and other migrant workers start digging in a hurry. Little Ma's body surfaces, smashed. Han builds a small altar on the heap of debris to hold a photo of Little Ma dressed up mim-icking the young mafia in *The Bund*. A boat carries Little Ma's body away, while Han Sanming remains on the shore, a part of the land in mutation that blurs classifiable media of representation. Cellphones, popular songs, teledrama series of worlds and psyches, photos of mis-identifications on piles of debris, the bodily persistence of Han Sanming and migrants, all these are combined here together to play the role of a 'built environment' representing a body-specific bio-ethos of the Three Gorges Region with all the Han Sanmings as its intimate expo-nents, humanly palpable and fundamentally intermedial. So much so that, when the actual monument built in Fengjie as a commemoration of the great migration for the people from the city is cinematically made to uproot itself and rise into the sky, merging into its vastness, such a sight comes as not a perplex-ing surprise, but as one more intermedial addition in the film's reflective layers of signification.[9] The same is the case when the film shows a UFO-like uniden-tifiable object flying across the sky, with Han Sanming standing on the bank of the river, quietly looking up and holding the moving object in his view, unper-turbed and undaunted. Here we have an intermedial cinematic artwork in argu-ably one of its most sophisticated instances, a particular kind of Brechtian *gestus* that invents as much as grounds the world of intermedial cinema.

The complexity and sophistication of such a real in the intermedial finds another intricate moment in the example of the television reportage cited in the film. It occurs in the scene partly discussed earlier where Han Sanming and Little Ma first exchange their cellphone numbers. Receiving Han's cell signal, Little Ma's cell rings the theme song of *The Bund*. The original sound track of the teledrama series takes the cue of Little Ma's cell and rises, the camera closes upon the two migrants at drinks for a second and then swiftly shifts to zoom in on a television screen in the room where a live reportage is being broadcast: it shows a woman in her 80s being carefully helped by the public security person-nel to step onto an oil ship, a ship full of locals of all age groups, genders and walks of life, leaving the region. A peasant woman in her twenties is holding the mast tightly, wailing, though there is no sound. The social ethos of *Yearnings* permeates the television live report, while the sound of *The Bund* in *Still Life*, the film, crisscrosses the cited footage and, sweeping across the cinematic

screen, indicates that a momentous decision is being made and implemented in the actual lifeworld, whose immense consequences are still unknown.

Live television broadcasting in itself constitutes a topic for intermedial studies. Of all the television screens with various scenes that appear in *Still Life*, this cited instance is singularly unique and generally suggestive in that the scene on television is a moment of a live reportage by Sichuan Television Studio in 1997, articulating 'the great patriotic spirit' with which 'people of the Three Gorges Region leave their old homes to re-establish their lives elsewhere in the service of the development of our country' (Sichuan Television Studio 2003). Let it also be noted here that, since the great migration of the Three Gorges Region was successfully accomplished in the 1990s, the Chinese government has instituted a policy of regional migration that aims to select and aid large-scale population relocations from various environments deemed to be void of arable land and other resources to more inhabitable regions, of which more reports are yet to be made public.[10] In *Still Life*, the camera then cuts away from this actual footage of a live TV reporting back to its own cinematic world, taking a long shot of a group of people running and then standing on the receding shores, waving their hands and clothes, sending blessings to all 'good person[s]'. A deep focus ensues and expands, within which an oil ship, indexed as the same ship in the TV live report cited earlier, is moving east on the Yangtze River into the distance, passing mountains along the banks, leaving behind the line 'Phase Three Water Level: 156.3M' written on an actual plastic board fixed on the receding hills, and Han Sanming the migrant worker stripped to his waist, staying on and standing still at a pier looking at the horizon between the river water and the sky: a still life, an intermedial telescopic, a humanly inhabited gesture, an embodied presence of an environmental bio-ethos, the aesthetic signature of Jia Zhangke cinema.

Featured with such an embodied multiple, Jia Zhangke's cinema jars with the politics of medial indistinction or the 'fantasies' of the 'naïve cinema' symptomatic of being complicit with a globalization of images in the service of a globalizing capital (Jameson 1992). The body-specific aesthetic is at work in *Still Life* with a built-in reflexivity suggesting a Brechtian *gestus* with a further turn of Jia Zhangke's intermedial energy, humanly embodied or trans-embodied. As critics have long noted, affirmatively or dismissively, the leading character in *Still Life* is performed by the director's cousin of the same name. In the light of the above discussed intermediality of *Still Life*, one may do better to take this beyond the merely affirmative or dismissive, which means to take it seriously, as one more consequential layering of the intermediality of the film and its mobile center of gravity, that is, Han Sanming's body, the layering that crosses the domains of the cinema and the lifeworld. Han Sanming is indeed the actor's real name, as his cellphone number is the same as the character's, disclosed to Little Ma in the film as it is to the viewing public in the world. He has not received many

calls on this publicized number, as movie stars of the world should. Han Sanming is a coal miner in the city of Fengyang, Shanxi Province, as the character is indexed in the film and, born in 1971, he has been working as a coal miner since he turned 18. Performing in film constitutes his activities 'after hours', an engagement in a kind of 'amateur' labour that is an actual immaterial labour, upon the invitation of his film-director cousin with payment somewhat 'better than that of a coal miner'. He clearly is not on his way to becoming – neither has he any intention of becoming – a 'real' film actor. He has however remained in the world of cinema as one of its contemporary loci and an active exponent in its being in the making and remaking.

It is within the bio-ethos of such trans-embodiment that the scene where Han Sanming and Ma Yaomei meet transpires in a way that is intimately affirmative but non-sentimental. Sitting face to face at the riverside, Yaomei asks Sanming whether he has enough clothes and food. Sanming asks Yaomei how she 'fares'. Learning that Yaomei's current husband is the owner of another shipping ferry and she was the payment to the ship master equivalent to the amount of 30,000 RMB (Old Ma's debt), a decision is made. Han Sanming will pay the amount, with his entire income in the coming year. A close-up cuts to where the two look at their daughter's photo; then a POV-shot leads to a close-up on the young woman of 16, standing in a blue-colour working uniform, facing the camera and smiling, with the entrance of a factory in the background. This is a familiar figure of another generation of migrant workers moving across China today; and her supple figure and sunny smile make a sight distinct from her earthly parents. The following scene keys these contiguity cuts. Yaomei and Han Sanming squat face to face on a mid-floor of a building in the process of being demolished. With all its upper floors and the four walls already gone, the place appears to be a fragile framework of a total opening barely balanced in a momentary pause, in space as in history, in striking contradistinction with the city openings in *Shanghai Women* and the other installments in Peng Xiaolian's trilogy. Yaomei affords this humanly endangered opening a humanly grounding content by offering Han Sanming a toffee of the most popular and appreciated brand – White Rabbits – among the ordinary Chinese in the entire PRC history and into the present. Han Sanming substantiates such a grounding by taking a bite of it and giving the other half to her. The character of 'toffees' appears on the screen and stays until the end of this scene. High-rises all around are collapsing one piece after another, issuing huge sounds of implosion. Yaomei and Han Sanming are in the thick of the evolving historical rupture, thereby redefining the nature of their relationship across the past, present and future temporalities and the process of rupture itself as a landscape of relational humanity in migration. 'At the beginning, I thought I was telling a story about search,' Jia Zhangke says in an interview, 'but, in the process of completing it, I realized that the film is about making decisions' (Jia 2006: 61).

I conclude this chapter by noting that such an intermedial aesthetic of trans-embodiment in motion is occurring in a growing body of Chinese films, be they made of human figures or other materials. The animated physiognomies of China and its land are turning increasingly into a focal point of contemporary Chinese cinema as part and parcel of the growing presence of such trans-embodiments, immanently irreducible in 'the industry of consciousness' which is the globalizing spectacle of the capital. It is not simply incidental that the desirable destination implied in *Still Life* is Shanghai, the implications of which *Shanghai Women* unpacks and re-envisions, and which *Still Life* echoes. When the rooted lives and regions are moving to make way for the movements of an urbanizing China, questions of how to inhabit such conditions of mobility and to be mobile in a world of productive and displacing fluidity arise and find their ways into cultural articulations. More changes are coming. More innovations in the realms of art-making are presently occurring. *Still Life* and *Shanghai Women*, put together here as an unlikely but indeed resonating constellation, afford us glimpses and visions of a humanly inhabited grounding as a built environment for cinematic art to grow and flourish, just as for an urban[izing] China to grow, to sustain and to take its place in the world of cities, in the years to come.

Notes

1 A different version of this chapter will appear in the *Journal of Chinese Cinemas*, vol. 7, no. 1, in 2013.
2 In the second piece of the trilogy, *Shanghai Story*, streets and public sites have a much lesser role to play, as the residential interiority constitutes the centre of gravity of the cinematic narrative; explainable, given the organizing impulse in the film of a genealogical restoration of a Shanghai entrepreneur family in the aftermath of the Cultural Revolution. In the director's own words: 'The main site is the homes of the capitalists in the 1930s' (from an e-mail exchange with the author on 16 October 2011). The few signature scenes of the streets and public sites in the film are nonetheless delivered with no less of a felt assurance in terms of its reliability for human mobility. In *Shanghai Rumba*, a story about the pioneering Chinese film artists set in the 1930s, the streets again function as the place where personal or political decisions are made. The streets are where hopes for social transformations are found and carried out. Both films are shot on Che Dun sets.
3 The plan was initiated by Dr. Sun Yet-sian, the founding figure of Republic China, in 1919, as outlined in his *Strategies of Building Modern China* (2011). In the 1940s, the nationalist government signed a contract with the US which stipulated collaboration between China and the US for building a dam in the region. John Lucian Savage visited China several times to conduct field research, finally publishing a report that recommended the project. The domestically and internationally orchestrated wars prevented the project from being implemented in the following years. After the founding of PRC, Mao Zedong put it on the agenda

in 1953. After debates throughout the subsequent decades, the proposal for the dam project was approved by the People's Congress on 3 April 1992.

4 It is reasonable and perhaps necessary to consider whether the total figure is higher than officially reported. More research is needed.

5 The place is a recurring trope in Chinese classical poetry since the Tang Dynasty. The ancient temple centrally located in the city in honor of Qu Yuan, the revered patriotic poet of Chu State, is representative of the ancient architecture laden with historical memories.

6 'Tang people', an established term in Chinese, means 'Chinese people' as a community descending since the Tang Dynasty.

7 The city of Fengjie in the heart of the Three Gorges Region has been stipulated in 1997 as part of the city of Chongqing, while the status of Chongqing was then elevated to the equivalent of a province, in addition to the cities of Beijing, Shanghai and Tianjing as a municipality directly under the Central National Governance.

8 This is one reading of the nature of the dramatic genre and Brecht's relation to it, taken from Alain Badiou (2007) who is directly linked with the Maoist legacy of PRC political thought.

9 When asked, Jia Zhangke reportedly answered the question about the nature and meaning of this entity flying across the sky (UFO): 'Something of a surreal kind, China today feels surreal, for example, a city with two thousand years of history disappeared in two years' (Jia: 2006).

10 The information – offered by Institute of Urban Design and Planning, Tongji University, March 2012 – is extremely important for scholarly communities in the humanities to consider with sustained attention rather than any dismissive judgment.

References

Anderson, Perry (1984). 'Modernity and Revolution', *New Left Review*, March-April, I: 144, pp. 96–113. http://www.newleftreview.org/?issue=140

Badiou, Alain (2007). *The Century*. Cambridge: Polity.

Benjamin, Walter (1992). 'The Work of Art in the Age of Mechanical Reproduction', in *Illuminations*, introduction by Hannah Arendt. London: Fontana.

Jameson, Fredric (1992). *The Geopolitical Aesthetic: Cinema and Space in the World System*. Bloomington: Indiana University Press.

——— (1998). *Brecht and Method*. London/New York: Verso.

Jia Zhangke (2005). '*Still Life* is a Kaleidoscope of Reality: An Interview' *NetEase*, 2005–12–31 15:34:23, www.163.com.

——— (2006). Jin Yan & Li Weiwei, 'Desolation and Resilience of the Three Gorges Region: An Interview', *Arts Criticism*, Issue 10, 2006, pp. 61–63.

Krauss, Rosalind (2000). *A Voyage on the Northern Sea: Art in the Age of Post-Medium Condition*. New York: Thames & Hudson.

Sun Yet-sian (2011 [1919]). *Strategies of Building Modern China*. Beijing: Zhongguo Changan Publishers.

Xu, Minxia (2000). *Turning Seventeen, Budding*. Shanghai: Budding Publishers
———— (2006) *Turning Seventeen, Cloth Tiger Youth Literature*. Shanghai: Chunfeng Arts and Literature Publishers.

Zhao, Zhenqiang (1980). *The Bund*, supervised (as general manager) by Zhao Zhenqiang, Hong Kong Television and Broadcast Corporation.

PART V

POST-MEDIUM

FILMS

Chapter 13

Chantal Akerman: Moving Between Cinema and Installation

Griselda Pollock

> There are fruitful cross-breedings which add to the qualities derived from the parents; there are attractive but barren hybrids and there are likewise hideous combinations that bring forth nothing but chimeras. So let us stop appealing to precedents drawn from the origin of the cinema and let us take up again the problem as it seems to confront us today.
>
> (André Bazin)

Thus wrote Bazin, whose problematic expression '*cinéma impur*' forms the overall paradigm for the following discussion. The terms employed by Bazin draw from genetic intermixtures of species such as the horse and the donkey, the crossing of which produces a new animal unable to reproduce: the mule. On the other hand, chimeras are fantastic, imaginative combinations of existing creatures whose monstrosity is intensified by unnatural fusions of elements. Impurity is burdened by racial discourse, with all its horrifying misrepresentations of unified human species as divided at the level of 'blood' giving rise in fascist and even non-fascist imaginations to phobias about miscegenation. The concept of mixing does not necessarily, therefore, carry with it notions of creative interface, transformative hospitalities, innovative crossovers that culturally intervene in and respond to social-economic, technological and aesthetic circumstances. Thus, with regard to the mixing of genres and media in visual culture, I adamantly place myself in opposition to any trace of an eugenic imaginary, and seek only to understand dialogue, exchange and the expansion of cultural possibilities through unexpected relocations of practices of the image.

Thus I shall approach the question of new forms of interaction between cultural forms not through a conversation with cinema from its outside. I explore what cinema has done to its outside, to the visual arts over the period of its existence as technological image system in the field of visual culture. I have a general hypothesis to present.

Around 1960, any major exhibition of the visual arts would have been largely composed of paintings and sculptures. By the early 1970s, there would perhaps be real objects, things reworked, texts and certainly photographs. If we visit any major contemporary art exhibition, we will find ourselves confronted now with an array of works involving time-based artwork using a variety of lens-based and reproductive media culminating in digital imagery. By 2000, therefore, the dominant form of contemporary art is time-based art using technologies of the photomechanical and digital image. How do we explain this extraordinary shift?

Does it register the imperialism of the cinema invading the domain of fine art? Or does artists' turn to film and video represent what we might call 'image envy' or even 'technology envy'? Is it symptomatic of a loss of nerve on the part of the formerly aristocratic modes of the visual arts: painting and sculpture? I suggest that there is a deeper correlation. The photomechanical image registers dimensions of Modernity and its reshaped consciousnesses that would eventually deconstruct both the fine arts (and its existing ideologies of singular creator and expressive oeuvre) and the singular space the photomechanical image created for itself at the intersection of literature, theatre, musical entertainment and the image: namely *cinema* (Pomerance 2006; Charney and Schwartz 1995).

Instead of asking about the impurity of cinema, I suggest that Modernity and its technologies of vision ultimately overcame the boundaries produced by premechanical modes of image making and reproduction (Crary 1990). Once the photomechanical image was invented in 1839 and once still images were articulated by their passing through the shutter at 24 times per second so as to produce the illusion of movement, after 1888, the visual arts would eventually have had to come to terms with this double event, not only as a technology of the image, but also as a radical intervention in visuality, vision and spectatorial subjectivity (Didi-Huberman 2009). It has in fact taken a very long time for this younger, and often disowned but sometimes appropriated cousin, the photomechanical image and its changing technologies as well as its symbolic impact as image, narrative, spectacle, entertainment, investigative probe and means of disclosure of what Walter Benjamin identified as an 'optical unconscious', to demand and receive deep and creative attention from the fine arts (Benjamin 1979). Already by the early twentieth century, there were mutually fruitful intersections between artists and photography, and artists and cinema, from Weimar cinema's use of Expressionism and Dada to Surrealism and Cubism's engagement with montage as collage. Some works of Surrealist art hover

between and are claimed by both film history and art history. But after about 1960 and certainly by 1970, the idea of an art film versus a commercial film could no longer contain the hybridizing explorations of the issues of time, sequence, the image and various kinds of attention and gazing that the cinematic, the photographic and, since the 1950s, the televisual had contradictorily inserted into culture as a whole. Indeed once cinema analysts themselves explored their domain not as a medium or industry alone, but in terms of semiotics of the image and of subjectivities created through structures of viewing, the shared conceptual plane of time, the image, visuality and subjectivity spread between new kinds of analysis of the visual arts in the twentieth century and new ways of thinking cinema (Doane 2002; Mulvey 2006; Rosen 2001).

By the final quarter of the twentieth century the visual arts had abandoned their traditional engagements with the virtual space of painting and the discrete object in space that was sculpture to enter what Rosalind Krauss named as the expanded field, intelligible only by grasping its logic (Krauss 1979: 30–44). Adapting Krauss' use of the mathematical Klein Group model, I suggest that art expanded into a field of operation which is at once film and not-film, cinema and not-cinema: an aspect that equally involves understanding the radical alterations to the manner in which we now consume cinema through domestic technologies such as DVD and computer downloads (Mulvey 2006: 181–96). This is the frame for analysis of developments of the image in the visual arts *qua* visual arts.

If there is evidence of a convergence between the hitherto distinct fields of visual art, cinema and TV, there has also been a follow-on effect for cinema, particularly what used to be called independent cinema, which shared with the political and the aesthetic avant-garde a critical interrogation of its own procedures, means and histories as well as a critical stance towards mass or popular visual cultures. Formerly, in Britain, the circulation of independent filmmaking was available through The Other Cinema, Cinenova and the Arts Council, which aided those of us wishing to teach independent film at the intersection between radical visual art practice and radical cinematic practice – epitomized for me by *Riddles of the Sphinx* (Laura Mulvey and Peter Wollen, 1976), and Mary Kelly's work for instance, to access this material. These institutions have largely disappeared or been archived, with videos and DVDs, but at the same time where do the creators of such new hybrids between cinema and art show their work now? By the 1990s, the expanded tendencies in visual arts and its expanding international exhibition spaces became new sites of dissemination and circulation of a certain kind of cinema that no longer had an institutional home. The filmmaker Chantal Akerman, epitome of a French tradition of independent or critical cinema, is now represented not only by Paradise films in Brussels, for access to her feature films, but also by Marion Goodman, a major New York and Paris gallerist for whom she produces 'installations'.

Akerman as Artist

D'Est: *the whole film is an implosion.*

(Chantal Akerman)

In 1989, 'when an entire continent was poised on the brink of passage from the known to the unknown, Akerman seemed ideally situated to observe and reflect on the situation' (Halbreich 1995: 7). Kathy Halbreich, Beal Curator of Contemporary Art at the Museum of Fine Arts in Boston, and Susan Dowling, producer for WGBH Television, in conjunction with critic and curator Michael Tarantino suggested to Chantal Akerman a work about the new situation of a potentially integrated Europe, subject, however, to new nationalisms and recurrent anti-Semitism. Halbreich was interested in history; Akerman wanted to focus on languages. When, in 1991, Kathy Halbreich moved to become Director of the Walker Art Center in Minneapolis, one of the prestige centres for modern and contemporary art in the US, the project with Akerman morphed into an idea for an installation and Halbreich, unable to finance the actual film, was now joined by Bruce Jenkins, curator of film and video at the Walker, a position that already indicated the emerging presence of these forms as practices to be curated in the contemporary art museum. In addition Cathérine David of the Galerie nationale du Jeu de Paume in Paris was also solicited as a partner (David would curate *Documenta* 10) to exhibit the installation.

In the summer of 1992, Akerman began a series of trips with a small crew through Germany and Poland, subsequently travelling through the Ukraine to Moscow. The film *From the East (D'Est)* was completed by 1993 and was shown in film festivals as well as being broadcast that year. In 1995, the film was integrated into an art installation that was shown in contemporary art spaces as *From the East: Bordering on Fiction (D'Est: Au Bord de la Fiction)* in the Galerie nationale du Jeu de Paume, Paris; Walker Art Center, Minneapolis; San Francisco Museum of Modern Art; Société des Expositions du Palais des Beaux Arts de Bruxelles, Brussels; Kunstmuseum Wolfsburg and IVAM Centre del Carme, Valencia.

In the mid-1990s, installation was a relatively new form of artistic practice that of itself is a hybrid of images, projections, objects, uses of real and virtual space, time, incorporation of the body and even participation of the spectator and so forth (Bishop 2005; de Oliveira and Oxley 2003). It already registers symptomatically the literally expanded field of contemporary post-medium artistic practice (Benjamin 1993; Bird 2001).

In 1995, the distinguished and respected cinéaste Akerman, formed in the tradition of Godard, Duras, Varda and Resnais as well as Rainer, Snow and Brakhage, would not create an 'artwork' to place in a gallery. Halbreich's invitation made possible a rethink of the mode by which her poetics of cinematic

écriture might be presented beyond the 'screening' of a feature-length film in the traditional circuits through which it had already been circulated since completion in 1993. The museum installation, now titled *Bordering on Fiction: Chantal Akerman's D'Est* was composed of three elements or chambers. There was a room in which a 35mm print of her 107-minute film *D'Est* was indeed screened cinematically. It ran continuously in a large room with a few seats so that it was already a wall-projected image rather than a film on a screen with a fixed start and end time. The visitor met the film at arbitrary points in its perpetual loop. Then there was a second room filled with eight triptychs composing 24 video monitors mounted on plinths, creating a medium-height forest of luminous boxes across which, in five-minute segments, the film *D'Est* was being streamed with computer-plotted sequencing (Figure 1). Selected scenes from the film that involved a mobile camera moving past people standing in the street waiting for transport or walking in the street flowed across the different boxes of light to activate in space the movement which the tracking shots of the camera mounted on a passing car already created. This focused on the scenes largely shot in Moscow or other Eastern European cities, at night and in winter when people waited for buses or walked in the street. Giuliana Bruno, introducing a discussion with Chantal Akerman at the List Centre, MIT in May 2008 on the occasion of an exhibition of several of her 'installation' pieces, remarked precisely on how this arrangement shifted the temporal function of the tracking shot in cinematic language so that 'the language of film becomes spatialized' (Bruno 2009).

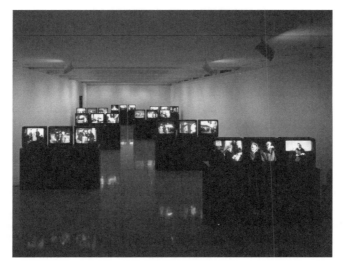

Figure 1: Chantal Akerman, Bordering on Fiction: D'Est, 1995, *mixed media, 25 channel video, 16 mm film (Minneapolis: Walker Art Center Justin Smith Purchase Fund © Chantal Akerman and Lieurac Films).*

Finally there was a third chamber – titled the *25th Screen* – with but one video monitor on the floor attached to two visible speakers placed like extended ears to the floor-level monitor. A repeating loop was played which involved a grainy shot of a night scene filmed from a car moving through an urban boulevard. This is accompanied by an intimate soundtrack of Chantal Akerman reading the text, in Hebrew and then in English, of the Second of the Ten Commandments in the Jewish Bible prohibiting idolatry through the making of a 'graven image'.[1] She has long been preoccupied with the Jewish tradition and the image (Godard 1980: 12). Akerman then speaks of writing during the making of the film as the process of discovering, once having made it, what the film was ultimately about. I shall return to this text later on.

The filming of *D'Est* was possible because of the opening up of Eastern Europe as a result of the break-up of the Soviet and Communist systems. Paradoxically, however, it was for Akerman a film of a 'return journey' but to places she had never visited before. Not only the inheritor of an existential condition of nomadism she herself identifies as a result of twentieth-century Jewish experience (Adams 2010), she was also brought up in the transposed Polish-Jewish culture from Eastern Europe, despite being born in Brussels marked by the legacies of the Shoah.

D'Est is not another *Shoah* (Claude Lanzmann 1985). After 1985, it would, of course, be impossible to make a film about travelling through Eastern Europe without invoking either the freight of the catastrophic history haunting this landscape or knowing the importance of Lanzmann's use of landscape as the ground of that history, that, in being revisited by his filming, pointed to the play of memory and amnesia about the genocide that took place there amongst its peoples and places. *D'Est* devotes long sequences to the landscapes of Poland and the Ukraine. Making the film was, however, an opportunity for Akerman to travel from the summer in Berlin eastwards to Moscow in winter in several different trips between 1992 and 1993. The territory to the east was, however, the uncanny 'home' of Akerman's Jewish childhood passed in Belgium in a family of Polish-Jewish Holocaust survivors living on the edge both economically and psychologically.[2] Not until the editing of the film, however, did the shadow of this ever-present trauma enter into *visibility* through the encounter with the actual landscape of that event disclosed in a Benjaminian manner by means of the camera. But this did not occur in what the camera shows; rather, it happened in what it *cannot* see.

The sense of trauma emerges from what the viewer with any understanding of European history since the 1940s imaginatively lends to what was being considered at such length by filming. The encounter was cinematic in so far as filming this place was undertaken with all the signature procedures of an Akerman film: long takes with a fixed camera, or long takes with a camera mounted on a car, almost no commentary or dialogue. Far from being a film

about language and languages, *D'Est* was in fact a silent film. Silence or explosion are marks of Akermanian cinema. Here, it was implosion.

I experienced this installation in its showing at the Jewish Museum, in New York, in 1997. When I first entered the space of the cinematic projection of *D'Est,* and seated myself in expectation of a work of typical Akermanian duration, but with no other idea of the project's problematic, I gradually came to realize what the filming was disclosing. The camera watched a landscape where women worked. Trucks trundled by. The camera stayed put. As I watched these scenes in Poland and the Ukraine in which, to use Ivone Margulies's (1996) term, nothing happens, I realized that I was in fact watching a landscape of agriculture and daily life more or less unchanged since before 1939. The underdeveloped technology and the still heavy manual labour meant that Poland and Eastern Europe had remained more or less frozen in the same world as before Communism except … for the absences. Absence was disclosed by what the film silently and persistently filmed. Visibility of an everydayness that had carried on with its relentless rhythms of seasons and work made absence – that of the Jewish world of Europe which had been so integral to these landscapes – unbearably tangible. Three million Jewish people had lived in Poland of whom less than 275,000 survived the genocide. *Einsatzgruppen* death squads murdered 800,000 Jewish people in the Ukraine after 1942, while a further three million non-Jewish Ukrainians also died from the German invasion.

Without any rhetorical device to point to any meaning, the image in *D'Est* is Rancierian. Rancière writes of Bresson's cinema, that 'images [are] … operations: relations between a whole and parts; between a visibility and a power of signification and affect associated with it; between expectations and what happens to meet them' (Rancière 2007: 3). In *D'Est* the lack of cuts or joins itself builds the growing awareness in the viewer of the tragic dimension of the missing presences that the filmmaker 'found', in the negative as it were, as the ready-made of the landscape before which she merely placed her camera and rolled the film. The film accumulated an unspoken sense of the weight of histories – Jewish and non-Jewish, the latter relating to the experience of the Communist regimes since 1945 that represented other kinds of menace, enclosure, forced labour, desolation; what Akerman calls 'being in jail' (Adams 2010).

The scenes that flowed in the second room were ordinary enough; they marked the movement of people, walking in the snow, waiting for buses or trams in cities of the east. Innocent and everyday, such scenes, however, were surcharged with anxiety, not by real experience but, I suggest, by cinematic memory – Akerman's possibly, this viewer's certainly (Figure 2). What made these scenes remarkable for me was the implicit incantation of the archival footage of stills and film used in Resnais's *Nuit et Brouillard* (1955). In shots that occur between 4.17–4.45 minutes, Resnais's film strategically sequenced a series of still photographs of the rounding-up of people destined for extermination

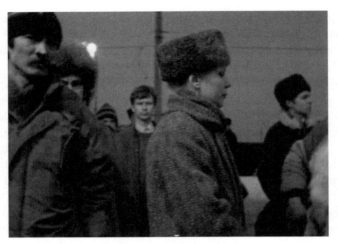

Figure 2 : Chantal Akerman, D'Est (1993, Lieurac Productions).

and concentration camps which is then broken into by film footage that sud-
denly *moves* us from the frozen history of the photographic shot to the terrible
impetus of the *moving* image of people – which retrospective knowledge endows
with the horror of their being herded towards death. Thus, through both his-
torical knowledge but also cinematic memory of vulnerable civilians, any image
of people walking, marching in the snow, with packages, as Akerman says in the
25th Screen, become infected by memories of people walking to the depots or
round-up points, and being marched away to deadly destinations. The voice-
over of the *25th Screen* says:

> And slowly we all realize that it is the same thing that is revealed.
> A little like a primal scene. And the primal scene for me, although
> I fight against it and end up in a rage. I have to face facts. It is far
> behind and always in front of all images barely covered by other lumi-
> nous or even radiant ones. All images of evacuation, of walking in the
> snow with packages toward an unknown place, of faces and bodies placed
> next to one another … And it was always like that. Yesterday, today
> and tomorrow, there were, there will be, there are at this very moment
> people whom history (which no longer has a capital H) whom history
> has struck down. People who were waiting there, packed together, to be
> killed, beaten or starved or who walk without knowing where they are
> going, in groups or alone. There is nothing to do. It is obsessive and I am
> obsessed. Despite the cello, despite cinema. Once the film is finished
> I said to myself, 'so, that's what it was; that again'. (Transcribed in Lebow
> 2003: 42)

It was that, again. But of course, it had not always been that. I contend that Akerman did not know that 'it' was what 'it' was. She arrived at the point of recognizing the traumatic nature of her cinematic aesthetic when the historical possibility of the journey-film arrived with the new conditions for presenting such a film non-cinematically.

This involved the technologies of small-screen video monitors, replicated, and computer-managed streaming that moves a series of images of movement across spatially differentiated sites to make moving image move through space, while yet moving within a screen. The image of movement accompanying the voiced *25th Screen* maintains this real and allegorical relation between cinema and movement, travel and film and the notion of the destined journey that seems endless and without arrival in a reticent, almost abstract image that formally signifies movement.

To understand what is happening there, let us return to Akerman's very first film made at the age of 18 by a young writer who bunked off school aged 15, discovered a Godard movie, *Pierrot le Fou* (1965), and decided to make film. She created a tragicomedy called *Blow up My Town* (*Saute ma ville*, 1968). The experience of watching this 13-minute film cannot be easily reproduced in words. It involves a key space for Akerman's oeuvre, the apartment in a European city, and specifically a kitchen, into which a young woman enters and where she undertakes various, seemingly arbitrary actions, cooking, cleaning her shoes, washing the floor, all interspersed with taping up the windows and sealing the doors. After a lively moment of dancing, the mood turns sombre, the young woman watches herself in a mirror splashing cream liberally over her face, before writing in apparent anger on the mirror's surface. With that she lights a taper and sets fire to a bunch of flowers, turning on the gas, laying herself over the top of the stove. We watch and then the screen goes black to the sound of an explosion, then repeating explosions as if this localized event has replicated itself to destroy an entire city. After a while, the careless voice of the young woman is heard humming and singing la-la-la before she reads out the credits. Violence of an order unanticipated by the essayistic scenario of everyday routines happens in film, but not visibly. The blankness at that moment erases the domestic space. Self-inflicted and then almost global destruction marks a light-hearted film with a level of the tragic it cannot contain while it does achieve a form within which such radical dissonances are being held in terrible tension. From this point Akerman went to New York for several years and then began to achieve recognition as a filmmaker, notably with a series of works initially acclaimed by the emerging feminist avant-garde in independent cinema such as *I, You, He, She* (*Je, Tu, Il, Elle*, 1974), *Jeanne Dielman, 23 Quai du Commerce, 1080 Bruxelles* (1975), *News from Home* (1976) and *Anna's Meetings* (*Les Rendez-vous d'Anna*, 1978).

In 2001, Akerman created an installation at the Venice Biennale, like *Documenta* a major event in the contemporary art world. She used the final

segment of her most famous film, *Jeanne Dielman, 23 Quai du Commerce, 1080 Bruxelles*, in which a widowed housewife, who works from home as a part-time prostitute to support her son, has her relentless and emotionally deadening routine inexplicably disturbed, kills a client and then sits, for seven minutes, unmoving, like a Vermeer *Lacemaker*, leaking red blood onto the polished table under a blinking blue haze. At Venice, the conclusion to the film was taken out of its narrative context and replayed across video monitors under the title of *Woman Sitting Down After Killing*. This entails a transformation into a different temporality offered by installation, past which visitors come and go according to their own will (unlike cinema, which enjoins participation in its duration in order to realize what the whole film has been) and where they may discover something in a flash or through lending their patience to the time demanded to witness the scene. This makes visible a dimension already in the film's ending, noted by J. M. Bernstein, who writes:

> But we do sit with her for quite a while; I suppose for an eternity. The length of the final shot is extended to yield that conclusion since, initially, we keep expecting an interruption (her son will return home from school with his friend), but it lasts just long enough for us to realize that this is not going to happen, that nothing will interrupt her sitting there, and that this scene could go on forever; given the patience of what has preceded, we wonder if it will until the realization dawns that this is eternity, that Jeanne's suffering has always been that, and that eternity is the name for the suffering of woman. (Bernstein 2006: 113)

Going beyond the deciphering of an affect and a meaning derived from the film's subject, Jeanne Dielman, Bernstein discerns a transformation of cinema itself:

> With that the film can end, but now under the condition that the ending is not an end and thus will not, by itself, license our freedom from her torment. In short neither the murder nor the film's end is, in any way, cathartic. (Bernstein 2006: 113)

Bernstein then reads a formal move on the part of Akerman, or rather the attempt to undo the link between form – wholeness – and an unrepresentable dimension that must not be grasped, but, in a method akin to that of Samuel Beckett, be endured, witnessed, felt without relief of fiction.

> Formally, then, the film's movement means to operate as continual suppression of form as the creation of a semblant whole. The continual effort to turn form into the collapse of form, as the source of filmic

betrayal of content, specifies the character of Akerman's modernism. (Bernstein 2006: 114)

Thus between 1995 and 2001 Akerman's work entered the art world, but she is not, by her own admission, now an artist. Her work remains centred in film-making, even while new forms of art such as installation extend the vocabularies for dealing with time, which is in fact no-time. The non-time of trauma and new technologies that are shared between filmmakers and artists enable essay films that do not require vast production costs. Her exploration of the everyday continues. Another travelling film, *Sud* (1998, 71 minutes), shot in the South of the United States, complemented *D'Est* but was followed by *From the Other Side* (*De l'autre côté*, 2002) which was then shown at *Documenta* 11 in 2002. This live-streamed film of a section of the Mexican/US border was projected onto a screen in Kassel but also in the very zone that was being filmed across the seven-hour time gap between Germany and Mexico. In 2008, Akerman had a 'retrospective' in a series of art galleries and museums in the United States in Houston, Cambridge, St Louis and Miami titled: *Moving Through Time and Space*. Terrie Sultan describes the exhibition of five 'works' as representing 'Akerman's unique ability "to cut out an absolutely peculiar, unique space between the cinema movie and the art installation" beginning with *D'Est* (1995) and concluding with *Women From Antwerp in November* (2007), a work commissioned for this survey exhibition' (Sultan 2008: 7).

Intersections

> Memory is always reinvented but with a story full of holes; it's as if there is no story left. What to do then? Try to fill the holes – and I would say even this hole – with an imagination fed on everything one can find, the left and the right and in the middle of the hole. One attempts to create one's own imaginary truth.
>
> (Chantal Akerman)

Preparing to make the fiction film *Tomorrow We Move* (*Demain on déménage*, 2004), Chantal Akerman visited her mother in Brussels one Sunday and asked her assistant Renaud Gonzalez to film an impromptu conversation.[3] A piece of 'research' for a prospective scene that would later be scripted for and performed by two professional actors (Aurore Clément and Sylvie Testud) in the commercial movie, this informal encounter filmed on a little digital camera, which recorded Chantal Akerman and her mother on screen together for the first time, was subsequently reworked into a dual-screen projection and framed by a two-part sculptural installation that was exhibited in Marian Goodman's

Gallery in 2004 in Paris and New York. The title of the installation was *To Walk Next to One's Shoelaces Inside an Empty Fridge* (referenced hereafter as *Walking/ Marcher*).[4]

In *Tomorrow We Move*, her widowed mother, her piano and all her furniture invade the living space of a writer, commissioned to produce an erotic novella. They put the apartment up for sale, bringing a series of bizarre and charming characters into their lives in the manner of an old-fashioned French farce. Yet the finely crafted humour of this romp is tinged with pathos as the shadow of the Shoah falls across the lives of both the estate agent trying to find them a new apartment and across the writer and her mother, a survivor. One potential buyer finds an old diary in a cupboard and takes it away only to return it later in the day. Suffering from insomnia that night, the writer finds the diary and begins to read, when her mother also joins her. She painfully reads aloud the Polish text and recognizes the diary as that of her own mother, murdered in Auschwitz. After falling silent, and reading a while, she turns to her daughter, brushes her check with her hand and kisses her, while the daughter-writer sits immobilized, reflective and shocked. What is happening in this scene?

Of her maternal grandparents Chantal Akerman has written:

> Like two lambs, they let themselves be taken by the Germans. They believed the Red Cross card would protect them.
>
> What happened to them over there, afterwards? Like everyone else I try to imagine it, even if they say it's impossible to imagine. Yet, I let myself imagine something anyway, and the worst part of it is imagining them naked. Him as well as her. 'Naked as a worm', as they say.
>
> Of him, my grandfather, there is only an identity photo. At least, there's that, even if it's only that. There are also some phrases that escape from time to time from my mother. That is how I know that he was a wonderful man, very religious, who closed his eyes to my grandmother's modern ways. It seems he let her do what she wanted. And of my grandmother there remains her young girl's notebook. My mother gave it to me. She said, it will protect you. She gave it to me when I was in need of being protected and she felt powerless. *She gave it to me instead of talking* [my emphasis]. She gave it to me, that's the point. It's been mine since 1984, I think. In fact everything changed in 1984. I sang so hard I exploded. Since then I explode from time to time.[5]

Explosion was, as you will recall, the concluding gesture of Akerman's very first film, *Blow up My Town* (1968), and it is going to resonate in retrospect from this text with a history Chantal Akerman carries as a child of survivors of the Holocaust. The child grows up without grandparents.[6] The mystery of the orphaned parent transmits to the child an additional enigma to be deciphered by attempting to

imagine both the beings of the parent's missing parents and, in the particularity of historical catastrophe that destroyed European Jewry in the middle of the twentieth century, the horror of their ending, namely their naked deaths in Auschwitz. In an interview in 2010, Akerman states of the gestures and routines so patiently 'documented' in *Jeanne Dielman, 23 Quai du Commerce, 1080 Bruxelles*:

> You have to understand that I am a child of the second generation, which means my mother was in Auschwitz; my mother's aunt was in Auschwitz with her, and my grandmother and grandfather died there. So yes, those gestures work for you, for them, to fill their time and not to feel their anxiety. But the child feels everything. It does not make the child secure. You put the child in jail. (Adams 2010)

And again:

> And jail is coming from the camps, because my mother was in the camps, and she internalized that and gave it to me. (Adams 2010)

Fetishizing relics functions as both substitutive memorials of the missing and markers of their horrible absenting: an identity photograph in one case and a notebook-diary in the other. The photograph of the grandfather installs an image and supports what Marianne Hirsch in her analysis of the households of survivor families with their fractured family albums calls *postmemory* (Hirsch 2002; 2008). Postmemory is mediated by the photographic index of another time, place, world and generation; it is a space in the child-subject that links it with a world and events it personally never knew but with which it acquires a dislocated, imaginary intimacy (Hirsch 2002).

Chantal Akerman also holds in her hands a material object, a diary written by the missing grandmother's own hand when she was herself a teenager and young woman in the 1920s. It contains her confessional writing and a watercolour portrait of a woman. Writing and painting mark the paper with two actions that defy the limited identities of the Orthodox Jewish woman in particular and the western bourgeois woman in general, neither of whom is expected to be a writer or an artist:

> I am a woman! That is why I cannot speak all my desires and my thoughts out loud. I can only suffer in hiding. So to you, this journal of mine I want at least to say some of my thoughts, my desires, my sorrows and my joys and I will be sure that you will never betray me because you will be my only confidant.[7]

How closely this tiny passage resonates with the writing of Virginia Woolf who, in the same decades of the early twentieth century, would also ponder on the

internal and external censorship on the full articulation of woman as desiring, thinking, imagining subject (Woolf [1931] 1979). The third aspect I want to note in the passage I quoted above is that Akerman states that her mother gave her the diary in 1984 'instead of talking'. As Bracha Ettinger, an artist also from a Polish-Jewish survivor family, writes in her *Notes on Painting: Matrix Halal(a) Lapsus* in 1992:

> My parents are proud of their silence. It is their way of sparing others and their children from suffering. But in this silence, all is transmitted except the narrative. In silence, nothing can be changed in the narrative which hides itself. (Ettinger 1993: 85)

Silence was the mark of *Jeanne Dielman, 23 Quai du Commerce, 1080 Bruxelles*, the film which made Akerman one of the major names of a new feminist counter-cinema. Critics then and since have always sensed that Akerman's films such as this and *News from Home* were ambivalent 'love letters' to the/her mother (Longfellow 1989: 84). This cannot be denied, but feminist language alone fails to acknowledge the inhabitation by trauma, what Ettinger names a *transcryptum*, referring to an encrypted trauma that is transposed across the generations carried across time through the pages of the multiply inscribed grandmaternal diary (Ettinger 2002).

When interviewed in 2010, Akerman was adamant that her mother never spoke of her past: 'No, no, no, never' (Adam 2010). Something could not be spoken; yet there was a transmission mediated by gesture and by this text-object. 20 years passed before mother and daughter were filmed together and the return to the diary enabled the beginning of talking which is what we are invited to witness in the installation created in 2004.

Transformations

> All these films have finally brought me to that. She finally feels better. She finally shed a tear. Thirty-three years of work with so many turns and detours, and she finally feels better. Is this what I was looking for?
>
> (Chantal Akerman)

To Walk Next to One's Shoelaces Inside an Empty Fridge (2004) is very different from the finely tuned, economic and affecting movie, *Tomorrow we Move* (2004), for which its footage was a kind of 'research'. Full of words, framed by a fragile double spiral labyrinth through which the viewer accesses the installation, the filmic element of the installation is embedded in a sculptural structure that was also a temporal one.

In the middle of the second room hangs a transparent tulle scrim in open space (Figure 3). On this scrim is projected a single painted portrait head of a young woman, dating from about the 1920s. Then there is a moving image of a page of handwritten text that wanders across the scrim. The shared surface suggests a relation between the open pages of a notebook and this small portrait. Looking through the punctuated scrim, the viewer sees a large, double-screen, out of focus, video projection. Over a period of 24 minutes, this projection unfolds the story of the filmmaker herself bringing to her mother a notebook/ diary, asking her to read it, painfully to translate its words from almost forgotten Polish, while slowly coming to realize that she is reading the handwriting of her own mother, who wrote this diary as a teenager, and became a mother who was murdered in her forties in 1943 in Auschwitz.

Having struggled with the poignant text that begins declaratively 'I am a woman!' and tells the diary that she is, therefore, alone with the book as her only confidant, and lonely because she has no one to share her heart with, the mother of the filmmaker falls silent and reads the returning words of her own mother written long before she herself was born. At this stage the viewer cannot know what she is reading when she falls silent and ceases to translate or comment. The effect of what she reads is, however, sufficiently moving to make her turn, weeping slightly, and to caress her daughter's cheek, and then to kiss it.

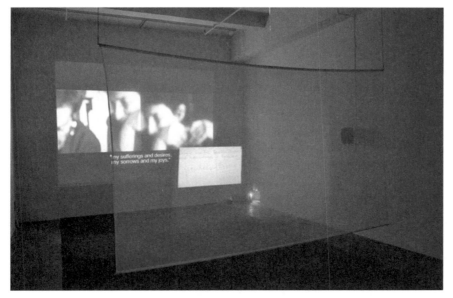

Figure 3: Chantal Akerman, Walking outside one's shoelaces beside an empty fridge *(2004), video projection with scrim, moving projection of image and notebook. Second part of installation (courtesy by the artist and Marian Goodman Gallery, Paris).*

This spontaneous gesture, enacted in silence in the middle of this manipulated double projection, functions as a hinge between the 'set-up' orchestrated by the filmmaker as 'research' for her movie to come and a time-reversing moment in which, for me as a student of Akerman's cinematic career, everything from the beginning of that career became suddenly plain. I suggest that an entire career had been undertaken, movie after movie, and since 1995, art installation after installation, to arrive at that possibility, that moment, that *gesture*, that *movement* captured not by the filmmaker looking through the lens, but as its recipient, her own skin brushed by the touch of the mother's hand and lips.

What caused the gesture? It appears that in reading to the end of the written pages of the diary, Nelly Akerman discovered, as if for the first time, her own inscription in 1945, as a bereaved 18-year-old, to her lost mother when, barely alive herself, she received this diary (she cannot remember how it came to her) as the only surviving relic of her murdered mother. She had written:

> This is the diary of my poor mother who disappeared so early, at the age of 40. I will never forget her young girl's life, I will always think of her as the best mother who ever lived. I am sorry that I did not love her more and love her better than I loved her. She was so good and so understanding that she will remain in my heart always, singular and unique, and no one will ever replace her for me. My dear little mother, *protect* me.
>
> Nelly

But the diary had been found by the daughter of Nelly, Chantal, when she was about ten (1960). She had found the inscription by her mother and added her own into this unique object already over-inscribed:

> Dear Mama,
>
> You can't imagine how I felt reading what you wrote in those few lines. I hope you feel *protected* and loved by all and that you are happy.
>
> Chantal

In turn, Chantal's younger sister also finds the diary and adds her own words:

> Dear Mama,
>
> I also felt something in my heart reading what you had written. No one can replace you dear Mama, I would have loved to know your beloved mother. Your daughter who loves you so much.
>
> Sylviane

I have highlighted the recurring word *protection*. It recalls another passage:

> My mother gave it to me. She said, it will protect you. She gave it to me when I was in need of being protected and she felt powerless. *She gave it to me instead of talking.*

The tears and the kiss are wordless; they are a response that returns to gesture as the movement towards, but also *with* another, and returns to the touch, to a moment of affect and contact that does not dissolve difference but opens onto a shared moment and creates a surface of meeting. What follows from the gesture of touching her daughter's face and kissing it, affirming her being there, is a long free-flowing conversation between them about the past – firstly about the plans and pre-war ambitions of Nelly Akerman and her artistic mother to work in some aspect of design, couture perhaps, then the regrets of Nelly Akerman who returned from her experience in the camps 'damaged and broken' unable to take up her studies, and in need of the support offered by her husband, a leather merchant. Yet this conversation about what her mother had endured, how she had been supported through the devastating hunger of her time in the camps by a friend, and how she was liberated puts in place the long-missing 'story' without holes.

In her notes on this work, Akerman tells us that Aurore Clément, who would play the mother in *Tomorrow We Move*, watched this 'raw' footage filmed in Brussels. For the movie, the contents were fictionalized and words and names were changed. But Aurore Clément developed something implicit within the filmed exchange. 'The Mother (Aurore) at one point says to her daughter in the film Charlotte (played by Sylvie Testud) "it's a miracle that I am here and that you're here, you know".' That is to say that the mother-to-be's survival at all was such an accident, that the very existence of a new generation is marked by the contingency of a survival that escaped the genocidal death sentence that engulfed the millions. Akerman adds: 'My mother did not say that, when Renaud and I filmed her. At one point, Aurore kisses her daughter. In the film, we do not know why.' Then she continues:

> In the images of my mother we do not know why either, why all of a sudden she kisses me. I know why, she has just discovered what I and my sister added. First, what she had written following her mother's last words. She did not remember it. She no longer remembered what she had written.

It seems that the preparation for the movie in 2004 through the Brussels visit created the moment in present time for an anamnesic re-encounter with a forgotten, a repressed past. In another reversal, Akerman also tells us that her

mother then watched Aurore Clément play the scene based on the filmed encounter.

> Suddenly I saw tears in her eyes. She tried to hold them back. But she could not. They were little tears, very discreet. The next day I telephoned and she said, you know I was a little overwhelmed yesterday, but I finally feel better.
>
> All these films have finally brought me to that. She finally feels better. She finally shed a tear. Thirty-three years of work with so many turns and detours, and she finally feels better. Is this what I was looking for?
>
> I have no idea.
>
> Maybe
>
> I'd like to believe it.
>
> But honestly not just that.

Nelly Akerman *feels* better. In what way does the translation of the 'event-encounter' that happened with the diary before the digital camera in her own home into a formal scene played by others 'transform' her own lived but traumatically disowned burden of history, bringing her back to her ability to feel, and thus to make a change without doing what Jeanne Dielman did when feelings interrupted her mode of surviving? How important is the trans-formation where the *trans* dimension of the movements between mothers and daughters, and then actors, links in with the *metamorphosis*, the trans-lation that is the creation of a form, a pathos-formula, through which the trauma that was always there as the equally constitutive void between mother and daughter is held now outside both of them by an aesthetic formulation precipitated and disclosed through the 'research' filming one Sunday in Brussels?

There is a danger here. The reader might think that we are finally finding the key, and a biographical key that unlocks the secrets of 33 years of Akerman's filmmaking. Reduction of a lifetime's work to one single, autobiographical causation is utterly ridiculous. It is in one deep sense quite just to say this, as Akerman admits. She adds importantly *[b]ut honestly not just that* and to this we have to pay acute attention.

Yes, we do have to make sense of the belated moment of realization when a single gesture *and its replay* and *revisioning* through the medium of digital recording and then cinematographic performance and registration appears to crystallize a shapeless haunting past into that which can be said, scripted, performed, watched and taken on. There were two moments when the 'trauma'– which is what we are dealing with – I suggest, leaks out of the body in the flow of slight tearfulness.

Conclusion

I am not suggesting that suddenly in Brussels before Renaud Gonzalez's digital camera the truth of Akerman's cinema was revealed as the long-secreted family history of destruction and survival in the Shoah. It was always there, obliquely, glimpsed in *Rendez-vous d'Anna* and *D'Est*. Yet I am suggesting, as others before, that this is the historical ground that cannot be ignored in tracing the specific aesthetics and ethics of Akerman's long career to date precisely because its deepest core, by definition, could never be directly confronted. I want here to stress its emergence across the sequence of events: the filming, the watching of that footage, the watching of its being turned into cinema, and after all three events, there is the moment of flowing words (later formalized by streams of them flowing over the convoluted sculptural forms through which the installation is accessed).[8] Yet before this moment, there was neither this flow of tears – feeling better – nor words. Indeed silence or violent explosion, missed communication and absence, marked the cinematic rhetoric of Akerman in ways which found acceptance and acknowledgement as part of an avant-garde at once Godardian, Warholian, Snowian and feminist. We accepted the signs of her extraordinary cinematic intervention, but we knew not the specifics of their causation in a deeper trauma than that of the choked feminine voice in culture enabled to speak in a newly feminized avant-garde formalism.

The spontaneous gesture, the mother's teary kiss, does not heal the breach. It cannot repair the rupture. It does not erase the past. It is the moment that the past becomes the past, allowing a movement into narrative and into the flow of dialogical speech. The physicality of her hitherto unshed tears and her touch of the skin of her own daughter for which the 'research' filming for the commercial feature movie set up the occasion allows the body to speak so as to make possible the narrative that releases the silent, encrypted trauma into aesthetically occasioned, and shareable memory.

My conclusion is not that we can now retrospectively place Chantal Akerman in a category, genre, or group sometimes identified with the Shoah, for that would be to contain the *work performed by her working*. If I can track a certain persistence that only retrospectively appears to us as having been the thread of continuity underlying a 40-year career moving from film to installation and now between the two, is it possible that the past only arrives once a future has been built to contain it? Was it only possible because of the other space offered by post-conceptual art practice and its kinds of temporalities and other, non-narrative yet durational spaces that involved both the sudden revelation of encounter and prolonged contemplative viewing? Yet it is the moment of Nelly Akerman witnessing the transformation of her own scene into fiction cinema that was as vital for her internal transformation.

Thus, far from dealing with impurity when cinema and art meet and exchange, this study has tracked a poignant contingency occurring precisely in the relay between forms, practices and moments that allowed trauma, personally and transgenerationally encrypted, to be released and transformed in the co-inhabited spaces of the aesthetic, the visual and the temporal.

Notes

1 For beautiful discussions of the meaning of Akerman's sensitivity to Jewish tradition's prohibition of the image in general, and the extension of the *Bilderverbot* to representations of the Shoah, see Olin (2001) and Lebow (2003).

2 For Akerman's extremely important analysis of the intersections of class and Jewish identity in her childhood, and her continuing sense of class identity vis-à-vis the entry into the art world where her installations are financed or purchased by the rich, experienced as class enemies, see Adams (2010).

3 The analysis of these two films is also developed in a different context of the study of trauma and aesthetics in my book *After-Affect/After-Image: Trauma and Aesthetic Transformation in the Virtual Feminist Museum* (2013).

4 The original French title includes the phrase: '*Marcher à côté de ses lacets*' which is an idiom meaning 'to be completely out of it'.

5 All unattributed quotations are from manuscript materials kindly provided by Marion Goodman Gallery, Paris. Some are the English translation of the materials printed in Chantal Akerman (2007).

6 Jean-Jacques Moscovitz articulates this question in Lacanian terms in his book *D'où viennent les parents?* (1991).

7 For a beautiful cinematic exploration of the concept of woman as a derelict and exile in phallocentric culture, see Sally Potter *The Gold Diggers* (1983; DVD, 2009).

8 I am reminded here of the use of Irigarayan imagery of the frozen wasteland turning to flowing water as the structure for Sally Potter's *The Gold Diggers*, which represents through landscape a journey undertaken by two women to deconstruct the patriarchal formation of femininity and come to their own, collaborative recognition of femininity under the sign of movement and fluidity.

References

Adams, Sam (2010). Interview with Chantal Akerman. Available at http://www.avclub.com/articles/chantal-akerman,37600/, last accessed 25 August 2012.

Akerman, Chantal (2007). *Neben seine Schnürsenkeln in einem leeren Kühlschrank Laufen*. Berlin: Jüdisches Museum and Laconic Press.

Bazin, André (1967). 'In Defense of Mixed Cinema', in *What is Cinema?*, translated and edited by Hugh Gray. Berkeley: University of California Press, pp. 53–75.

Benjamin, Andrew (ed.) (1993). *Installation Art*. London: Academy Group.

Benjamin, Walter (1979 [1931]). 'A Short History of Photography', in *One-Way Street and Other Writings*, translated by Edmund Jephcott and Kingsley Shorter. London and New York: Verso, pp. 240–57.

Bernstein, Jay M. (2006). 'Modernism as Philosophy', in *Against Voluptuous Bodies: Late Modernism and the Meaning of Painting*. Stanford: Stanford University Press, pp. 78–116.

Bird, Jon (ed.) (2001). '*Installation*: a special issue', *Oxford Art Journal*, 24:2.

Bishop, Claire (2005). *Installation Art, a Critical History*. London: Tate.

Bruno, Giuliana (2009). Introduction to Chantal Akerman, List Center, MIT. Available at http://video.mit.edu/search/?q=giuliana+bruno+chantal+akerman&x=0&y=0, last accessed 25 August 2012.

Crary, Jonathan (1990). *On Techniques of the Observer: Vision and Modernity in the Nineteenth Century*. Cambridge, MA: MIT Press.

Charney, Leo and Schwartz, Vanessa (eds) (1995). *Cinema and the Invention of Modern Life*. Berkeley, Los Angeles: University of California Press.

Didi-Huberman, Georges (2009). *Confronting Images: Questioning the Ends of a Certain Art History*. University Park, PA: Pennsylvania State University Press.

Doane, Mary Ann (2002). *The Emergence of Cinematic Time: Modernity, Contingency, the Archive*. Cambridge: Harvard University Press.

Ettinger, Bracha L. (1993). *Matrix Halal(a) Lapsus: Notes on Painting*. Oxford: Museum of Modern Art.

—— (2002). 'Transcryptum', in Linda Belau and Petar Ramadanovic (eds), *Topologies of Trauma: Essays on the Limit of Knowledge and Memory*. New York: Other Press, pp. 251–72.

—— (2006). 'Fascinance and the Girl-to-m/Other Matrixial Feminine Difference', in Griselda Pollock (ed.), *Psychoanalysis and the Image: Transdisciplinary Perspectives*. Boston and Oxford: Blackwell Publishing, pp. 60–93.

Godard, Jean-Luc (1980). 'Entretien sur un projet: Chantal Akerman', *Ça Cinéma* 19, pp. 12–13.

Halbreich, Kathy and Bruce Jenkins (eds) (1995). *Bordering on Fiction: Chantal Akerman's D'Est*. Minneapolis: Walker Art Center.

Hirsch, Marianne (2001). 'Surviving Images: Holocaust Photographs and the Work of Postmemory', *Yale Journal of Criticism* 14:1, pp. 5–37.

—— (2002). *Family Frames: Photography, Narrative and Postmemory*. Cambridge MA: Harvard University Press.

———— (2008). 'The Generation of Postmemory', *Poetics Today*, 29:1, pp. 103–28.

Irigaray, Luce (1991). 'The Bodily Encounter with the Mother', in Margaret Whitford (ed.), *The Irigaray Reader*. Oxford: Basil Blackwell, pp. 34–46.

———— (1977). 'Women's Exile', translated by Couze Venn, *Ideology and Consciousness*, 1, pp. 62–76.

Krauss, Rosalind (1979). 'Sculpture in the Expanded Field', *October*, 8, pp. 30–44.

Lebow, Alisa (2003). 'Memory Once Removed: Indirect Memory and Transitive Autobiography in Chantal Akerman's *D'Est*', *Camera Obscura* 52, 18:1, pp. 35–82.

Longfellow, Brenda (1989). 'Love letters to the mother: the work of Chantal Akerman', *Canadian Journal of Political and Social Theory Annual*, 19 (1–2), pp. 73–90.

Margulies, Ivone (1996). *Nothing Happens: Chantal Akerman's Hyperrealist Everyday*. Durham, NC: Duke University Press.

Moscovitz, Jean-Jacques (1991). *D'où viennent les parents?* Paris: Armand Colin.

Mulvey, Laura (2006). *Death 24x a Second: Stillness and the Moving Image*. London: Reaktion Books.

Olin, Margaret (2001). 'Graven Images on Video?: The Second Commandment and Contemporary Jewish Identity', in *The Nation without Art*. Lincoln and London: University of Nebraska Press, pp. 179–204.

Oliveira, Nicolas de and Nicola Oxley (2003). *Installation Art in the New Millennium: Empire of the Senses*. London: Thames & Hudson.

Pollock, Griselda (2013). *After-Affect/After-Image: Trauma and Aesthetic Transformation in the Virtual Feminist Museum*. Manchester: Manchester University Press.

Pomerance, Murray (2006). *Cinema and Modernity*. New Brunswick, NJ & London: Rutgers State University Press.

Rancière, Jacques (2007). *The Future of the Image*. London: Verso Books.

Rosen, Philip (2001). *Change Mummified: Cinema, Historicity, Theory*. Minneapolis: University of Minnesota Press.

Sultan, Terrie (2008). *Chantal Akerman: Moving Through Time and Space*. Houston: The Blaffer Gallery.

Tarantino, Michael (1995). 'It's not Just an Image: Interview with Chantal Akerman', *Parkett*, 45, p. 168.

Woolf, Virginia (1931). 'Professions for Women', *The Death of the Moth*, reprinted in (1979) Virginia Woolf, *Women & Writing*, edited by Michèle Barrett. London: The Women's Press, pp. 57–63.

Chapter 14

Projection as Performance: Intermediality in Japan's Expanded Cinema

Julian Ross

In this chapter, I will look at expanded cinema performances by three key Japanese avant-garde artists of the 1960–70s, namely Takahiko Iimura, Jōnouchi Motoharu and Terayama Shūji.[1] The chapter will provide examples of their intermedial practice that, on the one hand, reveals the malleability of the medial properties of cinema and performance, yet, on the other hand, draws our attention towards the specificity of both forms of expression. Framing the discussion within and beyond recent theoretical debates on intermedia, I will argue against Werner Wolf's categories of intermedia, proposing instead that media in expanded cinema is in a state of perpetual negotiation and dialogue with each other and resist such attempts at systematization. Through the analysis of these three Japanese artists' works and by opening up discussions beyond case studies from Europe and North America, this chapter will demonstrate the necessity for and benefits of interdisciplinary approaches to boundary-defying artistic practice, whilst contributing to the development of intermedia as a theoretical tool.

Despite the experimental practice of expanded cinema existing at the very early stages of cinematic development, research into film has largely ignored the artistic possibilities of exhibition.[2] Although research on expanded cinema may be sparse in the history of film studies, the integration of cinema into performance has existed from the early decades of cinema; for example, the assimilation of *Entr'acte* (René Clair 1924) in Francis Picabia's multimedia ballet performance *Relâche*, and Picabia's subsequent play *Cine-Sketch* (1924), influenced by the mechanisms of cinema, demonstrate early interests in exploring the boundaries between the art forms. Such developments in alternative ways

of film exhibition continued to fascinate filmmakers and the 1960s saw an explosion of enthusiasm for the expansion of cinema and the blurring of borders, in tune with poststructuralist impulses that had begun to challenge universality and fixedness. At the dawn of the 1960s, artists began to revisit the possibilities of the film form beyond the frame and the screen; rather than concentrating on what happens *within* the screen, the screen *itself* became subject to interrogation, and these experiments were soon dubbed 'expanded cinema'. Multiple and simultaneous projection, projector-performances, overlapping projections and human interaction with mechanical projections of light were just some of the experiments that were conducted by artists of the period. They rejected cinema's fixed frame, determined sequentiality and mechanical capacity for routine repetition, in favour of an organic creative process that considered film's encounter with space, audience and the artist which inevitably varied at each screening. Expanded cinema as an approach allowed space for impulsive spontaneity, celebrated diversity and invited collaborations with other art forms upon its presentation.

Likewise, intermedia as a concept and artistic practice emerged in the 1960s as a neighbouring and parallel phenomenon to expanded cinema. Fluxus artist Dick Higgins coined the term in 1966, describing the interaction between art forms as a possible space for artistic exploration; as Kiene Brillenburg Wurth explains, the term constituted 'a third space, hovering in a domain that could not yet claim a medial field of its own' (2006: 11). Expanded cinema can be understood to be intermedial in its nature, as the two forms of expression involved, cinema and performance, are subjected to a dialogue of reciprocation, at times illuminating each other's characteristic modalities, yet at other times throwing them into an indefinable flux. More recently, 'intermedia' has been resuscitated as a theoretical approach and embraced by academic disciplines worldwide.

Werner Wolf suggested interactions between two media could largely be separated into two categories: *overt* intermediality and *covert* intermediality (1999: 39–44). In his terminology, overt intermediality signals a mixture of media where 'each medium remains distinct and is in principle "quotable" separately' (40); covert intermediality, on the other hand, refers to 'a participation of (at least) two conventionally distinct media in the signification of an artifact in which, however, only *one* of the media appears directly with its typical or conventional signifiers and hence may be called the dominant medium' (41). For example, the prints by eighteenth-century English artist William Blake contain both visual illustration and written poetry and, although they coexist and resonate with each other on the same plane, they are discernible separately and therefore should be categorized as overtly intermedial. Georges Braque's painting *Homage to Bach*, on the other hand, might be useful to illustrate a covertly intermedial phenomenon, as Braque's paintbrush visually transposes or

translates properties of Johann Sebastian Bach's musical composition; it defines a relationship between a 'dominant' and a 'non-dominant' medium where properties of one medium, the 'source', is brought '*into*' another medium, the 'target' (Wolf 1999: 42).

Expanded cinema provokes a questioning of Wolf's categorizations, however, because in projection-performances, performance and film merge together, *intermedially*, to produce something that is radically different from the two art forms, whilst undoubtedly incorporating aspects of both. It is, therefore, neither overtly or covertly intermedial, but hovers in between in perpetual negotiation. In expanded cinema, the degree of intermediality and the levels of dominance of each medium are indeterminable and elude empirical observation.[3] Thus, expanded cinema as a practice invites us to revisit Susan Sontag's essay 'Film and Theatre' where she asks: 'The big question is whether there is an unbridgeable division, even opposition, between the two arts. Is something genuinely "theatrical," different in kind from what is genuinely "cinematic"?' (Sontag 1966: 24).

Although historical research on expanded cinema and intermedia so far have based their evaluations mainly on European and American case studies, intermedial practice has never been a Euro-American privilege. Japanese artists of the 1960s and 1970s similarly explored the in-between space that bridges performance and cinema; in fact, the Japanese had their own branch of 'intermedia', a translated response to their American counterparts mixed with traces of their own historical lineage, and by 1967 many events were coordinated using the word in their titles, testifying to the popularity of the approach.[4] This chapter will focus on the work of three artists, namely Takahiko Iimura, Jōnouchi Motoharu and Terayama Shūji and analyse their expanded cinema performances in relation to recent discussions on intermediality.

Takahiko Iimura

Takahiko Iimura is an experimental filmmaker who emerged out of a fine-art background onto the independent film scene in the early 1960s, and positioned himself at the vanguard of experimental cinema through his continuous pursuit of intermedial expression through his films, video-art pieces, installations and expanded cinema performances. An enthusiastic believer in the productive interaction between film and other arts, Iimura engaged in collaboration with artists from other medial contexts. Despite his dedication to the moving image, he was aware of its limitations and his early experiences with other arts, including poetry and painting, allowed him to feel comfortable incorporating and translating aspects of them into his cinematic practice in order to expand the possibilities of the medium. Iimura placed his practice within a context of

artists who sat outside his principal medium of cinema. For example, as the founding leader of a collective mobilized to encourage independent filmmaking called Film Independents, he invited noise-music artist Yasunao Tone, performance artist Kazakura Shō and a member of Hi-Red Centre,[5] Akasegawa Genpei, amongst other non-filmmakers, to submit a two-minute short film for an event organized by the group.[6] The effects of Iimura's position as an intermediary between various artistic media were most prominently demonstrated in his own cinematic endeavours, and in particular his projection-performances where osmosis occurred between performance and cinema.

In early screenings of his work, Iimura invited Yasunao Tone from Group Ongaku, Japan's pioneering improvised music collective that pursued the possibilities of chance-sound, to conceive the projection of film as if it were a live music performance, translating the properties of live music to film exhibition. In August 1963 he presented *Dada '62* (1962) at the Naiqua Gallery in Shinbashi, Tokyo, where he performed what he called a 'film concert' with improvised interpretations of a graphic score composed by Tone. Iimura spontaneously performed with an old projector where he was able to switch projection-speeds, freeze the frame, blur the focus, enact no-lens projection and reverse projection as well as move the projected image off the screen surface. As he explained, 'the screenings of these films were an attempt to recapture the performative essence of film exhibition, a way to resuscitate its dynamism that was disappearing as cinema became increasingly like ready-made products' (Ross 2010b). Each screening of these films was intentionally variegated in its approach, intended to challenge the conception of cinema as a one-dimensional medium fundamentally resistant to interaction. Iimura understood exhibition, the much neglected factor of film research and practice, as the essence of cinema, and stated: 'exhibition is probably the most important factor as it is the space where and time when it meets its audience. I wanted to rethink its significance' (Ross 2010b). Not only did each screening vary in its mode of exhibition but, for example, in the first five screenings of *Onan* (1963), a short film about a young man's preoccupation with his sexual desires also scored by Tone, Iimura re-edited the film by hole-punching different frames and repeating the altered scenes, in order to counter the notion of finality. As he explained, ' there is no one version of *Onan*, but many works under the same title' (Iimura 1968: 62).[7] As a result, a fixed version of the film was intentionally absent even prior to its display under different screening situations.

Iimura's conceptual foundation on intermedial activity is perhaps most visibly and thoroughly incarnated in his projection-performances of *White Calligraphy* (1967) (Figure 1). Firstly, *White Calligraphy* is a literal adaptation of the first page of what has been declared the first written text in Japan, *Kojiki*, a collection of myths dating from the eighth century that describe the birth of the four main islands of Japan. For the film each Chinese and Japanese logogram of

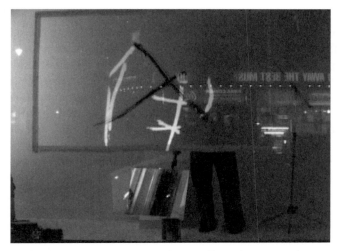

Figure 1: Takahiko Iimura's performance White Calligraphy Re-Read *at Window Gallery, Central St. Martin's University of the Arts London on 7 October 2010 (courtesy of Damien Sanville).*

the first few pages of the text was scratched into each frame of a black leader filmstrip, an act that physically transposes the literary medium onto the cinematic in a tangible procedure. The stasis of a printed text is made mobile through its displacement onto a filmstrip reeled through a projector. Moreover, the durational process of reading literature is highlighted, ironically, through the impossible task for the viewer of registering each linguistic symbol at 24 frames per second. The act is a genuine translation from text to screen, an adaptation of 'integral equivalent' that recalls Bazin's call for adaptations 'not simply to use the book as an inspiration, not merely to adapt it, but to translate it onto the screen' (2005: 66). Iimura's *White Calligraphy* reincarnates its subject-texts by pictorializing a literary mode of expression, taking inspiration not just from a novelistic style, what Bazin has dubbed as 'ultracinematographic' (2005: 64), but literally transposing it, one might say, in a *cinema-to-graphic* procedure. Bazin had even once asserted that '[t]he time of resurgence of a cinema newly independent of novel and theatre will return. But it may then be because novels will be written directly onto film' (2005: 74–5), a process of creation that strives for both media to be preserved in co-existence. This process, I would argue, was successfully enacted by Iimura with *White Calligraphy*.

Secondly, properties of theatrical performance are incorporated into the projection of *White Calligraphy* as, in his recent projection-performances of the film,[8] Iimura has deconstructed the stasis of cinema's fixed-frame by moving the projection around the walls, onto the ceilings, onto his audience and himself, allowing a fluid sense of surface, texture and shape for the projected frame.

In these performances, a duality of motion occurs – one *within* the frame and the other *of* the frame. The speed of projection is altered during the performance, occasionally arriving at a freeze-frame halt to highlight cinema's determined sequentiality. Since 2003 Iimura has spontaneously vocalized the logograms he is able to register so as to render an additional layer of chance-sound to the performance. The text of *Kojiki* itself, consisting of songs and poems, was written largely in *man'yōgana*, an ancient style of writing that emphasizes the phonetic aspect of reading. Iimura reinvigorates the aural aspect of the text by vocalizing the legible logograms in his performance, an act that, through the disassociation of the semiotic value of the letters by transforming them into pure sound, re-establishes the original intention for the text to be read aloud. Iimura's performance incorporates 'pre-modern' material into 1960s explorations of chance-sound, an emergent form of musical experimentation that was brought to prominence by Group Ongaku's performances at Sōgetsu Art Centre[9] from 1961 and John Cage and David Tudor's visit at the same venue in October 1962, dismantling the chronological layout of 'pre-modern', 'modern' and 'post-modern' art into a shape that defies the linearity that is often assigned to Japanese cultural history. John Cage had stressed the influence he drew from Japanese Zen Buddhism, and in particular the concept of *ma* (in-between), which triggered a revival in interest for the Japanese artists in their own local customs. Iimura's projection-performances of *White Calligraphy* registered the developments in both performance art and music that was practiced in Japan during the 1960s.

Finally, since 2005 Iimura has painted over the visible characters in the projection of *White Calligraphy*, in an attempt to physically capture the mobile texts using calligraphy. Again, the impossibility of seizing each logogram projected at 24 frames per second refocuses our attention onto the tactility of the filmstrip and how its form alters when projected. When the performance comes to a conclusion, what is left is an entirely abstract painting that will be different for every performance. Through the act of tracing over his projection, Iimura takes *White Calligraphy* full circle back into stasis, an adaptation that is filtered through different media and undergoes various processes of metamorphosis only to return to its origins.

Iimura's expanded cinema performances are punctuated by their impulsive spontaneity and critical attitude towards rigidity and fixed forms. The point of interest is, however, that despite Iimura's intent to disintegrate the borders between media, these projection-performances often call the attention back onto the filmic medium. Iimura himself stated that: 'By exposing the bare essence of a medium, intermedia expounds the independence of each medium' (Iimura 1968: 113). In other words, although the malleability of medial forms is highlighted, simultaneously the existence of *difference* between media is accentuated, specifically through the work's intermedial character. As Gene

Youngblood has stated, 'the exclusive properties of a given medium are always brought into sharper focus when juxtaposed with those of another' (1970: 365), and it seems the paradoxical tendency where the crux of a medium is highlighted through coalescence with another is universal across intermedial practices. Speaking about the relationship between media, Bertolt Brecht agreed with and championed media collisions that cause a realization of each other, rather than amalgamating them into homogeneity:

> So let us invite all the sister arts of drama, not in order to create an 'integrated work of art' in which they all offer themselves up and are lost, but so that together with the drama they may further the common task in their different ways; and their relations with one another consist in this: that they lead to mutual alienation. (Brecht 1964: 204)

In such ways, Iimura's film-performances highlight the idiosyncrasies and limits of film: the mobility of the image; the existence of a frame; the concept of time as an anchor of the medium; and the materiality of a filmstrip.

When conceptual categorizations of intermediality are applied to mixed-media practice, they fissure in friction with each other as certain questions emerge about their validity. Iimura's approach problematizes Werner Wolf's attempt at imposing classifications on intermedial expression as the artist's intention is an antithetical escape from classification. On the one hand, Iimura's projection-performances cannot be categorized as an example of an overt intermedial occurrence, as the media of performance and cinema refuse to remain distinct and are no longer quotable separately. On the other hand, although on the surface it seems the cinematic medium is dominant, as it appears to absorb properties from performance art as its source medium, the two media are in fact undergoing perpetual negotiation as performance art inflicts its impulsive behaviour onto the cinematic, whilst the projection attempts to maintain its durability on the performance. It is within this intentionally unstable in-between realm that Iimura positions his work, where the artwork loses its grip on both media. Irina Rajewsky may be making an astute observation when claiming that the concept of intermediality itself, somewhat ironically, 'implicitly presumes that it is indeed possible to delimit individual media, since we can hardly talk about *inter*mediality unless we can discern and apprehend distinguishable entities between which there could be some kind of interference, interaction or interplay' (2010: 52).

On discussing intermediality, Lars Ellestrom proposes that 'if we are to talk about borders we are better off talking about border zones rather than strictly demarcated borders' (Ellestrom 2010: 4), and it might be accurate to suggest that Iimura's practice explores the interaction between such border zones rather than the overlapping of delineated boundary lines. Iimura's practice in

projection-performance denies the existence of durable boundaries between media specifically through their interactivity, yet his process of defining the essence of a medial form counteracts the rejection of difference. To incorporate Zygmunt Bauman's terminological use of fluids in *Liquid Modernity* into the language of intermediality, it may be productive to describe medial forms as volatile shapes that are subject to inconstancy. Bauman suggests:

> [L]iquids, unlike solids, cannot easily hold their shape. Fluids, so to speak, neither fix space nor bind time. While solids have clear spatial dimensions but neutralize the impact, and thus downgrade the significance of time (effectively resist its flow or render it irrelevant), fluids do not keep to any shape for long and are constantly ready (and prone) to change it; and so for them it is the flow of time that counts, more than the space they happen to occupy: that space, after all, they fill but 'for a moment'. (Bauman 2000: 2)

Iimura's understanding of medial forms is similarly molten, as properties of media flow in and out of his works. In his rejection of affixed time and space, Iimura's intermediality occupies a tangible space 'for a moment', only to flow along to settle into another, an inconstant volatility that poses problems when we attempt to classify his mode of intermedial interaction, even within the in-between spaces of the border zones.

Jōnouchi Motoharu

Experimental filmmaker Jōnouchi Motoharu's screenings similarly rejected categorizations and strove for an approach to exhibition that varied in its presentation at each performance. Jōnouchi was one of the leaders of the legendary Nichidai Eiken (Nihon University Film Study Group), where students collaboratively created films that have often been cited as pioneering experimental films of Japan. The film society was set up in 1957 and, although they were attached to the university, they led an autonomous existence exhibiting their work outside of the educational institution. Jōnouchi set up the VAN Film Science Research Centre, a communal living space as well as an artists' space between 1960 and 1969, and the centre became a place where artists across disciplines interacted. Their manifesto embodied the 'two avant-gardes' of politics and art promulgated by Renato Poggioli in *The Theory of the Avant-Garde* (1968); according to Adachi Masao, another member of VAN, they aimed:

> to position film production as part of and a continuation of the political movement whilst placing it within interactions that transcend artistic

genres in order to integrate film expression within collaborative initiatives. In other words, to make 'mixed' films. (2002: 96)

Performance artists Kazakura Shō and Yoko Ono, noise-artists Yasunao Tone and Takehisa Kosugi, as well as Iimura, frequently visited the centre. Jōnouchi's experiences in collaborative filmmaking at Nichida Eiken and the VAN, as well as his interactions with artists working outside the cinematic medium, combined to inform him with an open-minded approach to filmmaking initiatives and exhibition practices.

In 1961, Zengakuren, the All-Japan Federation of Self-Governing Students, invited the members of VAN to produce *Document 6.15* for a demonstration event mourning the death of student protestor Kanba Michiko. With Jōnouchi's involvement, the film was conceived as part of a performance with light projection, slides and live-sounds, and the event became a precursor to the large-scale 'intermedia' events that became a staple of the art scene at the tail end of the decade. For the audience members who stood outside unable to enter the packed auditorium, one of the speakers was placed outside creating dissonance and aural imbalance in both spaces and VAN intended for the ensued chaos to interfere with the planned public announcement of the disbandment of Bund (Bundo) (Adachi 2002: 98), a strand of the Zengakuren that disassociated itself from the Japanese Communist Party. Such early events provided Jōnouchi with an appetite for screenings that offered an alternative to cinematic exhibition usually confined to a fixed physical and temporal frame.

Jōnouchi also participated in live-art performance, where artists used their bodies as a performative device and rejected gallery walls and proscenium stages to share their work on the streets of the city instead. At the screenings of Nichidai Eiken's sixth production *Closed Vagina* (*Sain*, 1963) in Kyoto, Jōnouchi, together with Kazakura, Akasegawa, Adachi and musicians Takehisa Kosugi and Koike Ryū amongst others, conducted live-art and music as an accompaniment, and the events was entitled *Sain no Gi* (*Ritual for Closed Vagina*). Two reels of the film were stolen immediately prior to the screening, instigating a riotous conflict between the performers and audience where a piano was destroyed (Okishima 2002: 106; Kuro Dalai Jee 2010: 200–202). Moreover, in 1967, Jōnouchi filmed a *butoh* dance performance by the co-founder of the influential *butoh* dance for his film *Hijikata Tatsumi*, which shot the dancer Hijikata Tatsumi using the *komadori* technique (frame-by-frame shooting). During the *butoh* performance of 'Bara-Iro Dance' ('Rose-Coloured Dance') in 1965, he got his head shaved on stage with Kazakura as an act of performance art. Jōnouchi's activities reveal a refusal to be labeled simply as a filmmaker, as his work shows breadth and scope that went far beyond holding a camera.

Due to his involvement with such activities, Jōnouchi began to incorporate aspects of theatrical performance into his exhibition practices in cinema.

He accompanied his screenings where he produced live soundtracks, poetry recitals or took a tape recorder to aurally project his soundtracks separately from the film print. For example, at an event at the Runami Gallery in February 1967 he presented the series 'VAN Document' where he interrupted the screening in different ways on each night, at times with his naked back, with a flashlight or with a whip (Sas 2011: 150–1).[10] Jōnouchi was inspired to consider possibilities of deconstructing cinema's identity as a fixed medium in a search for possible platforms to reinterpret cinema as a mercurial and durable medial expression. He re-edited films for each of his screenings, discouraging attempts to reduce his works to one version, and often incorporated sequences from one film into others, allowing a level of permeability between his films.[11] Each screening of Jōnouchi's work was intentionally different and it is important to understand a showcase of his films as merely one out of many possible versions. Jōnouchi had absorbed the impromptu spirit and spontaneity of the performance art scene and applied them to the cinematic medium.

Shinjuku Station (1974) (Figure 2) includes footage of a live performance by Jōnouchi, or at least a re-enactment of a previous performance.[12] Jōnouchi recites his poem about Shinjuku station whilst images that were filmed in the late 1960s during mass-scale protests are projected onto his face and body. Jōnouchi's body interrupts the flatness of the screen, adding a third dimension onto a projection intended to inhabit a smooth level plane. At least two movements occur during Jōnouchi's projection, the movement within the image and the gestures made by Jōnouchi himself. These motions interact and resonate against each other in different degrees, allowing for the layers to interact in

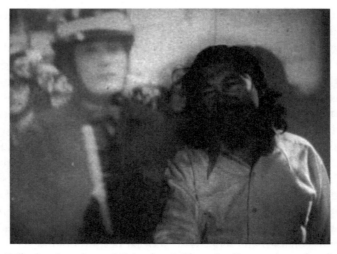

Figure 2: Still taken from Jōnouchi Motoharu's Shinjuku Station *(reproduced with kind permission of Jōnouchi Mineko).*

ways that vary at each occasion. The performance was emblematic of Jōnouchi's understanding of film exhibition as part of the process of creation that he shared with his audience. The delay between the process of creation and the time of creation was condensed to the point of occupying the same spatio-temporal realm, an approach that recalls his contemporaries in performance art recently chronicled in Kuro Dalai Jee's *Anarchy of the Body: Undercurrents of Performance Art in 1960s Japan* (2010).

Terayama Shūji

Screen experiments conducted by Terayama Shūji similarly explored the performative possibilities of projection, where intermediality was negotiated between performance and theatre through the collision of both media. 'A decathlete more than a specialist' (Ridgeley 2010: vii), Terayama Shūji was a prominent figure of his generation who refused to comply with genre and medial categorizations, instead producing an output that straddled various media. A *multi*-medial artist that worked between poetry, radio, TV, scriptwriting, essay-writing, songwriting, theatre-directing, filmmaking and sports, such as commentating boxing and horse-racing, Terayama was also an *inter*-medial artist in the sense that he incorporated, translated and displaced properties of one medial form onto another medial context. In his screen experiments, Terayama incorporated attributes of performance he transcribed through his experiences in theatre. For his short features, Terayama often investigated the surface of the screen by assimilating projection into his shooting process. Moreover, the act of projection in front of an audience was considered an opportunity for him, where, like in the case of his contemporary Jōnouchi Motoharu, live performers interacted with the projected image to add an ingredient of spontaneity and simultaneity to the conventionally rigid form of moving image projection. Terayama's experiments in cinema contribute to the disintegration of demarcated borderlines between different media and provide further complications for attempts at marking classifications for intermedial phenomena.

Terayama called his independent production company Jinriki Hikōki-sha ('Warehouse for Man-Powered Airplanes') a 'film laboratory', a term that recalls film labs where the material of film is directly handled on a daily basis. The title appropriately defines Terayama's practices, as he strove to deal with the material essence of cinema as physical matter to experiment with: the optical communication between light and shadow in moving image projection; the flatness of the projected image; and reels of film as tangible material. For example, in his first feature co-produced with the Art Theatre Guild,[13] *Throw Away Your Books, Let's Go Into the Streets* (*Sho o suteyo, machi e deyo*, 1971), Terayama deliberately

derails the film reel in the finale, initiating a moment of Brechtian distanciation that makes the raw material of film visible to debunk its illusion. In such ways, the surface of the screen was a perennial point of interrogation for Terayama's filmmaking and he often oscillated the depth of field by simultaneously presenting two layers of imagery resulting from the use of projection during his shooting process.

Terayama's films often display a level of understanding of the cinematic medium that undermines assumptions that his foray into cinema was purely to record the performative happenings he arranged with his theatre troupe Tenjō Sajiki (taking their name from the Japanese title of Marcel Carné's film *Children of Paradise/Les Enfants du Paradis*, 1945), as it interrogates the medium's essence and expands its boundaries. Writing, in the form of both calligraphy and printed text, is inscribed onto the screen surface over moving images in *Les Chants de Maldoror* (*Maldororu no Uta*, 1977) and his second ATG feature *Pastoral: Hide and Seek* (*Den'enni Shisu*, 1974), where the contrast between the stasis of the letters and activity of the recorded image is emphasized through their co-presence overlaid within the same frame. In *16 plus/minus 1* (*Chōfuku-ki*, 1974), a silhouette of a butterfly obstructs the film image as if a large butterfly has landed on the screen; the trick playfully forces an interaction between different scales and dimensions, disregarding a sense of proportional continuity within the frame. In *Labyrinth Tale* (*Meikyū-tan*, 1975) and *Les Chants de Maldoror*, a snail wiggles across the screen, an act that highlights the two-dimensionality of the projected image and deflates the illusion of three dimensions through, contrapuntally, superimposing a moving image on top of another. The projected image is physically attacked in *The Eraser* (*Keshigomu*, 1977), where a hand erases large portions of the screen whilst images are projected upon it and an alternative light source shines onto the effaced surface. *An Attempt to Take the Measure of a Man* (*Issun-bōshi wo kijutsu suru kokoromi*, 1977) is comprised of short vignettes of recorded performances that are suddenly interrupted by an assault on the projected screen that is visualized using compositing techniques with a blue screen and a video operator. The screen surface is cut in half by a saw, hammered in with nails, scrambled into a ball and obscured using a mirror; the savage attack against the screen denounces the assumption of a fixed shape, duration and dimension for the experience of cinema. Terayama's conception of duration was layered and pluri-dimensional rather than progressive, a simultaneity that questioned linear development in time as the only available experience, and proposed cinema's ability of exploring duration through multiplicity. Screens within the cinematic screen opened up further dimensions, particularly noticeable in *A Tale of Smallpox* (*Hōsō-tan*, 1975) where characters walk around the city with a detached door that they open, each time revealing another spatial reality. Terayama's projections within projections take apart the rigidity of the cinematic medium by making the act of destabilizing a projection

the narrative of the film, a recorded screen-performance that is transformed back into its fixed position as a moving image within a frame.

Terayama understood the medium-specific characteristics of cinema, such as the material presence of a film print and the projection of light, to possess the ability to interact and resonate with qualities deemed distinct to the medium of theatre. He added the ingredients of impulse, spontaneity and liveness, qualities that usually adhere more certainly to theatre, at the actual projection of his films to challenge the passivity of film projection. Following Matsumoto Toshio's pioneering Japanese multi-screen projection, *For My Crushed Right Eye* (*Tsuburekaketa migi me no tame ni*, 1968), Terayama attempted *A Young Person's Guide to Cinema* (*Seishōnen no tame no eiga nyūmon*, 1974),[14] a triple-projection piece where three projections were illuminated simultaneously alongside each other. The screens never interact and are instead divided by colour as well as their rendering of movement: the first screen shows static objects, such as photographs and legible texts, with mobile camera pans that scan on a fixed horizontal or vertical axis to encourage the eye to look at the other two screens; the second screen shows a recording of a performance with a fixed frontal camera; and finally, the third screen conveys camera movement that draws inwards, as well as minute and erratic motions in other directions. The multiplicity of the screens and their contrasting degrees of movement instigate an active engagement of the audience for their field of vision is fragmented in both time and spatial frames.

In screenings of his *The Trial* (*Shinpan*, 1975), performers at the screening, and whoever else cared to join, physically nailed the projected image into white-painted plywood (Ridgeley 2010: 120). Terayama's *Laura* (1974), a film where female prostitutes verbally attack the audience for coming to see art films only for the voyeuristic desire to encounter nudity, had performer Morisaki Henrikku sat down amongst the audience in a cinema for a scene where Morisaki jumped into the screen in reaction to their provocation, only to be stripped nude and thrown back out of the image (Figure 3). The short film highlights Terayama's desire for the dialectic collision of screen space and the realms of projection, as he continually strove to negate the opposition of audience and artwork, regardless of its genre. The women's accusations and their engagement with the off-screen audience refer back to the opening of *Throw Away Your Books, Let's Go Into the Streets*, where the protagonist Watashi (Me), played by Sasaki Hideaki, faces the camera and confronts his audience, smoking a cigarette and boasting that his audience would not be able to do the same in a cinema. The direct address highlights Terayama's openly Brechtian desire for an active spectatorship and refusal of illusionism so as to overwhelm and overcome his audience.

In *The Two-Headed Woman: A Shadow Film* (*Kage no Eiga: Nitou-onna*, 1977), Terayama explored shadows both within the screen and against it, where lights

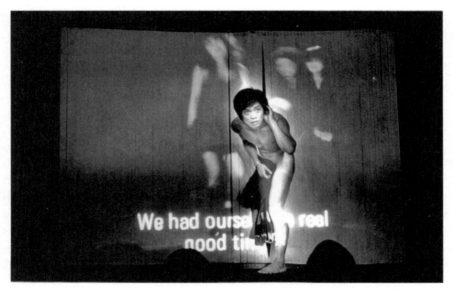

Figure 3: Still taken from Terayama Shūji's Laura, *featuring Morisaki Henrikku (courtesy of Terayama Museum; photograph by Herbie Yamaguchi).*

were shone from the projection booth and from behind the screen to cast sil-houettes of performers onto the moving image (Ridgeley 2010: 120). The live performers would interact with the image projected to produce interconnec-tions between the different layers of depth. The performers' bodies are two-dimensionalized as light is cast onto them against a levelled surface, producing a flat image that is stark in its absence of colour contrasted against the bright hues projected. In a similar manner to Jōnouchi and Iimura's, Terayama's pro-jection-performances were an attempt to investigate alternative avenues to the fixed regime of cinematic projection by supplying elements of spontaneity, simultaneity and performance that necessarily varied in degrees of intermedial-ity at every exhibition. Terayama's screen experiments positioned their focus onto the essential qualities of the medium, only to render it malleable by dis-placing its properties within a different medial context, a collision of perfor-mance and cinema that dissolves the boundaries between them.

Conclusion

The interaction with the screen on a performative domain enacted by experi-mental filmmakers Takahiko Iimura, Jōnouchi Motoharu, Terayama Shūji and other Japanese artists at the time merge properties of both performance and

cinema as medial forms to produce a form of expression that defies Wolf's inter-
medial categorization. The intermedial relations conjured between cinema and
performance is necessarily impossible to regulate in these performance-projec-
tions, as their collisions were intended to produce unforeseen and unexpected
results in an attempt to break through the monotony of the medium. The
degrees of intermediality are in perpetual oscillation as performance art migrates
into the realm of cinema and vice versa, to the point where the end result
becomes medially indistinguishable. These screen experiments in live perfor-
mances were transported into feature-length films of the period, especially in
titles co-produced by ATG, and found their ways into the realms of narrative.
For example, human interaction with projection makes an appearance in
The Inferno of First Love (*Hatsukoi Jigoku-hen*, Hani Susumu, 1968), *Eros
Plus Massacre* (*Eros purasu Gyakusatsu*, Yoshida Kijū, 1969) and *The Man Who
Left His Will on Film* (*Tōkyo Sensō Sengo Hiwa*, Ōshima Nagisa, 1970) (Figure 4).
In addition, at the Sōgetsu Art Centre's event EXPOSE '68: Nanika Ittekure,
Ima Sagasu (Say Something Now, I'm Looking for Something to Say) films
were reportedly projected onto the speakers at the conference during their
presentations.[15]

The projection experiments not only amalgamate at least two distinct media
but disparate time zones, proposing that there are alternative representations
and consumptions of time to the linear, chronological and empirical develop-
ments we have become accustomed to in screen narratives. In expanded cinema,
spectatorial time is favoured over represented duration where two media with
intrinsically disparate recognitions or productions of time come together to

Figure 4: Still taken from Ōshima Nagisa's The Man Who Left His Will on Film.

yield time-expressions that refuse to operate on systematic behaviours. As British expanded cinema artist Malcolm Le Grice asserts, 'in expanded cinema, the temporality of cinema is not constrained by the habits of narrative' (2011: 170). Not only does expanded cinema dismantle attempts at restricting inter-medial expression into categorical order, the very act proposes a reconsideration of the understanding of time, and Iimura, Jōnouchi and Terayama, along with other local and international artists, explored these artistic questions through their interrogation of the screen.

Notes

1 Japanese names are written in their native order, surname first, except in the case of filmmakers and artists who use the Western order in reference to themselves, for example, in the case of Takahiko Iimura, Yoko Ono, Takehisa Kosugi and Yasunao Tone who all reside in the United States.

2 Until with the recent publication of *Expanded Cinema: Art, Performance and Film*, Gene Youngblood's seminal 1970 book *Expanded Cinema* was the only title entirely devoted to phenomena whereby cinematic projection was conceived as a mode of theatrical performance.

3 Regarding the proliferation in definitions of and classifications within 'intermedia' as a theoretical framework, the author feels in line with Ágnes Pethö who opens her book, *Cinema and Intermediality*, by acknowledging the increasing number of categories that have been assigned in attempts to define intermedia only to confess the offering of another is not intended in her book (2011: 1–2).

4 The five-day event 'Intermedia' at Runami Gallery on 23–28 May 1967 and the 'Cross-talk: Intermedia' event at the Kokuritsu Yoyogi Kyōgijyō Dai-ni Taishikan on 5–7 February 1969 were two of the major cultural events with the word used in the title, but there were more than ten events with the word 'intermedia' used in the title between 1967 and 1971.

5 Hi-Red Centre was a performance group consisting of Takamatsu Jirō, Akasegawa Genpei and Nakanishi Natsuyuki, as well as some visiting members, and was active between 1960 and 1964. They often performed in public spaces but also exhibited at gallery spaces, such as the Naiqua Gallery where Takahiko Iimura had also screened his works, and its members later became associated with Fluxus.

6 The first Film Independents event was held at the Kinokuniya Hall in Shinjuku on 16–17 December 1964.

7 All translations by the author, unless otherwise stated.

8 Projection-performances of *White Calligraphy* can be found in Takahiko Iimura's DVD release, entitled *Writing With Light: White Calligraphy*, along with *White Calligraphy Re-Read*, a version of the film in its newly digital rendering where the speed of projection is adjusted.

9 Sōgetsu Art Centre was a platform where many artists from different genres were able to present their works on the same stage. Set up in 1958 by Teshigahara Hiroshi, son of the founder of the Sōgetsu flower arrangement school, Teshigahara

Sōfu, the art centre quickly became an influential space for the development of postwar Japanese arts, housing the first experimental film festival as well as staging improvised music, noise-music and free-jazz concerts, radical *angura* theatre and symposia to discuss contemporary art. For more information, visit the http:// post.at.moma.org/themes/4-sogetsu-art-center.

10 As acknowledged in endnote 3, Runami Gallery was instrumental to the development of 'intermedia' as an idea as it held the first major event on the concept in Tokyo. The gallery, located in Ginza, was where film screenings and avant-garde arts found a platform for exhibition.

11 For example, Sas (2011) notes that *VAN Document* incorporated *Hi-Red Centre Shelter Plan* (1964) and *Gewaltopia Trailer* (*Gewaltpia Yokokuhen*, 1968) also included footage from his previous films, Nichidai Eiken's third production *Pūpū* (1959), as well as extracts from horror classics *King Kong* (Cooper & Schoedsack, 1933), *The Lost World* (Hoyt, 1925), *Nosferatu* (Murnau, 1922) and *The Golem: How He Came Into the World* (*Der Golem*, Carl Boese and Paul Wegener, 1920).

12 Kanai Katsu (2011: 178) recalls he saw Jōnouchi Motoharu perform *Shinjuku Station* as an expanded cinema performance.

13 The Art Theatre Guild of Japan (ATG) began as distributors and exhibitors for foreign and local art-house films in the early 1960s, but began to support local independent productions in the mid-1960s and became responsible for ambitious projects by Ōshima Nagisa, Yoshida Kijū and Matsumoto Toshio, amongst others. For more information on ATG, see Domenig (2004), Hirasawa (2005) and Ross (2010a).

14 Terayama made the film for the 1st 100-ft Film Festival organized by Image Forum in 1974. Terayama also submitted a double-projection piece *Father* (*Chi-chi*, 1977) for Image Forum's 2nd 100-ft Film Festival in 1977 but one of the reels has since been lost.

15 Matsumoto Toshio's *Anpo Treaty* (*Anpo Jyōyaku*, 1960), *Nishijin* (1962) and *Mothers* (1967) and Konno Tsutomu's *Okinawa* and *Seven Police* (*Shichi-nin no Keiji*, 1961–69) were projected onto the speakers at the symposium. See Awazu (1968: 39).

References

Adachi, Masao (2002). 'Subete wa VAN Eiga Kagaku Kenkyūjyo kara haji-matta: Eiga-Undō ni kanshite no Danshō' ('Everything began from VAN Film Science Research Centre: A Passage on Film as Movement'), in Go Hirasawa (ed.), *Underground Film Archives*. Tokyo: Kawade.

Awazu, Kiyoshi (1968). *Design Hihyō* (*Design Review*), 6: 1–116. Special issue on EXPOSE '68 Nanika ittekure, ima sagasu (Say Something Now, I'm Looking for Something to Say) at Sōgetsu Art Centre.

Bauman, Zygmunt (2000). *Liquid Modernity*. Cambridge/Oxford/Malden: Polity Press.

Bazin, André (2005). 'In Defence of Mixed Cinema', in *What Is Cinema?* vol. 1, edited and translated by Hugh Gray. Berkeley, Los Angeles/London: University of California Press, pp. 53–75.

Brecht, Bertolt (1964). 'A Short Organum for the Theatre', in *Brecht on Theatre: The Development of an Aesthetic*, edited and translated by John Willet. London: Eyre Methuen, pp. 179–205.

Domenig, Roland (2004). 'The Anticipation of Freedom: Art Theatre Guild and Japanese Independent Cinema', in *Midnight Eye*. Available at http://www.midnighteye.com/features/art-theatre-guild.shtml, last accessed 24 August 2012.

Ellestrom, Lars (ed.) (2010). *Media Borders, Multimodality, and Intermediality*. London: Palgrave Macmillan.

Hirasawa, Go (2005). 'Underground Cinema and the Art Theatre Guild', in *Midnight Eye*. Available at http://www.midnighteye.com/features/underground_atg.shtml, last accessed 24 August 2012.

Iimura, Takahiko (1968). 'Imēji no Comunitī: Kankyō Geijutsuron' ('A Community of Images: An Essay on Environmental Art'), in *Geijutsu to Higeijutsu no Aida* (*The Space Between Art and Anti-Art*). Tokyo: Sanichi Shōbō, pp. 99–117.

———— (2005). 'Jikken Eiga, Gainen Geijutsu, Video Art' ('Experimental Film, Conceptual Art, Video Art'), in Yū Kaneko (ed.), *Filmmakers: Kojin Eiga no Tsukuri kata* (*Filmmakers: How to Make Independent Films*). Tokyo: Arts and Crafts, pp. 134–58.

Kanai, Katsu (2011). 'Independent Eiga no Senkusha' ('A Leader of Independent Cinema'), in Yū Kaneko (ed.), *Filmmakers: Kojin Eiga no Tsukuri kata* (*Filmmakers: How to Make Independent Films*). Tokyo: Arts and Crafts, pp. 159–84.

Kuro Dalai Jee (2010), *Nikutai no Anarchism: 1960 nendai Nihon Bijutsu ni okeru Performance no Chikatetsudō* (*Anarchy of the Body: Undercurrents of Performance Art in 1960s Japan*). Tokyo: Grambooks.

Le Grice, Malcolm (2011). 'Time and the Spectator in the Experience of Expanded Cinema', in A.L. Rees, Duncan White, Steven Ball and David Curtis (eds), *Expanded Cinema: Art, Performance, Film*. London: Tate Publishing, pp. 160–70.

Okishima, Isao (2002). 'Waratte, Waratte, Mijimede, Waratte: *Sain* wa AzamukuTsukurare, Kōkai Sareta' ('Laugh, laugh, wretched laughter: *Closed Vagina* was produced in disguise but screened'), in Go Hirsawa (ed.), *Underground Film Archives*. Tokyo: Kawade, pp. 100–7.

Pethö, Ágnes (2011). *Cinema and Intermediality*. Cambridge: Cambridge Scholars Publishing.

Poggioli, Renato (1968). *The Theory of the Avant-Garde*, translated by Gerald Fitzgerald. Cambridge, MA: Harvard University Press.

Rajewsky, Irina O. (2010). 'Border Talks: The Problematic Status of Media Borders in the Current Debate about Intermediality', in Lars Ellestrom (ed.), *Media Borders, Multimodality, and Intermediality*. London: Palgrave Macmillan, pp. 51–68.

Ridgeley, Steven C. (2010). *Japanese Counterculture: The Antiestablishment Art of Terayama Shūji*. Minneapolis/London: University of Minnesota Press.

Ross, Julian (2010a). 'The Story of the Art Theatre Guild', in John Berra (ed.), *The Directory of World Cinema: Japan*. Bristol: Intellect, pp.16–19.

——— (2010b). 'Interview: Takahiko Iimura', *Midnight Eye*. Available at http://www.midnighteye.com/interviews/takahiko_iimura.shtml, last accessed 24 August 2012.

Sas, Miryam (2011). *Experimental Arts in Postwar Japan: Moments of Encounter, Engagement and Imagined Return*. Cambridge, MA/London: Harvard University Press.

Sontag, Susan (1966). 'Film and Theatre', *The Tulane Drama Review*, 11: 1, Autumn: pp. 24–37.

Wolf, Werner (1999). *The Musicalization of Fiction: A Study in the Theory and History of Intermediality*. Amsterdam: Rodopi.

Wurth, Kiene Brillenburg (2006). 'Multimediality, Intermediality, and Medially Complex Digital Poetry', *RiLUnE*, 5, pp. 1–18.

Youngblood, Gene (1970). *Expanded Cinema*. London: Studio Vista.

Chapter 15

Shooting for a Cause: Cyberactivism and Genre Hybridization in *The Cove*

Tatiana Signorelli Heise and Andrew Tudor

The Cove (Louie Psihoyos, 2009) is about as 'mixed' or 'impure' a film as you can find, though perhaps not quite of the kind that interested Bazin (1967) all those years ago. While he was mainly concerned with the flow between the likes of drama, literature and film, *The Cove* functions in a cultural environment within which much more elaborate intertextuality has become routine. Viewed in isolation it is itself clearly textually mixed, and when seen in its context of Internet campaigning it sits at the heart of a whole array of flows of information and incitements to action. Of course, it is by no means the first film to deliberately locate itself through the Internet, whether for profit or to progress a campaign, but in the field of documentary it has certainly developed the most extensive of such networks. Examining *The Cove*, then, provides an opportunity to explore a phenomenon which will surely become increasingly significant as committed filmmakers seek to maximize their impact across a range of forms. We shall look first at the film text itself, paying particular attention to the ways in which it draws upon diverse generic conventions; secondly at its contextual locus at the heart of a variety of Internet-based systems of communication; and finally at its impact and reception.

The Cove as Generic Hybrid

Directed by National Geographic photographer Louie Psihoyos, *The Cove* revolves around Ric O'Barry, the former dolphin trainer for the *Flipper* TV series

(1964–7) dolphins, who subsequently became an active campaigner against keeping dolphins in captivity. The film follows O'Barry's and his companions' efforts to document the annual killing of many thousands of dolphins in a secluded cove in Taiji, Japan. Using underwater microphones, cameras camouflaged as rocks, and a variety of night-vision photographic equipment, Psihoyos and his crew expose the horrific spectacle of dolphin slaughter which had until then been concealed from the public by the Japanese authorities.

Described thus, the film sounds orthodox enough, if clearly part of the recent move to 'a new kind of documentary discourse which asserts the prerogative of the film-maker to have their very own take on the world' (Chanan 2007: 12). In practice, however, it is anything but a straightforward investigative documentary. Consider, for instance, its credits and opening sequence, where we are subjected to a rapid succession of cinematic styles. Beginning with night-time shots of a lighthouse accompanied by rumbling, somewhat ominous music, the film then cuts to the interior of a car at night, the driver wearing a mask, as an emergency vehicle of some kind drives past with its siren sounding. An unidentified voice-over announces: 'I do want to say that we tried to do the story legally', and, as the voice-over continues, there follows a series of night-vision shots of suspiciously criminal-looking activity: figures dressed commando style, barbed wire being cut, fences scaled, all the while accompanied by the same mood-building score. Following this 'hook', with its patent invocation of thriller genre traditions in its mysterious night-time world and its film noir-style voice-over, the film segues into a credit sequence. Again, the tone of mystery predominates, the visuals composed of monochrome negative images which at this stage make little sense to us although they are in fact shots that we will encounter later in their positive form.

As the credits end, and the John Carpenter-like rhythmic music holds its final chord, the tone changes and we dissolve to a different world, a landscape in colour identified in a subtitle as 'Taiji, Japan'. Of course, we could still be in the genre world of the thriller – such locationary titles have been common enough since *Psycho*'s famous 'Phoenix, Arizona' opening – and the fact that we are now in a car accompanying a masked man does little to undermine that possibility. But the new voice-over, which we will shortly discover is that of Ric O'Barry, the masked driver of the car, begins to tell us about Taiji and its secret. The music track is now calmer as we are treated to a series of travelogue-style shots of Taiji. Shortly, the original voice-over joins in, identifying O'Barry and observing that 'I went half-way across the world to end up in this car locked up with this paranoid guy', as O'Barry insists that they are being followed and that the local fishermen would kill him if they could. Now we have one foot in the thriller and the other in some as yet unidentified form of documentary, the latter view reinforced when we cut to an underwater shot of a dolphin and an orthodox lyrical nature documentary sequence begins accompanied by a voice-over explanation of the founding and work of the Oceanic Preservation Society. All this in just three minutes.

This generic mixing is not confined to the film's opening; it continues in varying degrees throughout, drawing upon both fiction and non-fiction movie conventions. Among the fictional forms, the thriller is particularly prominent, even identified as such when Louie Psihoyos, the film's director and initial voice-over, talks about needing a special group for the task of filming the Taiji slaughter which he describes as 'this *Ocean's Eleven* team'. Indeed, there is a sequence of team recruitment (a staple of heist and *Dirty Dozen* style movies right through to the recent pastiche world of *Inglourious Basterds*) as well as two night-shot thriller-style sequences in which the secret cameras and microphones are put in place. Typical of their genre origins, each of these sequences is identified by an onscreen title – 'MISSION 1 PLANTING HYDROPHONES' and 'MISSION 2 FULL ORCHESTRA' – and each is edited for tension in familiar thriller fashion (Figure 1).

Both feature jerky, hand-held camera movements, a combination of green night-vision and monochrome thermal cinematography, staccato editing, sound derived from often whispered radio contacts among the group (subtitled for clarity and to add to our sense that these are 'real-life' recordings), and forceful, rhythmic music, delivering a rising curve of tension as they condense the real time of events. Each sequence is structured classically to build tension to a moment when action is suspended, as a potential threat appears. In Mission 1, two figures are spotted, identified as guards and a frantic voice calls: 'Get out of there, get out of there now'. In the ensuing action the music rises to a crescendo and its percussive tempo increases, while the cutting accelerates into a hectic series of shots of the escape. We hear a strained voice say 'Holy Christ' as the activists tumble into their vehicle. Mission 2 is even more carefully constructed.

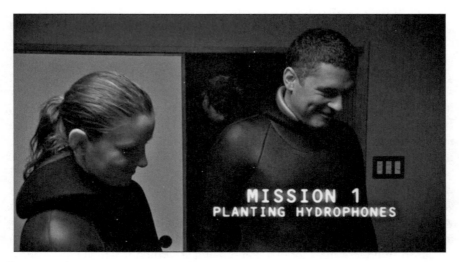

Figure 1: Setting out on Mission (The Cove).

Accompanied by two layers of rhythmic music, we see the various participants set out on their respective missions to plant cameras and microphones. Again, the cutting is rapid until we hear 'Guys, hold it right there' and, after a frozen moment, 'I see something up on the hills'. At this point the cutting slows and the powerful main drum rhythm pauses, leaving only the lighter underlying percussive pattern. 'Oh shit', we hear from one voice, and then 'Abort, abort' and 'Keep low, keep low'. The night-vision camera shows us movement on the hill, and then comes the tension-breaker: 'I think it was a marmot'. And we are back to rebuilding tension as the main drum rhythm returns to the foreground and the team complete their tasks. It may not be thriller montage quite in the class of Paul Greengrass, say, in his two Bourne films or *United 93*, but it is effective nonetheless, and there is a tangible sense of tension relieved when the music ends and the editing pace relaxes into something like normal (Figure 2).

These are the typical techniques of the thriller, not usually found in quite such realized form in a documentary. But then, *The Cove* cannot straightforwardly be classified as a documentary. Even where it does draw upon documentary conventions, it invokes a variety of such traditions which take their place along with the numerous genre devices borrowed from the fictional worlds of the thriller. If, for illustrative purposes, we take the six principal modes of documentary filmmaking that Nichols (2010: 31–2) distinguishes, all of them feature at one time or another in *The Cove*. There are sections, for example, in his 'poetic mode' which follow the familiar model of lyrical celebration of nature, enjoining us to experience the almost mystical pleasures of encountering dolphins in the wild. At other times the 'expository mode' dominates and the film adopts a standard current affairs/talking head position as it explores the political

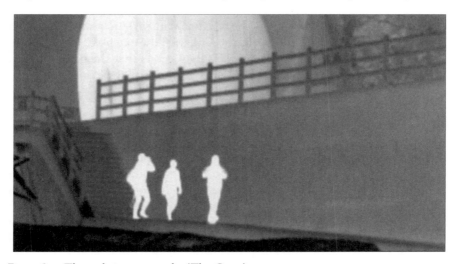

Figure 2: Thermal cinematography (The Cove).

obfuscation of the International Whaling Commission (IWC) at work, or investigates the illicit sale of unidentified dolphin meat and its serious contamination with mercury. This, as Nichols (2010: 31) notes, 'is the mode that most people associate with documentary in general'.

We also find the 'observational mode' with its distinctive 'unobtrusive camera', even if the latter is more conspiratorially unobtrusive than is customary; and, of course, like so many prominent contemporary documentaries, we find the 'participatory mode' whereby the filmmakers themselves feature interactively in the film, though happily not quite with the same self-aggrandizing quality found in Michael Moore's increasingly grotesque essays in public commitment. This participatory strategy then feeds powerfully into Nichols' 'performative mode', which stresses the filmmakers' involvement with the subject, their seeking 'a strong emphasis on their emotional and social impact upon an audience' (2010: 32). And, finally, the constant moving among all these forms – fiction and non-fiction – inevitably calls attention to the conventions of the cinematic construction itself: the 'reflexive mode'. *The Cove*, then, is a generic hybrid in almost every respect that we can imagine, drawing upon a remarkable array of cinematic resources to insist on the need for commitment and action.

Ultimately, of course, it is indeed commitment which is at the heart of this film; a life-long commitment to dolphins by Ric O'Barry as well as a courageous commitment on the part of the filmmakers to exposing the appalling slaughter with which, like many a thriller, the film climaxes. The decision to draw upon such diverse documentary styles and to frame much of the film's narrative as a 'real-life' thriller, complete with carefully constructed 'heroes' and 'villains', was no doubt motivated by a desire to reach a wide audience who would not, perhaps, be attracted to a sober disquisition of the type found in, say, *An Inconvenient Truth* (Davis Guggenheim, 2006). If this was the aim, then the extensive and continuing Internet-mediated activity around the film suggests that the goal has been achieved, and it is to this aspect of *The Cove*'s 'impurity' that we now turn.

The Cove and Internet Activism

Here we are concerned with *The Cove*'s locus in relation to extra-textual material used as part of a digital campaign to raise awareness about the dolphin slaughter in Taiji. As noted earlier, the use of the Internet to promote a film is nothing new, and almost every major release is accompanied today by an official website running trailers, images, press releases and information about story and crew. At the same time, the Internet has become an increasingly important tool for social activists, most notably, for example, in the cases of the Zapatista movement in Mexico and anti-globalization protests around the world (Van

Aelst and Walgrave 2004; Wright 2004; Vegh 2003). Yet the number of cases in which an activist film and digital media converge as part of a social campaign is still small. If we narrow the scope to films addressing broadly similar issues to *The Cove*, it becomes even smaller. Four such documentaries immediately come to mind: *An Inconvenient Truth*, Al Gore's Oscar-winning filmed lecture about climate change; *Food, Inc.* (Robert Kenner, 2008), which denounces the abusive practices of America's industrialized food system and its effects on the environment, animals and human health; *The End of the Line* (Rupert Murray, 2009), about the consequences of overfishing; and *Earthlings* (Shaun Monson, 2005), a graphic investigation of animal abuse in the food, fashion, pharmaceutical and entertainment industries. Some of these films were promoted by forceful marketing campaigns, yet, as we shall see, none of them has achieved the same success as *The Cove* in keeping audiences engaged after the immediate media attention had gone. Part of this success can be attributed to the wide variety of strategies and resources employed in *The Cove*'s campaign, as is demonstrated in Table 1. Each dot represents the number of times a particular tool is used, e.g. *The Cove* utilizes three websites, four blogs and one Twitter account.

 The Cove distinguishes itself from the other campaigns both in terms of the number and the variety of media employed. While all the films have one official website, *The Cove* has three, with customized versions for Japan and China and a tool that enables them to be translated into 53 languages. Like most of the other campaigns, it keeps viewers informed by means of blogs, Facebook and Twitter accounts, but the frequency of its updates is considerably higher.[1]

Table 1: compiled by the authors

	An Inconvenient Truth	Food, Inc.	The End of the Line	Earthlings	The Cove
Website	•	•	•	•	•••
Blog	•	•	•••		••••
Twitter		•	•	•	•
Facebook		•	•	•	•
Facebook 'Causes'					•
Email list					•
Mobile text					•
Video downloads		•			•
Free online streaming				•	

The Cove is the only one of the five campaigns using a text messaging system whereby subscribers receive updates on their mobile phones, and an email sub-scribers' list for similar purposes. It is also the only campaign using a Facebook application called 'causes' whereby users can sign petitions, send letters, make donations, fundraise for the cause and recruit supporters online.[2] Finally, it employs YouTube and other digital channels to broadcast material relating to the campaign such as public service announcement videos (PSAs), interviews, extracts from TV programmes and footage produced by volunteers. Some of these videos are widely copied and re-posted by cyberactivists; *The Cove's* PSA is one such case. At the time of writing it had been viewed over 26,000 times on the Facebook 'causes' page and over half a million times on YouTube, but because many users upload it to their own Facebook profiles or share it via email, the actual number of viewings is impossible to calculate. In the video, well-known actors including Naomi Watts, Jennifer Aniston, Woody Harrelson and James Gandolfini urge us to support the cause by drawing our attention to dolphins' similarities with human beings and praising their extraordinary skills such as speed, intelligence and high sensitivity to sound. It is much the same anthropomorphic technique that is used in *The Cove* itself, which emphasizes the similarities between dolphins and humans to justify the view that dolphins are special animals who merit protection. In the PSA, black-and-white testimo-nials are intercut with colour extracts from the film and, like the film, it closes with an invitation for viewers to take part in the cause by visiting a website.

Providing a URL after a trailer or the final sequence of a film is the most common strategy whereby campaigning films recruit supporters. While most films refer us to a website by means of small letters at the bottom of the screen, *The Cove* enhances this technique with powerful images and soundtrack. After a short sequence informing us of advances that the film helped to achieve, such as a decision by the authorities in Taiji to stop serving dolphin meat in school lunches, an image of the iconic cove appears next to a series of titles beginning with 'The Taiji dolphin slaughter begins every September'. This is followed by the phrase: 'Unless we stop it'. The screen then goes black and large letters appear in the middle: 'Unless you stop it'. This invocation is accompanied by the opening instrumental riff of David Bowie's 'Heroes' and the addresses of the three websites appear at centreframe. They remain visible for a full 12 seconds before Bowie's voice enters with the lyrics: 'I wish I could swim like dolphins can swim ... We can be heroes just for one day'. The underwater image that we now see is that of a large group of dolphins swimming in a clear blue ocean. The camera moves swiftly on into the middle of the group, giving us the impression that we are indeed swimming among them. Such techniques as this help to establish a sense of identification between the viewer and the cause. Most importantly, they enhance the routine act of visiting a website, using the song to suggest that this is the first step towards a thrilling and heroic experience,

mirroring the actions of the film's team on their daring and tension-filled missions. This passionate ending poses a sharp contrast to *Earthlings*, for example, which makes no reference to a website and leaves us with no clue as to what we can do to reverse the horrific practices depicted in the film. While watching *The Cove* is hardly any more comfortable an experience than watching *Earthlings*, the film nevertheless ends on a constructive and positive note by reassuring us that we can act to stop the brutality.

Another feature which sets *The Cove* apart from the other campaigns, and which certainly contributes to its extraordinary impact, is the prominence and charisma of the film's protagonist. Images, interviews, film clips, blog entries and letters linked to O'Barry are everywhere in the campaign, and they all reinforce the image of him constructed in the film as a fearless, uncompromising and resourceful activist. This emphasis on the film's 'hero' makes two important contributions to the campaign: credibility and inspiration. As observed by Gurak and Logie (2003: 43) web protests are usually relatively anonymous, and this raises potential concerns over credibility. Since the film leaves audiences fully familiar with O'Barry's story and motivations, using him as the name and face at the heart of the campaign is a key strategic move. He may not share the same status as a public figure as, say, Al Gore but, in the film and campaign, he comes across as more influential and certainly more charismatic. The progressive engagement of viewers with O'Barry can usefully be described in the terms that Murray Smith (1995) uses to conceptualize the spectator's relation to fictional film characters: recognition, alignment and allegiance. Information provided in the film and campaign allows us to recognize O'Barry as the famous dolphin trainer who, after realizing the terrible consequences of his profession, devoted the rest of his life to attempting to correct them. The film aligns us with him by showing us the world from his point of view and giving us access to his thoughts and emotions, as exemplified in the sequence in which we find him standing by the shore in Taiji observing fishing boats through his own photographic equipment. He describes to us how the fishermen drive dolphins into the fishing nets by creating a barrier of sound. A subjective shot aligns us with his viewpoint and shows us exactly what he sees through his camera lens: dozens of fishermen banging hammers onto long metal poles placed in the water, creating the sound which terrifies the dolphins and drives them to their deaths. As O'Barry briefly turns his face towards us, we see his expression of anger and despair. He says: 'I think I can actually hear the banging. But I hear it all the time. I hear it in my sleep. That sound never goes away' (Figure 3).

Combined with the subjective shot and the sound of hammering on the metal poles, O'Barry's revelation allows us to understand and to a degree experience some of his emotions. This understanding is a precondition for us to develop Smith's (1995: 90) third level of engagement, an 'intense and unqualified' sympathy for the character. One sequence stands out as a particularly compelling

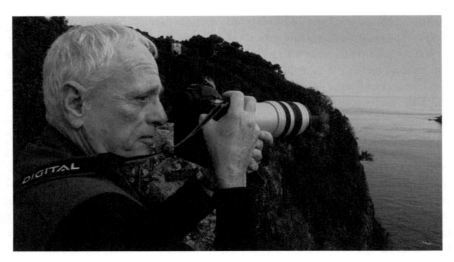

Figure 3: *Ric O'Barry* (The Cove).

invitation for the spectator to take O'Barry's side. It follows a passage in which a small group of Australian activists come to support him in Taiji but end up being arrested shortly after their demonstration. Over the image of an inconsolable O'Barry standing by the cove and gazing into the distance, director Louie Psihoyos expresses his support and admiration: 'My heart went out to him. I watched *Flipper* as a child. I grew to love the oceans partly because of *Flipper*.' O'Barry then points to the water and reasserts his determination: 'We are going to stop this. We're going to stop this.' Cut to an extreme close up which fills the screen with the sad expression in his eyes. Psihoyos's voice-over picks up again: 'And here's the guy who started it all. He's trying to rectify this huge problem but he can't find anybody to help him. If we could just get in there we could stop this.'

In these ways the film calls upon our empathy for O'Barry, and portrays him throughout as a passionate activist, deeply committed and determined to stop the dolphin hunt. These qualities are also constantly foregrounded in the more general campaign, as exemplified in one of the websites, savejapandolphins.org, which opens with a large close-up image of O'Barry bearing a tragic expression similar to the one described above. Letters, notes and declarations from him proliferate in the campaign as a way of inspiring people to act. This strategy appears to have produced results: on 14 October 2010, hundreds of people gathered in front of Japanese consulates and embassies across the world, including Tokyo, to demonstrate against the dolphin hunt. All that O'Barry did was propose the idea and contact partner organizations to provide local support; cyberactivists took care of the rest. After the demonstrations, many of them shared their stories and photos online, continuing to feed news into the system and attract further attention to the cause.

Impact and Critical Reception

The Cove's positive incitement to activism and the emphasis on O'Barry goes some way towards explaining the extraordinary success of its digital campaign, even though its box-office takings are well below those of both *An Inconvenient Truth* and *Food, Inc.*, which grossed $49 million and $4.5 million respectively, but nevertheless failed to inspire the same level of focused Internet-based activism.[3] On 12 January 2011, *The Cove* had over 12,000 followers on Twitter, 50 times more than *Food, Inc.* and thrice the number of *Earthlings* and *The End of the Line*. On Facebook, where it concentrates most of its campaign efforts, *The Cove* has thus far attracted 485,683 fans, twice the total number of *Earthlings*, *Food, Inc.* and *The End of the Line* combined.[4] Its 'cause' application has over a million supporters who, according to the campaign statistics, have so far contributed over $130,000 in donations. In terms of money raised, *The Cove* is the second most important animal-related campaign on Facebook 'causes'.

If *The Cove* has had a significant impact online, its repercussions in the film community and the mainstream media in general have been no less impressive. The documentary won over 25 prestigious film awards, including the 82nd Academy Award for Best Documentary Feature and the Best Documentary from the Environmental Media Awards. Most critics were enthusiastic about the film's use of thriller conventions, including Jeanette Catsoulis (2009) of the *New York Times*, who described it as 'one of the most audacious and perilous operations in the history of the conservation movement', and *Time Magazine*'s Mary Pol (2009), for whom *The Cove* 'puts Hollywood capers like *Mission: Impossible* to shame'. According to *Rotten Tomatoes*, a website which aggregates film reviews and audience comments, *The Cove* received positive reviews from 96 per cent of a total of 121 critics and an average audience rating of 4.3 out of 5.

The major negative claims that have surfaced have been made by a minority of critics relating to the film's alleged stereotyping of the Japanese as a culturally and politically inferior people. The most forceful of these criticisms is made by Ilan Kapoor (2010) who observes that 'apart from two resistant Taiji councillors, all the other Japanese characters in the film are portrayed as colluding "bad guys"' in stark contrast to the North Americans who are depicted as 'environmental heroes'. Kapoor also accuses the film of failing to admit North America's own role in the capture and slaughter of dolphins and refusing to explore the implications of that involvement:

> Early on in the film, there is an admission that one of the key reasons for the high demand for dolphins is the creation of Sea Worlds and other animal amusement parks across North America ... But soon this admission is dropped – I suspect because the obvious response would be that, rather than picking exclusively on Japan, one would need to agitate to

close down such parks or to seriously problematize the making of TV
series such as *Flipper*. (Kapoor 2010)

These two issues, the alleged racist undercurrent and the exclusive laying of the
blame on Japan, were at the heart of a heated controversy which surrounded
the theatrical release of *The Cove* in that country (Matsutani 2010; Tabuchi
2010). The screenings programmed for June 2009 were cancelled after the dis-
tributors received threatening emails and telephone calls from Japan's major
right-wing nationalist group, Issuikai. The decision was reversed months later
due to continued pressure by a number of influential Japanese journalists, schol-
ars and filmmakers, including Tatsuya Mori, whose outspoken admiration for
The Cove helped to fuel media attention. The film received limited screenings
in Osaka, Sendai, Yokohama, Kyoto and Hachinohe, amid ongoing protests.

Unsurprisingly, the makers of *The Cove* strongly deny that the film is anti-
Japanese and their subsequent campaign reveals many efforts to correct this
impression by incorporating Japanese individuals into the team and reposition-
ing themselves as 'Japanese-friendly'.[5] In the campaign's blog, Twitter and
Facebook entries, O'Barry has repeatedly praised the contribution of Kyoko
'Kiki' Tanaka, a Tokyo-based journalist who started working as translator and
coordinator for the campaign in August 2010. In October of the same year, Kiki
and her colleague Tosh Geckocat, also Japanese, collected 163 signatures from
national government personnel for a petition urging authorities to stop the
dolphin slaughter. They handed the petition to the Japan Fisheries Agency and
sent a copy to the Governor of Wakayama Prefecture. Their actions generated
emphatic praise in O'Barry's blog (2010) directed at 'the many Japanese people
who are willing to oppose the dolphin slaughter under very difficult conditions'.
Clearly, then, the overall campaign has successfully sought Japanese involve-
ment, but it remains notable that many of these efforts were made after produc-
tion of the film and that *The Cove* itself – seen in isolation from the broader
campaign – does lean toward some ethnic stereotyping. Indeed, the very use of
a thriller format leads the filmmakers into a hero/villain structure which, in the
particular circumstances in Taiji, inevitably works itself out along Japanese
versus non-Japanese lines.

In addition to responding to such criticism by asserting their willingness to
work with the Japanese and not against them, the campaign managers have also
shifted some of the focus away from Japan and encouraged supporters to learn
more about the dolphinarium industry and the problems of dolphin captivity
worldwide. Rather than focus exclusively on Taiji fishermen and authorities,
the campaign now targets the World Association of Zoos and Aquariums
(WAZA) as a key agent in the dolphin hunt and urges supporters never to buy
tickets to dolphin shows or sea parks. This wider perspective is also prominent
in the *Blood Dolphins* television series, a spin-off of *The Cove* in which O'Barry

is joined by his son in his continued efforts to save dolphins in the South Pacific and in other parts of the world.

Conclusion

It would be difficult to deny that *The Cove* has been at the heart of an extraordinarily successful campaign, and that a significant element of that success derives from its character as 'impure cinema'. Audiences certainly do respond to its immediate power. They get caught up in its thriller-like representation of 'heroic' activists in Manichean contrast with carefully identified 'villains'. They find themselves pinned to their seats by the unremitting tension building of its Mission sequences, made all the more compelling by their knowledge that at some level these are 'real' events despite their evident cinematic construction. Furthermore, by utilizing the full panoply of documentary modes *The Cove* seeks to ensure that it provides all possible opportunities to hold the attention of a potentially diverse audience and to encourage their subsequent participation in the campaign. In this respect, the film cannot be separated from its Internet manifestations; they are part of its very constitution as a piece of mixed cinema. Of course, as Kapoor's (2010) persuasive criticisms suggest, there is a price to pay for that kind of single-minded commitment to the larger campaigning goals. *The Cove* does not have the reflective intellectual depth of, say, Errol Morris' *The Fog of War* (2003) nor the perception and subtlety of, for example, Fred Wiseman's extraordinary documentaries. But then, that is hardly its intention. It is, rather, a thoroughly modern campaigning artefact, the foundation stone for a multi-media approach to the construction of active political involvement in a specific cause. At this task it has surely proved to be remarkably effective.

Notes

1 *An Inconvenient Truth* and *Earthlings* were released before Twitter existed and before Facebook achieved its current popularity – 995 million monthly active users in June 2012, according to statistics published in the Facebook Newsroom page (http://newsroom.fb.com/content/default.aspx?NewsAreaId=22). While *Earthlings* eventually incorporated both websites into its campaign, *An Inconvenient Truth* has thus far not done so.
2 Causes is an independent company using Facebook as a platform to promote viral donations to charities and non-profit organizations. Created in May 2007, it claims to have mediated over $8 million's worth of donations to its registered charities and non-profits.
3 *The Cove* grossed $1,152,961 worldwide. Source: Box Office Mojo.

4 A 'fan' is a Facebook user that establishes a connection with a Facebook page. Everything that is posted on the page (news, videos, photos, links) automatically appears on the fans' newsfeeds. The fan is allowed to comment upon the posts and interact with other fans.

5 Louie Psihoyos (2010) has stated: 'The Cove is a love letter to the Japanese people because we are giving them the information that the government is trying to cover up'.

References

Bazin, André (1967). 'In defence of mixed cinema', in André Bazin, What Is Cinema?, translated and edited by Hugh Gray. Berkeley: University of California Press, pp. 53–75.

Catsoulis, Jeannette (2009). 'From Flipper's Trainer to Dolphin Defender', in The New York Times, 31 August. Available at http://movies.nytimes.com/2009/07/31/movies/31cove.html, last accessed 25 August 2012.

Chanan, Michael (2007). The Politics of Documentary. London: BFI.

Garrido, Maria and Alexander Halavais (2003). 'Mapping Networks of Support for the Zapatista Movement: Applying Social-Networks Analysis to Study Contemporary Social Movements', in Martha McCaughey and Michael D. Ayers (eds), Cyberactivism. New York/London: Routledge, pp. 165–84.

Gurak, Laura J. and John Logie (2003). 'Internet protests, from text to web', in Martha McCaughey and Michael D. Ayers (eds), Cyberactivism. New York/London: Routledge, pp. 25–46.

Kapoor, Ilan (2010). 'Troubled waters: crashing into The Cove', Bright Lights Film Journal, 68, May. Available at http://www.brightlightsfilm.com/68/68thecove.php, last accessed 25 August 2012.

Matsutani, Minoru (2010). 'Rightist also tells theatres to run The Cove', The Japan Times Online, 11 June. Available at http://search.japantimes.co.jp/cgi-bin/nn20100611a3.html, last accessed 25 August 2012.

Nichols, Bill (2010). Introduction to Documentary. Bloomington/Indianapolis: Indiana University Press.

O'Barry, Ric (2010). 'A first: Japan Dolphin Day in Tokyo', Savejapandolphins Blog, 15 October. Available at http://savejapandolphins.blogspot.com/2010/10/first-japan-dolphin-day-in-tokyo.html, last accessed 25 August 2012.

Pols, Mary (2009). 'Rescue at sea', Time Magazine, 10 August. Available at http://www.time.com/time/magazine/article/0,9171,1913757,00.html, last accessed 25 August 2012.

Psihoyos, Louie (2010). Comment published on the blog BlueVoiceViews. Available at http://bluevoiceviews.blogspot.com/2010/02/cove-and-blue-voice.html, last accessed 25 August 2012.

Smith, Murray (1995). Engaging Characters: Fiction, Emotion and the Cinema. Oxford/New York: Oxford University Press.

Tabuchi, Hiroko (2010). 'Japan's far right blocks screenings of *The Cove*', *OCALA.com*, 19 June. Available at http://www.ocala.com/article/20100619/ZNYT03/6193005?tc=ar, last accessed on 25 August 2012.

Van Aelst, Peter and Stefaan Walgrave (2004). 'New media, new movements? The role of the internet in shaping the "anti-globalization" movement', in Wim Van De Donk, Brian D. Loader, Paul G. Nixon and Dieter Rucht (eds), *Cyberprotest: New Media, Citizens and Social Movements*. London: Routledge, pp. 97–122.

Vegh, Sandor (2003). 'Classifying forms of online activism: the case of cyber-protests against the World Bank', in Martha McCaughey and Michael D. Ayers (eds), *Cyberactivism*. New York/London: Routledge, pp. 71–95.

Wright, Steven (2004). 'Informing, communicating and ICTs in contemporary anti-capitalist movements', in Wim Van De Donk, Brian D. Loader, Paul G. Nixon and Dieter Rucht (eds), *Cyberprotest: New Media, Citizens and Social Movements*. London: Routledge, pp. 77–93.

Other Films Cited

The Bourne Supremacy (Paul Greengrass, 2004)
The Bourne Ultimatum (Paul Greengrass, 2007)
The Dirty Dozen (Robert Aldrich, 1967)
Mission: Impossible (Brian De Palma, 1996)
Inglourious Basterds (Quentin Tarantino, 2009)
Ocean's Eleven (Steven Soderbergh, 2001)
Psycho (Alfred Hitchcock, 1960)
United 93 (Paul Greengrass, 2006)

Chapter 16

David Lynch Between Analogue and Digital: *Lost Highway, The Straight Story* and the *Interview Project*

Anne Jerslev

During their discussion of *Lost Highway* (1997) in Chris Rodley's interview book *Lynch on Lynch* (1997), the director David Lynch states that he hates digital equipment. Regarding the construction of the sequence in *Lost Highway* where Fred transforms into Pete, Lynch says:

> Morphing and Computer Generated Imaging and all this stuff is like the Avid to me now. Everybody and his little brother is doing it. It's super-expensive, it's completely time-consuming and it's the kind of thing that I'm not sure how much you can really see before you're locked into accepting the final product ... I wanted to find a different way. Actually, there are a lot of elements in that transformation, but they're all organic: in the camera.
>
> I did this thing for Michael Jackson, a computer-generated thirty-second teaser trailer for the album *Dangerous*. It had its own look, which was OK, but it didn't look like film. So when a CGI sequence comes back and is cut into your feature film, how is it going to look? Is it going to look like plastic next to beautiful wood? I don't know.

(Rodley 1997: 238)

Since then, however, Lynch has enthusiastically surrendered to digital film, not least because he realized that digital film can produce the same textured surfaces and sense of duration – 'beautiful wood' – as can analogue film. In his vignette book *Catching the Big Fish*, he announces that 'working with film is so cumbersome' and 'I'm through with film as a medium. For me, film is dead ... I'm shooting in digital video and I love it' (Lynch 2006: 150, 149). For several years now, Lynch has explored the aesthetic and communicative possibilities as well as the limitations of different digital media, not least through his website www.davidlynch.com. The same goes for his *Interview Project* website (www.interviewproject.davidlynch.com) where, from June 2009 through May 2010, a new short documentary portrait was posted every third day, together with photographs, written text and a spoken introduction by David Lynch.[1]

Yet the preoccupation with film as an analogue time-based medium – or an 'art of duration' as David Rodowick (2007: 79) puts it – and aesthetic figurations of continuous time remains prominent in Lynch's work. Images of transformation abound, including the traces of passed time in organic material. In this article, I take Lynch's comments on the digital, the analogue and time as duration as a point of departure for my reading of three of his works: *Lost Highway* (1997), *The Straight Story* (1999) and *Interview Project* (2010). I read the works through a number of recent, intriguing – and intriguingly different – theoretical revitalizations of discussions on the medium specificity of film, filmic time and how to conceptualize the analogue and the indexical in an era of digital media (Rodowick 2007, Rosen 2001, Doane 2003, Wahlberg 2008, Mulvey 2006, Gunning 2008). Along these lines and in the wake of Gunning's and Rosen's critical take on the photographic index, my interest in this Peircean term is aesthetic rather than semiotic. Besides, like Rosen, to argue that the indexical quality of a photograph is not just a prerogative of the analogue photograph, Gunning (2008) reminds us that Peirce's semiotic term may not be fully able to grasp photography's richness of meaning. Rosen, on the other hand, underlines, less sceptical, and more phenomenologically oriented, the index as a trace of pastness. Accordingly, I am interested in the ways in which the works provide us with a phenomenological sense of time and the world rather than with their functions as signs. I argue that the aesthetic figurations of continuous time and time passed in *The Straight Story* and *Interview Project* and, conversely, the collapse of time as duration in *Lost Highway* may be regarded as ways of thinking through the possibilities and limitations of analogue and digital media and ways of conferring upon digital media the sense of time and indexicality associated with analogue film.

In the following section, I argue that CGI technologies resonate as a kind of *structuring absence* in *Lost Highway*, the strange story of Fred's incomprehensible metamorphosis into Pete and possibly back again, and how the dissolution of continuous time provides the film with an overwhelming sense of horror.

The second section discusses how, on the other hand, *The Straight Story* enacts continuous time on numerous levels: Through the story of the old man's slow ride on a lawnmower and through the camera's close-ups on the old face, not just an index in itself but also a reminder of film as indexical medium. Finally, in the third and longest section, I address the documentary site's medium-specific possibilities. I argue that, in *Interview Project*, indexicality is *performed* on a digital platform and in the generic form of a website, which remediates film, photography, written text and graphics (a road map). I propose an understanding of *Interview Project* as a digital documentary work concerning time and the irreversibility of time, providing the website with something similar to what Wahlberg (2008) calls 'the aura of the imprint' in an 'era of digital simulation' (Rodowick 2007). It inscribes the indexical 'powers of photography and cinema' (Wahlberg 2008) on a digital genre and simultaneously pays tribute to the new creative possibilities offered by this genre.

Lost Highway is, in a sense, about what it is not (digital image manipulation and digital time as the disintegration of time as duration) and *The Straight Story* could be regarded as a melancholic swansong to film as an analogue medium. In contrast, *Interview Project* is a multimedia documentary site where the indexically-anchored documentary real and the material inscription of the irreversibility of time associated with film as an analogue medium is aesthetically reinvented and preserved in a digital medium and genre. The three works are thus discussed as reflections on medium specificity and its blurred boundaries and on the possibilities and limitations of the digital and the analogue.

Lost Highway and Morphing

The two pivotal scenes in *Lost Highway* concern metamorphosis. In the first, Fred on the death row visually transforms into Pete and, in the second, during the final moments of the film, he apparently begins the process of metamorphosis anew, in the same way as the film itself seemingly continues in a narrative loop. Many film scholars have discussed *Lost Highway* (for example, Nochimson 1997, Zizek 2000, Hainge 2004, Jerslev 2004, McGowan 2007). Here I shall consider it as an audiovisual work, which establishes a dialogue with the digital image culture. For example, the fact that *Lost Highway*'s Mystery Man can be in two places at once makes perfect sense in a digital culture where cut, copy and paste are simple computer operations. The digital image culture is – among many other things – characterized by the ability to fashion visually magical and rapid transformations (metamorphoses – or *morphings* to put it in digital terms) of human form from one shape to another and to effortlessly transgress physical laws. The film's uncanny, narratively motivated metamorphoses resonate with the morph and morphing as a digital technology for producing visual transformation. The analogue image metamorphoses in *Lost Highway* are thus,

in a sense, conceived through the logic and technological design of the digital morph.

In Lynch and Gifford's (1997) script for the film, the first transformation of Fred into Pete is described as an uninterrupted movement from one human shape to another, as if the writers were trying to verbally imitate the digital morph:

> Fred is still curled on the floor, but spasms begin to rock his body. He goes into convulsions, blood gushes from his nostrils. His head is badly swollen. Fred vomits repeatedly, and drags around in his mess. Fred turns, straining upwards as we've seen him do before. His face and head are hideously deformed.
>
> Fred brings his shaking, tortured hands to his forehead. He pulls his hand down across his face, squeezing it as it goes. As his hand passes over his face, Fred's features are removed, leaving a blank, white mass with eye sockets.
>
> We move into the eye sockets and beyond.
> ...
>
> Fred's blank face begins to contort and take on the appearance, feature by feature, of Pete Dayton.
>
> Fred Madison is becoming Pete Dayton. (Lynch and Gifford 1997: 48–49)

However, the visual realization of the transformation is more amorphous and uneven, accentuating the abstract and opaque. Digital morphing techniques would obviously have been necessary for the realization of the writers' vision, as described in the script. But in the actual production, no CGI was involved. The metamorphosis was carried out as a much more diffuse, painful and chaotic transformation of recognizable human form into an amorphous mass of matter.

Technically speaking, morphing is the transformation of one visual object into another by means of a computer program. Morphing is a visual transformation process performed without usual cinematographic techniques like the cut or the dissolve or other ways of moving from one image or one frame to the next. Computer graphics make these transitions seamless, smooth and rapid – like the fluid metal T-1000's famous transformations in *Terminator 2: Judgment Day* (James Cameron, 1991) or the faces in the equally famous video for Michael Jackson's *Black or White* (John Landis), also from 1991 (Krasniewicz 2000). Computer-generated images always possess the possibility of being morphed into another form – or back into a former form. The process is quick and reversible and metamorphoses can continue *ad infinitum* without leaving a trace. Morphing is thus an obvious example of Rosen's characterization of digital image processes as capable of 'practically infinite manipulability' (Rosen 2001: 321). The morph is a visual figure of transformation defined by its physical and temporal impossibility. It questions established categories and can create new

and otherwise unthinkable connections (Krasniewicz 2000: 52). By recalling Mary Ann Doane's thinking through the ontology of cinematic time, her recapitulation that 'the cinematic apparatus, given its indexically based representation of movement and time, is often perceived as *the* exemplar of temporal irreversibility' (Doane 2002: 27) allows us to conceptualize the digital morph's time-relatedness as somehow un-filmic, diametrically opposed to analogue cinematic time.

Vivian Sobchack (2000a) proposes that the term *morphing* should also be set aside as a metaphor for what she eloquently labels a contemporary *quick-change* culture. Designating a 'cultural imagery', the digital morph 'links a present digital practice to a much broader history and tropology of metamorphosis and its meanings' (Sobchack 2000a: xiv). Morphing questions established categories by creating unthinkable new connections – between human and dead, organic and inorganic, man and woman, young and old and so on. Morphing represents, says Sobchack (2000b: 151), 'human transformation, metamorphoses, mutability outside of human time, labor, struggle, and power, seemingly transcending structures of hierarchy and succession'.

But why this discussion of the morph as digital technology and metaphor in relation to the metamorphoses in *Lost Highway*? The film's metamorphoses are precisely *not* produced by CGI and are therefore not, technically speaking, morphings. This discussion is necessary for two reasons that bring us back to the digital as structuring absence in *Lost Highway*. The first reason is that, besides the obvious 'morphed' way in which Lynch and Gifford verbally describe the first transformation of Fred, it seems as though the description of morphing as computer technology *and* metaphor could just as well be a description of *Lost Highway*'s imploding narrative. *Lost Highway* concerns an impossible transformation. The narrative seems endlessly reversible and without closure. There is no obvious narrative hierarchy between Fred and Pete. The transformations uncannily transgress the human. Duration in time is suspended as the film ends where it began; space is equally fragile and transgressable. It thus appears that *Lost Highway* not only transports the time-specific logic and technological potentialities of CGI into an analogue medium, but it also transforms the logic of CGI into an uncanny story about human metamorphoses. *Lost Highway* responds to CGI as image technology with uncanny images of the impossibility of digital time, of lack of duration and hence of lack of closure.

The second reason is that morphing's smooth and effortless elimination of time and labour is diametrically opposed to the apparent driving force and aesthetic preoccupation of Lynch's films, paintings and photography, namely what happens to nature and man over the course of time. *Lost Highway* must therefore take the form of a nightmare. In *Lost Highway*, the rapid and seemingly ever-reversible metamorphoses are horrifying because they, by their

very logic, deny transformation in time, irreversibility, materiality and hence death.

By the end of the film, Fred may be transforming again. The ultra-quick dissolves that produce grotesque distortions of the face create much the same effect as the morph. Yet they are more 'edgy' and the face is not transformed from one form to the other but from form to (Bacon-like) abstraction,[2] as in Fred's first transformation into Pete. The last frames of the metamorphosis, preceding the repetition of the shaky images of the lost highway's median strip, are of a dense and textured darkness. Fred is gone, has disappeared into a black hole. Or perhaps the shot has no narrative meaning. Perhaps the darkness is a trace of film's analogue specificity, the film frozen in the black space between two frames. Interpreted in this way, *Lost Highway* ends by calling attention to the medium specificity of analogue film and cinematic time at its most basic level: a myriad of frames projected as moving images.

The Straight Story

Whereas movement in time is mainly an issue in *Lost Highway* because of its absence, *The Straight Story* is literally about moving through time. The film concerns the ageing Alvin, who travels from Iowa to Wisconsin on his lawnmower in order to reconcile with his estranged brother. The film concerns the passing of time and time passed. It also concerns slowness and closure as well as the irreversible – visible – imprints made on the body by time passed. As such, the film is definitely anti-morph.

In many of Lynch's films, including *Lost Highway*, as well as in his works in other media, aesthetic inscriptions of time as duration are realized in close-ups of organic processes.[3] In a vignette titled 'Beauty' in his book *Catching the Big Fish*, Lynch says of the transformation caused by time's imprint on materials that:

> When you see an aging building or a rusted bridge, you are seeing nature and man working together. If you paint over a building, there is no more magic to that building. But if it is allowed to age, then man has built it and nature has added to it – it's so organic.
>
> But often people wouldn't think to permit that, except for scenic designers. (Lynch 2006: 119)

I think that Lynch's many images of the seemingly unpainted ordinary face, which becomes extraordinary when mediated by the camera, as seen in *The Straight Story* and *Interview Project*, are expressions of the same kind of organic transformation. What the camera captures in the face is a *texture of ageing*, the

traces of time and lived life's imprint on the body. Unlike in *Lost Highway*, time is omnipresent as a melancholic tone in *The Straight Story*. In contrast to Mystery Man's plain facemask, which resembles a grotesque and impenetrable inorganic screen (like the plastic to which Lynch opposes beautiful wood in the quote above), time has left its mark on Alvin's face in the form of a map (Kember 2004), a crisscross of lines.

The close-ups of Alvin's watery eyes and wrinkled features contribute to the feelings of authenticity conveyed by the story, an authenticity that can never be provided by the smooth, timeless face. The close-up is at once a fragment of a larger cinematic whole and a 'totality in its own right' (Doane 2003: 93). The wrinkled face also constitutes a disparate unity of parts, each of which is a trace of lived experience. In Balázs' words from his famous essays on *The Close-Up* and *The Face of Man*, the close-up establishes a 'profound truth' (1970 [1923]: 75). Balázs argues that the close-up of the face is concrete and individual, 'complete and comprehensible in itself' (61). In the mediated face, we are able to grasp what 'cannot be put into words' (72), providing us with access to 'the bottom of a soul' (63). The close-up establishes proximity and makes us feel that we 'have suddenly been left alone with this one face to the exclusion of the rest of the world', says Balázs (61). But it is also abstract and creates a distance. To grasp the full complexity of Balázs' essay, it is important to note that the precondition for access to the truth in 'the mute soliloquies of physiognomy' (72) is the close-up's creation of distance. Because of this ambiguity (the face is close yet also remote), the close-up can show us 'all the pathos of human greatness' (67). We should also bear in mind that Balázs furthermore regards the close-up as an abstract configuration, pointing to more complicated and inaccessible or uninterpretable layers of meaning on the face. It is also a map. Even though it provides us with a profound sense of truth, it is not necessarily an open book; the truth it reveals may be nothing but the abstract trace of the passing of time. In *The Straight Story*, time has carved its history onto Alvin's face as an enigmatic web of meanings. This face-map cannot be immediately interpreted; however, its traces are connected with the irreversibility of time. As such, the mediated face in the film is profoundly indexical and, in a sense, stands in for the filmic.

The Straight Story has been criticized as procuring a stereotypical image of the American mainland (Johnson 2004) and for not being a proper Lynch film (McGowan 2007).[4] However, the film makes perfect sense in the light of this chapter's approach to Lynch's work. *The Straight Story* is an allegorical *mise-en-scène* of the *medium specificity of film* as it was originally understood, that is, essentially of a *hybrid* nature (Rodowick 2007: 13), an analogue and indexical medium that unfolds simultaneously in time and space. *The Straight Story* is basically a film about duration. It beautifully and melancholically enacts what Rodowick proposes 'we have valued in film', that is, 'our confrontation with time and time's passing' (2007: 73).

On a less abstract level and in the light of the later *Interview Project*, it seems that what Lynch seeks in the film is much more banal than the twisted and complex stories from the cultural and psychological underworld in most of his other films. *The Straight Story* and *Interview Project* are stories about encounters between people and the mutual trust that is a prerequisite for such encounters. *Interview Project* presents 121 encounters between the project's production team (including Lynch's son Austin Lynch but not David Lynch himself) and the people they accidentally meet and ask to interview on their journey through the USA[5] (Figure 1).

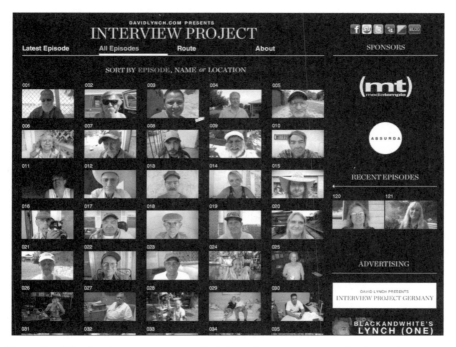

Figure 1: The first thirty interviewees. A click on the image activates the short video (Interview Project).

Interview Project

The *Interview Project* website hosts the 121 documentary interviews, each of them edited down from one or two hours of conversation to 3–5 minutes. The documentaries are *conceived* for the web genre *as much as* they derive from documentary filmmaking traditions (Hight 2008). They thus adhere to forms that the Internet has created such as brevity, community, seriality, sequentiality and

connectedness (community and interactivity) (Birchall 2008: 282). Each sequence is *short*. The project has a *serialized* format. It consists of separate episodes and you must click on each episode individually in order to play it. The films are *sequentialized*. Episodes may be regarded in a random order or sorted by episode, name, or location. Finally, the site invites specific forms of *interactivity* as many of the stories (from Episode 48 onwards) have a commentary link and can be followed on Facebook and Twitter.

But *Interview Project* is more than just 121 documentaries formed by the Internet and hosted by a website. It is a multimedia project – or, semiotically speaking, a multimodal project (Engebretsen 2006) – in which a range of different media (written word, photography, advertisement, logos, graphics and video) converge on a website. Despite the careful cinematic framing with credits of each documentary film, this conventional understanding of the films proves inadequate because it does not account for the ways written text, photography and commentary combine with each film and contribute to the new and diverse digital documentary genre, the *multimedia documentary*.

Each of the documentaries starts with producer credits, 'davidlynch.com presents'. On the soundtrack we hear a – typically Lynchian – scratching polyphony of sounds, like someone turning quickly from station to station on an old-fashioned radio. The letters begin zigzagging and there is a cut to a medium close-up of Lynch himself, which starts in the same manner, distorted in the way that analogue signals react to disturbances. Sitting at his worktable, surrounded primarily by his tools for painting, with distant thunder on the soundtrack, Lynch says 'Hello' and informs us, using a slightly outdated radio metaphor, that we are now '*tuned* into *Interview Project*'. Addressing us in the present tense, he presents the person we are about to meet in one sentence. This sentence is often slightly surreal, as is the case with the introduction to Suzy (Episode 47): 'Today we are meeting Suzy. Suzy is Daniella's aunt.' We do not, of course, know Daniella and Suzy never mentions her in the documentary. After Lynch has invited us to 'Enjoy the interview' and right before the crediting of Lynch's production company, Absurda, there is a cut to a caption stating that opinions in the interview may not correspond with the general views of the *Interview Project*. Simultaneously, the soundtrack features the sound of another analogue medium, this time reminiscent of a gramophone record rotating endlessly in the same groove. Each documentary is thus, in a sense, framed within 'traces of analogue' sounds from the analogue radio and gramophone, just as Lynch himself appears on an apparently analogue screen.

When the mouse touches an icon, a sound bite from the interview emanates from the computer. So if the mouse is hovered quickly across multiple icons, a choir of voices is produced, reminiscent of the analogue radio or as if the voices were united and all speaking at once. There are several entrances to each documentary, but a click on one of the 121 image icons prompts a short written

of *the team's having been there*, once, in a past present. The photographs are not just imprints of what was in front of the camera but also of who was behind the camera at that particular moment in time, watching, listening and recording. Texts, photographs and filmic snapshots add to the interviews what I would call a pro-filmic indexicality – inasmuch as they are traces of objects that were there. The memory of the unique encounter, a prerequisite for the films, are traces, in Wahlberg's (2008) take on the term, images filled with the sentiments of remembrance (Figure 3).

Many of the photographic image memories are visual recollections of objects, landscapes, skies, road signs and so on, fragments of the real as the eyes of the cinematographers captured them. Many of the pictures show the results of 'man and nature working together', picturesque images of rusty tools or ornaments, peeled-off wood surfaces, weeds. However, they are also strong deictic signifiers pointing out, 'We were there, then!' Doane's point (following Peirce) that the index has primarily a deictic function and is thus 'evacuated of content' (Doane 2002: 92) may support an understanding of the sensuous snapshots as not only memory images of things and places but also as indexical traces of a particular communicative act, a meeting.[7] By adding to the monologic, confessional form

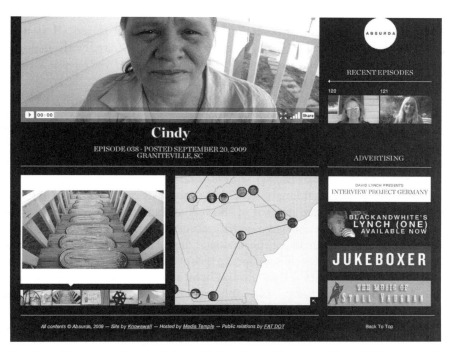

Figure 3: Bottom left the photo frieze and above it an enlargement of one of the photographs (Interview Project).

of the documentaries, the photographs perform *the traces of the former dialogue*. They claim that documentary films (whether shot on analogue or digital film) are never finite and finished works but are, rather, the result of and embedded in encounters as actual communicative processes.

Balázs argues that the face provides us with direct access to the soul. However, certain visual strategies confer a distance upon the close-ups and the people portrayed in *Interview Project*, which despite the spatial closeness and intimacy separates the interviewees from the production team. At the same time as the site contextualizes each interview as social interaction and encounter, the person is captured – and respected – as a stranger. The portraits are thus only superficially created in the manner of the confessional discourses of contemporary first-person media (Dovey 2000). Even though the stories are heavily condensed, the production team maintains the humility they inscribe on the written text by means of a variety of distancing strategies. Interviewees, for instance, occasionally direct their speech to someone outside the image frame instead of to us/the interviewer beside the camera. Interviewees are also sometimes captured by the camera silent and motionless while their recounting continues on the soundtrack. Their voices are also heard over shots of the things surrounding their houses. These momentarily disembodied sounds of the shaky, hoarse, or otherwise deeply personal voices function as aural equivalents to the image memories in the photographic frieze. The *indexical powers* (Rodowick 2007) of this web multimedia documentary, usually associated with analogue film and photography, may therefore be provided precisely by the many indexical traces performed and scattered throughout the site.

In *Interview Project*, the sound of 'analogue' and the distorted screen images in Lynch's introduction, the photographs, the faces, the emphasis on contingency and the careful construction of the site as developing in time may thus be said to *perform* the function of indexical traces. Rosen's tautological term *indexical trace* can point out precisely what is going on in the site. The tautology is reminiscent of Wahlberg's (2008) term *the trace of the trace*. Both designations are open to an understanding of the trace as not only ontologically associated with the film as analogue imprint of the real and indexically pointing to the presence of absence but also as a cinematic strategy. Both terms make it possible to think of the index outside of the analogue-digital divide and more as a sensibility associated with the medium-specific possibilities of a digital genre like the website. *Interview Project* is thus an excellent example of a digital genre that unfolds 'cinematic strategies to stage the image as a trace of the past' (Wahlberg 2008: 57).

In a short video, Lynch presents *Interview Project* as 'a portrait of everyday Americans filmed during an extensive road trip through the United States' (Figure 4). But in reality, the opposite is the case. The large number of films, in their totality, questions the idea of the ordinary or everyday and shows that

Figure 4: *David Lynch introducing* Interview Project.

there is, to a certain extent, no everyday American. The mere abundance of interviews emphasizes the uniqueness of human life and how it is, in all its banality, anything but insignificant. The project team were not looking for eccentrics or people who could tell dramatic or spectacular life stories – even though some deeply traumatic stories are told.

The video ends with a montage of black-and-white shots in which the interviewees repeat one of the existential questions (cut from the interviews) they were asked by the team. For example: How would I describe myself? What were my dreams as a child? Do I have any regrets? What are my plans for the future? What am I most proud of? How would I like to be remembered? Answers to the big and difficult questions posed by the team are often formulated in brief but concise sentences, for instance by 42-year-old Lynn, one of the younger participants (Episode 14). As a child, she was molested by her father and when apparently asked how she would describe herself, she answers, 'How would I describe myself? Broken ... Broken, I guess.' Or the big questions lead to touching, simple answers, like 67-year-old Mike Case (Episode 81), who has said that the most important thing in his life was when he met his wife many years ago. When apparently asked how he would like to be remembered, he answers, 'I would like

to be remembered as George Case's husband, who lived at 404 North Maine Lagan and didn't bother people, just liked to have a pretty house and that's it.'

The many images of worn-out voices, wrinkles and furrows, mottled chins, grey hair and baldness, of reminiscences of strokes, in short, of the traces that the passing of time continuously and irreversibly prints on the body, point in an entirely different direction than the morph's quick-changes. In morphing, time implodes and the transformation leaves no trace, whereas in *Interview Project*, as in *The Straight Story*, traces of time passed abound.

Lynch's project thus enters into dialogue with a central discussion concerning time in modernity, formulated by David Rodowick as 'how we experience or inhabit duration as the passing of present time' (2007: 74). Rodowick phrases this timely tension quite delicately: as human beings, we are placed in a present that contains both past and future and are, in a sense, lost to a present that is never really here. This sentiment is inscribed on the site precisely due to the digital genre's distinctive affordances, which permits the uploading of an infinite number of separate films.

Conclusion

These three works by David Lynch respond in different ways to the changed condition of the filmic in contemporary digital media culture. All three works respond to the phasing out of analogue processes of filmmaking. They relate to time and indexicality in different ways. *Lost Highway* dramatizes the uncanny implosion of time built into the logic of the digital morph, whereas *The Straight Story* and *Interview Project* revolve around time as duration and the passing of time. But unlike *The Straight Story*, which pays tribute to film as a time-based medium, the multimodal documentary site investigates new aesthetic and technological possibilities in film as a digital medium. *Interview Project* experiments with ways of procuring in a digital genre a sense of the analogue indexical that is associated with film. What happens on the website might thus be understood as a performative blurring of the boundaries between the analogue and the digital at the same time as the site blurs the boundaries between art forms and genres into a kind of intermedia composite.

I have regarded *Lost Highway* as a film that to a certain extent thinks through the technological possibilities afforded by digital image manipulation programs. The film constructs a vision of imploding time, the uncanny return of which is emphasized by morphic spectacles. Contrary to this nightmarish rejection of the digital time figure, Lynch's long-standing preoccupations with time as duration and processes of transformation in organic material are inscribed in *The Straight Story* and *Interview Project*, not least by the many images of elderly faces. In both works, the face allegorizes the relationship between time, the index and

Figure 4: David Lynch introducing Interview Project.

there is, to a certain extent, no everyday American. The mere abundance of interviews emphasizes the uniqueness of human life and how it is, in all its banality, anything but insignificant. The project team were not looking for eccentrics or people who could tell dramatic or spectacular life stories – even though some deeply traumatic stories are told.

The video ends with a montage of black-and-white shots in which the interviewees repeat one of the existential questions (cut from the interviews) they were asked by the team. For example: How would I describe myself? What were my dreams as a child? Do I have any regrets? What are my plans for the future? What am I most proud of? How would I like to be remembered? Answers to the big and difficult questions posed by the team are often formulated in brief but concise sentences, for instance by 42-year-old Lynn, one of the younger participants (Episode 14). As a child, she was molested by her father and when apparently asked how she would describe herself, she answers, 'How would I describe myself? Broken ... Broken, I guess.' Or the big questions lead to touching, simple answers, like 67-year-old Mike Case (Episode 81), who has said that the most important thing in his life was when he met his wife many years ago. When apparently asked how he would like to be remembered, he answers, 'I would like

to be remembered as George Case's husband, who lived at 404 North Maine Lagan and didn't bother people, just liked to have a pretty house and that's it.'

The many images of worn-out voices, wrinkles and furrows, mottled chins, grey hair and baldness, of reminiscences of strokes, in short, of the traces that the passing of time continuously and irreversibly prints on the body, point in an entirely different direction than the morph's quick-changes. In morphing, time implodes and the transformation leaves no trace, whereas in *Interview Project*, as in *The Straight Story*, traces of time passed abound.

Lynch's project thus enters into dialogue with a central discussion concerning time in modernity, formulated by David Rodowick as 'how we experience or inhabit duration as the passing of present time' (2007: 74). Rodowick phrases this timely tension quite delicately: as human beings, we are placed in a present that contains both past and future and are, in a sense, lost to a present that is never really here. This sentiment is inscribed on the site precisely due to the digital genre's distinctive affordances, which permits the uploading of an infinite number of separate films.

Conclusion

These three works by David Lynch respond in different ways to the changed condition of the filmic in contemporary digital media culture. All three works respond to the phasing out of analogue processes of filmmaking. They relate to time and indexicality in different ways. *Lost Highway* dramatizes the uncanny implosion of time built into the logic of the digital morph, whereas *The Straight Story* and *Interview Project* revolve around time as duration and the passing of time. But unlike *The Straight Story*, which pays tribute to film as a time-based medium, the multimodal documentary site investigates new aesthetic and technological possibilities in film as a digital medium. *Interview Project* experiments with ways of procuring in a digital genre a sense of the analogue indexical that is associated with film. What happens on the website might thus be understood as a performative blurring of the boundaries between the analogue and the digital at the same time as the site blurs the boundaries between art forms and genres into a kind of intermedia composite.

I have regarded *Lost Highway* as a film that to a certain extent thinks through the technological possibilities afforded by digital image manipulation programs. The film constructs a vision of imploding time, the uncanny return of which is emphasized by morphic spectacles. Contrary to this nightmarish rejection of the digital time figure, Lynch's long-standing preoccupations with time as duration and processes of transformation in organic material are inscribed in *The Straight Story* and *Interview Project*, not least by the many images of elderly faces. In both works, the face allegorizes the relationship between time, the index and

the analogue. As such, it stands in for the filmic. Furthermore, the images of the ageing and seemingly naked face and the often worn-out bodies, worked upon by time, correspond to the amalgamation between man-made and natural, such as the old building or the rusted bridge spoken of by Lynch.

The Straight Story and *Interview Project* narrativize the passing of continuous time. Both works deliver a strong sense of indexicality. Interestingly, however, the website seems to be a perfect platform for combining Lynch's two-fold interest in new and old media – to exploit the many aesthetic possibilities of digital equipment and to simultaneously confer traces of analogicity upon the digital surface.[8] The website makes us aware that, in digital visual media, indexicality can be performed by means of a wide range of audiovisual strategies, such as the face, or references to the sounds of analogue media. *Interview Project* is a contemporary media work that lends support to both Philip Rosen's and Tom Gunning's arguments against regarding analogue and digital as opposite terms. Rosen coins the term *digital mimicry* for the ability of digital media to imitate photographic or filmic forms as one example of the complex intertwining of digital and analogue. He even suggests the contradictory term *digital indexicality* in order to understand the ways in which certain kinds of surveillance technology work (Rosen 2001: 307–09). A term such as *performing the index* or *performing the analogue* could be another means of designating new ways for the filmic and its indexical powers to be transposed into digital media and genres.

Notes

1 At the time of finishing this article it is not possible to access *Interview Project* directly from www.davidlynch.com anymore. Formerly, it was possible to link directly from David Lynch's homepage to *Interview Project* (www.interviewproject. davidlynch.com) without a password. *Interview Project* received a Webby Award in 2010. The Webby Award honours excellence on the Internet in many different categories. *Interview Project* received the award in the Documentary Series category.

2 Lynch tells Chris Rodley that Francis Bacon is his 'number one kinda hero painter' (Rodley 1997: 17). See also Hainge (2004), who refers to the same passage in the script; his point, however, involves Bacon similarities rather than morphing.

3 In Toby Keeler's 1997 documentary *Pretty as a Picture: The Art of David Lynch*, Lynch discusses the effort of conferring upon the camera an apparent analogicity and tactility akin to that of the painter's hand when he uses a brush. Similarly, in the film, his previous wife says of his experiments in combining painting and organic matter (for example, raw meat) that 'He wanted his paintings to move. He wanted them to do more. He wanted them to make sounds.'

4 See also Lynch's remarks in Sragow (1999).

5 A smaller *Interview Project* has been completed in Germany (www.interviewproject.de), also presented by David Lynch and directed by Austin Lynch.

6 This stress on reciprocity in the interviews runs counter to the emphasis on the one-sided distribution of power in most documentary discourses, as put forward by Nichols (1991).

7 Rodowick makes a similar point. He refers to Philippe Dubois for the argument that 'while photographic indexicality designates and attests, it does not necessarily *signify*' (Rodowick 2007: 75).

8 For further discussions of Lynch and the digital, especially in relation to *Inland Empire*, see Jerslev (2012).

References

Balázs, Béla (1970 [1923]). 'The Close-up' and 'The Face of Man', in Béla Balázs, *Theory of the Film: Character and Growth of a New Art*. New York: Dover, pp. 52–88.

Barthes, Roland (1980). *La Chambre claire. Note sur la photographie*. Paris: Cahiers du Cinéma and Gallimard Seuil.

Birchall, Danny (2008). 'Online Documentary', in Thomas Austin & Wilma de Jong (eds), *Rethinking Documentary: New Perspectives, New Practices*. Maidenhead/New York: McGraw Hill, pp. 278–84.

Doane, Mary Ann (2002). *The Emergence of Cinematic Time: Modernity, Contingency, the Archive*. Cambridge, Mass: Harvard University Press.

――― (2003). 'The Close-Up: Scale and Detail in the Cinema', *Differences*, 14: 3, Fall, pp. 89–111.

Dovey, Jon (2000). *Freakshow: First Person Media and Factual Television*. London: Pluto Press.

Engebretsen, Martin (2006). 'Making Sense with Multimedia: A Text Theoretical Study of a Digital Format Integrating Writing and Video', *Seminar.net*, *International Journal of Media, Technology and Lifelong Learning*, 2 (1).

Gunning, Tom (2008). 'What's the Point of an Index? Or, Faking Photographs', in Karen Beckman & Jean Ma (eds), *Stillmoving: Between Cinema and Photography*. Durham/London: Duke University Press, pp. 23–41.

Hainge, Greg (2004). 'Weird or Loopy: Specular Spaces, Feedback and Artifice in *Lost Highway*'s Aesthetics of Sensation', in Erica Sheen & Annette Davison (eds), *The Cinema of David Lynch: American Dreams, Nightmare Visions*. London/New York: Wallflower, pp. 136–51.

Hight, Craig (2008). 'The Field of Digital Documentary: A Challenge to Documentary Theorists', *Studies in Documentary Film*, 2:1, pp. 3–7.

Jerslev, Anne (2004). 'Beyond Boundaries: David Lynch's *Lost Highway*', in Erica Sheen & Annette Davison (eds), *The Cinema of David Lynch: American Dreams, Nightmare Visions*. London/New York: Wallflower, pp. 151–65.

――― (2012). 'The post-perspectival: screens and time in David Lynch's *Inland Empire*', *Journal of Aesthetics and Culture*, 4. Available at http://www.

aestheticsandculture.net/index.php/jac/article/view/17298, last accessed 12 November 2012.

Johnson, Jeff (2004). *Pervert in the Pulpit: Morality in the Works of David Lynch.* Jefferson, NC and London: McFarland.

Kember, Joe (2004). 'David Lynch and the Mug Shot: Facework in *The Elephant Man* and *The Straight Story*', in Erica Sheen & Annette Davison (eds), *The Cinema of David Lynch: American Dreams, Nightmare Visions.* London: Wallflower, pp. 19–35.

Krasniewicz, Louise (2000). 'Magical Transformations: Morphing and Metamorphosis in Two Cultures', in Vivian Sobchack (ed.), *Meta-Morphing: Visual Transformation and the Culture of Quick-Change.* Minneapolis/London: University of Minnesota Press, pp. 41–59.

Lynch, David (2006). *Catching the Big Fish: Meditation, Consciousness, and Creativity.* London: Penguin.

Lynch, David and Barry Gifford (1997). *Lost Highway.* London and Boston: Faber and Faber.

McGowan, Todd (2007). *The Impossible David Lynch.* New York: Columbia University Press.

Mulvey, Laura (2006). *Death 24x a Second: Stillness and the Moving Image.* London: Reaktion Books.

Nichols, Bill (1991). *Representing Reality.* Bloomington/Indianapolis: Indiana University Press.

Nochimson, Martha P. (1997). *The Passion of David Lynch.* Austin: University of Texas Press.

Rodley, Chris (1997). *Lynch on Lynch.* London/Boston: Faber and Faber.

Rodowick, David N. (2007). *The Virtual Life of Film.* Cambridge, MA/London: Harvard University Press.

Rosen, Philip (2001). *Change Mummified: Cinema, Historicity, Theory.* Minneapolis/London: University of Minnesota Press.

Sobchack, Vivian (2000a). 'Introduction', in Vivian Sobchack (ed.), *Meta-Morphing. Visual Transformation and the Culture of Quick-Change.* Minneapolis/London: University of Minnesota Press, pp. xi–xxiii.

_____ (2000b). '"At the Still Point of the Turning World": Meta-Morphing and Meta-Stasis', in Vivian Sobchack (ed.), *Meta-Morphing: Visual Transformation and the Culture of Quick-Change.* Minneapolis/London: University of Minnesota Press, pp. 131–159.

Sragow, Michael (1999), 'I Want a Dream When I Go to a Film', *Salon.com.* Available at http://www.salon.com./ent/col/srag/1999/19/28/lynch/index.html, last accessed August 20 2012.

Wahlberg, Malin (2008). *Documentary Time: Film and Phenomenology.* Minneapolis and London: University of Minnesota Press.

Zizek, Slavoj (2000). *The Art of the Ridiculous Sublime: On David Lynch's Lost Highway.* Seattle: Walter Chapin Simpson Center for the Humanities.

Index

Index of Films